TEXTILE DESIGN AND COLOUR

TEXTILE DESIGN AND COLOUR

COLOUR

ELEMENTARY WEAVES AND FIGURED FABRICS

BY

WILLIAM WATSON

SUPERINTENDENT AND LECTURER IN TEXTILE MANUFACTURE, THE ROYAL
TECHNICAL COLLEGE, GLASGOW; FORMERLY HEADMASTER OF THE
TEXTILE DEPARTMENTS OF THE ROYAL TECHNICAL INSTITUTE,
SALFORD, AND THE TECHNICAL SCHOOL, SHIPLEY

WITH DIAGRAMS

LONGMANS, GREEN AND CO.
39 PATERNOSTER ROW, LONDON
NEW YORK, BOMBAY, AND CALCUTTA
1912

PREFACE

AN exhaustive treatise on the designing and colouring of textile fabrics has been found by the writer to be much beyond the scope of a single volume, and this book deals chiefly with cloths that are composed of one series of warp and one series of weft threads. The subject is continued in a second volume—entitled *Advanced Textile Design*—which treats on compound and special classes of cloths.

In the following pages the construction and combination of simple and special weaves, the structure of standard classes of cloths, the theories of colour, and the application of colours to textile fabrics are described and illustrated; while the designing of ordinary figured fabrics, to which eight chapters are devoted, forms a very important section of the work. Textile calculations, and the principles and limitations of weaving machinery, so far as they concern woven design, are fully dealt with. The illustrations form a distinct feature in both number and quality, and there are 413 figures which include over 1800 different diagrams, designs, and representations of woven fabrics.

The chapters on the designing of figured fabrics have previously appeared in the form of serial articles in the *Textile Recorder*, while the section on colour and weave effects has similarly been published in the *Textile Manufacturer*. The writer is indebted to the editors and proprietors of these journals for encouragement in the preparation of the articles. In re-issuing this matter in book form many of the original illustrations have been used, but opportunity has been taken to carefully revise the text, and to introduce new examples. And to the matter which has been previously published eleven chapters have been added, in order to make the book a complete work on the designing and colouring of the simpler classes of cloths.

To the publishers and printers the writer wishes to express his indebtedness for the regard they have had to his wishes in the preparation of the book.

W. W.

GLASGOW, *October*, 1912.

A 1

CONTENTS

CHAPTER I

CONSTRUCTION OF SIMPLE WEAVES

CHAPTER II

CONSTRUCTION OF DRAFTS AND WEAVING OF PEGGING PLANS

CHAPTER III

ELEMENTARY WEAVES AND THEIR BASES

CHAPTER IV

FANCY TWILLS AND DIAMOND DESIGNS

CHAPTER V

CONSTRUCTION OF SIMPLE SPOT FIGURE DESIGNS

CHAPTER XI

APPLICATION OF COLOUR—COLOUR AND WEAVE EFFECTS

CHAPTER XII

COLOUR AND WEAVE STRIPES AND CHECKS

CHAPTER XIII

SPECIAL COLOUR AND WEAVE EFFECTS

CHAPTER XIV

JACQUARD MACHINES AND HARNESSES

CHAPTER XV

JACQUARD FIGURED FABRICS—POINT-PAPER DESIGNING

CHAPTER XVI

COMPOSITION OF DESIGNS AND ARRANGEMENT OF FIGURES

CHAPTER XVII

HALF-DROP DESIGNS

CHAPTER XVIII

DROP-REVERSE DESIGNS

CHAPTER XIX

SATEEN SYSTEMS OF ARRANGEMENT

CHAPTER XX

CONSTRUCTION OF DESIGNS FROM INCOMPLETE REPEATS

CHAPTER XXI

FIGURING WITH SPECIAL MATERIALS

TEXTILE DESIGN AND COLOUR

CHAPTER I

CONSTRUCTION OF SIMPLE WEAVES

Classification of Woven Fabrics. Design Paper. Plain Weave. *Weaves derived from Plain Weave*—Warp Rib Weaves—Weft Rib Weaves—Hopsack, Mat, or Basket Weaves—Denting of Weft Rib and Hopsack Weaves. Repetition of Weaves. Drawing of Flat-Views and Sections of Cloths. *Simple or Ordinary Twill Weaves*—Relative Firmness of Twill Weaves—Large Twills or Diagonals. Influence of the Twist of the Yarns. *Sateen Weaves*—Regular Sateen Weaves—Irregular Sateen Weaves.

CLASSIFICATION OF WOVEN FABRICS

Woven fabrics are composed of longitudinal or warp threads and transverse or weft threads, which are interlaced with one another according to the class of structure and form of design that are desired. The terms " chain " and " twist " are applied to the warp, and the warp threads are known individually as " ends," while the terms " picks " and " filling " are applied to the weft threads. In the following the term threads is used in referring to warp and weft collectively, but in order to clearly distinguish one series from the other the warp threads are mostly described as " ends," and the weft threads as " picks."

Woven textures may be conveniently divided into three principal classes, as follows :—

(1) Fabrics in which the ends and picks intersect one another at right angles, and in the cloth are respectively parallel with each other. In addition to " single or simple " cloths which are composed of one series of ends and one series of picks, this class includes compound textures that contain two or more series of ends, or picks, or both ends and picks, as in extra warp and extra weft-figured styles and backed, double, treble, etc., cloths.

(2) Cloths in which certain of the ends interweave alternately to right and to left of adjacent ends. Gauze and leno fabrics of all kinds are included in this class, and also lappet structures.

(3) Pile or plush fabrics in which a portion of the threads (either warp or weft) project from a foundation cloth and form a nap or pile on the surface.

DESIGN PAPER

The order in which the warp and weft threads interweave in a fabric, or are required to interweave, can be conveniently indicated upon design or point-paper. The paper is ruled in vertical parallel lines, as shown at A in Fig. 1, the spaces between which represent warp threads ; and in horizontal parallel lines, as shown at B, the spaces between the lines in the latter representing weft threads. The crossing of the lines divides the paper into small rectangular spaces, as shown at

1

C; and in indicating a design it is necessary to consider the paper, not as small rectangular spaces, but as vertical spaces or warp threads, which are crossed by horizontal spaces or weft threads. That is, each small rectangular space represents a position where a warp and a weft thread cross one another; hence, the insertion of a mark on a space may be taken to indicate that one thread passes over the other. According to the idea of the designer the marks may indicate ends passing over picks (warp up), or picks passing over ends (weft up); the blanks, in either case, representing the opposite of what the marks indicate. Thus, the cross shown in C (Fig. 1) may indicate either that the second end passes over the second pick, or that the second pick passes over the second end, according to whether the marks indicate warp up or weft up. In the same manner the dot indicated in C may show that the sixth end passes over the fifth pick, or the fifth pick over the sixth end. As a further illustration, D in Fig. 1 is a flat view diagram showing the interlacing of the threads in plain cloth; if warp on the surface is indicated (that is, if the marks indicate how the ends are raised during weaving) the structure will be represented as shown at E. On the other hand, if the marks

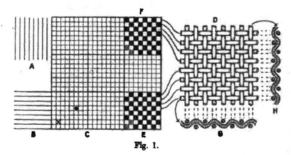

Fig. 1.

are taken to represent weft on the surface, the structure will be indicated as shown at F. Conversely, the blank spaces in E correspond with the positions where the weft is on the surface, and in F, where the warp is on the surface. Marking either for " weft up " or " warp up " may be practised; the designer should be accustomed to both methods, as frequently the type of design or class of structure renders one method more convenient than the other.

An arrangement of marks, to correspond with a given or required order of interlacing, is termed a plan, weave, or design; and it may extend over two, or any greater number of vertical and horizontal spaces of the point-paper. In each vertical and each horizontal space of a design, there must be at least one mark and at least one blank.

Design paper is divided by thick lines into a series of squares, as shown at C in Fig. 1, in which every eighth line, both vertically and horizontally, shows more prominently than the others. In the construction of small weaves the presence of the thick lines is chiefly of use in facilitating the counting of the spaces or threads, the number of spaces between the thick lines being immaterial except in special cases; paper which is divided in eighths (8 × 8) is extensively used. In the construction of large designs, however, it is necessary to use design paper which is

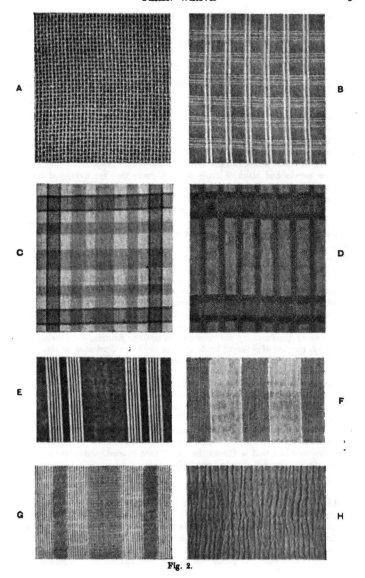

Fig. 2.

ruled to suit the ratio of warp threads to weft threads, while the arrangement of the hooks and needles in a jacquard is a determining factor. Examples of differently ruled paper are given in Fig. 258.

PLAIN WEAVE

In plain weave the threads interlace in alternate order, and if the warp and weft threads are balanced—that is, are similar in thickness and number per unit space, the two series of threads bend about equally. This is illustrated at G in Fig. 1, which shows how the first pick of E interlaces, and at H, which represents the interlacing of the last end of E. In this class of plain cloth each thread gives the maximum amount of support to the adjacent threads, and in proportion to the quantity of material employed, the texture is stronger and firmer than any other ordinary cloth. The weave is used for structures which range from very heavy and coarse canvas and blankets made of thick yarns that are numbered by the yards per ounce, to the lightest and finest cambrics and muslins, which are made in cotton yarns of 150's count and upwards. In the trade such terms as tabby, calico, alpaca, and taffeta are applied to plain cloth.

Plain weave produces the simplest form of interlacing, but it is used to a greater extent than any other weave, and diverse methods of ornamenting and of varying the structure are employed, as for example : Threads which are different in colour, material, thickness, or twist are combined ; the number of threads per split of the reed, or of picks in a given space, is varied in succeeding portions of a cloth ; the ends are brought from two or more warp beams which are differently tensioned, or are passed in sections over bars by which they are alternately slackened and tightened ; while by means of a specially shaped reed which rises and falls the threads are caused to form zig-zag lines in the cloth. Two or more of the foregoing methods may be employed in the same cloth, and after weaving further variety may be produced by the processes of dyeing, printing, mercerising, and finishing. A number of different kinds of plain cloth are illustrated in Fig. 2. A represents a plain white canvas cloth ; B shows the combination of threads which vary in thickness in both warp and weft ; in C the threads are all of the same thickness, but different colours are combined in check form ; in D the threads are the same in colour, but in both warp and weft they vary in material (silk and cotton) and in thickness ; E illustrates the combination of threads which are different in colour and in thickness ; in F the pattern is formed by combining different orders of denting ; G shows a crinkled or " crepon " stripe produced by using two warp beams which are differently tensioned ; while H represents an all-over crepon effect that is due to the use of hard-twisted (crepon) weft which, when the cloth is scoured, shrinks irregularly.

WEAVES DERIVED FROM PLAIN WEAVE

The next simplest form of interlacing to plain weave consists of extending the latter either vertically, or horizontally, or both vertically and horizontally, by which warp rib, weft rib, and hopsack or mat weaves are respectively produced.

Warp Rib Weaves.—These result from extending the plain weave vertically, as shown in the examples given at A to F in Fig. 3. A, B, and C produce regular warp ribs in which each end passes alternately over and under 2, 3, and 4 picks

respectively, and is brought prominently to the surface on both sides of the cloth. This is shown at G in Fig. 3, which indicates how the ends interlace with the picks in the plan A. Lines or ribs, that are equal in size, are formed running the width of the cloth, as shown in Fig. 4, which represents a fabric produced in the weave given at A in Fig. 3.

D, E, and F in Fig. 3 are irregular warp ribs, which produce horizontal lines that are unequal in size. In D and E the odd ends are chiefly on the surface (taking the marks to indicate warp up), while the even ends are mostly on the back, as shown at H, which represents how the threads interlace to correspond with the

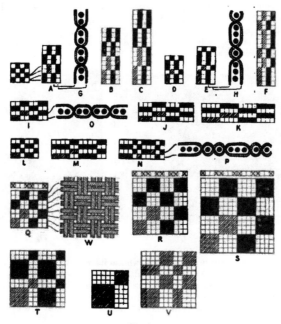

Fig. 3.

weave E. By using a good class of material, such as silk, for the odd ends, and a cheaper material—say, cotton—for the even ends, a cloth with a good appearance may be economically produced in designs such as D and E. In the design F in Fig. 3 a wide rib alternates with two finer ribs, but in this case all the ends are equally on the surface.

Weft Rib Weaves.—These are opposite to warp rib weaves, and result from extending the plain weave horizontally, as shown in the examples I to N in Fig. 3. In I, J, and K, which are regular weft ribs, each pick of weft passes alternately under and over 2, 3, and 4 ends respectively ; the weft is brought prominently

to the surface and forms lines running the length of the cloth on both sides. L, M, and N are irregular weft ribs, which produce longitudinal lines that are unequal in size ; and L and M, in which the even picks are mostly on the surface (taking the marks to indicate warp up), may be economically woven with better material for the even than for the odd picks. The diagrams O and P respectively correspond with the plans I and N, and show how the picks interlace with the ends. The fabric represented in Fig. 4, if turned one-quarter round, will illustrate the appearance of a weft rib weave. (Special classes of rib weaves are described and illustrated in Chapter VII.)

Hopsack, Mat, or Basket Weaves.—These are constructed by extending the plain weave both vertically and horizontally, so that in both directions there are two or more threads working together in the same order. Q, R, and S in Fig. 3 are regular hopsacks arranged respectively 2-and-2, 3-and-3, and 4-and-4 ; the warp and weft show equally on the surface of both sides of the cloth in the form of small equal-sized squares or rectangles. The flat-view given at W represents

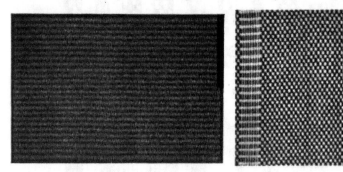

Fig. 4. Fig. 5.

how the threads interlace in the weave Q, while a fabric to correspond is illustrated in Fig. 5. T, U, and V in Fig. 3 are irregular hopsack weaves, which form unequal spaces in the cloth. On account of the loose method in which the threads interlace in ordinary hopsack weaves, large designs are only employed in fine fabrics. Special methods of obtaining greater firmness and variety in the weaves are illustrated in Fig. 75.

Denting of Weft Rib and Hopsack Weaves.—The ends which work together tend to twist or roll round each other as the cloth is woven, and if this takes place the cloth suffers in appearance, while the weaving process is made more difficult. The twisting of the ends can be prevented by denting them in such a manner that those which work alike are separated by the wires of the reed. Above each plan Q, R, and S in Fig. 3 a system of denting is given in which the marks and blanks indicate the order in which the ends are passed together through the reed, the threads of a group being passed through different splits. The same orders of denting are applicable to the weft rib weaves I, J, and K.

Cloths are produced in plain weave which resemble the plan given at A in Fig. 3

by inserting the weft in double picks, and a special effect is sometimes obtained by having differently coloured threads wound alongside each other on the cops or pirns. The withdrawal of the weft in the direction of the length of the pirn or cop causes the threads to make one twist round each other for every revolution made by them on the pirn or cop. The slight amount of twist thus inserted causes the colours to show intermittently in the cloth, an irregular or streaky colour effect being formed, as shown in the fabric represented in Fig. 6. A similar effect to the

Fig. 6.

plan given at I in Fig. 3 is obtained in plain weave by placing two ends in each mail, in which case, if they are differently coloured, the rolling of the threads round each other causes the colours to show intermittently in the cloth.

REPETITION OF WEAVES

Any weave repeats on a certain number of ends and picks (or of vertical and horizontal spaces): generally only one repeat need be indicated on design paper. In most of the examples given in Fig. 3 four repeats are shown, but one exact repeat is indicated by shaded marks. The number of ends and picks in a repeat may be equal, or unequal, but in every case the complete repeat must be in rectangular form on account of the threads interlacing at right angles. For instance, a weave cannot take the form shown at A in Fig. 7; if, as shown in the example, any part of the complete repeat extends over 10 ends and 10 picks, every other portion must extend over 10 ends and 10 picks.

It is necessary for the marks and blanks to join correctly at the sides, and at the top and bottom of a design, in order that when the pattern is repeated in the loom from side to side and from end to end of the cloth an unbroken weave will result. The joining of the repeats of a weave is illustrated at B and C in Fig. 7, in which B shows four complete repeats of a weave on 6 ends and 6 picks detached from each other. In each repeat the last end and pick respectively join correctly with the first end and pick, so that when the repeats are put together, as shown at C, a continuous and unbroken weave is formed. A warp, 30 inches wide, with 80 ends per inch, will contain $30 \times 80 = 2,400$ ends, which will give $2,400 \div 6 = 400$ repeats of the weave B across the width of the cloth.

D and E in Fig. 7 show that a weave may appear different on account of being

commenced in a different position, if only one repeat is shown, but such an altera-
tion does not cause any change in the woven cloth, as either D or E will produce
exactly the same effect as C.

DRAWING OF FLAT-VIEWS AND SECTIONS OF CLOTHS

The representation of simple cloths by means of drawings, used in conjunction
with the design paper method, is of great assistance in enabling systems of inter-
lacing to be understood ; while in many complex structures it is almost impossible
to reason out how the threads interlace without the aid of drawings. A simple,
but convenient, method of constructing flat-views and sections is illustrated at
F to K in Fig. 7. First, vertical and horizontal lines, to represent the positions

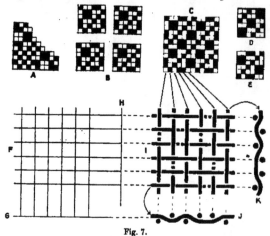

Fig. 7.

of the warp and weft threads, are ruled faintly in pencil about three-sixteenths
of an inch apart, as shown at F, and lines are drawn below and alongside, as
indicated at G and H. The vertical lines are then thickened to correspond
with the surface warp floats, and the horizontal lines to correspond with the
surface weft floats, as shown at I in Fig. 7, which is a representation of one repeat
of the design given at C, the marks in the latter being taken to indicate warp
up. Also, where there is a float on the underside the lines are dotted between
the threads. D in Fig. 1. and W in Fig. 3 illustrate more elaborate methods
of constructing flat-views, in both of which each thread is first represented by
a double base line.

In constructing the warp section given at J in Fig. 7, which shows how the
first pick of I interlaces, the ends that are raised are indicated above, and those
that are depressed, below the construction line G, the interlacing of the pick being
then readily shown. A similar method is employed in drawing the section through
the weft given at K, which shows how the last end of I interlaces with the picks.
(The foregoing method of constructing sections is sufficiently accurate when they

are drawn in conjunction with a flat-view, but a more correct method is illustrated in Fig. 11, in which the threads that are floated over in succession are placed close together.)

SIMPLE OR ORDINARY TWILL WEAVES

The twill order of interlacing causes diagonal lines to be formed in the cloth, as shown in the fabric represented in Fig. 8. The weaves are employed for the purpose of ornamentation, and to enable a cloth of greater weight, substance, and firmness to be formed than can be produced in similar yarns in plain weave. Twilled effects are made in various ways, but in simple or ordinary twills (which are now under consideration) the points of intersection move one outward and one upward on succeeding picks. A twill cannot be made upon two threads, but upon any number that exceeds two; a simple twill is complete upon the same number of picks as ends (or of horizontal spaces as vertical spaces). Twill lines are formed on both sides of the cloth, and the direction of the lines may be either to the right or to the left, but the direction on one side is opposite to that on the other side when the cloth is turned over. Warp and weft floats on one side of the cloth respectively coincide with weft and warp floats on the other side;

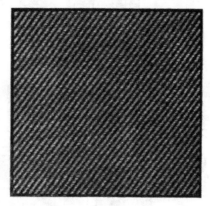

Fig. 8.

thus, if warp float predominates on one side weft float will predominate in the same proportion on the other side.

A, B, C, and D in Fig. 9 illustrate all the possible ways in which twills on three threads may be woven. If A forms the face C will form the reverse side when the cloth is turned over, and *vice versa*; and in the same manner B and D are the reverse of each other. Actually only one twill order of interlacing—viz., 1-and-2—is possible on three threads, but, as shown at A, B, C, and D, the twill may run either to right or left, and there may be either one-third or two-thirds of either yarn on the surface The terms " Cashmere," " Jean," " Jeannette," and " Genoa " are applied to the 1-and-2 twill.

On four threads two twill orders of interlacing can be made—viz., 1-and-3 and 2-and-2—but as the 1 and-3 order may be arranged with either weft or warp predominating, three different twills can be formed, each of which may be inclined in either direction. Hence twills on four threads may be formed in six ways, as shown at E, F, G, H, I, and J in Fig. 9. The weaves E, F, and G on one side will have H, I, and J respectively on the other side when the cloth is turned over. Next to plain weave the 2-and-2 twill, which is similar in appearance to Fig. 8, is probably used more than any other weave, and it is known by special terms ;

as, for instance, " serge," " blanket," " sheeting," " shalloon," and " cassimere." The term swansdown is applied to the 1-and-3 twill weave.

On five threads six twill weaves, running to the right, may be woven, as shown at K to P in Fig. 9, while similar effects may be made twilling to the left. K and N are opposite to each other, and also L and M, and O and P; therefore, if one weave of a pair is formed on the face, the other weave will be formed on the reverse side, but twilling in the opposite direction, when the cloth is turned over. Actually, there are only three different orders of interlacing, and the six weaves can be

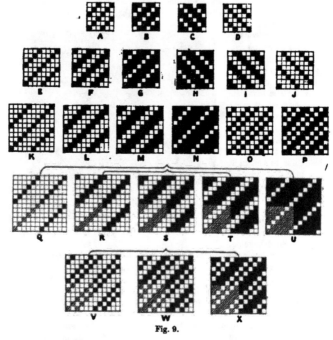

Fig. 9.

obtained from the plans K, L, and O by taking the marks to indicate first warp up, and then weft up.

The complete series of 6-thread twills, running to the right, is given at Q to X in Fig. 9, and, as before, each twill may be inclined in the opposite direction. There are really only five different orders of interlacing, as the weaves that are bracketed together are alike except that in one the marks predominate, and in the other the blanks. In S and W the warp and weft floats are equal, and each produces the same effect on both sides of the cloth, but the twill lines run in opposite directions. Fig. 8 illustrates the appearance of the Design S.

A systematic method of constructing simple twills is illustrated in Fig. 10,

which shows all the possible effects on seven threads. A single row of marks is inserted in the first weave A, then in each weave B to F a line of marks is successively added alongside. Commencing again with A, a single line of marks, separated by one space from the marks previously inserted, is added to A, B, C, and D, as shown at G, H, I, and J ; then the single line is placed two spaces distant, as shown at K, L, and M ; and afterwards three spaces apart, as indicated at N and O. A double line of marks is then added to A, B, and C with one space between, as shown respectively at P, Q, and R ; then to A and B with two spaces between, as indicated at S and T ; and afterwards to A with three spaces between, as shown at U. A commencement is again made with A, and two separate lines of marks are added, as shown at V and W.

The process may be carried still further in constructing twills on a larger number of threads, and by working systematically, as shown in the foregoing, it is possible to ensure that all the possible twills are obtained. It is necessary, however, to examine the weaves carefully, and weed out those that are duplicates of others. In Fig. 10, for the purpose of illustration, duplicate weaves (which are indicated in dots) are included, and it will be found that H, O, P, and U are alike, also I and M, K and N, L and S, and Q and T. A close

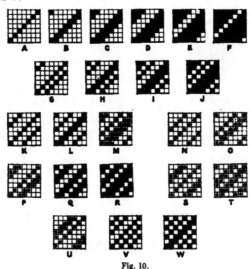

Fig. 10.

examination will also show that seven threads only give eight different twill orders of interlacing, since in the following pairs the weaves are opposite to each other :—A and F, B and E, C and D, G and J, H and I, K and R, L and Q, and V and W. Further, it will be seen that each plan A to F contains one warp and one weft float in the repeat, or is in two parts ; each plan G to U contains two warp and two weft floats in the repeat, or is in four parts ; while in V and W a repeat contains three warp and three weft floats, or is in six parts.

Relative Firmness of Twill Weaves.—Where a weave changes from marks to blanks, and *vice versa*, the warp and weft threads correspondingly change from one side of the cloth to the other, or " intersect " each other. Each thread must make at least two intersections in a complete repeat of a weave, one in passing from the face to the back, and another in passing from the back to the face ; otherwise

the thread will float continuously on one side of the cloth. The intersecting of the threads gives the cloth firmness, and (with certain exceptions) the more frequent the intersections are the firmer the cloth is. If a twill fabric is correctly built " on the square "—that is, with the warp and weft threads equal in thickness and in number per inch—each intersection causes the threads to be separated by about the thickness of a thread. Therefore, other things being equal, the more frequently the intersections occur the further apart should the threads be placed. This is illustrated in Fig. 11, in which three 8-thread twill weaves are given at A, B, and C, while the interlacings of the first pick of the designs are represented at D, E, and F respectively, the marks being taken to indicate warp float. The dotted vertical lines are placed apart a distance equal to the diameter of a thread, and each intersection is taken to occupy a space equal to a diameter. (This is not strictly accurate, but is near enough for practical purposes.) Weave A repeats on eight threads,

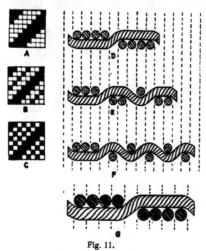

Fig. 11.

and each thread has two intersections, and thus occupies the space of ten diameters, as shown at D ; the repeat of B contains eight threads and four intersections, and thus occupies the space of twelve diameters, as represented at E ; while in the repeat of C there are eight threads and six intersections, which occupy the space of fourteen diameters, as indicated at F.

It will be readily understood that a cloth, which is of suitable firmness when woven in the weave C, will be looser if woven in the weave B, and will be still more lacking in firmness if woven in the weave A. That is, assuming that the warp and weft threads are the same thickness in each case, B will require more threads per unit space than C, and A than B ; the relative proportions being (approximately) A 12 threads to B 10 threads ; A 14 threads to C 10 threads ; and B 14 threads to C 12 threads. On the other hand, assuming that the threads per unit space are the same in each case, thicker threads can be employed for A than for B, and for B than for C. This is illustrated at G, which represents the thickness of the yarn (approximately) that can be employed for the weave A if the threads per unit space are the same as for the weave C. It will be seen that 10 diameters in G occupy the space of 14 diameters in F. A loose weave (such as A), therefore, allows more yarn to be put into a cloth than a firmer weave (such as B), and permits a heavier cloth to be formed.

Large Twills or " Diagonals."—The term " diagonal " is applied to large twills, particularly those which show a prominent line, as in the example repre-

weft threads may be placed in relation to each other as regards the direction of the twist. In C the warp twist is as shown at A, and the weft twist as at B, the surface direction of the twist being to the right in both threads when the weft is laid at right angles to the warp. D is the exact opposite of C, the surface direction of the twist being to the left. In E both series of threads are twisted as shown at A, and in F as at B. In C and D the direction of the twist, on the under side of the top thread, is opposite to that on the upper side of the lower thread, hence the threads do not readily bed into, but tend to stand off from each other, which assists in

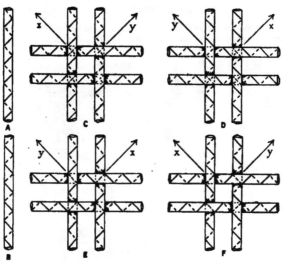

Fig. 14.

showing up the weave and structure of the cloth distinctly. In E and F, on the other hand, the twist on the underside of the top thread is in the same direction as that on the upper side of the lower thread, hence in this case the conditions are favourable for the threads to bed into each other and form a compact cloth in which the weave and thread structure are not distinct.

In twill fabrics the clearness and prominence of the twill lines are accentuated if their direction is opposite to the surface direction of the twist of the yarn. If, however, the lines of a twill are required to show indistinctly, the twill should run the same as the surface direction of the twist of the yarn. If one yarn predominates on the surface the twill should oppose, or run with, the twist of the surface threads according to whether the effect is required to show prominently or otherwise. Thus, in C and D in Fig. 14 the arrows X indicate the direction in which the twill should run if the lines are required to show boldly and clearly, and the arrows Y if an indistinct twill effect is desired. In E and F the arrows X show the proper direction for producing a bold twill, and the arrows Y for producing an indistinct

twill if the weft yarn predominates on the surface. If, however, the warp forms the face of the cloth in E and F, the arrows Y indicate the proper direction for a bold twill effect, and the arrows X for an indistinct twill.

If a twill runs both to right and left in a cloth (a herring-bone twill), it shows more clearly in one direction than the other. Also, the difference in the appearance of right and left twist is sufficient to show clearly in a twill fabric in which the weave is continuous, and "shadow" effects are produced in warp-face weaves by employing both kinds of twist in the warp threads.

SATEEN WEAVES

In pure sateen weaves the surface of the cloth consists almost entirely either of weft or warp float, as in the repeat of a weave each thread of one series passes

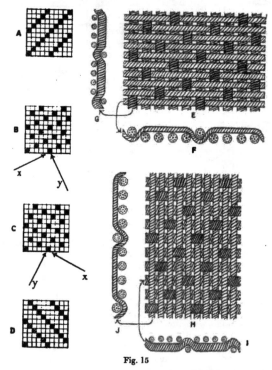

Fig. 15

over all but one thread of the other series. The production of what is practically a solid weft or a solid warp surface is a valuable feature in certain fabrics, but this is by no means the limit of the usefulness of sateens, as they are extensively

employed as bases of textile designs. The weaves are of two kinds—viz., regular sateens and irregular sateens.

Regular Sateen Weaves.—The examples given in Fig. 15 will enable the construction of twills and regular sateens to be compared. In twill weaves the distance from a mark on one thread to the corresponding mark on the next thread—termed a step, move, or count—is one, hence in the cloth the intersections support each other, and distinct twill lines are formed. In regular sateen weaves the step, move, or count is more than one, so that the intersections do not support each other, but as the distance moved each time is equal and regular a certain degree of twilliness is formed in the cloth. In the same yarn the prominence of the twill line varies according to (a) the order in which the threads interlace; and (b) the direction of the twill line in relation to the direction of the twist of the yarn. In the best regular sateens the points of intersection are equally distributed over the repeat area, and if the twill lines and the twist run in the same direction, a smooth, lustrous, and almost untwilled surface is formed.

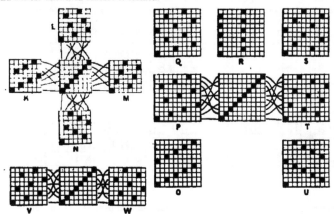

Fig. 16.

In Fig. 15, A shows a 5-thread twill in which the marks are arranged in the order of 1, 2, 3, 4, and 5 ; in B the move or count is two to the right, hence the marks are indicated on the spaces in the order of 1, 3, 5, 2, and 4 ; while in C the count is three to the right, the order of arrangement being 1, 4, 2, 5, and 3. By counting one less than the number of threads in the repeat a reversed twill is produced, as shown at D in Fig. 15. If a weft sateen surface is required the marks will represent warp up, and the angle of the twill line will be that indicated by the arrows X. If, however, the surface is warp sateen the marks will represent weft up, and the arrows Y will indicate the angle of the twill line. The designs B and C are alike, except that the twill lines run in opposite directions.

E in Fig. 15 shows a flat view of the plan B, assuming that a weft surface is formed, while F represents the interlacing of the first pick, and G of the first end. If the twist in the yarn is in the direction indicated on the threads in E the twill

2

lines will show indistinctly. (The term " broken twill " is applied to 5-thread weft
sateen cotton fabrics in which the twill line is scarcely discernible.) The flat view,
given at H in Fig. 15, corresponds with the design B, assuming that a warp surface
is formed, the interlacing of the third pick being represented at I, and of the first
end at J. In this case if the threads are twisted in the direction indicated, a rather
distinct twill, running to the left, will be formed. (In cotton cloths the term " drill "
is frequently applied to this structure.)

All the possible sateens on seven threads are given in Fig. 16 at K, L, M, and
N, the threads of which are shown connected by lines with the 1-and-6 twill. K
is constructed by counting two, L by counting three, M by counting four, and N
by counting five, in each case to the right on succeeding picks. It will be seen,
from an examination of the foregoing weaves, that the move may be either upward
or outward; thus, in K the count upwards is four; in L, five; in M, two; and
in N three on succeeding ends. N is similar to K, and M to L, but twilling in the
opposite direction, and it will be noted that in each design the count is two either
outward or upward, and to right or left. A typical sateen structure is not produced

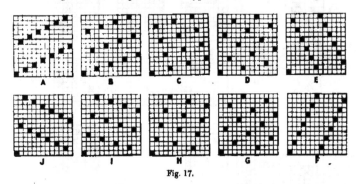

Fig. 17.

on seven threads, because the points of intersection fall into distinct lines in one
or other direction.

O, P, Q, R, S, T, and U in Fig. 16 are constructed on ten threads by counting
2, 3, 4, 5, 6, 7, and 8 respectively, but only P (counting 3) and T (counting 7),
which are similar but twilling in opposite directions, are proper weaves. In each of the
others no marks are placed on some of the threads, hence 2, 4, 5, 6, and 8 cannot
be counted in designing sateens on ten threads. From the example the following
rule for the construction of regular sateens may be drawn :—Any number (with
the exception of one, and a number that is one less than the number of threads
in the repeat) may be counted which has no measure in common with the number
of threads in the repeat of the weave. Similar effects, but twilling in opposite
directions, are produced by counting in numbers that are respectively higher and
lower than half the number of threads in the repeat. Thus, on eight threads, only
3 and 5 can be counted, which produce similar but opposite twilling effects, as
shown at V and W in Fig. 16.

In Fig. 17 all the possible sateens on thirteen threads are given at A, B, C,

D, E, F, G, H, I, and J, which are produced by counting 2, 3, 4, 5, 6, 7, 8, 9, 10, and 11 respectively. Similar sateens result from counting 2 and 11, 3 and 10, 4 and 9, 5 and 8, and 6 and 7, and in Fig. 17 the weaves are arranged in pairs one above the other to correspond. A, E, F, and J give poor sateen effects, because of the distinct twill lines that are formed ; B, C, H, and I are better, but in each of these the marks form a more prominent line in one direction than in the other ; in D and G, however, the distribution of the marks is perfect.

Irregular Sateen Weaves. — Regular sateens cannot be constructed on four and six threads, because no number can be counted which has not a measure in common with four and six. A in Fig. 18 shows the 4-thread sateen in which the marks are arranged in the order of 1, 2, 4, and 3 ; the terms broken twill and broken swansdown are applied to the weave. In

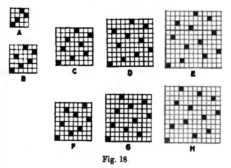

Fig. 18

the 6-thread sateen, given at B in Fig. 18, the marks are arranged in the order of 1, 3, 5, 2, 6, and 4. Irregular sateens are entirely free from twill lines, a feature that frequently gives them an advantage over regular sateens, and for this reason sateens are arranged irregularly on eight, ten, twelve, etc., threads. C

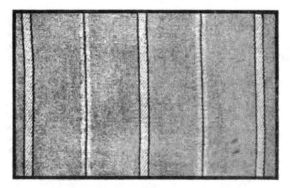

Fig. 19.

in Fig. 18 shows an irregular sateen on eight threads, in which 3 is counted to the right for four picks ; on the fifth pick the count is equal to half the number of threads in the repeat—viz., 4—then on the succeeding picks 3 is counted to the left. A 10-thread irregular sateen is given at D, in which the count is 3

for half the number of picks, then 5 is counted, and afterwards the move is in 3's to the left. In the 12-thread irregular sateen given at E the count is 3 and 5 alternately for six picks, then 6, and afterwards 3 and 5 alternately to the left. The weaves F, G, and H respectively correspond with C, D, and E, and are constructed in the same manner except that the count is upward instead of outward.

In pure sateen weaves it is only possible to introduce different colours effectively in the threads which form the surface. In weft sateens, however, the colours run transversely, which is seldom desired, so that the introduction of coloured threads is practically limited to warp sateens. The latter weaves, however, so long as the warp threads are of good quality and free from lumps and thick places, are particularly suitable for displaying colours in stripe form, because the smooth, lustrous, and almost unbroken surface of the cloth enhances the brightness of the colours. Different materials may also be effectively combined in the warp, and in Fig. 19 a five-thread warp sateen cloth is represented, in which differently coloured silk and cotton ends are employed, while the weave is varied by the introduction of narrow stripes of 4-and-1 warp twill.

CHAPTER II

CONSTRUCTION OF DRAFTS AND WEAVING OF PEGGING PLANS

Limitations in Tappet and Dobby Shedding. Methods of Indicating Drafts. *Systems of Drafting* —Straight-over Drafts—Sateen Drafts. *Conditions in Designing, Drafting, and Pegging* —Construction of Designs from Given Drafts and Pegging Plans—Construction of Drafts from Given Designs and Pegging Plans—Construction of Drafts and Pegging Plans from Given Designs. Reduction in Fineness of Healds. *Heald Calculations*—Casting-out in Healds.

A DRAFT indicates the order in which the warp threads are drawn through the eyes or mails of the healds (the terms shafts, leaves, staves, cambs, and heddles are synonymous with the term healds). A weaving or pegging plan indicates the order in which the healds rise and fall. The weave or design results from the combination of the draft and the weaving or pegging plan.

Limitations in Tappet and Dobby Shedding.—The weaves now under consideration are such as can be woven in tappet or dobby looms, in both of which types there are certain limitations with which the designer should be familiar. Tappet looms, which are required to produce only one kind of weave, are, for economical reasons, made as simple in construction as possible, provision only being made for operating the required number of healds in the precise order desired. Thus, looms that are built to weave plain cloth only will accommodate not more than two healds (or four healds coupled together in pairs), which are operated in alternate order. In other cases tappet looms are built to accommodate any number of healds from two to five, and to weave designs repeating on from two to five picks. Again, some tappet looms will accommodate any number of healds up to eight, and can be arranged to weave any design repeating on eight or a less number of picks, and it may be taken that eight healds, and eight picks to the repeat is the general limit in ordinary tappet shedding. Further, a set of ordinary tappets will only produce one, or at most a small group of interlacings (with the same

tappets the 2-and-2, 3-and-3, and 4-and-4 orders of interlacing can be obtained). Woodcroft tappet looms, however, are built to accommodate eight healds, and to weave designs repeating on as many as twenty-four picks, while looms furnished with oscillating tappets will take twelve healds and weave designs repeating on from fifty to one hundred picks. The special forms of tappets, moreover, can be readily changed so as to produce a variety of interlacings, but they are chiefly used in weaving heavy fabrics for which a positive shedding motion is necessary. Therefore, as a general rule, in constructing weaves for tappet looms, the designer is limited to what can be woven in an ordinary loom in which, for each different system of interlacing, a different form of tappet is required.

Dobby shedding motions are constructed in different sizes, and will operate from eight to twenty-four healds (sometimes more), according to the build ; from sixteen to twenty healds being most common. As many healds as the dobby is built for, or any smaller number, can be employed, while the number of picks to the repeat is only limited by the amount of space and the method of support that are available for the lags which form the pattern chain. In experimental work, and when only a small length of cloth is required in a new weave, it is frequently found convenient and economical to use a dobby shedding motion for designs that are within the range of tappets.

Each heald represents one order of interlacing in a design ; therefore, in ordinary tappet looms from two to eight different orders of interlacing, repeating on from two to eight picks, can be obtained, whereas in dobby shedding from two to twenty-four different orders, repeating on an almost unlimited number of picks, can be woven. In each type of loom diversity of design is produced by varying the draft and the weaving or pegging plan, both of which form important elements in the origination of designs.

METHODS OF INDICATING DRAFTS

Various methods of indicating drafts may be employed, as for instance—(a) By ruling lines, as shown in Fig. 20 at A, B, and C, in which the horizontal lines represent the healds, and the vertical lines the warp threads, while the marks placed where the lines intersect indicate the healds upon which the respective threads are drawn. (b) By the use of design paper, as shown at D, E, and F in Fig. 20, in which the horizontal spaces are taken to represent the healds, and the vertical spaces the warp threads. Marks are inserted upon the small squares to indicate the healds upon which the respective threads are drawn. This method is usually the most convenient. (c) By numbering, as shown by the numbers below the designs given at J, K, and L in Fig. 20, which refer to the number of the healds (the front heald is number one). In this case the threads are successively drawn on the healds in the order indicated by the numbers.

SYSTEMS OF DRAFTING

There are several well-defined orders of drafting which are known by such terms as the following :—Straight-over or straight-gate, sateen, skip, broken, reversed, herring-bone, transposed, pointed, curved, combined, etc.

Straight-over Drafts.—These can be made upon any number of healds within the capacity of the loom. The examples given at A, B, and C, and at D, E, and F

in Fig. 20 are straight-over drafts upon four, five, and six healds respectively. In this order of drafting the number of ends in the repeat of the woven design cannot exceed the number of healds employed, but may be a measure of the number of healds; the number of picks in the repeat may be equal to, or greater, or less than the number of healds. Thus, any weave, repeating upon two ends, or upon four ends, as shown at G and J in Fig. 20, is suitable for the draft A; any weave on five ends such as H and K is suitable for the draft B, while weaves repeating on two, or three, or on six ends, as shown at I and L, can be woven on the draft C. For the purpose of illustration, in each example more than one repeat of the design and the draft are given (different marks are shown in the first repeat), but in practice it is necessary to show only one repeat. The draft is repeated in the healds across the full width of the warp (with the exception in some cases of the selvages), and if there are 2,400 threads in the warp the draft A will be repeated 600 times, the draft B 480 times, and the draft C 400 times.

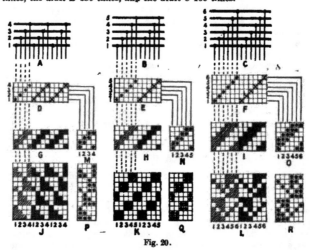

Fig. 20.

The examples M, N, O, P, Q, and R in Fig. 20 are the respective weaving or pegging plans for the designs alongside which they are placed; they indicate the order in which the healds are raised and depressed in forming the design. (Weaving plan is the more correct term to apply to M, N, and O, which are suitable for tappet shedding, the marks and blanks in the plans indicating how the tappets will be arranged. P, Q, and R are, however, correctly described as pegging plans, because they indicate how the lags will be pegged in dobby shedding, the latter motion being necessary, although only a few healds are required, because of the comparatively large number of picks in the repeat.) The numbered vertical spaces of the weaving and pegging plans correspond with the numbers at the side of the drafts; the vertical space numbered 1 in the pegging plans indicates how the first heald is operated; that numbered 2, the second heald; that numbered 3,

the third heald ; and so on. The plans further show how the healds are raised and depressed on succeeding picks ; thus, assuming that the marks represent warp up, M indicates that on the first pick the healds 1 and 4 of the draft D are raised, and the healds 2 and 3 depressed ; on the second pick, the healds 1 and 2 are raised, and the healds 3 and 4 depressed ; on the third pick numbers 2 and 3 are raised, and 1 and 4 depressed ; and on the fourth pick numbers 3 and 4 are raised, and 1 and 2 depressed. In the same manner P indicates that on the first pick the healds 1, 2, and 3 are raised ; on the second pick, the healds 1 and 2 ; on the third pick, the heald 1 ; on the fourth pick, the healds 2, 3, and 4 ; on the fifth pick, the healds 2 and 3, and so on.

In each example given in Fig. 20 the weaving or pegging plan is exactly the same as the corresponding design, a feature, however, which only occurs in straight-over drafts. The threads of a warp may be drawn straight-over from right to left instead of from left to right (this is not commonly done), which, unless allowed for in pegging the lags, will cause the direction of the design to be reversed, while the same result may occur in a left-to-right draft if the pegging of the lags does not coincide with the arrangement of the dobby.

Sateen Drafts. — A sateen draft enables rather finer set healds to be employed than a straight - over draft, hence for very finely set warps it is sometimes used in preference to the latter. The principle is illustrated in Fig. 21 in reference to a sateen draft on five healds, and it will be found useful to compare these examples with those shown in connection with

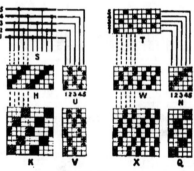

Fig. 21.

the straight-over draft on five healds given in Fig. 20. The examples which are alike in the two figures are lettered the same. As shown at S and T in Fig. 21, the threads in the order of 1, 2, 3, 4, 5 are drawn on the healds in the order of 1, 3, 5, 2, 4, therefore the threads are not lifted in the same order as the healds are raised. Thus, in order to produce the design H, the weaving plan U is required, and to produce the design K, the pegging plan V. In the same manner the weaving plan N produces the design W, and the pegging plan Q, the design X. Further, the plan N indicates that on the first pick the healds 1 and 5 are raised, which lift the first and third ends in each repeat of the design W ; on the second pick the healds 1 and 2 are raised, and lift the first and fourth ends ; on the third pick the healds 2 and 3 lift the fourth and second ends, and so on ; the design W thus resulting from the combination of the draft T and the weaving plan N. A draft is complete on the same number of ends, and a weaving or pegging plan on the same number of picks, as the design.

CONDITIONS IN DESIGNING, DRAFTING, AND PEGGING

The three factors—the design, the draft, and the pegging-plan—may be considered from the following points of view :—

(1) To construct the design from a given draft and pegging-plan.

(2) To construct the draft from a given design and pegging-plan.

(3) To construct the draft and pegging-plan from a given design.

(4) To construct a range of designs and the corresponding drafts to suit a given weaving plan. (This is necessary in tappet shedding when the loom is mounted to give only one order of lifting.)

(5) To construct a range of designs and the corresponding pegging-plans to suit a given draft. (This is required in dobby shedding in working out effects on a warp that is in the loom.)

Fig. 22.

(6) To construct a range of designs, and the corresponding drafts and pegging-plans. (In this case the scope of the designer is almost unlimited.)

The principles involved in the first, second, and third sections should be thoroughly understood, and an intimate knowledge of the various bases upon which weaves are constructed be acquired, before the fourth, fifth, and sixth conditions are attempted.

Construction of Designs from Given Drafts and Pegging-Plans.—The method of constructing the design from a given draft and pegging-plan is illustrated in stages in Fig. 22, in which A shows the draft and B the pegging-plan. The vertical spaces in B, in the order of 1, 2, 3, and 4 respectively, indicate how the healds 1, 2, 3, and 4 are operated, and, assuming that the marks represent warp up, the marks of B indicate healds raised. Thus, the first vertical space of B shows that the first heald is raised on the picks 1 and 2, therefore all the threads that are drawn on the first heald will be correspondingly raised, as shown at C in Fig. 22. The second vertical space of B shows that the second heald is raised on the picks 2 and 3, all the threads drawn upon the second heald being, therefore, lifted, as shown at D. In the same manner the third heald is raised on the picks 3 and 4, and lifts the threads drawn upon it, as shown at E, while the fourth heald is raised on the picks 1 and 4, and produces the lifts indicated at F. The marks given in C, D, E, and F are shown combined at G, which thus indicates the design produced by the draft A and the pegging-plan B.

As a further illustration a 5-heald draft is given at H, and the pegging-plan at I, which produce the design shown at J ; the ends upon each heald, and the corresponding order of working are represented by a different mark in order that the building up of the design J may be conveniently followed.

Construction of Drafts from Given Designs and Pegging-Plans.—This process is illustrated in stages in Fig. 23, in which K shows the design, and L the pegging-plan. The first vertical space of L indicates that the first heald is raised on the picks 1 and 2, therefore all the threads of the design K, which are raised on the picks 1 and 2, are drawn on the first heald, as shown at M. The second vertical space of L shows that the second heald is raised on the picks 3 and 4, therefore all the threads in the design K that lift on the corresponding picks are drawn on the second heald, as shown at N. In the same manner, all the threads which are raised on the picks 2 and 3 to correspond with the third vertical space of L, are drawn on the third heald, as shown at O, and those that are raised on the picks 1 and 4, to correspond with the fourth vertical space of L, are drawn on the fourth heald, as indicated at P. Q shows the marks of M, N, O, and P combined, and thus indicates the draft, which will produce the design K if the pegging-plan L is employed. The design K in Fig. 23 is similar to the design G in Fig. 22, but the pegging-plan L is different from the pegging-plan B, therefore in one case the draft Q is required in producing the design, and in the other case the draft A.

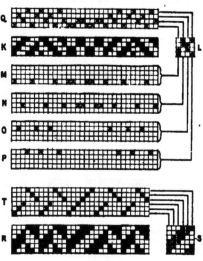

Fig. 23.

In further illustration, a design is given at R in Fig. 23 and a pegging-plan at S, for which the draft indicated at T is required ; the different marks will enable the successive stages in the construction of the draft to be followed.

Construction of Drafts and Pegging-Plans from Given Designs.—The construction of the draft and peg-plan for a given design is illustrated in stages in Fig. 24. The rule in drafting is as follows :—The threads in a design, which are raised and depressed simultaneously—that is, are indicated the same in the design—may be drawn on the same heald ; the threads that are different from each other must be drawn on different healds. As many healds are, therefore, required as there are threads working different from each other in the repeat of a design ; thus a 4-thread twill requires four healds, a 5-thread twill five healds, etc. In practice it is sometimes found advantageous to use more healds than the least possible number.

The design A in Fig. 24 is based upon 2-and-2 twill, and in constructing the draft the first end is indicated on the first heald, then all the ends in the design, which work the same as the first end, are also indicated on the first heald, as shown at B. The working of the first heald is copied from the design A on to the first vertical space of the pegging-plan, as shown at C. The second end in the design A works different from the first end, and is, therefore, indicated on the second heald, and all the ends, which work like the second end, are indicated on the same heald, as shown at D; while the working of the second heald is copied from the design on to the second vertical space of the pegging-plan, as indicated at E. The third end in the design A works different from either the first or the second, and is, therefore, indicated on the third heald, and also all the corresponding ends, as shown at F; then the working of the third heald is indicated on the third vertical space of the pegging-plan, as shown at G. In the same manner the fourth end of the design, which works different from either the first, second, or third, is indicated

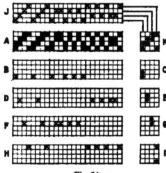

Fig. 24.

on the fourth heald, and also all the corresponding ends, as shown at H (this completes all the ends in the repeat), while the order of working is indicated on the fourth vertical space of the pegging-plan, as shown at I. B, D, F, and H are shown combined at J, and C, E, G, and I at K, which thus respectively show the complete draft and pegging-plan for the design A.

The foregoing system of constructing a draft and pegging-plan fully illustrates the principles involved, but the usual method of procedure is that represented in stages at A to O in Fig. 25, in which A shows the design. The draft is made first, the ends of the design being taken in succession, and commencing with the first end it is indicated on the first heald, as shown at B. (It does not follow, however, that the first end of a design should in all cases be indicated on the first heald, this being shown at Q in Fig. 62). The second end is different from the first, hence it is indicated on the second heald, as shown at C in Fig. 25; the third end, is like the first, and is, therefore, indicated on the same heald as the first end, as shown at D; the fourth end is like the second, and is indicated on the same heald as the second end, as shown at E; the fifth end is like the first and third ends, and is indicated on the same heald, as shown at F; the sixth end is different from any of the preceding, and is, therefore, indicated on the next heald (the third), as shown at G; the seventh end is different again, hence it is indicated on the fourth heald, as shown at H; the eighth end is like the sixth, and is indicated on the same heald, as shown at I; the ninth end is like the seventh, and is, therefore, indicated on the fourth heald, as shown at J; while the tenth end is like the sixth and eighth, and is indicated on the third heald, as shown at K.

In constructing the pegging-plan, the healds are taken in succession from front to back, and the order of working of the corresponding ends is copied from the

design on to successive vertical spaces from left to right. Thus, the working of the ends, drawn on the first heald, is indicated on the first vertical space of the pegging-plan, as shown at L in Fig. 25 ; of the ends, drawn on the second heald, on the second vertical space, as shown at M ; while in the same manner the working of the third heald is indicated on the third vertical space, as shown at N, and of the fourth heald on the fourth vertical space, as represented at O. The pegging-plan is complete on as many vertical spaces as there are healds in the draft, and on as many horizontal spaces as there are picks in the design. The threads are conveniently

followed if the draft is placed directly above or below, and the pegging - plan alongside the design.

In drafting the ends of a design from the first to the last in successive order, it is not always advisable to indicate those which are different from each other in the same order on the healds as they are found in the design. A draft should be arranged in an order which can be easily followed and remembered by the drawer-in and weaver, and to accomplish this, in many cases, it is necessary for the order of drafting to correspond with the basis upon which

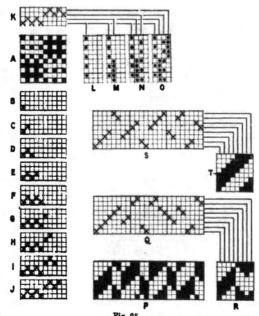

Fig. 25.

the design is constructed. For example, P in Fig. 25 shows a 4-and-4 twill design in which the threads are reversed in sections of four and two ; if the threads which work different from each other are indicated on the healds successively in the order in which they are found in the design, the draft will be as shown at Q, which is too irregular to be readily remembered. By indicating the draft to correspond with the arrangement of the design, as shown at S, however, the order of drawing in is simply four to right and two to left, with a break of four healds at each change. In the latter method the weaving plan also is more regular, as will be seen by comparing the plans R and T, which respectively correspond with the drafts Q and S. Certain designs can be drafted in different ways, but a change in the order of drafting necessitates a corresponding change in the pegging-plan.

The healds for designs in which different weaves and different yarns are combined, may usually be divided into two or more distinct sections, which are put together to form the complete set of healds. The different sections should be placed in such positions relative to each other as will most contribute to successful weaving. There is no fixed rule that can be practised, but, generally, the healds should be placed nearest the front, which (a) carry the weakest yarn, (b) carry the threads which are subjected to the most strain (are most frequently interlaced), and (c) are the most crowded with the threads.

REDUCTION IN FINENESS OF HEALDS

In weaving finely set fabrics which require a small number of healds it is customary to use more healds than are actually necessary for the weave, in order

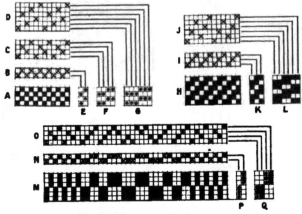

Fig. 26

that the leashes will not be too crowded on the shafts. For example, the plain weave indicated at A in Fig. 26, may be drawn on two healds, as shown at B, if the cloth is coarse ; or on four healds, as shown at C, if the cloth is of medium fineness ; or on six healds, as indicated at D, if the cloth is very fine. Assuming in each case that there are 20 leashes per inch on each shaft, draft B will give 40 ends per inch ; draft C, 80 ends per inch ; and draft D, 120 ends per inch. In tappet shedding, with the draft C the first and second healds are tied together, and the third and fourth together ; and with the draft D the first, second, and third together, and the fourth, fifth, and sixth together. The operation of two plain tappets then lifts the odd threads on one pick, and the even threads on the next pick. In dobby shedding, the pegging-plans for the drafts B, C, and D are as shown at E, F, and G respectively.

The 3-thread twill, given at H in Fig. 26, may be drawn on three healds as shown at I, or on six healds, as shown at J. In the latter case the healds 1 and 2 are coupled together, and 3 and 4, and 5 and 6, if ordinary 3-thread twill tappets

are employed ; but in dobby shedding the pegging-plans for the respective drafts are as shown at K and L.

The method of arranging a draft upon an increased number of healds is further illustrated by the examples M to Q in Fig. 26. M shows a stripe design, composed of 3-and-3 warp rib and hopsack, which may be drafted upon two healds, as shown at N. In doubling the number of healds the threads of each heald of the draft N are indicated alternately (as shown by the different marks) on two healds, in the manner represented at O. A 3-and-3 tappet plan may be employed for the drafts, or the respective pegging-plans P and Q.

HEALD CALCULATIONS

In constructing tappet and dobby designs, the draft that will be required should be considered, in order to avoid needlessly complicating the healds ; a good design, however, should not be sacrificed in order to simplify the arrangement of the healds. It is necessary for the ends to occupy the same width in the healds as in the reed, and for each end a mail or eye must be provided in the healds in the proper position relative to the position that the end occupies in the reed. An ideal draft, so far as regards the healds, is obtained when (a) an equal number of ends is drawn on each heald, and (b) the mails on each heald are evenly distributed across the width. The first point is illustrated by the examples given in Fig. 27, in which two rather similar designs are given at A and C, each of which repeats on 42 ends, while the respective drafts are indicated at B and D. The design A is constructed in such a manner that in the repeat the same number of

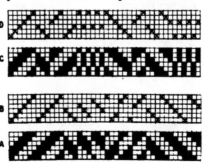

Fig. 27.

ends—viz., 7—are drawn on each heald, as indicated in the draft B, hence all the healds are alike. Assuming that there are 84 ends per inch in the reed, each heald will have (84 ends ÷ 6 healds) = 14 mails per inch, and if the healds are 40 inches wide, each will contain (40 × 14) = 560 mails. In the design C, however, the conditions are different, as will be seen from an examination of the draft D, in which in the repeat of 42 ends, 8 ends are indicated on each of the healds 1, 3, 4, and 6, as compared with 5 ends on each heald 2 and 5. Assuming, again, that there are 84 ends per inch in the reed, each of the healds 1, 3, 4, and 6 will require $(84 \times \frac{8}{42}) = 16$ mails per inch, while each of the healds 2 and 5 will require $(84 \times \frac{5}{42}) = 10$ mails per inch. If the healds are 40 inches wide, each of the shafts 1, 3, 4, and 6 will contain (40 × 16) = 640 mails, and each heald 2 and 5 (40 × 10) = 400 mails.

In reference to the second point, while the distribution of the ends on each heald, in the drafts B and D in Fig. 27, is not perfectly uniform, it is near enough

to allow each heald to be knitted at a uniform rate. It is usually in rather broad stripe designs that the healds require to be knitted in stripe form to coincide with the pattern. This condition, of course, is not necessary in the case of wire or sliding healds in which the leashes are loosely mounted on the shafts. In the latter type the number on a shaft may be readily increased or decreased, while the mails assume the correct position when the threads are tautened in the loom. The construction of a heald knitting plan for a stripe draft is illustrated in Fig. 137.

Casting-out in Healds.—This is a process by which healds are adapted to weave cloths which are coarser in sett than the mails on the shafts. For instance, assuming that the six healds for the equal draft given at B in Fig. 27 have been knitted with 84 mails per inch, and that they are required to weave a cloth which contains 60 ends per inch in the reed; (84 mails — 60 ends) = 24 mails per inch will be cast out. That is, for every 60 ends drawn upon the healds 24 mails require to be left empty. The 24 mails are equal to four rows or " gates " of the six healds, and in drawing in the warp the empty rows of mails are distributed as evenly as possible across the width. As 60 ends require to be drawn in and 24 mails cast out, the proportion is 5 gates filled to two gates cast out, while a better distribution is 3 gates filled, 1 gate cast out, 2 gates filled, 1 gate cast out.

As a further illustration, it has previously been shown that in weaving the draft D in Fig. 27 with 84 ends per inch, each of the healds 1, 3, 4, and 6 requires 16 mails per inch, and each heald 2 and 5, 10 mails per inch. Six healds, each containing 16 mails per inch, could readily be adapted to the draft by casting out the healds 2 and 5 in the proportion of 10 mails filled and 6 mails cast out, or 5 filled and 3 cast out. A still more uniform distribution of the mails on the two healds would be 2 filled, 1 cast out, 2 filled, 1 cast out, 1 filled, 1 cast out.

CHAPTER III

ELEMENTARY WEAVES AND THEIR BASES

Weaves constructed upon Sateen Bases—Sateen Re-arrangements of Ordinary Twills—Origination of Designs on Sateen Bases—Extension of Sateen Weaves. *Angle of Inclination of Twill Weaves*—Construction of Elongated Twills from Ordinary Twills—Origination of Elongated Twills. *Broken Twills*—Transposed Twills. Construction of Small Weaves by Reversing. *Combinations of Twill Weaves*—Combination Twills running at 45 deg. Angle.

WEAVES CONSTRUCTED UPON SATEEN BASES

In addition to being extensively used in their pure form, sateen weaves are very largely employed as bases in the construction of new weaves, to which the term " sateen derivative " is applied. A sateen, as well as many other bases, can be used in two ways in the construction of new designs—viz., (a) in producing a re-arrangement of the threads of a given weave, usually a twill; and (b) in originating new interlacings.

Sateen Re-arrangements of Ordinary Twills.—In this system of construction the threads (either warp or weft) of a given twill are arranged in the new design

in the order of a sateen that repeats upon the same number of threads as the twill. The method is illustrated in Fig. 28, in which A and B represent two sateen re-arrangements of the ends, and C and D two similar re-arrangements of the picks, of a 9-thread twill with which they are shown connected by lines. The shaded squares show the bases of the designs. In A the 9-thread sateen base counting 2 outwards is employed, and in B counting 2 upwards, hence the ends, which in the twill are in the order of 1, 2, 3, 4, 5, 6, 7, 8, 9, are arranged in A in the order

of 1, 6, 2, 7, 3, 8, 4, 9, 5, and in B in the order of 1, 3, 5, 7, 9, 2, 4, 6, 8. In the same manner, in C the picks of the twill are arranged in the order of 1, 3, 5, 7, 9, 2, 4, 6, 8, and in D in the order of 1, 6, 2, 7, 3, 8, 4, 9, 5.

A convenient method of re-arranging a twill in sateen order is illustrated at E to H in Fig. 28. The sateen base is first inserted, as shown at F, then each sateen mark is taken to be one mark of the twill, and to it the other marks of the twill are added in regular order. In re-arranging the ends of the twill the marks are added above and below the base marks, as shown at G, whereas if the picks are re-arranged the marks are added alongside the base

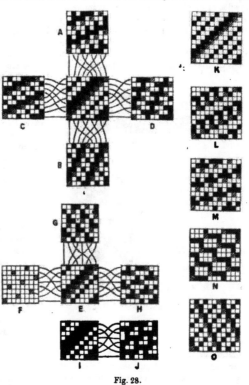

Fig. 28.

marks, as indicated at H. In each design G and H the marks and blanks are alike; also the weaves appear very similar on paper, but they yield quite different effects in the cloth because in G the principal floats are in the warp, and in H in the weft.

In some cases, a re-arranged weave produces a much looser structure than the original twill, as will be evident from a comparison of the twill I in Fig. 28, and the sateen re-arrangement given at J. G and H, on the other hand, are quite

as firm as the original twill E, on account of the manner in which the floats cut with each other. The original twills E and I, however, are similar in firmness, the only difference between them being that the latter contains more marks than the former, but this is sufficient to affect the firmness of the re-arranged weave very considerably. It will, therefore, be evident, from a comparison of the examples E, G, and H with I and J, that the re-arrangement of twills which are equally firm may result in structures being formed that differ materially in firmness. Certain twills, of which I in Fig. 28 is an example, produce the same design whether they are re-arranged in the warp or in the weft.

Four sateen re-arrangements in the warp of the 11-thread twill K, are given in Fig. 28 at L, M, N, and O, in which the count is 2, 3, 4, and 5 respectively; it will be seen that the design O is much firmer than the others. By turning the designs one-quarter round, so that the vertical spaces become horizontal, four re-arrangements in the weft will be obtained. The ex-

Fig. 29.

amples are thus illustrative of the great variety of weaves that can be produced in the foregoing system, particularly if it be taken into account that a large number of different twills can be made on eleven threads, each of which will produce a different series of effects.

The chief disadvantage of constructing a new design by re-arranging the threads of a *given* twill is that the order of interlacing is governed by the twill, and the resulting design may be quite unsuitable for the cloth for which it is intended. The system, however, is useful, because a twill and a sateen re-arrangement in the warp can be woven in the same healds by means of straight and sateen drafting.

Origination of Designs on Sateen Bases.—In this system the sateen base is first inserted on the required number of threads, then the new design is built up (according to the kind of weave and structure required) by adding marks in the same relative position to each base mark. Thus, the " Venetian " weave, given at A in Fig. 29, is produced by adding one mark to each mark of the 5-thread sateen, while the " Buckskin " weave, shown at B, is similarly constructed by adding one mark to each mark of the 8-thread sateen. The weaves A and B—taking the marks to indicate weft—produce a warp surface, but similar designs may be constructed, as shown at C and D, which form a weft surface, the marks in this case being taken to indicate warp. The latter class of weave is used in the production of heavy weft-faced cotton fabrics that are employed for workmen's clothing,

and are known by such terms as "imperial," "swansdown," and "lambskin."
By introducing comparatively few ends per inch a very large number of picks can
be inserted, and a compact, strong cloth is produced, which generally has a soft,
downy surface, formed by "raising" the weft. A cloth may be woven with 56 ends
per inch of 2/30's cotton warp, and from 150 to 200 picks per inch of from 16's
to 20's cotton weft. The design E in Fig. 29 is reversible, and if heavily wefted
the cloth has a dense weft surface on both sides.

The examples F to J in Fig. 29 are constructed on a 10-thread sateen basis.
It is usually convenient to commence a design by adding a few marks to each
base mark, as shown at F, and to then add other marks in stages (if considered
necessary), as indicated in the designs G, H, I, and J.

As a rule, in constructing small weaves the marks should be added in the same
order to the base marks, in the manner represented at A to J in Fig. 29. In the
case of a few sateens, however, such as the 8, 12, and 15-thread weaves, in which

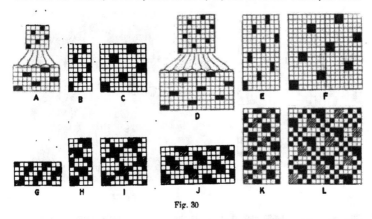

Fig. 30

the sateen marks run in line with each other at 45° angle, and join with each other
in succeeding repeats, the method may be deviated from. Thus K, L, and M in
Fig. 29 show interesting designs which result from the addition of marks in irregular
order to the 8, 12, and 15-thread sateens respectively. (Examples of larger and
more elaborate sateen derivatives are given in Fig. 47, p. 49).

Extension of Sateen Weaves.— Sateen weaves may be extended horizontally,
as shown at A and D in Fig. 30; or vertically, as indicated at B and E; or both
horizontally and vertically, as represented at C and F; the examples illustrating
the system in reference to the 5 and 8-thread sateens. Their chief value, when
used in the forms shown at A to F is that with the same number of healds longer
floats are formed on the surface of the cloth than is the case with ordinary sateens.
For instance, the design B, which requires five healds, has a warp float of 8 (taking
the marks to indicate weft), and is a very suitable weave for displaying a lustrous
warp stripe prominently on the surface of a cloth if only a small number of healds
are available.

3

The extended sateens may be readily employed as bases in the construction of new weaves, which are usually of a bolder character than those produced upon ordinary sateen bases. Marks are added systematically to the base marks, as shown in the designs G to L in Fig. 30, which respectively correspond with the plans A to F.

ANGLE OF INCLINATION OF TWILL WEAVES

The angle formed in the cloth by a twill weave varies according to the relative number of ends and picks per unit space. (The angle of a twill is taken as that formed by the twill line and the weft.) If the ends and picks per unit space are equal an ordinary twill, in which one is counted, as shown at A in Fig. 31, runs at an angle of 45°. If, however, there are more ends than picks per inch in the cloth, the line of an ordinary twill more nearly approaches the vertical, or becomes

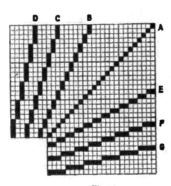

Fig. 31.

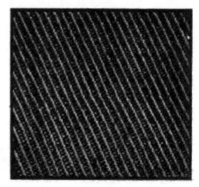

Fig. 32.

steeper; while if the picks exceed the ends the line more nearly approaches the horizontal, or becomes flatter. A fabric, in which a steep twill is formed, is represented in Fig. 32, which, if turned one-quarter round, will also show the appearance of a flat twill.

Elongated twills, running at various angles, are constructed by moving the points of intersection two or more threads in one direction to one thread in the other direction, as shown at B to G in Fig. 31. If the cloth contains the same number of ends as picks per unit space, by counting 2 upward to 1 outward, as shown at B, a twill line running at the angle of 63° is formed; by counting three upward to 1 outward, as shown at C, the angle is 70°; and by counting 4 upward to 1 outward, as indicated at D, the angle is 75°. Further, by counting 2 outward to 1 upward, as represented at E, the twill runs at 27° angle; whereas counting 3 upward to 1 upward, as shown at F, produces the angle of 20°; and counting 4 outward to 1 upward, as indicated at G, the angle of 15°. As in ordinary twills, however, the actual angles formed in the cloth are modified from those shown on the square design paper according to the proportion of ends to picks per unit space. Thus a twill

designed at the angle indicated at B will run at the angle shown at D if there are twice as many ends as picks in the cloth.

Construction of Elongated Twills from Ordinary Twills.—One method of designing elongated twills consists of selecting, or re-arranging the threads of a given ordinary twill in certain orders, as illustrated by the examples given in Fig. 33. Each thread in the elongated twills is shown connected by a line with the corresponding thread in the original twill, and the four designs made from each twill correspond with the bases indicated at B, C, E, and F in Fig. 31. Commencing with the first end of the given twill, the steep twill H is constructed by inserting every second end of the twill, and the steep twill I, by inserting every third end. Then, commencing with the first pick, the flat twill J is constructed by inserting every second pick of the given twill, and K by inserting every third pick. As the number counted is in each case a measure of the number of threads in the given twill, the repeat of the new design in one direction is proportionally less.

Fig. 33.

The examples L to O illustrate the method of procedure when the number counted is not a measure of the number of threads in the given twill. The twill repeats on 13 threads, therefore, in counting 2, it is necessary to go through the weave twice, and to arrange the threads in the order of 1, 3, 5, 7, 9, 11, 13, 2, 4, 6, 8, 10, 12, as shown at L and N; while in counting 3, the twill is gone through three times; the threads being ultimately arranged in the order of 1, 4, 7, 10, 13, 3, 6, 9, 12, 2, 5, 8, 11, as indicated at M and O. It should be noted that in this case exactly

the same designs would result from re-arranging the twill in sateen order, counting 2 and 3.

Origination of Elongated Twills.—The foregoing method has the limitation stated in reference to the sateen re-arrangement of given twills. In originating elongated twills, a base line of marks is first inserted running at the desired angle, and repeating upon the required number of ends and picks. Other marks are then added systematically to the base marks, in the manner illustrated at P to Y in Fig. 34. P, Q, and R are steep twills on 5, 6 and 8 ends respectively. counting 2 upward to 1 outward. The fabric, represented in Fig. 32, corresponds with the design R. S and T are steep twills on 6 and 7 ends respectively, counting 3 upward to 1 outward ; while U is a flat twill on 7 picks, counting 2 outward to 1

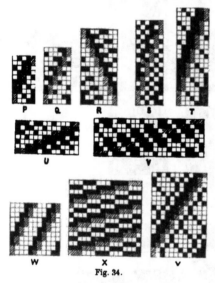

Fig. 34.

upward, and V a flat twill on 8 picks, counting 3 outward to 1 upward. W and X illustrate how the base marks are carried through a design, in order to obtain correct repetition, when the number counted is not a measure of the number of threads in the repeat. The design Y, in which the count is 2 and 1 alternately, will serve to illustrate how the angle of the twill line may be still further varied.

In steep twills the warp should, as a rule, show more prominently on the surface than the weft, and *vice versa* in flat twills; hence, in the steep twills, given in Figs. 33 and 34, the marks should be taken to indicate "warp up," and in the flat twills, "weft up." Steep twills, which produce distinct twill lines of warp in the cloth are termed "whip cords." The addition of marks to the edges of a line of warp float, as shown in Q and R, develops the prominence of the line.

Unless the cloth is firmly set the threads are liable to slip in elongated twill weaves. Firmness of texture can be obtained to some extent by inserting a suitable firm weave between the floating twill lines ; thus 2-and-1 twill naturally fits a weave in which the count is 2, as shown at P in Fig. 34, and plain weave, or 1-and-3 twill, when the count is 3, as shown at S and T. (Other examples of steep and flat twills are illustrated in Figs. 43, 44, and 47.)

BROKEN TWILLS

The term "broken twill" is applied to a large variety of weaves that are modifications of ordinary twills. A very useful system of construction, which

is particularly applicable to twills that are composed of equal warp and weft float, consists of " filling-and-missing " the threads of an ordinary twill. Any number of threads may be filled and missed respectively at a place, but generally the most suitable number of threads to miss is one less than half the number of threads in the repeat of the twill. If the latter condition is observed in certain equal-sided twills, the warp and weft floats oppose each other, and a fine line or " cut " is made where the twill is broken.

The method of procedure in filling-and-missing is illustrated in Fig. 35, in which three repeats of 2-and-2 twill are given at A, while at B the threads of A are shown arranged in the order of 2 filled and 1 missed. C shows the draft for B, if a 2-and-2 twill weaving plan is employed ; and it will be noted that the order of drawing in is 2 healds drawn and 1 heald missed or skipped, and thus coincides with the basis upon which B is constructed.

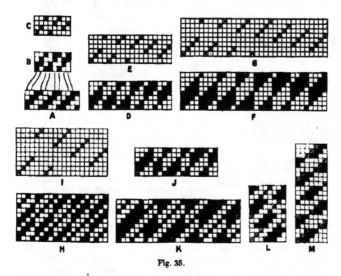

Fig. 35.

D in Fig. 35 shows the 3-and-3 twill arranged in the order of 3 filled and 2 missed : F the 4-and-4 twill arranged 4 filled and 3 missed ; and H a 10-thread twill arranged 4 filled and 4 missed ; while E, G, and I represent the bases of construction, and the drafts for the respective designs. The number of threads in the repeat of a design can be ascertained by noting the number of squares that corresponding positions of the weave are distant from each other. Thus, in F corresponding positions move one square downward and four squares outward each time ; and as there are 8 picks in the weave there are :—4 × 8 = 32 ends in the repeat. In H there are 10 picks in the weave, and the move is 2 downward and 4 outward ; therefore in the repeat there are :—(10 + 2) × 4 = 20 ends.

The designs may be varied by filling unequal numbers of threads, as shown

at J in Fig. 35, in which the 3-and-3 twill is arranged 4 filled, 2 missed, 2 filled, and 2 missed. In the same manner, K shows a 9-thread twill arranged 6 filled, 3 missed, 3. filled, and 3 missed, and this example also illustrates that the system of construction is by no means limited to twills which are composed of equal warp and weft float, but can be used with good results in re-arranging the threads of almost any type of twill.

Designs can also be constructed by filling and missing the picks, as shown at L and M in Fig. 35 ; the former of which consists of an 8-thread twill arranged 3 picks filled and 3 picks missed, and the latter of a 7-thread twill arranged 3 picks filled and 2 picks missed. Further, in either the warp or weft method, if the base marks are inserted first, as shown by the shaded squares in the designs given in Fig. 35, marks may be added to them in any desired order.

In another method of constructing broken twills, a small effect, which is based on the twill, is inserted at intervals and is arranged either to cut or to join with the twill. For instance, N in Fig. 36 shows a 2-and-2 twill with a 2-and-2 mat effect introduced at intervals, which cuts at one side and joins at the other side with the twill. In the design O in Fig. 36 there are four threads of 2-and-2 twill cutting with four threads of the 2-and-2 twill modified ; while P shows the 3-and-3 twill arranged five threads of straight twill cutting with three threads of the weave modified. In the same manner in Q the 3-and-3 twill is cut at irregular intervals with two threads forming warp rib, and two threads working together. Threads which are different in colour or material may be effectively introduced at the places where a weave is broken. Also an advantage of the broken twill system of contruction is that variety of design is produced with little or no effect upon the firmness of the structure, so that the yarns and set which are suitable for an ordinary twill are equally suitable for the same twill broken.

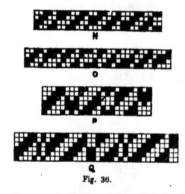

Fig. 36.

Transposed Twills.—The term transposing can be used in describing various methods of reversing a weave, but here it is applied to the construction of broken twills by transposing or reversing the threads of a given twill in groups of 2, 3, or more, as illustrated by the examples A to L in Fig. 37. The base line of a 12-thread ordinary twill is indicated at A, while at B the marks are transposed in groups of 2, at C in groups of 3, and at D in groups of 4. In E. F. G. and H, and in I, J, K, and L, the shaded squares correspond with the base marks indicated in A, B, C, and D, respectively. At F, G, and H respectively the twill E is re-arranged in the warp according to the transposed bases B, C, and D ; while J, K, and L similarly show the twill I re-arranged in the weft. A comparison will show that the ends of the ordinary twill E, taken consecutively from 1 to 12, are arranged in F in the order of 2, 1 ; 4, 3 ; 6, 5 ; 8, 7 ; 10, 9 ; 12, 11 ; in G in the order of 3, 2, 1 ; 6, 5, 4 ; 9, 8, 7 ; 12, 11, 10 ; and in H in the order of 4, 3, 2, 1 ; 8, 7, 6, 5 ; 12, 11, 10, 9.

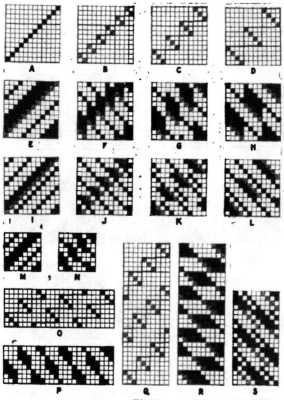

Fig. 37.

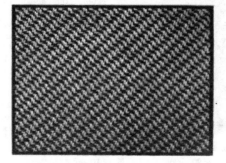

Fig. 38.

In J, K, and L respectively the picks of the twill I are arranged in corresponding orders.

The design given at N in Fig. 37 corresponds with the fabric represented in

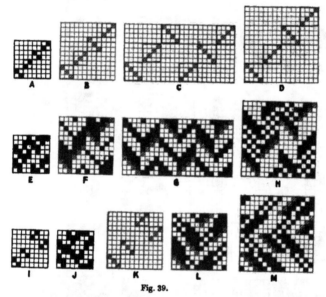

Fig. 39.

Fig. 38. The weave is termed the Mayo or Campbell, and is formed by transposing the ends of the 8-thread twill M in 2's. O and P illustrate the transposition of the

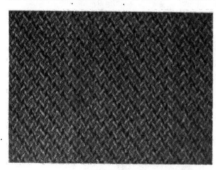

Fig. 40.

ends of a 3-and-5 twill in 3's. in which it is necessary to extend the design over a number of ends, which is the L.C.M. of 8 and 3—viz., 24. The ends of the twill are thus arranged in the order of 3, 2, 1; 6, 5, 4; 1, 8, 7; 4, 3, 2; 7, 6, 5; 2, 1, 8; 5, 4, 3; 8, 7, 6. In the same manner in transposing the picks of a 10-thread twill in 3's, as shown at Q and R, the repeat extends over 30 picks—the L.C.M of 10 and 3; while in transposing a 10-thread twill in 4's, as shown at S, the repeat extends over 20 picks—the L.C.M. of 10 and 4.

A variation of the foregoing method consists of arranging the groups of threads in transposed and straight order alternately, as shown at A to D in Fig. 39, and the corresponding designs E to H. The design H coincides with the fabric represented in Fig. 40. In another method the groups of threads are arranged in 4-sateen order ; thus the design J in Fig. 39 corresponds with the base I, and the design L with the base K. The design M is arranged similarly to J and L, but the repeat is on 16 threads, and the marks of the weave are added at the side of the base marks.

In constructing transposed designs the base marks should be inserted first, and it will be found convenient to previously indicate the squares in groups of 2×2, 3×3, etc., as shown, for instance, by the thick lines in B, C, and D in Figs. 37 and 39. It will be understood that the base marks, may not only be used in re-arranging the threads of a given twill, but as a base to which marks may be regularly added in any desired order.

By drafting the ends in the healds in transposed orders, transposed warp effects are produced by employing straight twill pegging-plans ; but for transposed weft effects, straight drafts are required with transposed weaves for the pegging plans.

CONSTRUCTION OF SMALL WEAVES BY REVERSING

The reversing of equal-sided twill weaves in very small sections, as shown at A, B, C, and D in Fig. 41, produces neat designs which are too little to show as definite stripes. In the design A the 3-and-3 twill is arranged alternately two ends to right and two ends to left, and in B three ends to right and three ends to left. In C the 4-and-4 twill runs four ends to right and left alternately, while D shows the 2-and-2 twill arranged four to right and two to left alternately. By turning the plans one-quarter round the reversing of the picks of the twills will be illustrated.

Twills which are not equal-sided can be reversed in the same manner, and the reversal may simply apply to the direction in which the threads twill, as shown at E in Fig. 41 ; or it may also include the substitution of marks for blanks, and blanks for marks in succeeding sections of the design, as indicated at F. If the warp and weft are about equally on the surface, as in E and F, the reversing of a few threads at a place produces more the appearance of an all-over effect than of a stripe, although F is more distinctly stripy than E because of the manner in which the sections cut with each other. If, however, the warp predominates in one section, and weft in the other, as shown in the design G, the reversing of the threads produces a very distinct stripe, particularly if the warp and weft are different in colour.

The examples H to L in Fig. 41 illustrate a method of employing the reversing principle by which neat little check designs are formed. A small unit weave (which need not be a complete weave in itself) is first made on any suitable number of ends and picks, and the complete design is then constructed by reversing the unit vertically and horizontally. Thus, taking H as the unit weave, I is obtained by reversing the ends of H, and J by reversing the picks, while K results either from reversing the ends of J or the picks of I. Corresponding threads are connected by lines, and it will be seen that the ends of H, in the order of 1, 2, 3, 4, are the reverse of the ends of I in the order of 4, 3, 2, 1 ; the marks in one coinciding with the blanks in the other, while the weave is turned in opposite directions. In the same manner the

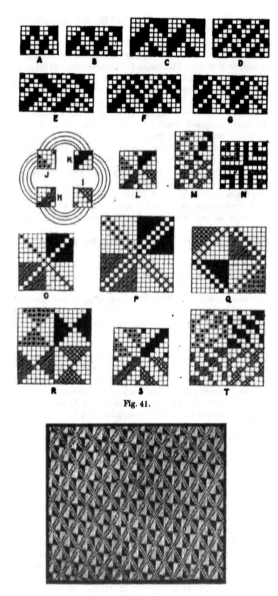

Fig. 41.

Fig. 42.

picks of H are the reverse of the picks of J, the ends of J the reverse of the ends of K, and the picks of I the reverse of the picks of K. The design L, which shows the parts H, I, J, and K put together, repeats on twice as many ends and picks as the unit weave, and consists of four sections which cut with each other where they are in contact.

The examples M to T in Fig. 41 are constructed in the same manner as L, the different stages of working being represented by different marks. The unit weave of M is on four ends and six picks, and produces a design of a " crêpe " character that repeats on eight ends and twelve picks. The design N is termed a " basket " weave, and is constructed from a 5 × 5 unit, while the designs O, P, Q, and R, to which the term " barley-corn " is applied, result from 6 × 6, 8 × 8, 8 × 7, and 8 × 8 units respectively. The fabric represented in Fig. 42 corresponds with the design P in Fig. 41.

The unit of the design S in Fig. 41 consists of one exact repeat of 3-and-3 twill, and the unit of T of one repeat of the Mayo weave, and the designs can be used in the form shown, or each section may be extended a number of times so as to form large check designs. The construction of large check designs on the reversing principle is illustrated in Fig. 115.

COMBINATIONS OF TWILL WEAVES

Different methods of constructing designs by combining small ordinary twill weaves in the order of an end or a pick of each alternately are illustrated in Figs. 43, 44, and 45. In combining the 4 and 5-thread twills, given respectively at

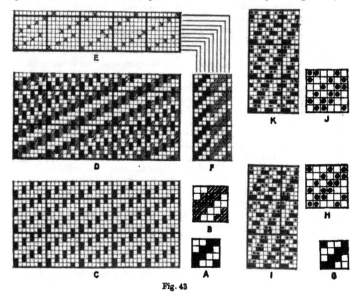

Fig. 43

A and B in Fig 43, an end of each alternately, one twill—say A—is first indicated on the odd vertical spaces, as shown at C. Then, to complete the design, the other twill (*B*) is indicated on the even vertical spaces, as shown at D. Each twill must be carried out on 20 ends and picks—the L.C.M. of 4 and 5, hence the design D consists of 20 threads of A combined with 20 threads of B, and thus repeats on 40 ends and 20 picks.

The proper method of drafting the design D is illustrated at E in Fig. 43, in which the ends of the 2-and-2 twill are indicated on four healds placed at the front of the five healds upon which the ends of the 3-and-2 twill are drawn. The arrangement enables the order of drawing in to be readily followed, while the most crowded healds are placed at the front and carry the ends which interweave most frequently. The pegging-plan is given at F.

The 4- and 6-thread twills, given respectively at G and H in Fig. 43, are shown combined—a pick of each alternately—at I, the 2-and-2 twill being inserted on the odd horizontal spaces, and the 6-thread twill on the even horizontal spaces. In this case, as 12 is the L.C.M. of 4 and 6, each twill is extended over 12 ends and picks so that the design I consists of 12 picks of G combined with 12 picks of H, and repeats on 24 picks and 12 ends.

When the repeats of the twills that are combined have no measure in common only one design results in either the warp or the weft method of combination, as each twill gets into every possible relationship with the other twill. If, however, the repeats have a common measure more than one design can generally be constructed by altering the relative position of the two twills. Thus, 2 will divide into 4 and 6—the respective repeats of G and H in Fig. 43, and it is therefore possible to produce a second design, as shown at K, by commencing the 6-thread twill in the position indicated at J, while retaining the 2-and-2 twill in the original position. It will be found by experiment that any further change in the relative position of the two twills will simply produce a duplicate of either I or K.

The construction of different designs by varying the relative position of two twills can be carried still further if the twills are equal in size or if one is double the size of the other. Thus, in combining the two six-thread twills given at A and B in Fig. 44, —an end of each alternately—six designs are obtained, as shown at C, D, E, F, G, and H ; and, as 6 ends of one twill are combined with six ends of the other, each design repeats on 12 ends and 6 picks. One twill—say A—is inserted in the same position on the odd vertical spaces of each design, then the twill B is indicated on the even vertical spaces ; commencing in the design C with the first end of B ; in D with the second end ; in E with the third end ; in F with the fourth end ; in G with the fifth end ; and in H with the sixth end. The twills can be combined—a pick of each alternately—in the same manner, and the latter method has the advantage that each design only requires six healds, whereas each design C to H in Fig. 44 requires 12 healds.

The twills I and J are shown combined—a pick of each alternately—at K, L, M, and N in Fig. 44, only four changes being possible in this case as J is on four threads. It is necessary, however, to use 8 threads of the weave J to conform with the repeat of I, hence the complete designs repeat on 16 picks and 8 ends. The weave I is indicated in the same position on the odd horizontal spaces of K, L, M, and N ; then the weave J is inserted on the even horizontal spaces commencing with the picks in turn in succeeding designs.

A still further development, which is illustrated by the examples O to S in Fig. 44, consists of using the same twill for both the odd and the even threads. The weave O is indicated on the odd vertical spaces of the designs P, Q, R, and S, commencing each time with the first end; but in inserting the weave on the even vertical spaces, P commences with the first, Q with the third, R with the fourth, and S with the fifth end of O. In this weave any further change of position will produce a duplicate of one of the preceeding. In end-and-end combinations the method has the advantage that only half as many healds are required as there are

Fig. 44.

ends in the repeat. The picks of a twill may be combined in the same manner as the ends. Also the principle of combining the threads of a twill may be extended to include such designs as those shown at U and V in Fig. 44, which are produced from the twill T.

Combination Twills running at 45° angle.—In the foregoing combinations, flat or steep twills are respectively produced according to whether the ends or the picks are combined. The examples given in Fig. 45 illustrate methods of combining twills by which designs—twilling at the angle of 45°—are formed. The designs C to J are constructed by first indicating *alternate* ends of the twill A on the odd

vertical spaces in the same position in each design. Then *alternate* ends of the twill B are inserted on the even vertical spaces, commencing with the following end in each succeeding design. Thus C commences with the first end of B, D with the second end, E with the third end, and so on.

Fig. 45.

In the same manner, the designs M, N, O, and P in Fig. 45, are constructed by inserting alternate picks of the twill K in the same position on the odd horizontal spaces ; then alternate picks of the twill K, commencing each time with a different

pick, are inserted on the even horizontal spaces. In this case as each twill repeats on an odd number of picks, all the picks must be combined, and the resulting designs therefore repeat on 14 picks and 7 ends. All the positions in which the twill L can be placed are not shown, as the remaining positions simply produce duplicates of M, N, and P; it will be found that duplicate designs result when the marks of the original twills are arranged symmetrically.

A useful method of employing two small twills in the construction of a large fancy twill running at the angle of 45° is illustrated by the examples Q, R, S, and T in Fig. 45. One twill—say Q—is indicated where the *odd* vertical and horizontal spaces intersect, in the manner represented in the portion given at S, then the design is completed by inserting the second twill (R) where the *even* vertical and horizontal spaces intersect, as shown at T. The number of ends and picks in the repeat of the design is equal to twice the L.C.M. of the threads in the repeat of the twills—or $2 \times 5 \times 4 = 40$ ends and picks. Marks should largely predominate over the blanks in the twills that are combined, or the floats in the resulting designs will be too large. A warp or weft surface is produced according to whether the marks are taken to indicate weft or warp. The draft for the design T is given at U, and the pegging-plan at V; and an important feature of the arrangement is the small number of healds that is required. In each of the foregoing systems of combination more than two twills can be employed which may be either unequal or equal in size.

CHAPTER IV

FANCY TWILLS AND DIAMOND DESIGNS

Fancy Twills—Large Diagonals—Shaded Twills—Diagonals on Sateen Bases—Spotted and Figured Twills—Pointed Waved, or Zig-zag Twills—Curved Twills. *Diamond and Diaper Designs*—Construction of Diamond Designs upon Pointed Drafts—Diamond Designs that are not Pointed.

FANCY TWILLS

Large diagonals.—A method of constructing ordinary twills or diagonals by combining two or more small twills in diagonal form is illustrated at A and B in Fig. 46. These diagonals, however, cannot be drafted on to a small number of healds. A is composed of 3-and-1 and 1-and-3 twills, while B is a compound of 3-and-3, 2-and-1, and 1-and-3 twills, the last twilling in the opposite direction to the diagonal. The chief points to note in constructing the weaves are that the twills are joined together in a suitable manner, that they are sufficiently different from each other, and that each is allotted enough space to give the large twill a distinctly diagonal appearance. By reversing one of the twills, as shown in B, the diagonal form is developed very clearly.

Shaded twills.—These are designed, as shown at C, D, and E in Fig. 46, by combining a number of small twills in which the floats increase or decrease in size. C is composed of five twills on six threads, which are arranged 5-and-1, 4-and-2, 3-and-3, 2-and-4, and 1-and-5. The term " single-shading " is applied to this style because each kind of float shades in one direction only. " D is a double-shaded "

style which is composed of the 1-and-4, 2-and-3, 3-and-2, and 4-and-1 twills, the floats of which are arranged to shade in both directions. E is composed of 5-and-1, 4-and-1, 3-and-1, and 2-and-1 twills, which are so arranged as to form distinct warp and weft sections each of which is single shaded. The last style can be readily modified to produce warp and weft sections which are double-shaded.

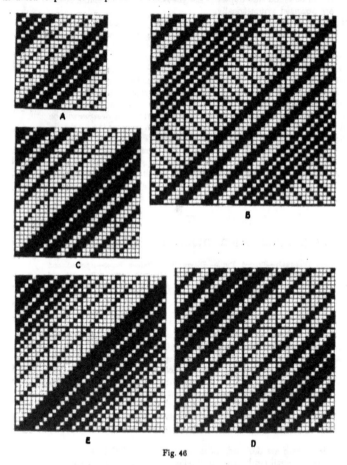

Fig. 46

Diagonals or Sateen Bases.—These are constructed by combining two or more sateen derivatives, in the method illustrated in Fig. 47. Certain sateens, such as the 8, 10, and 15-thread weaves, can be used in constructing diagonal designs

running at 45° angle. An example is shown at F in Fig. 47, which is based on the 8-thread sateen counting 5. Sateens can also be selected which will yield steep twills, as shown at G, or flat twills, as shown at H. G is based on a 10-thread sateen counting 3, and H on a 7-thread sateen counting 2. According to the angle in which the diagonal is required to run the sateen base is inserted over an equal or an unequal number of ends and picks ; thus in F the ends and picks are equal ; G is on three times as many picks as ends ; and H on twice as many ends as picks. The number

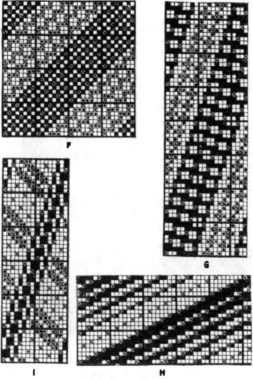

Fig. 47.

of ends and picks in a design must be a multiple of the number of threads in the repeat of the sateen. In adding marks to the sateen marks the weaves in the respective sections should be made sufficiently different from each other to show clearly, except when a shaded diagonal effect is formed, as shown at H, in which the weave is changed very gradually. Diagonal lines may be arranged to run at different angles in a design as shown at I, which is constructed on the 8-thread sateen basis.

Spotted and Figured Twills.—The examples, given at A, B, C, and D in Fig. 48, illustrate the arrangement of small spots or figures in conjunction with, and running at the same angle, as ordinary twills. A spot may be repeated diagonally one or more times in each repeat of the twill lines ; and in finding the repeat of a spot it is necessary to count the spaces diagonally. For example, in the design A the crosses, which indicate corresponding positions of the spots, occur on every third space— counted diagonally, and in order to show this clearly, dots are indicated between the crosses. The complete repeat of the twill is upon 12 threads or diagonal spaces,

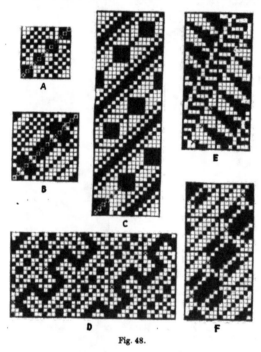

Fig. 48.

and the spot is therefore repeated four times. A representation of the design A, in the woven fabric, is given in Fig. 49.

The twill in the design B in Fig. 48 repeats on 16 threads, and as the figure repeats on 8 diagonal spaces, as indicated by the crosses and dots, it is inserted twice in the complete design. In C the twill lines repeat upon 16 threads, but in this case the spot repeats on 6 spaces—counted diagonally, hence the complete repeat extends over 48 packs—the L.C.M. of 16 and 6. The design C could be arranged similarly to repeat upon 48 ends and 16 picks by extending the weave horizontally, and in the design D a figured twill is shown thus arranged. The twill repeats

upon 20 threads, and the figure on 8 diagonal spaces, hence the complete design occupies 20 picks and 40 ends, the latter number being the L.C.M. of 20 and 8. In dobby shedding it is necessary to extend the designs vertically, but in Jacquard weaving the horizontal method has the advantage that a saving of cards is effected. In designing spotted twills it is convenient to first insert lightly a diagonal line of marks as a basis; the spaces occupied by the figure and the twill then require to be adjusted to the size of the repeat, or *vice versa*.

Small figures may be arranged in combination with steep or flat twills, and an example is given at E in Fig. 48 in which the twill repeats on 16 ends and 32 picks, while the distance between corresponding parts of the figure is two spaces, outward, and four spaces upward. The design F is inclined at the same angle as E, the distance between corresponding parts of the figure being four out-

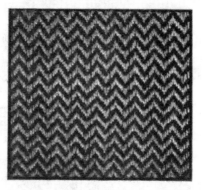

Fig. 49.

ward and eight upward, but in this case the space between the figures is simply filled in with 1-and-3 ordinary twill.

Pointed, Waved, or Zig-zag Twills.—Twills which run to right and left alternately, and turn upon one thread, produce pointed, waved, or zig-zag effects in the cloth. Sometimes the term "herring-bone" is used, but this term is also applied to twills in which the floats oppose each other where the weaves reverse, in the method illustrated at C in Fig. 111. Small twills, such as the 2-and 2, when turned upon one thread, have more of a herring-bone than a waved appearance, but twills which contain a distinct line of float, form prominent zig-zag lines running horizontally or vertically in the cloth. The horizontal waved line effects are economically produced in pointed or V drafts, and good styles may be

Fig. 50.

woven on a few healds by means of twill tappets. The vertical line effects, however, mostly require a dobby shedding motion, because of the comparatively large number of picks in the weaving plan. Fig. 50 illustrates a horizontal waved line pattern that corresponds with the weave given at D in Fig. 51,

while by turning Fig. 50 one-quarter round a vertical effect is shown that corresponds with the weave O in Fig. 51.

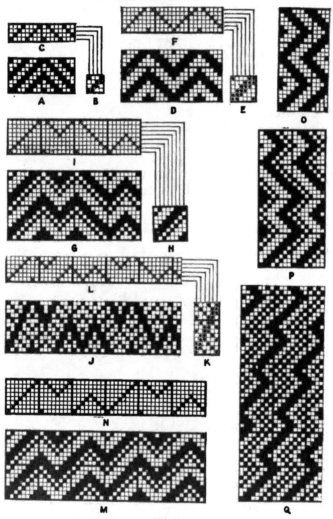

Fig. 51

A in Fig. 51 shows the 2-and-2 twill given at B, arranged 8 ends to right and 8 ends to left, turning on the first and ninth ends, whilst D shows the 3-and-3 twill E running 6 ends to right and 6 ends to left, turning on the first and seventh ends. A more complex arrangement is illustrated at G, in which the 8-thread twill H is turned on the ends 1, 9, 13, 17, 25, and 29. In each case the design is, for convenience, so arranged that an equal number of ends is drawn on each heald, as shown in the pointed drafts C, F, and I, which respectively correspond with the designs A, D, and G.

A further variation of the pointed system of drafting is indicated on six healds at L in Fig. 51, but in this case the healds are more complicated, because the number of ends drawn upon each is unequal. Any twill repeating on 6 ends, can, of course, be used as the weaving plan for the draft L; and, in order to show how other twills than ordinary twills can be arranged on the pointed principle a zig-zag steep twill is given at J for which K is the pegging plan and L the draft.

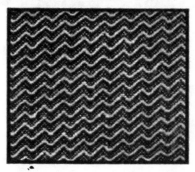

Fig. 52.

In the designs A, D, G, and J, the twills run for as many threads to the right as to the left, so that each twill line returns to the level at which it commenced. In the design M, however, for which N is the draft, the twill H is arranged to run 8 ends to the right and 4 ends to the left alternately, so that the zig-zag line gradually rises and runs at a flat angle from side to side of the cloth, as shown in the corresponding fabric represented in Fig. 52.

The designs O and P in Fig. 51, which correspond with D and G, illustrate the method of producing vertical waved lines in the cloth. In the former the twill turns on the picks 1 and 7, and in the latter on the picks 1, 9, 13, 17, 25, and 29. The design Q shows a 10-thread twill arranged to run seven picks to right and three picks to left alternately, a zig-zag twill, running at a steep angle, being produced. A defect of the pointed twill arrangement is the formation of an increased float where the weave turns, the long float occurring in the weft in the horizontal waved effects, and in the warp in the vertical patterns. Occasionally, two threads are worked alike at the turning points; but this is liable to give a defective appearance.

Curved Twills.—The principle of construction of curved twills will be understood from an examination of the design R in Fig. 53, which is constructed from the

8-thread twill given at S on the basis of the curved draft indicated at T. This class
of design is only used to a limited extent, as there is the disadvantage that the length
of the weft float and the firmness of the cloth vary in different parts of the twill line.

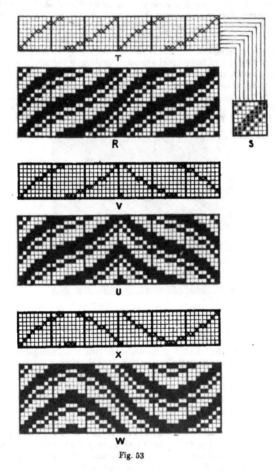

Fig. 53

Curved twills may be reversed in direction so as to form zig-zag effects in
which each curve terminates in a point, as shown at U in Fig. 53, and the corre-
sponding draft V; or a rounded zig-zag twill may be made, as indicated at W and
the corresponding draft X.

DIAMOND AND DIAPER DESIGNS

Construction of Diamond Designs upon Pointed Drafts.—Point-drafted diamond and diaper effects may be constructed in the following two ways :—(1) By employing a twill for the pegging-plan, which is reversed vertically to coincide with the horizontal pointed arrangement of the draft. (2) By indicating a diamond base and building up the design in the same manner on each side of the centre ends.

In the first method the design really results from employing horizontal and vertical zig-zag twills in combination. This is illustrated at A, B, C, and D in Fig. 54

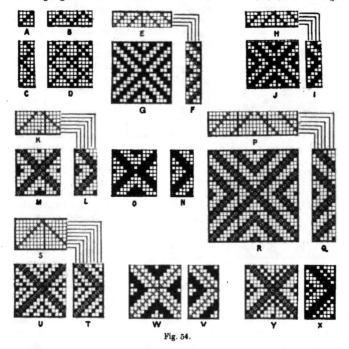

Fig. 54.

in which A shows a 1-and-3 twill that is arranged at B as a horizontal pointed twill in the order of 1, 2, 3, 4, 3, 2, while C represents the same twill arranged to zig-zag vertically in the order of 1, 2, 3, 4, 3, 2 (two repeats are given in each direction). If B be taken as a draft with C as the weaving plan, the small diamond design given at D will result.

In the same manner E, F, and G in Fig. 54, illustrate the construction of a diamond design based upon 2-and-2 twill. The draft E (which is similar to C in Fig. 51) turns in the first and ninth ends, and the pegging-plan F, which, as shown by the crosses, runs in the same order vertically as the draft is arranged horizontally,

turns on the first and ninth picks. The combination of E and F produces the diamond design given at G, in which, however, it will be noted that the diamond spaces are not alike. This is due to the additional mark of the 2-and-2 twill being necessarily placed at one side of the base marks in the pegging-plan. It is possible, however, to produce similar diamond spaces in the 2-and-2 twill by making the repeat two threads larger in one direction than in the other, as shown at H, I, and J in Fig. 54. The design J corresponds with the woven pattern represented in Fig. 55.

The construction of three diamond designs, based upon 3-and-3 twill weave, is illustrated at K to R in Fig. 54. The draft K turns upon the first and seventh ends, and the corresponding pegging-plan L upon the first and seventh picks. In the latter the base line (indicated by the crosses) forms the centre of the float of three, and the arrangement results in the formation of a perfectly symmetrical diamond design, as shown at M. A pegging-plan for the draft K is given at N, however, in which the base line does not form the centre of the

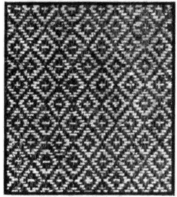

Fig. 55.

3-and-3 twill weave, and this results in the production of a design, as represented at O, in which the diamond spaces are not alike. By employing more than one repeat of the twill in each direction, as shown at P, Q, and R in Fig. 54, a larger diamond design is produced. If the base line of the pegging-plan forms the centre of the marks of the twill weave, a continuous line of marks in each direction is formed which enclose the diamond spaces. The marks may, of course, indicate either warp or weft up.

The drafts E, K, and P in Fig. 54 turn on the same heald (the first) each time, and the arrangement has the advantage that the same number of ends is drawn upon each heald. Pointed drafts, however, are frequently made to turn on the first and last healds, which thus require half as many mails as the centre healds, as shown at S in Fig. 54. In order to illustrate certain features in the designs, three pegging-plans are given at T, V, and X, in each of which an 8-thread twill weave is reversed in the same order as the draft S, while the corresponding designs are indicated at U, W, and Y. The same twill weave is used in both T and V, and in both cases the base line of marks forms the centre of the twill. In the plan T, however, the base line is in the centre of the float of three, whereas in V it coincides with the single line of marks. The difference in the position of the twill results in the formation of two quite different designs, as will be seen from a comparison of U and W. In the pegging plan X the base line of marks is in the centre of the float of three, but the single line of marks is not in the centre of the space between, hence in the resulting design, given at Y, the two diamond spaces are dissimilar. This, however, is not necessarily a disadvantage.

Fig. 56 shows the construction of a more elaborate diamond design than any of the foregoing, and also illustrates a method of using straight and pointed twills

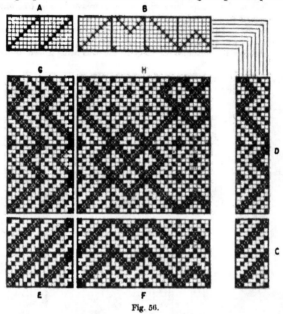

Fig. 56.

in the production of bordered fabrics. A shows a straight draft, and B a fancy pointed draft (the latter is the same as I in Fig. 51) on 8 healds, while C and D represent straight and pointed twill pegging-plans to correspond. The straight twill, given at E results from the combination of A and C; the horizontal zig-zag twill F from the combination of B and C; the vertical zig-zag twill G from the combination of A and D; and the diamond design H from the combination of B and D. By suitably repeating the respective sections a number of times a bordered fabric may be formed in which E forms the corners,

Fig. 57.

F the cross-borders, G the side-borders, and H the centre. A diamond figure that is arranged on the same principle as H in Fig. 56, but which requires 16 healds, is shown arranged in stripe form with another weave in Fig. 57, while the corresponding draft is indicated at A in Fig. 138.

Fig. 58 shows another form of diamond figure which repeats upon 90 ends and picks, and can be woven in 18 healds. The order of drafting is indicated by the black squares on the first 18 horizontal spaces of K, the ends being drawn to right

Fig. 58.

and left alternately in the order of 18, 9, 18, 18, 9, 18. The pegging-plan, which is based on the weave given at L in Fig. 59, is indicated on the first 18 vertical spaces of Fig. 58 ; and, as shown by the solid marks, the order of reversing is the same as in the draft. A method of preventing the formation of an increased float where the twill reverses (which is common to pointed twills) is illustrated by the example. The draft is arranged to turn always on the first, or the tenth heald, and the pegging-plan on the first or the tenth vertical space. The squares, where the first and tenth

ends and picks intersect in the weave L in Fig. 59, are therefore taken as centres, and the twill line of float is cut across as shown. Therefore, instead of the floats

Fig. 59.

Fig. 60.

joining together small spots are formed at each place where the twill lines cross one another in Fig. 58. In order that the form of the design may be clearly seen the complete weave is shown only on the first 18 ends and picks of Fig. 58.

It is very necessary for the weave, which is used as the basis of the pegging-plan, to be systematically constructed in order to ensure that a symmetrical design will result. For the purpose of further illustrating this point two fancy twill weaves are given at M and N in Fig. 59 which are suitable for the draft of Fig. 58. A single line of marks is first inserted diagonally, as shown by the dotted squares in M and N, then the first and tenth threads (on which the draft reverses) are taken as centres, and a weave is built up which will reverse either in the direction of the warp or the weft without forming an increase in the float. Also the remainder of the weave is constructed in the same manner on each side of the centre line of marks.

In the second class of point-drafted diamond designs, a woven example of which is illustrated in Fig. 61, a pointed draft is first indicated on the required

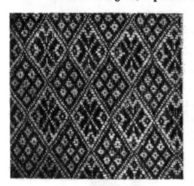

Fig. 61.

number of healds, as shown at A or B in Fig. 60, which are arranged on nine healds. Marks are then inserted in reverse order, as shown at C or D, and the repeat, which is on two threads less than twice the number of healds in the draft, is thus divided by the base marks into two diamond spaces. The base marks, which serve as a guide in building up the design, may be converted into distinct lines that cross one another, as shown at E ; or a weave may be indicated only in the diamond spaces, as represented at F. The two diamond spaces may be filled in in the same manner, as shown in E, or different effects may be inserted, as indicated in F, which shows one diamond space in weft float, and the other in warp float. In each case, however, it is necessary for the threads to work alike on each side of the centre ends.

In constructing diamond designs in which the sections are equal in size and exactly the reverse of each other, the repeat should be made two threads larger in one direction than the other. The method is illustrated at G and H in Fig. 60 ; G showing how the diamond base is arranged, and H a design in which the warp float in one space exactly corresponds with the weft float in the other space.

If a hopsack weave is employed, the small squares should be arranged to reverse properly from the centre, as shown in the design given at I in Fig. 60, which is constructed on the basis of a pointed draft on 13 healds.

The design J, which corresponds with the pattern represented in Fig. 61, shows an elaborate style that is weavable on a 16-heald pointed draft. (Other examples of point-draft diamond designs are given in Figs. 309, 310, and 311.)

Diamond Designs that are not Pointed.—The construction of diamond designs that are not weavable on pointed drafts, gives greater freedom to the designer, as

compared with the foregoing, but in dobby shedding the size of the repeat is more limited. For convenience diamond base marks may be first indicated in the same manner as in the construction of point-drafted designs. Very interesting interlacing twill designs are produced in this system, and a convenient method of working is illustrated at K and L in Fig. 62. From the centres where the diamond base lines intersect, lines of marks are inserted running to right and left alternately, as indicated by the solid squares in K. Marks are then added to the base lines to give the required length of float, as shown at L, but blank squares are left where the twills cross one another in order to break the continuity of the lines.

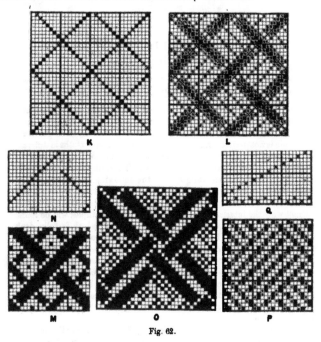

Fig. 62.

In dobby shedding, in order to obtain a larger number of threads in the repeat than the number of healds employed, an interlacing twill design may be arranged to suit a modified form of pointed drafting. An example is given at M in Fig. 62. which repeats on 22 threads but can be drafted on 16 healds, as indicated at N.

The design O in Fig. 62 illustrates a method of interlacing the twills when two or more lines are introduced ; this design cannot be drafted on to less than 29 healds, and is therefore beyond the capacity of the ordinary type of dobby.

The diamond design given at P in Fig. 62 illustrates a principle by which comparatively large effects can be woven on a small number of healds. The even

ends work continuously in 2-and-2 order, as indicated by the solid marks, and can be drawn upon two healds, as shown in the draft Q. The 2-and-2 twill weave is caused to run to left or to right in the design according to the position in which the marks are inserted upon the odd ends. Effects can be produced in 1-and-3 twill weave in the same manner.

Two examples of large diamond designs are given in Figs. 230 and 231, which are different from the preceding, but no difficulty will be found in following the bases of construction.

CHAPTER V

CONSTRUCTION OF SIMPLE SPOT FIGURE DESIGNS

Methods of drafting Spot Figures—Distribution of Spot Figures—Reversing Spot Figures—Irregular Sateen Bases—Calculations relating to Spot Figure Designing.

DESIGNS in which the ornament consists chiefly of small, or comparatively small, detached spots or figures are employed in nearly all classes of yarn and yarn combinations, for dress fabrics, fancy vestings, and other textures in which elaborate figure ornamentation is not desired. Spotted effects are produced in cloths in different ways—e.g., by employing fancy threads in which spots of contrasting colour occur at intervals, and by introducing extra warp or extra weft threads which are brought to the surface where the spots are formed. In the following, however, only the system of producing spot figures is considered in which the spots are formed by floating the ordinary weft or warp threads on the surface of the cloth in an order that is in contrast with the interlacing in the ground. (The examples will be found useful as an introduction to the designing of figured fabrics, which is fully dealt with in subsequent chapters.) The figures show most prominently when the warp and weft threads are in different colours or tones; but if the two series of threads are alike the difference in the reflection of the light from the different weave surfaces is sufficient to render the figures clearly visible. Other things being equal, the weft usually forms brighter and clearer spots than the warp: (1) because it is more lustrous on account of containing less twist; and (2) because cloths generally contract more in width than in length, the weft thus being brought more prominently to the surface than the warp.

Methods of Drafting Spot Figures.—Simple spot figures are readily designed directly upon point paper, and the outline may be first lightly indicated in pencil, as represented at A in Fig. 63. The squares are then filled in along the outline, as indicated at B, and this is followed by painting the figure solid, as shown at C. If the ground weave is plain, in painting the outline, the moves should be in odd numbers of squares, as shown at D in Fig. 63, in order that the edge of the figure will fit correctly with the plain marks. If only short floats are required in the figure a simple weave (e.g., a twill or sateen) may be inserted upon it in a colour of paint that is in contrast with the first colour, as represented by the blanks in the figure shown at E in Fig. 63. On the other hand, the binding marks may be inserted in such a manner as to give a special appearance to the figure as indicated at F. The

prominence of the figure is usually reduced about in proportion to the firmness of the binding weave, but, as a rule, however pronounced a figure is required to appear, a longer float than three-sixteenths of an inch in the cloth should not be made, or the structure will be too loose.

In producing a given size of figure in the cloth the number of small spaces, or

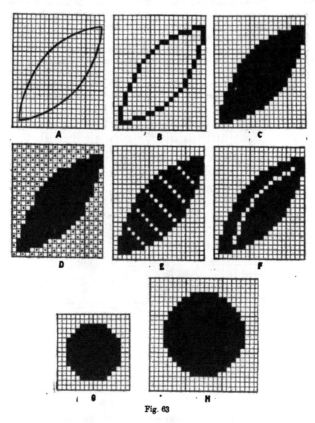

Fig. 63

threads, upon which it is designed, varies according to the set of the cloth. For instance, if a spot three-sixteenths of an inch in diameter is required : For a cloth containing 64 ends and 64 picks per inch, the spot will be designed upon 12 squares in each direction, as shown at G in Fig. 63 ; whereas for a cloth counting 96 ends and 96 picks per inch it will be designed upon 18 squares, as indicated at H. If the ends and picks per unit space are unequal, to enable the figure to be drawn in

proper proportion, design paper should be used which is ruled to correspond.
(see Fig. 258).

Spot figures which are rather intricate may be sketched upon plain paper, and
then be drafted upon design paper in the manner illustrated at I, J, and K in Fig. 64.
As shown at I, two lines are drawn at right angles to each other to correspond
with the direction of the warp and weft threads, the position of the lines in relation
to the figure determining the angle at which the latter will be inclined in the cloth.
The area over which the figure extends is then divided into equal spaces, as shown
at J, each space corresponding to a number of ends and picks in the cloth, or of small
spaces of the design paper. The figure is then drawn to the required scale upon the
point-paper, as shown at K in Fig. 64, in which one large square, or eight ends and
picks, correspond to one space of the sketch J. If the figure is required to appear
the same size in the cloth as in the sketch, the ruling of the sketch and the number
of small spaces of the design paper that each space in the sketch represents, are

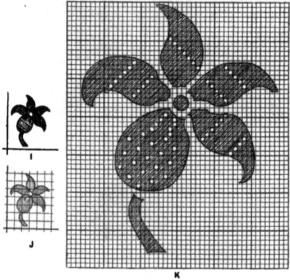

Fig. 64.

determined by the number of ends and picks per inch in the finished cloth. It is
generally convenient, in designing small figures, to rule the lines at such a distance
apart in the sketch that they correspond to the thick lines of the design paper.

Distribution of Spot Figures.—It is only in special cases, as for instance, when
a spot is arranged to fit in the centre of a coloured check, that a figure is used only
once in the repeat of a design. Generally, two or more figures are contained in
the repeat, and it is necessary for them to be placed at a suitable distance apart, and

evenly distributed over the repeat area. The repeat must be at least so large that
the figures do not encroach upon each other, and the factors which influence the

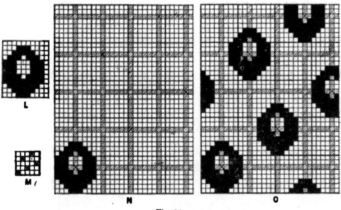

Fig. 65

number of ends and picks in a design are as follows :—(a) The size and shape of
the figure ; (b) the number of figures ; (c) the amount of ground space required ;
(d) the number of threads in the repeat of the ground weave. Even distribution
of the figures is secured by
employing a simple weave—such
as plain and certain sateens—
as the basis of the arrangement.

A method of distributing
figures upon design paper, that
will be found applicable to any
shape of figure, is illustrated in
Fig. 65, which shows the spot
L arranged in the order of the
5-sateen base given at M upon
30 ends and 40 picks. As shown
at N, the figure is first painted in
near the bottom left-hand corner
of the sheet of point paper, and
the square which is nearest its
centre is marked, as indicated by
the cross on the fifth end and
sixth pick. From the marked
end and pick the repeat is divided

Fig. 66.

in both directions into as many parts as figures to be used—in this case five ;
and lines are lightly ruled in pencil on the spaces, as represented by the shaded

5

lines in N. It will be seen that the vertical lines occur at intervals of six ends and the horizontal lines at intervals of eight picks to correspond with the division into five parts each way of the repeat of 30 ends and 40 picks. Then, as indicated by the crosses in N, the squares where the divisional lines intersect are marked in

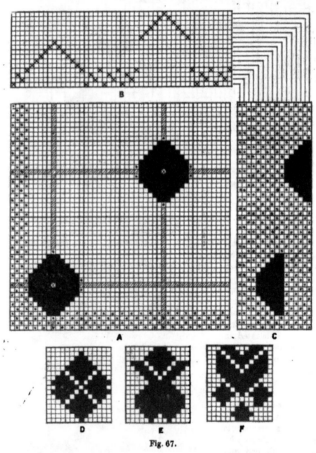

Fig. 67.

the order of the sateen base. The final stage in designing the figures consists of copying the first spot square by square in the same relative position to each centre mark, as shown at O in Fig. 65.

In the plain weave basis the figures are arranged in alternate order, as shown

in the example given in Fig. 66 and the corresponding design indicated at A in Fig. 67.

In this case, as there are two figures in the repeat, the number of ends and picks in the design are divided into two parts from the tenth end and pick which form the centre of the first spot.

In dobby weaving pointed drafts enable spot figures to be produced with comparatively few healds. Thus, as shown at B in Fig. 67, the design A requires only twelve healds in addition to the four healds upon which the ends, which work in plain order throughout, are drawn. The pegging plan, to correspond with A and B, is given at C. With a given draft a variety of spots can be formed, and for the purpose of illustration examples are given at D, E, and F, which are suitable for the draft B.

Fig. 68.

Reversing Spot Figures. —The figures shown in Figs. 65 and 67 are symmetrical, hence they are placed the same in each position. Figures that are not symmetrical can be turned in opposite directions to each other, and in Fig. 68 examples are given which illustrate the different ways in which figures can be placed. In each design the centres of the figures are indicated by crosses on the ninth and twenty-fifth end and pick, and the direction in which the figures are turned is represented by a diagonal row of dots from each centre. A in Fig. 68 shows both figures turned the same way,

Fig. 69.

a method which imparts a monotonous appearance to a design, and is liable to cause the figures to fall into diagonal lines. In B and C the two figures are inclined in opposite directions, the second figure in the former design showing the first figure turned over horizontally, and in the latter design turned over vertically. In D the two figures are inclined in the same direction, but in the second position the figure is turned round 180°.

In Fig. 69 the figure is arranged in alternate order as in the preceding examples, but in this case it is turned in four ways, and used eight times in the repeat. The

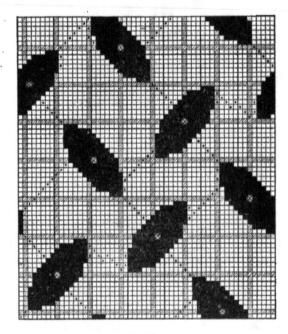

Fig. 70.

arrangement is very suitable for small effects, as a better all-over distribution is obtained than when only two figures are introduced. In order to distribute the figures regularly over the given size of repeat, the approximate centre of the first figure is found, as shown by the cross on the eleventh end and pick. From this position the repeat is divided in both directions into four equal parts, as shown by the shaded lines. Crosses are then inserted in alternate order where the shaded lines intersect, to indicate the centres of the remaining figures, and a diagonal row of dots is run in to show the inclination of the figure and to enable the outline to be more readily followed square by square. In this example the repeat is divided

into only four parts for the eight figures, because two centres are placed upon each divisional line.

In Fig. 70 an inclined spot, which can only be turned in two directions, is shown arranged in 8-thread regular sateen order upon 56 ends and 64 picks. The figure is designed to fit with plain ground, and the example illustrates that it is sometimes

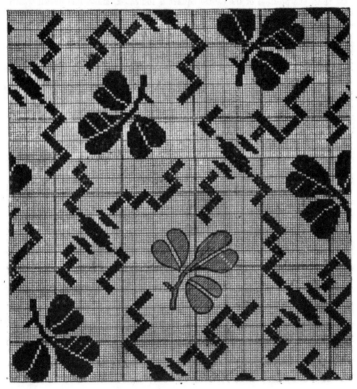

Fig. 71.

necessary to alter the position of certain of the figures in order that the outline will join correctly each time with the plain weave. Thus the centres of alternate spots in Fig. 70 are one square to the right of the places where the divisional lines intersect. The design shows the proper method of reversing an inclined figure in the 8-thread regular sateen order of distribution, two figures in one direction alternating with two in the other direction. It will be found by experiment that if the spots are reversed alternately cross twill lines are formed in each of which the figures are inclined in the same direction.

Fig. 71 shows the arrangement in 5-sateen order of a floral object which is turned in four directions, the fifth figure being placed like the second. Three of the figures are shown copied square by square from the first: but the shaded figure illustrates a system of copying the outline by "tracing." In this method the outline of the first figure is copied upon transparent tracing paper, upon which, at the same time, the position of the centre square is indicated, and a line drawn which is parallel to the horizontal lines of the design paper. The tracing is then turned

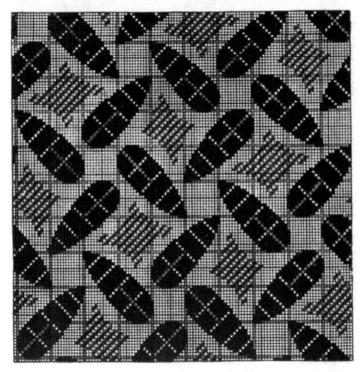

Fig. 72.

over, or round, and placed successively in the required position with the centre mark coinciding with the centres that are indicated on the design paper, and with the line on the tracing paper retained in a horizontal direction. The first copy is made by pencilling over the outline on the reverse side of the tracing paper, and simultaneously the tracing is prepared for being turned over again. Subsequent copies can be made by "rubbing" the tracing paper, either by means of the thumbnail or the back of a knife-blade. Also the figure can be distinctly copied

by placing black carbon paper between the tracing and the design paper while the outline is pencilled over. After all the figures have been traced, the outline of each is painted over independently.

In order to give a more varied appearance to the sateen arrangement, indicated in Fig. 71, small subsidiary figures, from which a trail effect branches, have been inserted in the ground spaces. The floral objects, together with the small figures, form a 10-sateen arrangement, and the example thus illustrates how certain bases enable two different shapes to be introduced in a design.

The example given in Fig. 72 also shows a figure arranged in 5-sateen order, but in this case, to enable the figure to be placed an equal number of times in each of four positions, the basis is repeated twice in both directions. The figure is, therefore, contained twenty times in the repeat, and it will be seen that the objects group in fours in such a manner that the ground spaces form definite shapes. A subsidiary effect in 2-and-1 twill is shown in the ground, which is arranged to fit with a 1-and-2 twill ground weave.

Irregular Sateen Bases.—The chief disadvantage of the regular sateen orders of distributing figures is that the systematic arrangement causes the objects to form continuous twill lines with each other in the cloth. A design appears less monotonous, and usually more pleasing, if the spots seem to be arranged indiscriminately, as shown in the example given in Fig. 73. An indiscriminate appearance, combined with uniform distribution, can be secured by employing an irregular sateen (see Fig. 18, p. 19) as the basis of the arrangement; the 8-, 10-, and 12-thread irregular weaves being particularly serviceable when the spots are small. (The difference in the appearance of the regular and irregular bases is illustrated by the designs given in Fig. 366.)

Fig. 73.

Fig. 74 shows a spot, similar to that represented in Fig. 73, which is arranged in the 8-thread irregular sateen order indicated in the bottom left-hand corner. The figures are formed in both weft and warp float, as indicated by the solid marks and circles. The grouping in pairs, together with the system of reversing, gives the design additional interest. (More complex examples of designs, in which the figures are arranged in sateen order, are given in Chapter XIX., while the method of inserting ground weaves, which is a very important matter, is described and illustrated in Chapter XV.)

Calculations relating to Spot Figure Designing.—It is sometimes necessary to arrange a given figure, or similar figures, in different orders with the same relative

amount of ground space. The number of ends and picks in the repeat of a re-arranged design can be found by the following formula :—

$$\sqrt{(\text{ends or picks in given design})^2 \times \frac{\text{figures required}}{\text{figures given}}} = \text{required ends or picks.}$$

For example, assuming that the spot given in Fig. 65 (in which five spots are distri-

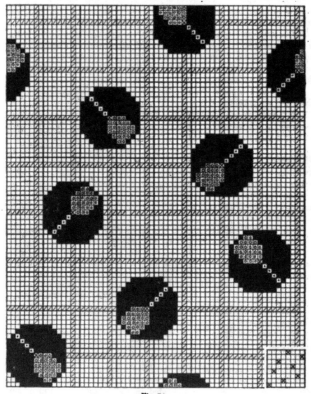

Fig. 74.

buted upon 30 ends and 40 picks) is required to be re-arranged in 8-sateen order, with the same proportion of ground space as before :—

$$\sqrt{(30 \text{ ends})^2 \times \frac{8 \text{ figures}}{5 \text{ figures}}} = 38 \text{ ends.}$$

$$\sqrt{(40 \text{ picks})^2 \times \frac{8 \text{ figures}}{5 \text{ figures}}} = 50 \text{ picks.}$$

The ascertained number of ends and picks may require to be modified to suit the repeat of the ground weave, and in some cases it may be found that the number is quite inappropriate to the new arrangement because of the change in the relative position of the figures.

CHAPTER VI

SPECIAL CLASSES OF ELEMENTARY WEAVES AND FABRICS .

Derivatives of Hopsack or Mat Weaves—Hopsack and Rib Combinations—Barley-corn Weaves—Stitched Hopsacks—Twilled Hopsacks. *Crêpe Weaves*—Construction of Crêpe Weaves upon Sateen Bases—Combinations of a Floating Weave with Plain Threads—Crêpe Weaves produced by Reversing—Insertion of One Weave over another—Armures. *Honeycomb Weaves*—Ordinary Honeycomb Weaves—Brighton Honeycomb Weaves. *Huckaback Weaves. Imitation Gauze on Mock Leno Weaves*—Perforated Fabrics—Distorted Thread Effects.

DERIVATIVES OF HOPSACK OR MAT WEAVES

THE ordinary mat weaves, given at Q, R, and S in Fig. 3 (p. 5) are modified in various ways with the object of obtaining variety of pattern, and in order to make the structures firmer. Examples are given in Fig 75, in which A shows the 3-and-3 hopsack stitched in the centre of each small square, while B and C represent two methods of stitching the 4-and-4 hopsack. The small squares are not so clearly defined as in the ordinary hopsacks, but the weaves are firmer. The design D shows a modification of A obtained by extending or doubling the latter.

The design E in Fig. 75, which is derived from the 3-and-3 hopsack, shows how a weave may be modified by reversing the float at one corner of each small square, while the design F, which is based upon the 4-and-4 hopsack, shows the floats reversed at opposite corners of each square. In both cases, the complete design results from reversing the section in which the shaded squares are indicated.

Hopsack and Rib Combinations.—Examples G, H, and I in Fig. 75 respectively show the 2-and-2, 3-and-3, and 4-and-4 hopsacks combined with warp and weft ribs ; the latter separate the small squares in groups, so that small check affects are formed. The designs J, K, and L are also combinations of hopsack and warp and weft ribs, but in this case the small squares are separated from each other individually. The designs G to L are frequently woven with finer yarns for the rib threads and picks than for the hopsack threads. Thus, the pattern represented in Fig. 76, which corresponds with the design J, is arranged two double ends of 20's cotton (hopsack) and two ends of 40's cotton (warp rib), and two picks of 10's cotton (hopsack), and two picks of 40's cotton (weft rib).

Barley-Corn Weaves.—A mat weave also forms the foundation of each of the designs M, N, O, and P in Fig. 75, to which the term " barley-corn " is applied. (These effects are similar to those given at O, P, and Q in Fig. 41 (p. 42). The cross-twill in the designs gives a considerable degree of firmness to a cloth as compared with ordinary hopsacks of similar sizes, particularly when the cross-twill is in double lines of marks, as shown in O and P. In all the foregoing examples the floats of warp and weft cut with each other perfectly.

Stitched Hopsacks.—The designs Q and R in Fig 75 illustrate methods of imparting firmness to large weaves by the introduction of plain stitching threads. In Q the plain threads are introduced only in the warp, so that the floats in the weft sections of the design are broken. In R, however, certain threads of both series interweave plain, and similar warp and weft sections are formed.

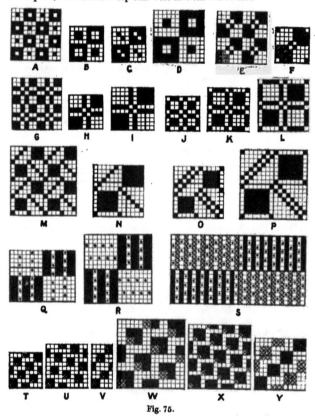

Fig. 75.

The design 8 in Fig 75 is really a stitched warp rib weave that repeats on four ends, and the cloth is entirely warp surface. By colouring the ends in the order indicated by the solid marks and the crosses—viz., 1 dark, 1 light, for 16 ends, and 1 light, 1 dark, for 16 ends, distinct sections in light and dark are formed. The cloth should contain about twice as many ends as picks per unit space, the sections then being square, so that the design appears like a hopsack.

Twilled Hopsacks.—The designs T to Y in Fig. 75 are twilled hopsacks, in

which the small squares, which are formed by only one series of threads (either warp or weft), run in twill order. The weaves are not so stiff as the ordinary hopsacks, and are generally more suitable than the latter for suitings and trouser-ings. The 2 × 2 hopsack effect given at T, is based on an 8-thread sateen; that at U on a 10-thread sateen; and that at V on an extended 5-thread sateen. The 4 × 4 effect, given at W, is constructed on an extended 8-thread sateen basis, or by doubling the weave T. X, and Y represent 3 × 3 twilled hopsacks, the former being constructed on a 15-thread sateen base, and the latter by inserting two rows of squares as equally distant from each other as possible on 12 threads.

CRÊPE WEAVES

The term crêpe is applied to weaves that contain little or no twilled or other prominent effect, and which give a cloth the appearance of being covered by

Fig. 76.

Fig. 77.

minute spots or seeds, as shown in the fabric represented in Fig. 77. The weaves are used alone, and in combination with other weaves in a great variety of cloths, and very frequently are employed in forming the ground of figured fabrics.

Construction of Crêpe Weaves upon Sateen Bases.—The weaves are constructed in a number of different ways, one of the simplest of which consists of adding marks in certain orders to some of the sateen bases. A and B in Fig. 78 are constructed on an 8-thread regular sateen base. In the former both the warp and the weft are floated, the same effect being produced on both sides of the cloth, whereas the latter, in which one yarn is brought chiefly to the surface, is arranged to suit a cloth in which one kind of yarn is better material than the other. C in Fig. 78 is constructed on a 10-thread sateen basis, and contains equal floats of warp and weft; the term "sponge" is applied to this weave.

The irregular sateens, because of the entire lack of twilliness, are particularly suitable to use as bases in the construction of crêpe weaves. D in Fig. 78 is a simple,

but very useful, crêpe which is based on the 4-thread sateen; E is constructed on a 6-thread irregular sateen, and F and G on 8-thread irregular sateen bases.

Combinations of a Floating Weave with Plain Threads.—In this system of constructing crêpe weaves threads that work plain are combined with threads of a floating weave which are arranged in sateen order. H in Fig. 78 illustrates one method of arrangement in which plain marks are indicated on the odd ends, as shown by the dots, and sateen marks on alternate picks of the even ends, as shown by the crosses. Marks are then added to the sateen base marks in an order which fits with the plain weave, as shown at I, in which the floating threads are arranged on the basis of a 4-thread sateen. The designs J and K are similarly constructed, the floating threads in the former being arranged upon the basis of a 5-thread sateen,

Fig. 78.

and in the latter upon the basis of a 6-thread sateen. In each case the design repeats upon twice as many ends and picks as the sateen base that is employed. The plans L and M, which correspond with H and I, show how the floating weave may be inserted horizontally. The designs appear rather different in the two methods and by comparison it will be seen that whereas in the design I the number of healds can be reduced by drafting the plain ends on to one shaft, in design M as many healds are required as there are ends in the repeat of the design.

In the designs I, J, and K all the odd ends work alike; but good crêpe designs are also produced by operating them in opposite order, as shown at N in Fig. 78, and combining the threads with similar floating weaves. Thus in the design O the floating weave is arranged in the same manner as in I, but the resulting design is quite different. A different basis of the floating weave is employed in the design P, which, however, is simply a modification of the 4-sateen, a base mark being indicated

on every pick, so that the repeat is on twice as many ends as picks. This is also the case in the design Q, which is a simple but effective crêpe that can be woven by means of a combination of 2-and-2 twill side tappets, and plain under tappets. The design R shows another variation in which two plain threads alternate with two floating threads, the latter being again arranged on a 4-sateen basis.

Crêpe Weaves produced by Reversing.—The reversing principle of constructing designs, illustrated in Fig. 41 (p. 42), can be employed in the construction of neat crêpe effects, and an example is given at S in Fig. 78 in which the shaded marks indicate the motive weave. Also, weaves containing minute floats are built up in stages, as shown at T, U, V, W, and X in Fig. 78, one portion being reversed or turned in the opposite direction to another portion, as indicated by the different marks in the designs. The fabric represented in Fig. 77 corresponds with the design V in Fig. 78.

Insertion of One Weave over Another.—This method of constructing crêpe weaves consists of inserting two different weaves one over the other. In order to produce an irregular effect one at least of the weaves should be irregular in construction, and it is usually better if both are irregular. The method is illustrated in Fig. 79, in which A shows an 8-thread regular sateen derivative, and B the 4-thread sateen; while at C the marks of both A and B are combined in the same design. As the marks of the two weaves coincide in certain places, in order to prevent con-

Fig. 79.

fusion the weave that is marked in first should be indicated lightly, the second weave being then inserted in a different kind of mark. Afterwards the marked squares may be filled in solid in order to show the complete weave properly. In most cases, if the repeats of the two weaves have a measure in common different effects are formed by changing the position of one weave. Thus by inserting the weave A in the same position each time, and changing the 4-sateen to the positions shown at D, F, and H in Fig. 79, the combinations produce the designs given at E, G, and I respectively. In the same manner, the combination of the 8-thread irregular sateen derivative, given at J, with the weaves B, D, F, and H produces the designs indicated at K, L, M, and N respectively.

The number of threads in the repeat of a design is equal to the L.C.M. of the threads in the repeats of the weaves that are combined. The combination of the 4-thread sateen B with the 6-thread weave given at O in Fig 79, thus produces a design repeating on 12 ends and 12 picks, as shown at P. The design Q shows the

weave O combined with the 4-sateen in the position indicated at D, but this is a case in which a change of position of one weave does not produce a real alteration in the resulting design, as will be evident from a careful comparison of Q and P. The method of construction can be further extended by inserting three different weaves over one another.

Armures.—The term " Armure " is frequently applied to weaves of a somewhat irregular or broken character which produce more pronounced effects than crêpe

Fig. 80.

weaves. In some designs a small form is arranged twice in the repeat of a design, as shown at A and B in Fig. 80. If the form is inclined it may be turned in opposite ways, as shown at C, D, and E, in each of which it will be seen that the ground weave and the figure are arranged to fit very neatly with each other. F, G, and H in Fig. 80 are arranged on small diamond bases. The form may be indicated several times in the repeat of a design ; thus in the design I a small spot occurs three times in the repeat : in J. five times ; and in K, six times.

HONEYCOMB WEAVES

In the cloths produced in honeycomb weaves the threads form ridges and hollows which give a cell-like appearance to the textures. Both the warp and the weft threads float somewhat freely on both sides, which, coupled with the rough structure, renders this class of fabric readily absorbent of moisture. The weaves are, therefore, very suitable for towels ; and they are also used in various forms for bedcovers and quilts, and in combination with other weaves for fancy textures. The weaves are of two classes—viz., (1) ordinary honeycombs which give a similar effect on both sides of the cloth ; (2) Brighton honeycombs which produce the cellular formation on one side of the cloth only.

Ordinary Honeycomb Weaves.—In most cases these can be woven in pointed drafts, and a method of constructing the designs on this principle is illustrated at A, B, and C in Fig. 81. A pointed draft is indicated on the required number of healds—in this case, five, as shown at A ; then the marks are reversed, as indicated at B. Afterwards, one of the diamond spaces is filled in while the other is left blank, as represented at C. D shows a similar honeycomb design which is weavable

on six healds, and E a design that requires seven healds. In the foregoing system of arrangement either diamond space may be filled in, as will be seen from a comparison of D with C and E, but one yarn is floated on the surface more than the other. Thus, if the marks indicate warp up, in the design D the weft floats are 9, 7, 5, 3, and 1, as compared with floats of 7, 5, 3, and 1 in the warp. The fabric represented in Fig. 82 corresponds with the design E in Fig. 81.

The plan F shows a method of arranging the base so as to obtain equal warp and weft float; the resulting design repeating on two more picks than ends, as indicated at G. The basis may also be arranged on two more ends than picks, as shown at H, the complete design for which is given at I. The latter method, however,

Fig. 81.

requires a heald more than the former in producing the same length of float. The design J, which is constructed in a similar manner to G, produces the same weft float as D, and the same warp float as E. In each design G, I and J it is necessary for the marks to be inserted in the larger diamond space.

Large honeycomb weaves are liable to be loose in structure when constructed in the ordinary manner, and in order to secure firmness of texture a double row of base marks is inserted, as shown in the design K in Fig. 81, which is weavable on nine healds. The designs L and M, each of which requires the same number of healds as K, illustrate the two methods previously described, of obtaining equal warp and weft float in the firmly stitched weaves.

The plan N in Fig. 81 shows a base that is sometimes used in constructing honeycomb weaves ; but in this system a straight draft is required. One space is filled in and the other left blank, as shown at O. The design P illustrates a similar weave which repeats on a larger number of threads, and Q a firmly stitched large weave.

In the designs given in Fig. 81 the ridges occur where the long floats of warp

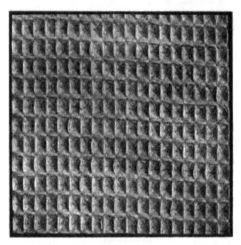

Fig. 82.

and weft are formed and the hollows where the threads interweave in plain order. Thus, taking the marks to indicate warp up, in each of the designs C, E, G, J, K, and L, a warp ridge is formed by the first end, and a weft ridge by the first pick. The plain weave, about the centre of these designs, tightens the threads, and causes a

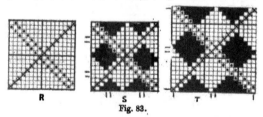

Fig. 83.

depression to be formed ; and although the weaves are constructed on a diamond basis, the cellular formation makes the patterns appear rectangular in the cloth. In the design D the ridges occur on the sixth end and pick, in I on the sixth end and fifth pick, and in M on the ninth end and eighth pick ; while in O, P, and Q, two threads

form a ridge—viz., the first and last end, and the first and last pick in each case. Suitable weaving particulars for the design D in a heavy cloth are :—2/12's cotton warp and weft, 50 ends and picks per inch ; and in a lighter cloth, 24's cotton warp and 18's cotton weft, 88 ends and 80 picks per inch.

Brighton Honeycomb Weaves.—These are quite different in construction from the usual type of ordinary honeycomb, and require to be woven in straight drafts : also the number of threads in a repeat must be a multiple of four. The construction of a Brighton weave on 16 threads is illustrated at R and S in Fig. 83. A diamond base is first made by inserting a single row of marks in one direction, as shown by the crosses in R, and a double row in the other direction, as indicated by the dots. Taking the marks to indicate warp up, marks are then added to the double rows so as to form a small warp diamond in the right and left corners of each diamond space, as shown in S ; a similar weft diamond being left in the upper and lower corners. The length of float of the centre thread of each small spot is one thread less than half the number of threads in the repeat. Thus in the design S each centre float passes over—$(16 \div 2) - 1 = 7$ threads, while in the design T, which shows a Brighton weave on 20 threads, each centre float passes over—$(20 \div 2) - 1 = 9$ threads.

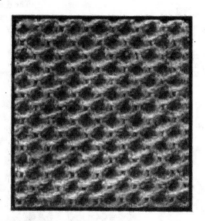

Fig. 84.

In the same manner as in ordinary honeycomb weaves, the long centre floats of warp and weft form vertical and horizontal ridges ; but in the Brighton weaves two sizes of hollows are formed, a large hollow at each place where the double line of marks crosses the single line, and a small hollow in the centre of each diamond repeat. There is also the difference that in an ordinary honeycomb weave each repeat only forms one cell, whereas a Brighton weave produces two large and two small cells. The fabric represented in Fig. 84 corresponds with the design S in Fig. 83. About the same weaving particulars may be employed for the design S in Fig. 83 as those given for the design D in Fig. 81. The Brighton structure is sometimes made, however, with two thicknesses of yarn arranged in 2-and-2 order ; the two thick threads being inserted where the longest floats are made.

In both classes of honeycombs there are two places where coloured threads may be effectively introduced : First, where the long floats are formed on the surface, as indicated by the position of the marks along the bottom and at the side of the design C in Fig. 81, and S in Fig. 83 (taking the marks to indicate warp up). Second, in the intermediate positions, as similarly indicated along the bottom and at the side of E in Fig. 81, and T in Fig. 83. In the first position the colours follow the ridges, and show very distinctly on the surface in the form of a small

6

check. In the second position the colours are only brought to the surface where the threads interweave plain, so that small spots of colour are formed at the bottom of the cells.

HUCKABACK WEAVES

These weaves are largely used for linen and cotton towels, glass-cloths, etc. The foundation is plain weave, which gives the cloths firmness and good wearing qualities, while comparatively long floats are formed by the yarns, so that the fabrics are rendered capable of readily absorbing moisture. The standard weaves are given at A and B in Fig. 85 ; the former, which is termed the 6-pick or " Devon " huck, being used for the lower grades of cloths and the latter for fine qualities.

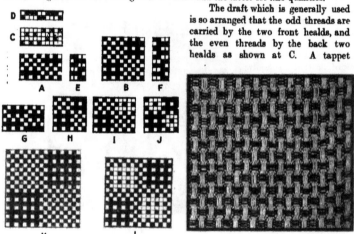

The draft which is generally used is so arranged that the odd threads are carried by the two front healds, and the even threads by the back two healds as shown at C. A tappet

Fig. 85. Fig. 86.

shedding motion is usually employed and the weaving plan for the design A is given at E, and for the design B at F. The purpose of the special draft is to enable plain cloth to be woven in the healds (without re-drawing the warp) by coupling the healds 1 and 2 together, and 3 and 4 together, and operating them by the first and fourth tappets.

The weaves tend to draw the ends into groups of five, and, to prevent this, it is customary to place the last end of one group in the same split of the reed as the first end of the next group, while the centre three ends are placed in one split. The threads are thus dented in the order of two and three alternately, as shown at D in Fig. 85.

The ordinary huckaback weaves are modified in various ways ; thus G in Fig. 85, which is derived from A, contains four floats in the repeat: H shows a variation of B that repeats on 8 ends and picks ; I repeats on 10 ends and 8 picks and produces the same effect on both sides of the cloth ; while J, although not reversible, shows both warp and weft floats on each side of the cloth.

The principle of the huckaback weave is also used in the construction of designs which repeat upon a larger number of threads and contain longer floats, as shown in the design K in Fig. 85. The term " honeycomb-huckaback " is applied to this weave. A further development is illustrated by the design L which, when woven in coarse yarns, belongs to a class termed " Grecian." Fig. 86 represents the appearance of the design L in the woven fabric.

IMITATION GAUZE OR MOCK LENO WEAVES

The weaves included under this head, when properly carried out, produce effects that are similar in appearance to styles obtained with the aid of a doup mounting. Two kinds of structures are produced by the weaves—viz. (1) perforated fabrics in imitation of open gauze effects, an illustration of which in stripe form is given in Fig. 88; (2) distorted thread effects in imitation of " spider " or " net " leno styles, examples of which are represented in Figs. 90 and 93.

Perforated Fabrics.—Illustrations of weaves of this class are given in Fig. 87, in which A, B, and C respectively show the 3×3, 4×4, and 5×5 imitation gauzes. Each weave is constructed by reversing a small unit, which in A, B, and C is indicated by the crosses. The weaves are in sections which oppose one another, and there is a tendency for the outer threads of adjacent sections to be forced apart, whereas in each section the order of interweaving permits the threads to readily approach each other. The warp threads thus run in groups with a space between, and are crossed by weft threads which are grouped together in a similar manner. The open appearance of the cloth, however, can be either improved or obscured by the system of denting that is employed. If the last

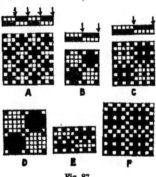

Fig. 87.

end of one group is passed through the same split as the first end of the next group, the tendency of the threads to run together is counteracted ; but if each group of ends is passed through a separate split the reed naturally assists in drawing the threads together in groups. Thus the designs A, B, and C should be dented 3, 4, and 5 ends respectively per split as shown above the plans. The open appearance of the weaves may be further increased by using a rather fine reed and missing alternate splits ; the arrows above the denting plans in Fig. 87 indicating the positions of empty splits.

The design D in Fig. 87 is simply a modification of B, and E of C, and both weaves should be dented five ends per split. The design F shows a style in which the ends and picks one to five group together, and are clearly separated from the sixth end and pick. In a coarse reed the ends may be dented five and one per split alternately ; in a reed of medium fineness, five in two splits; one split missed, one per split, one split missed ; while in a fine reed (40 to 50 splits per inch) a suitable order of denting is two, one, and two ends per split, one split missed, one per split,

one split missed. In the design F only one yarn is floated on the surface, whereas in the other designs the warp and weft are floated equally.

The open gauze weaves are sometimes used alone, as in canvas cloths, and in cheap fabrics for window curtains ; but for light dress fabrics, blouses, aprons, etc. they are, to a large extent, employed in combination with other weaves. In Fig. 88

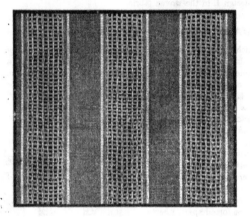

Fig. 88.

the 3 × 3 imitation gauze weave, given at A in Fig. 87, is shown arranged in stripe form with plain weave, while the 4 × 4 structure indicated at B, is shown as a ground weave to a figure in Fig. 280. When the same threads have to form both an open effect and ordinary interlacing, as shown in Fig. 280, it is, of course impracticable to leave splits of the reed empty ; and in some cases, in order that the figure will be

J K L

Fig. 89.

properly developed, each group of threads is placed in more than one split, but care is taken to split the groups of threads by the reed in regular order. Imitations of open leno effects are obtained in plain weave simply by missing splits in the reed ; as for instance, a stripe effect might be woven in a fine reed with 3 plain ends in one split alternating with two splits missed.

Distorted Thread Effects.—The imitation gauze weaves of this class may be arranged to distort certain threads in either the weft or the warp, or in both weft and warp. J in Fig. 89 illustrates one of the simplest methods of producing a distorted warp effect. The ground structure is plain weave, and the fourth and eleventh ends, which are distorted, float over all the plain picks (the marks indicate warp up), but pass under the fourth and eleventh picks. The latter float over one group of plain ends, and under the next group in alternate order. The distorted ends are placed on a separate beam and are given in more rapidly than the ground ends, hence they are drawn towards each other where the picks four and eleven float over the ground ends. As the latter floats occur in alternate order, the ends are drawn together in pairs, and

Fig. 90.

then separated, as indicated by the zig-zag lines on the right of J.

The design K in Fig. 89 produces a similar effect to J, but the distorted ends (5 and 13), and the picks (4, 6, 12, and 14) which float over them, are more firmly interwoven. Also the ground ends float loosely on the back of the cloth where the distorted ends are drawn together, the bending of the ends being thus facilitated. The fabric represented in Fig. 90 corresponds with the design K.

The design L in Fig. 89 shows a modification of K, in which all the distorted ends work alike, and produce independent zig-zag lines in the cloth, as indicated on the right of the design.

The distorted warp effects are chiefly used in combination with other weaves in stripe form, and an example is given in Fig. 91 (the marks in this

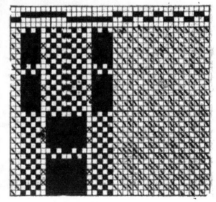

Fig. 91.

case indicating weft up) which corresponds with the pattern shown at the sides of the figured stripe represented in Fig. 346. When used in stripe form the ends which form the zig-zag effect should be somewhat crowded in the reed; and in producing the pattern represented in Fig. 346, the nine ends which form

each group, as indicated above the plan given in Fig. 91, were dented in three splits, while the ground ends were woven two per split.

Examples of distorted weft effects are given at R and S in Fig. 92, in which the marks indicate warp up. The design R is arranged with plain ground on the same principle as J in Fig. 89. The floating ends pass over all the distorted picks,

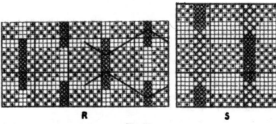

R S

Fig. 92.

and alternately over the ground picks between; therefore the distorted picks, which float over all the ground ends, are alternately drawn together and separated, as shown by the zig-zag lines on the right of R. Fig. 93 represents a fabric woven in the design R. In this method, the degree of distortion varies according to the difference in the shrinking of the distorted picks, which float loosely, and the ground picks, which interweave frequently; hence the best results are obtained when a ground texture is formed that shrinks considerably in width.

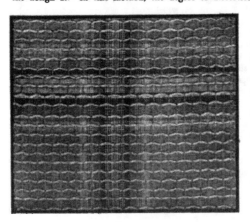

Fig. 93.

The design S in Fig. 92, illustrates a style which is used to some extent in thick yarns. In order to more fully develop the zig-zag effect two picks are floated on both sides of each distorted pick, and the ends, which draw the floating picks together alternately float and interweave plain. The loosely-woven picks are beaten up close together so that those in the centre are forced prominently to the surface, and are in a proper position for being drawn together, and then the plain interweaving of the floating ends produces the most suitable conditions for forcing the distorted picks apart.

In combining distorted warp and weft effects, a stripe, in which the threads interweave on the principle illustrated at K in Fig. 89, may be overchecked with a weave similar to R in Fig. 92, the bulk of the check being composed of plain or other simple weave. Colours may be introduced either in the floating threads or the ground threads, and Fig. 93 represents a cloth with a coloured check foundation.

CHAPTER VII

SPECIAL RIB AND CORD STRUCTURES

Rib and Cord Effects produced in Plain Weave—Methods of Increasing the Prominence of the Ribs—Soleil Weaves—Combination of Weft Cords with other Weaves. *Corkscrew Weaves*—Warp Corkscrew Weaves—Weft Corkscrew Weaves. Modified Rib and Cord Weaves—Longitudinal Warp Cords—Diagonal and Waved Ribs—Diamond Ribs. *Bedford Cords*—Plain-Face Bedford Cords—Wadded Bedford Cords—Crepon Bedford Cords—Bedford Cords arranged with alternate Picks—Twill Face Bedford Cords. *Welts and Piques*—Ordinary Welt Structures—Weft Wadded Welts—Fast-Back Welts—Waved Piques.

Rib and Cord Effects produced in Plain Weave.—In addition to the rib weaves, which are produced by extending the plain weave in the methods illustrated at A to N in Fig. 3 (p. 5), rib and cord effects are produced in a number of different ways. (The term cord is frequently applied to ribs that run the length of the cloth in order to distinguish them from those that run horizontally.) A rib or cord structure is largely due to the manner in which the warp and weft threads are proportioned as regards thickness, and number per unit space. Thus, in pure plain weave, if the number of ends per unit space largely exceeds the number of picks, the latter tend to lie straight in the cloth with the former bending round them, and a warp rib structure results. If the opposite conditions prevail, the ends tend to lie straight with the picks bending round them, a weft rib structure being formed. In each case the prominence of the rib is accentuated if the straight threads are thicker than those which bend. If all the warp threads are similar in thickness, and all the weft threads also similar, rib lines are formed on both sides of the cloth which are uniform in size, as shown at A in Fig. 94. A different form of rib structure is produced

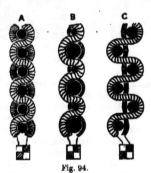

Fig. 94.

in plain weave, however, if a thick and a fine thread alternately are employed in warp and weft, as shown at B in Fig. 94. In forming a warp rib the thick ends always pass over the thick picks, and under the fine picks ; whereas in forming a weft rib, the thick picks always pass over the thick ends and under the fine ends. In the warp ribs there should be more ends per unit space than picks, and in the weft ribs more picks than ends. In this case, the rib lines, which are separated from each other by fine lines, show prominently on one side of the cloth only.

In another method of producing a warp rib structure in plain weave the odd ends are brought from one warp beam, and the even ends from another beam. One beam is much more heavily tensioned than the other, with the result that the heavily tensioned ends lie almost straight in the cloth and force the picks into two lines. The lightly tensioned ends are therefore compelled to bend round the picks in the manner illustrated at C in Fig. 94, so that horizontal ridges and depressions are formed in the cloth. The rib formation is quite prominent if all the ends are equal in thickness, but it is still more pronounced if the lightly tensioned ends are thicker than the others.

Methods of Increasing the Prominence of the Ribs.—In warp ribs, instead of one very thick end, two or more ends (which work together as one) may be employed to each fine end, and the ends may be placed at different tensions; while the weft may be either all alike, or arranged in the order of a thick and a fine pick alternately. The structures are similar to that represented at B in Fig. 94, except that the ends which form the rib spread out more and cover the surface better. A cotton cloth which is made in imitation of "pique," is constructed on the principle illustrated at C in Fig. 94, but with two slack ends to each fine tight end, and the following

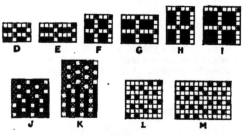

Fig. 95.

are suitable particulars :— 32's cotton warp, 126 ends per inch ; 16's cotton weft, 40 picks per inch. If consecutive ends that work alike are passed through the same mail, the latter should be provided with a separate eye for each thread.

Warp rib structures with two and three ends to each fine end are represented in full on design paper at D and E respectively in Fig. 95. The weave D is exactly the same as that given at L in Fig. 3 (p. 5), which is described as a weft rib, from which it will be evident that the same weave can be used in producing entirely different structures. If the number of ends per unit space largely exceeds the number of picks, the weave D produces a warp rib, but under the opposite conditions a weft rib is formed, the structure also being affected by the relative thicknesses of the threads. For example, the weave given at D in Fig. 95 yields a warp-rib structure with the particulars given above for an imitation pique; whereas with the following weaving particulars, a weft-rib structure is formed :—Warp—2 ends, 2/30's cotton. 1 end, 40's cotton, 50 ends per inch ; weft—20's cotton, 104 picks per inch.

The rib lines may be made to show more prominently by passing the ends which form the rib over two thick picks and under one fine pick, in which case the weaves will be represented in full on design paper, as shown at F and G in Fig. 95 ; while still greater prominence is imparted to the rib lines by arranging the weaves, as shown at H and I, to suit a 3-and-1 order of wefting. In looms with changing

boxes at one side only, a 2-and-2 order of wefting may be employed for the designs H and I; one of the fine picks going into the same shed as the two thick picks. The weaves D to I in Fig. 95 form the foundation of " matelasse " fabrics ; and good warp-rib structures result, if the warp is properly set, when the weft is all of the same thickness.

Soleil Weaves.—The designs, given at J and K in Fig. 95, produce a type of warp rib to which the term " soleil " is applied. In order to more fully develop the horizontal rib lines the warp threads are sometimes arranged alternately right and left hand twist, the direction of the twist in one rib line being thus opposite to that in the next line. For piece-dyed fabrics the reverse twist yarn is usually

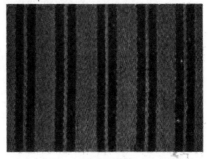

Fig. 96.

tinted with a fugitive colour in order that it may be distinguished from the grey ordinary twist yarn during the beaming, healding, and weaving operations.

The designs L and M in Fig. 95 are constructed on the same principle as J and K, but in this case the surface of the cloth is covered by longitudinal weft cords (the marks indicate warp up). A pick-and-pick order of wefting, either in different colours, twists, or materials, may be employed.

Combination of Weft Cords with Other Weaves.—The arrangement of weft cords in stripe form with another weave is illustrated by the fabric represented in Fig. 96, and by the designs N to V in Fig. 97. A weft-cord stripe is produced in plain cloth by introducing one or more thick ends, or by working together several ends of the ground warp, at intervals. (A plain corded zephyr fabric is represented at E in Fig. 2, p. 3.) The cord ends do not take up so rapidly as the ground ends, therefore unless they

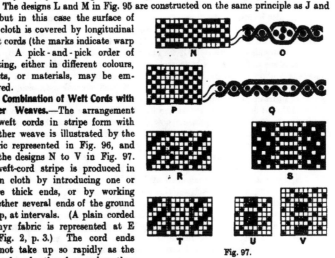

Fig. 97.

are brought from a separate beam, a difficulty is liable to be caused in weaving. The design N in Fig. 97 shows a simple form of cord combined with plain weave, which is produced by working four ends together in one split of the reed. The four ends group together, as represented in the drawing given at O, and if they

are in the same colour as the weft solid narrow lines of colour are formed in the cloth. A wide cord is obtained by denting a number of ends in two or more splits of the reed, and interweaving the weft on the underside, as shown at P (the marks indicate warp up). The picks interweave in nearly plain order on the underside, as represented in the diagram Q, so that the cord is kept out to the full width.

The designs R and S in Fig. 97 illustrate the combination of weft cords with other weaves than plain ; 2-and-2 twill and 5-thread sateen respectively being shown in the examples. If the cords are required to show very clearly, they should be stitched at each side with a plain end, as shown in R and S. The design T also shows a weft cord combined with 2-and-2 twill, but in this case the stitch ends at the sides are arranged to interweave with the same degree of firmness as the ground ends. The cords, however, are not so clearly defined as when the stitching ends at the sides work in plain order. The designs U and V in Fig. 97 show how weft cords may be constructed to cut with a given warp-face ground weave ; the marks in this case indicating weft up.

CORKSCREW WEAVES

Weaves of the corkscrew type, which are really twilled ribs, are used either alone or in combination with other weaves for a variety of purposes. In their simplest form they produce either a warp or a weft surface ; and they are most regular in construction when the repeat contains an odd number of threads. A warp corkscrew stripe fabric is represented in Fig. 227, which, if turned one-quarter round, also illustrates the appearance of a weft corkscrew texture.

Warp Corkscrew Weaves.—Ordinary weaves of this class are constructed on a sateen base counting 2 outwards, as shown at A, B, and C in Fig. 98, which repeat on 7, 9, and 11 threads respectively. If the marks of the designs indicate warp up, as many marks are added vertically to each sateen base mark as will make each vertical space contain one mark more than it contains blank squares. Thus, in the 7-thread warp corkscrew, shown at D in Fig. 98, each vertical space contains four marks and three blanks·; in the 9-thread weave E, five marks and four blanks ; and in the 11-thread design F, six marks and five blanks. From an examination of the drawing given at G, which represents how the threads 1 and 2 of the design F interlace, it will be seen that the face and back of the cloth are nearly alike, the warp preponderating on both sides.

Sometimes, in order to make the weaves firmer, the floats on the back are stitched in the method indicated at H in Fig. 98, which shows the design F modified. The threads then interlace, as represented at I, the floats on the face not being interfered with, whereas on the back the threads form nearly plain weave.

In constructing warp corkscrew weaves that repeat on an even number of threads, it is necessary to employ a modification of the foregoing method. As shown at J and K in Fig. 98, which represent the bases of the 8- and 10-shaft warp corkscrew weaves respectively, the repeat is upon twice as many ends as picks. A base line of marks, as shown by the crosses, is inserted on the odd vertical spaces, counting 2 ; then a second line—indicated by dots—is run in on the even vertical spaces, as centrally as possible. The design is completed by arranging each vertical space with two more marks than blanks, as shown at L, or with the marks and blanks equal, as represented at M. In the latter case, however, the weft shows slightly on the surface of the cloth.

The standard 13-shaft warp corkscrew, which has been extensively used for fine worsted coatings, is based on a 13-thread sateen, counting 4 outwards. as shown at N in Fig. 98. Marks are added to the base marks in the order of 4, 2, 4, and 2, as indicated at O, and very flat twill lines are formed in the cloth. as represented by the different marks in the design.

Weft Corkscrew Weaves.—These are exactly the opposite of the warp cork-screws, and when the repeat contains an odd number of threads, are constructed

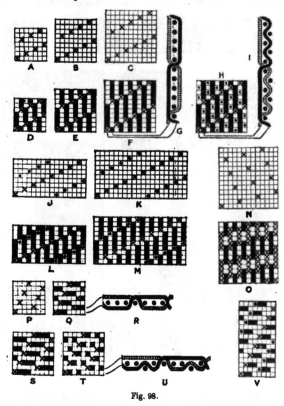

Fig. 98.

on a sateen base, counting 2 upwards. Marks are then added horizontally to the base marks, and if warp float is indicated, the number of marks on each horizontal space should be one less than the number of blanks. Thus, P in Fig. 98 shows the basis of the 7-thread weft corkscrew, and Q the complete design; while R represents how the picks 1 and 2 interlace with the ends, a weft surface being formed on both sides. The 9-thread weft corkscrew is given at S, and the same weave with the

weft stitched on the under side at T. The drawing U represents the interlacing of the picks 1 and 2 of T, and shows how the cloth is made firmer on the under side without the face floats being affected. The design V illustrates the method of constructing an 8-thread weft corkscrew. The systems of applying colour to corkscrew weaves, and special modifications of the structures are described and illustrated in Chapter XIII.

Modified Rib and Cord Weaves.—Very neat and effective designs are constructed by commencing a rib weave in a different position in succeeding sections. Thus,

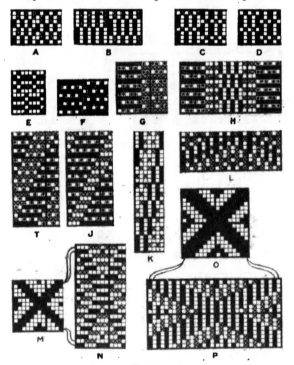

Fig. 99.

in Fig. 99 A shows a 2-and-2 warp rib arranged in sections of 6 × 6, and B a 4-and-4 warp rib in sections of 8 × 8; while at C and D a 3-and-1 warp rib is indicated in sections of 6 × 6, and 5 × 5 respectively, the latter forming more of a warp surface than the former. The designs A to D are effectively developed by colouring the ends in the order indicated by the different marks. E in Fig. 99 shows a weft rib arranged on the same principle as D.

Longitudinal Warp Cords.—The designs F and G in Fig 99 are cord weaves

which produce longitudinal cut lines at intervals of six ends. In F the first six ends interweave in plain order on the odd picks, and are raised on the even picks, while the second six ends are raised on the odd picks and interweave plain on the even picks. The change in the interlacing of the weft from plain weave to float at the back, and *vice versa*, causes a fine line or cut to be made every six ends. The design G is similar to F except that the plain weave is replaced by 2-and-1 warp twill, which brings the warp more prominently to the surface, while the direction of the twill is reversed in succeeding sections so as to develop the cut line more clearly. The design H shows the weave given at G combined with ordinary warp and weft rib weaves.

Diagonal and Waved Ribs.—Different methods of constructing ribbed diagonals are illustrated at T, J, and K in Fig 99. In the design T the two weaves, indicated at F, are arranged in diagonal form, while in J a weft rib is combined diagonally with one of the weaves given at F. The design K shows a very steep diagonal in which 4-and-4 warp and weft ribs are combined.

The design L in Fig. 99 shows a waved rib structure which is constructed on the basis of the soleil weaves given at J and K in Fig. 95.

Diamond Ribs.—A method of constructing elaborate weft rib designs, to suit a pick-and-pick order of wefting, is illustrated by the examples M and N in Fig. 99. The marks of M are indicated on the odd picks of the design N, as shown by the solid marks, then marks are inserted on the even picks, as shown by the crosses, to correspond with the blanks of M. By introducing about twice as many picks as ends per inch, the design N will produce an effect similar to M, but with a weft surface on both sides of the cloth ; and if two colours of weft are employed in 1-and-1 order the same design is formed on both sides except that one colour replaces the other.

The examples O and P in Fig. 99 similarly illustrate the construction of fancy warp rib designs, the marks of O being indicated on the odd vertical spaces of P, as shown by the full squares ; while marks are inserted on the even vertical spaces, as shown by the crosses, to correspond with the blanks of O. In this case about twice as many ends as picks are required, and by arranging the ends in two colours, 1-and-1, a reversible warp-faced design in two colours is formed. The colouring of cord weaves is described in Chapter XIII.

BEDFORD CORDS

Plain-Face Bedford Cords.—The Bedford cord class of weave produces longitudinal warp lines in the cloth with fine sunken lines between, as shown in the fabric represented in Fig. 100. The method of constructing the *ordinary* type of Bedford cord weave is illustrated in stages by the examples A to I in Fig. 101. At intervals pairs of ends work in perfectly plain order with the picks, therefore these lifts are first indicated, as shown at A, D, and G ; the number of ends between the pairs of plain ends being varied according to the width of cord required. The next stage consists of inserting marks (which indicate warp float) on the first and second picks of alternate cords, and on the third and fourth picks of the other cords, as shown at B, E, and H. The object of arranging the marks of the cord ends in alternate order is chiefly to equalise the lifts of the ends. The designs are then completed, as shown at C, F, and I, by inserting plain weave on the cord ends, which joins with the plain working of the pairs of ends. The cord ends float over three picks and under

one, while the picks float in pairs on the back of one cord and interweave in plain order in the next cord, as shown in the drawing given at J, which corresponds with the design F. In the design C each cord is six ends wide, and in F eight ends wide ; but I produces cords which vary in width in the order of 10, 8, 6, and 8 ends. Other widths and variations can be readily schemed.

The usual order of drafting is indicated at K in Fig 101, the plain ends being drawn on the healds at the front. The weaving plan is a combination of plain and 3-and-1 twill shedding, as shown at L. In order to fully develop the sunken lines, the plain ends should be separated by the splits of the reed, as shown in the denting plan given at M ; in some cases, however, the pairs of plain ends are dented together as indicated at N. Two, three, or more ends are passed through each split according to the fineness of the cloth (two ends per split are indicated in M and N) ; and some times the plain ends are woven two per split, and the cord ends three or four per split. The number of ends in the width of a cord has some influence upon the order of denting.

Fig. 100.

Wadded Bedford Cords. — These structures contain thick wadding or padding ends which lie between the rib face cloth and the weft floats on the underside ; the object of the arrangement being to give greater prominence to the cords. The method of introducing wadding ends in to the designs C, F, and I is illustrated by the examples O to T in Fig. 101 ; the arrows indicating the positions where the cord ends are introduced. The wadding ends, which are represented in O, Q, and S by the shaded squares, are additional to the ordinary ends. In the complete designs given at P, R, and T they are raised where the picks float at the back, as shown by the crosses, and are left down where the picks interweave in plain order. The order in which the picks interlace with the ends is illustrated by the diagram given at U, which corresponds with the design R. The draft for the design P is indicated at V, and the pegging-plan at W ; while X shows a method of denting which is based upon two ends per split, the wadding ends being dented extra. The number of wadding ends to each cord may be varied according to requirements.

The designs may be arranged with an odd number of ends (not including the wadding ends) to each cord, but it is then necessary to reverse the marks of alternate pairs of the plain ends, in order that the plain weave will join correctly. An example, without wadding ends, is given at Y in Fig. 101, which contains seven ends in each cord stripe. Suitable weaving particulars of a Bedford cord are :—Face warp, 30's cotton, 108 ends per inch ; wadding warp, 2/20's cotton ; weft, 36's cotton, 84 picks per inch.

Crepon Bedford Cords.—In both worsted and cotton cloths, hard-twisted (crimp) weft is sometimes used, the excessive shrinking of which causes the cords to stand up very prominently. The design Z in Fig. 101 is specially arranged to suit an order of wefting in which two picks of hard-twisted weft alternate with two picks of ordinary weft; the former floating on the underside of the cords. Each section of the design, which is enclosed by brackets, should be repeated about four times; it will be noted that the plain ends in one section are mid-way between those in the other section. In the process of finishing the hard-twisted weft floats on the

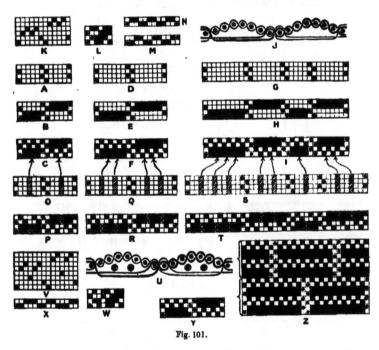

Fig. 101.

under side shrink extremely, and an irregular or " crepon " surface is imparted to the cloth.

Bedford Cords, arranged with Alternate Picks.—Bedford cords are also made with alternate picks floating at the back, in which case the pairs of plain ends require to be indicated in reverse order. An example, in which each cord is ten ends wide on the surface, is shown worked out in stages, at A to E in Fig. 102. The marks of the pairs of plain ends are indicated, as shown at A; then marks, which cut with the plain marks, are inserted on alternate horizontal spaces, as represented at B. Afterwards, plain weave is inserted on the blank horizontal spaces of the cords, as indicated at C, but in this case the plain does not join perfectly with the plain marks of

the pairs of ends. If wadding ends are introduced in the positions indicated by the arrows, the complete arrangement of the ends will be as shown at D, in which the

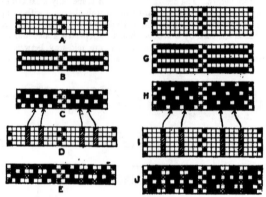

Fig. 102.

shaded marks represent the wadding ends. The complete design is given at E, in which the wadding ends are shown raised over the picks which float at the back.

Twill-Face Bedford Cords.—Another modification of the Bedford cord structure

Fig. 103.

consists of using a warp twill instead of plain weave for the picks which interweave on the face of the cord stripes, the warp being thus brought more prominently to the surface. The examples F to J in Fig. 102 illustrate the different stages in designing a cord eleven ends wide on the face, in which 2-and-1 twill is employed for the face picks. H shows the complete design without wadding ends, while J shows H modified so as to include wadding ends, which are introduced in the positions indicated by the arrows below H. It will be seen by comparison that C and E in Fig. 102 are modifications of the design given at F in Fig. 99, and in the same manner H and J in Fig. 102 are modifications of G in Fig. 99.

WELTS AND PIQUES

A typical pique structure consists of a perfectly plain face fabric composed of one series of warp and one series of weft threads, and a series of back or stitching warp threads. The stitching ends are placed on a separate beam which is very

heavily weighted, whereas the face ends are kept at moderate tension. At intervals the tight stitching ends are interwoven into the plain face texture, with the result that the latter is pulled down and an indentation is formed on the surface. In order to increase the prominence of the unstitched portions of the cloth, it is customary to insert wadding picks between the tight back stitching ends and the slack face fabric.

Ordinary Welt Structures.—The term " welt " is applied to the pique structure when the indentations form continuous sunken lines or cuts which run horizontally in the cloth, as shown in the fabric represented in Fig. 103. The number of face picks in the width of a cord is varied according to requirements, but usually the number of consecutive picks that are unstitched should not exceed about twelve. The construction of the designs is illustrated in stages in Fig. 104, in which A, E, I, and M represent the first stage of weaves repeating on 6, 8, 10, and 18 picks respectively ; the plain weave of the face fabric is indicated by the dots, while the positions of the stitching ends is shown by the shaded squares. The ends are arranged in the order of 1 face, 1 stitching, and 1 face, in each split of the reed, or in the proportion of 2 face to 1 stitching end. The complete designs (without wadding picks), to correspond with A, E, I, and M, are given respectively at B, F, J, and N in Fig. 104, the solid marks indicating the lifts of the tight stitching ends into the plain face texture on two conse-

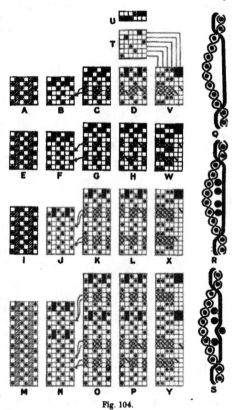

Fig. 104.

cutive picks. In the design B there are four picks between the indentations or cuts; in F six picks, and in J eight picks ; but in the design N, which produces two sizes of ·cords in the cloth, there are ten and four picks alternately between the cuts.

....

7

Weft Wadded Welts.—The designs C, G, K, and O in Fig. 104 illustrate the method of inserting wadding picks (the positions of which are indicated by the crosses) into the respective designs B, F, J and N; the object being to increase the prominence of the horizontal cords, and to make the cloth heavier and more substantial. Usually the wadding weft is thicker than the ground weft, and is inserted two picks at a place, as shown in C, K, and O; the looms being provided with changing shuttle boxes at one side only. Sometimes, however, the same kind of weft is used for both the face and the wadding, looms with a single box at each side being employed; and, in such a case, one wadding pick at a place may be inserted, as shown in the design G. Again, in some cloths thick wadding picks which are inserted in pairs, are supplemented by single wadding picks of the face weft. All the face ends are raised when the wadding picks are inserted, as indicated by the crosses in the designs, while the stitching ends are left down.

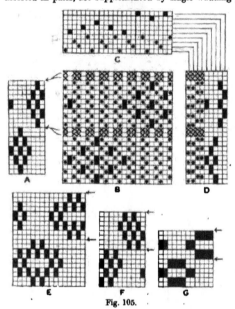

Fig. 105.

Fast-Back Welts.—In each of the foregoing designs, the stitching ends are only lifted to form the indentations, the term "loose-back" being applied to this type of structure. The term "fast-back" is applied to cloths in which all, or a portion of the wadding picks are interwoven in plain order with the stitching ends. The designs D, H, L, and P in Fig. 104 show the respective designs C, G, K, and O made fast back, the diagonal strokes indicating where the stitching threads are raised over the wadding picks. In the designs D and H all the wadding picks are thus interwoven, but in the design L only one of each pair, and in P only the two wadding picks in the centre of the broad cord, are woven plain.

The drawings Q, R, and S, in Fig. 104, which respectively correspond with the designs J, K, and L, show how the threads interlace with the picks in the three types of structures, viz., loose-back without wadding picks; loose-back wadded; and fast-back wadded.

The order of drafting is indicated at T in Fig. 104 and the denting plan at U, each split containing a stitching end between two face ends. The pegging plans for the designs D, H, L, and P, are given respectively at V, W, X, and Y.

Waved Piques.—A waved pique is a simple modification of the welt structure in which the indentations are not in a horizontal line but are arranged in alternate groups, as shown at A in Fig. 105, the marks in which indicate the lifts of the stitching ends on the face picks. The groups of marks do not overlap horizontally, as one commences on a face pick immediately following that on which the other has finished. Between succeeding groups two wadding picks are inserted, as indicated by the arrows at the side of A in Fig. 105. The complete design to correspond with A is given at B, in which the ends are arranged in the same order as in a welt, while there are ten face picks to two wadding picks. The lifts of the tight stitching ends force the wadding picks first in one direction and then in the other, so that waved

Fig. 106.

lines are formed across the cloth. This is shown in Fig. 106, which represents in the upper and lower portions respectively, the face and underside of a cloth that corresponds with the design B in Fig. 105. The draft of the design is given at C, and the pegging plan at D in Fig. 105. Other motive designs for waved piques are given at E, F, and G in Fig. 105, which are respectively arranged, as indicated by the arrows, to suit the introduction of 10, 8, and 6 face picks between the wadding picks. Suitable weaving particulars of a pique cloth are :—Face warp, 40's cotton, stitching warp, 28's cotton, 72 face and 36 stitching ends per inch ; face weft, 50's cotton, 96 picks per inch, wadding weft, 20's cotton.

CHAPTER VIII

STRIPE AND CHECK WEAVE COMBINATIONS

Forms of Stripes and Checks—Selection of Weaves—Joining of Weaves—Relative Firmness of the Weaves. Classification of Stripe and Check Designs—Effects produced in one Weave turned in opposite directions—Combinations of Weaves derived from the same Base Weave—Combinations of Warp and Weft-Face Weaves—Arrangement of Weaves in Dice Check Designs—Method of Over-Checking Warp Sateen Weaves—Rib and Cord Stripes and Checks—Combination of different Weaves. Construction of Designs upon Motive Weave Bases.

STRIPE and check designs result from the combination, in equal or unequal spaces, of two, three, or more weaves or weave variations. Weaves that are suitable for combining in stripe form can very frequently be combined also in check form, while each transverse section of a check design, can generally be used alone in forming a stripe pattern. For these reasons, and in order to avoid repetition, the two classes of designs are described and illustrated together. The introduction of differently coloured threads may modify the appearance of both stripe and check weave combinations to a considerable extent, as shown in Chapter XII, but here only weave structure is considered.

Forms of Stripes and Checks.—Weave combinations are employed in nearly all kinds of fabrics and in every class of material ; the kind of cloth to be woven, and its purpose. largely influence the form or style of the design, and the selection of the weaves that are combined. As a rule, very diverse form is more suitable for stripes than for checks, because in the latter the surface of the cloth is more broken up by the weave changes than in the former. In both styles the form should be originated, not haphazardly, but orderly ; the degree of contrast of space and of weave between the several sections being kept clearly in mind.

The examples given in Fig. 143, in which the different markings may be taken to represent different weaves, illustrate a method of designing a range of stripe patterns by " modification," a commencement being made with a simple equal stripe. Greater diversity can be obtained than is shown in the examples by combining three or more different weaves. Fig. 107 illustrates the various forms of weave checks that are in general use, and in this case also it will be understood that different weaves may be introduced in a more varied manner than is indicated by the different markings. Thus, the form shown at A, in which the sections are equal in size, permits of the combination of two, three, or four weaves, although two only are employed most frequently. The pattern indicated at B, in which the spaces vary in size, is particularly suitable for the combination of three weaves, the large and small squares being in different weaves, and the oblong spaces both in a third. C and D are modifications of A, while E shows a further development than B of the combination of spaces of different sizes. The " set " form of check, indicated at F, is too stiff for ordinary purposes, but the introduction of an overcheck, as shown at G, greatly improves the effect, particularly if the overchecking lines are emphasised. Such arrangements as those given at H and I are especially useful when it is desired to show an expensive material prominently on the surface.

Selection of Weaves.—In selecting weaves for combination it is necessary to take into account the nature of the cloth as to : (*a*) the class of material ; (*b*) the thickness of the threads and the number of threads per unit space ; and (*c*) the kind of finish that is applied. Either simple or elaborate weaves may be employed when the threads are smooth and even—*e.g.*, silk, cotton, linen, and worsted yarns—and if the finishing process removes the loose fibre from the surface of the cloth ; because the smooth thread structure that is formed renders the weaves clearly

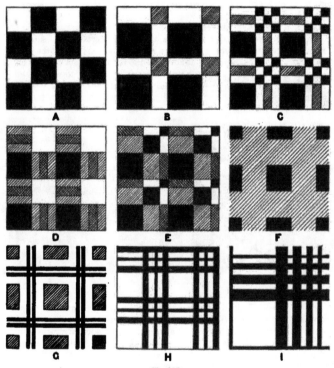

Fig. 107.

apparent. Woollen cloths vary considerably according to the class of yarn that is used and the finish that is employed, but as the threads, in any case, are somewhat rough and uneven, weaves of a fancy character are usually unsuitable. The finest woollen cloths, which are finished with a clear face, however, admit of the combination of such weaves as twills, sateens, whipcords, ribs and corkscrews, but for similar cloths which have a raised or " dress " face, and for rough cheviots and tweeds, only the very simplest weaves are suitable. When different materials are used in

a cloth weaves should be employed which will bring the better and more expensive threads chiefly to the surface.

More elaborate weaves may be employed in fine yarns and fine setts than in thick yarns and coarse setts, because in producing a given length of float more threads are passed over in the former case, which enables more detail to be introduced in the weaves.

In any material, if a raised finish is applied, the weave structure is more or less concealed by the surface fibres, hence it is useless to employ elaborate weaves. A clear finish, on the other hand, develops the weaves so that a design is shown under the most favourable conditions.

Joining of Weaves.—It is very important to avoid the formation of long floats where the different sections of a design are in contact. Certain equal-sided twills, and weaves that are the reverse of each other, may be arranged to cut at the junctions —that is, with warp float against weft float. If the weaves will not cut they require to be carefully joined together, and, if possible, no longer float should be made at the junctions than there is in the weaves

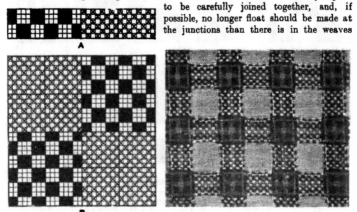

Fig. 108. Fig. 109.

that are combined. In joining the weaves vertically the prevention of long weft floats on the face side of the cloth is of most importance, whereas at horizontal junctions (in check designs) long surface warp floats have chiefly to be avoided. Long floats on the underside are of secondary importance, but they should be prevented as much as possible. Sometimes it is necessary to modify one or both weaves where they are in contact in order to make them join properly, and in some cases a weave with a minimum length of float—such as plain—is introduced between two weaves.

Relative Firmness of the Weaves.—In stripe designs, if the warp is brought from one beam, the weaves that are combined should be similar in firmness. If there is much difference in the relative number of intersections in the weaves, the ends should be brought from separate beams to correspond, in order that the take-up of each series may be properly regulated. For example, the plain ends of the stripe design given at A in Fig. 108 will take up much more rapidly than the ends that

form the 3-and-3 hopsack, hence if all the warp is brought from one beam the plain ends will become very tight, and the others slack. This will not only make it very difficult, if not impossible, to weave the cloth, but will result in the fabric having an uneven or " cockled " appearance. In check designs similarity in the firmness of the weaves is not of the same importance, because succeeding sections of the design compensate for one-another, so that the average take-up of the ends is about equal. Thus, 3-and-3 hopsack weave and plain, when combined in check form, as shown at B in Fig. 108, will weave all right, except that in a heavily wefted cloth the picks tend to group together in the hopsack sections, and to spread out in the plain sections, and, therefore, are distorted in the cloth. This is illustrated in Fig. 109 in which a fabric is represented that is woven in a check combination of 3-and-3 hopsack and plain weave similar to the design B in Fig. 108.

CLASSIFICATION OF STRIPE AND CHECK DESIGNS

Stripe and check weave combinations may be conveniently classified as follows:—

(1) Designs in which the same weave—usually a twill—is used throughout, but turned in opposite directions.

(2) Designs in which the sections are in different weaves that are derived from the same base weave.

(3) Combinations of warp and weft face weaves.

(4) Combinations of different weaves.

Effects produced in one Weave turned in opposite directions.—A stripe weave of this class is shown in Fig. 110, which represents a fabric that is composed of

2-and-2 twill running to left and to right, as indicated in the corresponding design given at C in Fig. 111. The dots in the design C indicate positions where coloured ends are introduced in the cloth. The form of the stripe is similar to that shown at B in Fig. 143.

Examples of check designs are given at D and G in Fig. 111, the former of which is constructed in the form

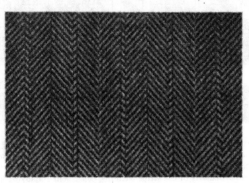

Fig. 110.

represented at B in Fig. 107, and the latter in the form shown at A. In the design D each section consists of 3-and-3 twill, and in G of a 3-and-3 twill derivative, both designs being capable of being drafted on to six healds, as shown at E and H respectively. Each draft is in two sections, and by using reversed 3-and-3 twill pegging plans, as indicated at F and I, the check designs are formed ; whereas if an ordinary 3-and-3 twill weaving plan is employed stripe

designs, consisting of the first six picks of D and G, will result. An example of a 2-and-2 twill check design is given at D in Fig. 206.

In fine warp-face cloths, such weaves as warp sateens, warp twills, whip-cords, and warp corkscrews—twilling in opposite directions—are suitable for stripe patterns when a strong contrast between the sections is not desired. Mostly, however, they are not fit for checks, because the preponderance of warp float makes it impossible, as a rule, to avoid the formation of long surface floats at the horizontal junctions, J in Fig. 111 shows a stripe design composed of a warp-faced 10-thread twill, while K shows a whip-cord weave arranged in stripe form.

In the foregoing designs the difference of effect, due to reversing the direction

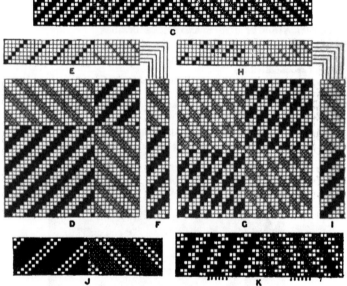

Fig. 111.

of the weave, is emphasised by the twist of the yarns alternately running with and opposing the direction of the twill. A useful method of varying the appearance of the designs, particularly of the stripe patterns, consists of employing both right and left-hand twist in the threads. Thus, each section of the design K in Fig. 111 might be arranged in the warp in the order of 8 ends right-hand twist, 6 ends left-hand twist, and 8 ends right-hand twist ; the left-hand twist ends occupying the positions indicated by the marks below K.

Combinations of Weaves derived from the same Base Weave.—When the same base weave is used throughout a design, two or more different systems of drafting are employed ; a stripe design resulting from a simple weaving plan, while a check design is formed by constructing the pegging-plan in sections upon bases which corres-

pond with the draft. For instance, the design given at L in Fig. 112, which is based
upon an 8-thread twill weave, is produced by means of a combination of
straight and sateen drafting, as indicated at M. If the straight twill given in the
lower portion of the plan N is used for the weaving plan, a stripe design will be
formed consisting of the first 8 picks of L; whereas the complete check design results
from using the whole of the plan N for the pegging-plan. It will be seen that the
shaded squares in N, which show the basis of the pegging plan, are arranged vertically

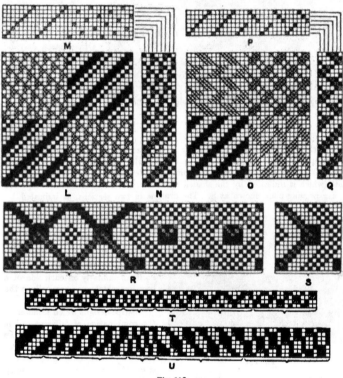

Fig. 112.

in the same order as the marks are indicated horizontally in the draft M. The twill
weave shown in the upper right-hand section of L is produced by the combination
of a sateen draft and a weaving plan that is based upon the sateen. It does not
necessarily follow that such a result will be obtained in all cases, as sometimes the
combination simply produces another sateen re-arrangement of the twill.

The design given at O in Fig. 112 illustrates the construction of a check design

by combining weaves that are based upon 3-and-3 twill. The draft, which is indicated at P, is in straight and broken order alternately, and corresponds with the basis of the pegging-plan given at Q. In this case the check design is composed of

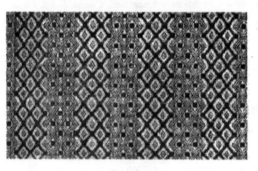

Fig. 113.

four different weave effects, which is due to the marks of the twill having been added horizontally to the base marks in the upper portion of the pegging - plan Q. Other bases may be combined on the same principle as in the foregoing examples, but if care is not taken in selecting a suitable base weave, and in arranging the different sections, bad floats at

the junctions of the weaves may readily occur, particularly in check designs.

A stripe fabric is represented in Fig. 113, for which the corresponding design is given at R in Fig. 112. The pattern results from the combination of a fancy pointed draft (which is indicated by the shaded squares in the design R) and the spotted zig-zag pegging-plan, shown at S. The draft is in two sections, as indicated by

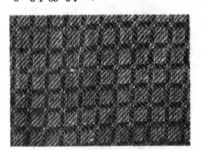

Fig. 114.

the brackets below R, in the first of which the threads are arranged 8 to right and 8 to left, and in the second 8 to left and 8 to right. The symmetry of the design is due to the pegging-plan S having been built up similarly on each side of a base line which runs vertically in the order of 8 to right and 8 to left.

Stripe designs which result from the combination of different orders of drafting are less liable than checks to contain bad floats at the junctions, and they, therefore, give greater scope than the latter in producing

variety of effect. The examples T and U in Fig. 112, in which the different sections are indicated by brackets, are given simply to show how different weaves may be constructed and combined. Two or more of the sections may be used together, and each section be repeated a number of times, according to the size of pattern required. In each design the shaded squares indicate the bases of the weaves, and also the draft, while the weave in the first section forms the weaving plan. The pattern represented in Fig. 19 (p. 19) shows a combination of 5-thread sateen and 5-thread twill which has been woven by drafting

on five healds. The chief advantage of this system, and also of that illustrated in Fig. 111, is that the designs can be produced in a comparatively few healds; and, further, if the base weave can be woven by ordinary tappets, the stripe designs can be obtained without any modification of the loom. Check designs, however,

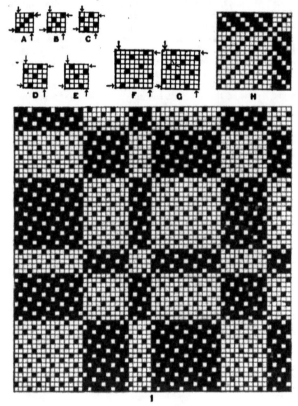

Fig. 115.

on account of the large number of picks in the repeat, require a dobby shedding motion even though the base weave repeats on a small number of threads.

Combination of Warp and Weft Face Weaves.—These produce the clearest effects in the cloth, particularly if there is a difference in colour between the warp and weft yarns. *Dice check* designs, a simple example of which is represented in Fig. 114, are produced on this principle by combining two opposite twill or sateen weaves. It is particularly necessary, in dice patterns, that the weaves cut at the

junctions both vertically and horizontally in order that the sections will be firmly bound at the edges ; otherwise the outermost threads, which are floated, are liable to slip over the threads in the adjacent sections.

Arrangment of Weaves in Dice Check Design.--The principle of reversing, illustrated in Fig. 41 (p. 42), may be employed in the construction of dice checks, but the base weave requires to be constructed very precisely in order that a uniform design will result. The marks of the base weave should be arranged in such a manner that the first and last picks are alike, and also the first and last ends, when followed in opposite directions. The examples, given at A to G in Fig. 115, in which the arrows indicate the direction in which the threads should be followed, fulfil these conditions. For instance, in the plan F a mark is placed in the second square of the first pick, counting from the left, and in the second square of the last pick, counting from the right ; and in the

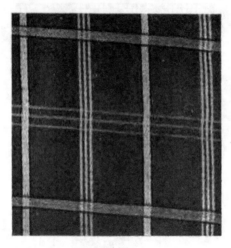

Fig. 116.

third square of the first end, counting from the top, and in the third square of the last end, counting from the bottom.

Twill base weaves are readily arranged by running a single line of marks through the centre, as shown at A in Fig. 115. The 4-thread sateen may be inserted in two positions, as indicated at B and C, while the 5-thread sateen may be arranged to twill in either direction, as shown at D and E. The 8-thread sateen, counting three to the right, may be indicated in two positions, as shown at F and G, and these plans, when turned one quarter round, show similar effects, counting three to the left.

The design H in Fig. 115, which corresponds with the fabric represented in Fig. 114, shows the combination of 4-thread warp and weft twill weaves. The large design in Fig. 115 shows the combination of 5-thread warp and weft sateen

weaves, and is arranged in the form illustrated at E in Fig. 107, nine different shapes of sections being formed in warp and weft.

Method of Over Checking Warp Sateen Weaves.—In producing a coloured over-check in a warp sateen cloth, it is necessary to employ a weft-face weave where the specially coloured picks are required to show distinctly on the surface. A representation of a sateen cloth, checked with colour, is given in Fig. 116, the weave of which is 5-thread warp sateen, except where the horizontal lines are formed. The plan J in Fig. 117 shows how the weaves are arranged, the 5-thread warp sateen being crossed by a 10-thread weft sateen weave (indicated in the upper portion of J) where the special picks are inserted. The cloth contains nearly twice as many ends as picks per unit space, therefore, a longer float is employed in the weft sateen weave than in the warp sateen, in order that the yarns will show about equally prominently on the surface. In

Fig. 117.

the example the weft sateen is carried across the corresponding colours in the warp, the arrangement enabling the design to be woven in a straight draft on ten healds. The warp weave might be carried through the corresponding weft colours, but this would complicate the draft and necessitate the use of more healds.

Rib and Cord Stripes and Checks.—Warp and weft face rib or cord, and corkscrew weaves are readily combined in stripe and check form. K in Fig. 117 shows a check design, which is composed of 3-and-3 warp and weft rib weaves, except that each section commences with a float of two in order that no longer float than three will be made where the weaves join. The design L in Fig. 117 illustrates the combination of warp and weft Bedford cord weaves, while an example of a check design that is composed of warp and weft corkscrew weaves, is given at H in Fig. 228.

Combinations of different Weaves.—In this class of stripe and check designs, there is practically no limitation to the variety of effect that can be obtained except what is imposed by the loom and the materials employed. For fabrics such as

suitings and coatings the patterns are not striking in appearance, and designs or
the class shown at A, B, and C in Fig. 118 are employed, in each of which it will
be noted that the weaves join well together. In the warp and weft rib sections
of the design C, the threads should be more finely set than in the body of the check.

Fig. 118.

Combinations of different weaves in stripe form are illustrated in Figs. 189, 194, 199
202, and 204 ; and in check form in Figs. 224 and 226, in Chapter XII.

CONSTRUCTION OF DESIGNS UPON MOTIVE WEAVE BASES

In this system, which is an extension of the combination of weaves in check
form, a small motive weave is first constructed. Then each square of the motive
is taken to represent a convenient number of ends and picks in a new design, in
which different weaves are combined in an order that corresponds with the arrange-
ment of the marks and blanks of the motive. For example, A in Fig. 119 shows
a motive which repeats on 6 × 6, and forms the basis of the fancy dice design
given at B ; each square of the motive represents 8 ends and 8 picks, and the blanks
and marks respectively correspond to the 4-thread weft and warp sateens that are
combined in the design. The full repeat is upon 48 ends and 48 picks, but an
examination will show that the design can be drafted upon 16 healds.

C in Fig. 119 shows how a motive may be arranged so as to represent the com-
bination of more than two weaves. Thus, in the design D, in which 8 ends and 8 picks
correspond to one square in C, the twilled hopsack sections coincide with the solid
marks, the 4-thread warp twill with the dots, the Mayo weave with the crosses,
and the 4-thread weft twill with the blanks of C. It is necessary for the weaves to
be as carefully joined together as in check weave combinations. The method of
construction enables the sections of a large design to be readily arranged in advance,
and there is also the advantage that if a well balanced motive weave is made,
the design constructed from it will be correctly balanced.

Fig. 119.

CHAPTER IX

SPECIAL CLASSES OF STRIPE AND CHECK FABRICS

Crammed Stripes and Checks—Fancy Weave Stripes upon Warp Sateen Grounds—Zephyr
Stripes and Checks—Oxford Shirting Cloths—Harvard Shirtings—Wool and Union
Shirtings—Combination of Bedford Cord and Pique Weaves. Construction of Heald
Knitting Plans for Stripe Drafts. Comparison of Structures—Diameters of Yarns—
Setting of Simple Structures—Cloths in which the Warp and Weft Threads are
Different in Thickness—Comparative Setting of Weaves.

CRAMMED STRIPES AND CHECKS

THE weave combinations that are used in fancy vestings, shirtings, dress and
blouse fabrics, and skirtings, are frequently in much greater contrast and more
elaborate than the examples given in the preceding chapter, and colours are employed

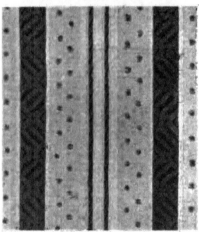

Fig. 120.

more prominently in order to
emphasise the form of the design.
Further, the threads in certain
sections of the designs are some-
times crammed—that is, there
are more threads per unit space
in one portion than in another
portion. The objects of cram-
ming certain threads in a cloth
are : (a) To produce a pattern
in one weave by varying the
density of the cloth. (An ex-
ample of this type of structure
is given at F in Fig. 2, which
shows a voile stripe dented one
per split combined with a mer-
cerised stripe dented two per
split.) (b) To show a special
material or colour prominently
on the surface. (c) To secure
firmness of structure in threads
which are more loosely woven

than the ground threads. (d) To obtain a uniform ground texture when extra
threads are introduced.

Fig. 120 represents a stripe blouse fabric in which a prominent warp figure
and fine lines of a steep twill are produced in mercerised cotton yarn woven two ends
per mail and four ends per split, while the ground ends are ordinary cotton woven
one per mail and two per split. The arrangement of the stripe is indicated by the
different marks in the corresponding design given in Fig. 121 ; each vertical space
of the crammed weaves, which are represented by the solid marks, corresponding
to two ends. Firmness of texture is secured in the broad figured stripe by the threads

interweaving in plain order between the figures ; while the narrow stripes are shown up very prominently by the threads interlacing in steep-twill order—a method which gives a rich and distinct appearance to a lustrous yarn when only a few ends are used at a place. Diagonal marks are indicated in Fig. 121 to show where crimped or " crepon " stripes have been formed by bringing a portion of the ground ends from a lightly tensioned separate beam ; these ends taking up about 35 per

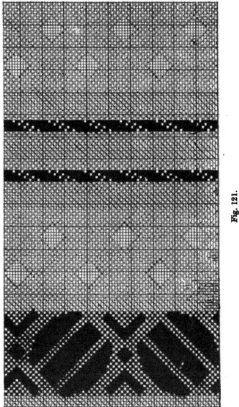

Fig. 121.

cent. more rapidly than the ground ends. The small spots in the ground stripe are due to floating the weft, which is composed of ordinary cotton.

A crammed stripe fabric is represented in Fig. 122, which is composed of cotton ground warp, crammed silk warp, and botany worsted weft, and illustrates a style that is suitable for either a dress, blouse, or shirt fabric. The corresponding design is given at A in Fig. 123, above which the order of denting is indicated. The ground

8

weave is plain and is dented 2 per split, while the crammed stripe consists of 5-and-1 warp twill woven 5 per split, and 3-and-3 warp rib woven 8 per split; and, in addition, lines of colour are formed in a 5-and-1 stitch weave.

Fig. 124 represents a crammed check fabric, the corresponding design for a portion of which is given at B in Fig. 123. In this case the ground ends are dented 2 per split, and the crammed ends 4 per split, as indicated above the design, while a similar weft cram is produced by making the take-up motion inoperative on alternate picks where the brackets are indicated at the side of the design. The ground weave is plain, and the crammed weaves 4-thread warp and weft sateens, except that the warp sateen weave is doubled vertically where the crammed weft sateen is intersected. This is in order that the surface floats will be of the same length throughout the design. The system of drafting is illustrated at C in Fig. 123, while D shows the corresponding pegging-plan.

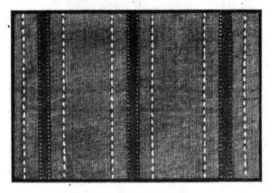

<p style="text-align:center">Fig. 122.</p>

A crammed check fabric is represented in Fig. 125, in which the over-check is formed by interweaving specially coloured ends and picks in warp and weft rib order respectively. A portion of the corresponding design is given in Fig. 126, in which the marks indicate weft. In the crammed warp sections, 15 ends are arranged, 1 dark, 1 light, and dented in four splits; while in the crammed weft sections, 20 picks are arranged 2 dark, 2 light in order to fit a loom with changing boxes at one end only. In cramming the weft the up-take catch was raised by the shedding mechanism a sufficient number of times to compress the 20 picks into the same space as the four splits of the reed occupied by the crammed ends.

A checked dress fabric is represented in Fig. 127 for which the corresponding design is given at A in Fig. 128. The design is simply a stripe combination of plain weave and crêpe, but in order to show the latter weave more prominently in the cloth it is developed in double ends and woven 4 per split, whereas the plain weave is in single ends dented 2 per split. The two sections of the design are in different colours of warp, and the checked appearance of the cloth is due to the weft being arranged in two colours to correspond with the order of warping.

Fancy Weave Stripes upon Warp Sateen Grounds.—Certain features to be noted in forming a prominent fancy weave stripe upon a warp sateen ground, are illustrated by the example shown in Fig. 129, and the corresponding design given at B in Fig. 128.

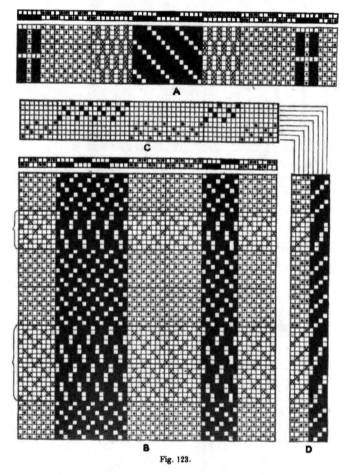

Fig. 123.

The cloth represented is a type of cotton texture that is used for skirtings, boys' suitings, and workmen's jackets, and very frequently these fabrics, although finely set in the warp, are for economical reasons woven with proportionately only a small

number of picks. It is, therefore, impossible to produce a prominent stripe effect by floating the weft, and, further, the weft should be in the same colour as the

Fig. 124.

ends which form the warp sateen ground in order that the latter will be quite solid in appearance. However, by employing contrasting colours in the warp, and particularly if double ends are used for the special stripe, as indicated in B, Fig. 128,

Fig. 125.

any required degree of prominence can be given to the fancy weave. Plain threads may be introduced to separate the different weaves, but this necessitates the use of

extra healds if none of the threads in the special weave interlace in plain order. If, however, the weaves are so arranged that the sateen floats do not obscure small figuring floats at the sides of the stripe, they may be placed directly in contact.

Fig 126.

Zephyr Stripes and Checks.—In zephyr stripes and checks, which are used for dress, blouse, and shirt fabrics, the bulk of the cloth is generally in plain weave

Fig. 127.

and the pattern is very largely due to colour. Cord threads are frequently introduced (a representation of a plain corded zephyr is given at E in Fig. 2 (p. 3), and in

some cases certain threads are floated and brought prominently to the surface by cramming, as shown in the example given in Fig. 124 ; while plain and crêpe weaves are combined, as indicated in the fabric represented in Fig. 127. More or less elaborate figures frequently form part of the ornamentation, and a neat style of zephyr cloth is represented in Fig. 130, in which a small figured effect is formed on a corded stripe. The corresponding design is given in Fig. 131, in which the crosses

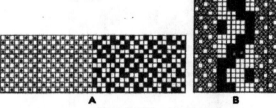

Fig. 128.

indicate the cord stripes (each of which is produced by placing two thick white ends in one mail and one split of the reed), the solid marks the weft figure, and the dots the plain ground.

In stripe zephyrs, the weft is most frequently white, the colour being obtained in the warp, and a distinct feature is that finer weft than warp should be employed,

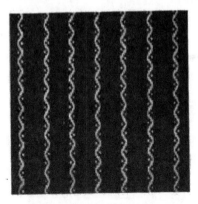

Fig. 129.

or the cloth is liable to appear irregular or " shady." A fine quality may be woven in 2/120's cotton warp, 100 ends per inch, and 80's bleached cotton weft, 104 picks per inch ; and a medium quality in 50's cotton warp, 84 ends per inch, and 60's or 70's weft, 80 picks per inch. 2/20's to 2/30's cotton is suitable for the cord stripes. In the best cloths silk weft is used instead of cotton weft, and coloured weft, both silk and cotton, is employed in the production of " shot " zephyrs.

Oxford Shirting Cloths.—Stripe designs are largely employed in Oxford shirting fabrics, and a typical example is represented in Fig. 132, for which the corresponding design is given at A in Fig. 133. The best qualities of these textures are full, soft,

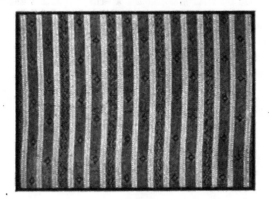

Fig. 130.

and somewhat lustrous, and thick weft—spun with little twist from long stapled cotton—is employed, while the warp yarn is also made from a good grade of cotton. Standard cloths are woven with two ends per mail (tapes), with the bulk of the weave

Fig. 131.

plain, but they are also made in hopsack weaves (termed matting Oxfords), in fancy mat weaves, such as that shown at B in Fig. 133, and in plain weave with the warp composed of single ends (termed single warp Oxfords). The double-end arrangement

in the warp causes the cloth to be chiefly weft surface, so that the warp colours are subdued, whereas in single-warp Oxfords the warp colours show more prominently while the cloth is harder in the handle. The textures are not heavily coloured, but are particularly neat and clean in appearance, a white foundation being most

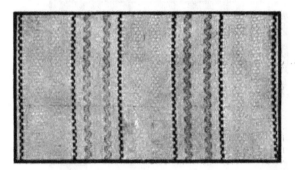

Fig. 132.

frequently made upon which fine lines of colour, in the form of stitch threads and small fancy weaves, are developed. In some cases, however, a coloured warp is used for the ground, but the weft is almost invariably white. In order to make a colour show clearly on a white double end foundation in the plain weave, three

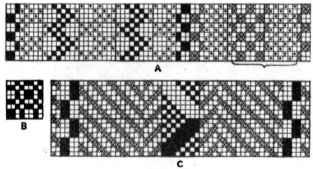

Fig. 133.

ends of the colour may be placed in each mail instead of two, while to get fine solid lines of colour the coloured ends may be drawn one per mail and dented four per split. The single ends in the latter arrangement take up more rapidly than the double ends, and it is, therefore, usually necessary to place them on a separate beam in order to ensure good weaving. A good quality of Oxford cloth may contain 56 double ends per inch of 36's cotton, and 52 picks per inch of 14's cotton; and

a coarser cloth, 40 double ends per inch of 40's cotton, and 40 picks per inch of 10's cotton. In the design given at A in Fig. 133, each vertical space represents two ends in the cloth, and the solid marks indicate the weave formed by the coloured threads; the bracketed portion, which consists of plain and 2-and-2 hopsack, is repeated.

Harvard Shirtings.—The stripe fabric, represented in Fig. 134, is a Harvard shirting, the corresponding design for which is shown at C in Fig. 133. This cloth is made in single ends, and the ground weave is generally 2-and-2 twill; and, compared with an Oxford fabric, darker colours and rather cheaper yarns are employed, the cloth being stiffer and harder, while the ornamentation is more pronounced. Sometimes, however, the Harvard cloth is made in imitation of an Oxford, as regards quality, design, and colouring, but the 2-and-2 twill ground is retained. The weft is all white, except in checked Harvards, in which a few picks of coloured weft are introduced. The weave ornamentation consists largely of variations of the 2-and-2 twill, and of mat and rib weaves working in 2-and-2, and 4-and-4 orders, by which small spot and chain effects in strong colours are formed. A 4-and-4 order of working is obtained in a 2-and-2 twill tappet loom by coupling to the ordinary tappets a " scroll " tappet which moves a heald in one direction at one complete revolution, and in the other direction at the next revolution.

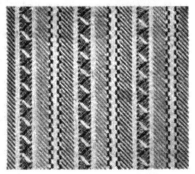

Fig. 134.

Harvard cloths that are woven in dobbies are ornamented by fancy weaves and small figures along with which plain weave is generally introduced, as shown in C, Fig. 133, in order that the figuring threads will be about equal in firmness to the threads which form the 2-and-2 twill ground. Very frequently the 2-and-2 twill makes a bad junction with the fancy weave, rather long white weft floats being formed, which, however, are made almost invisible by placing white ends at each side of the coloured stripe upon which the fancy weave is brought up. The 2-and-2 twill ground weave is modified on the principle illustrated at P in Fig. 62 (p. 61) so as to produce considerable variety of effect on a small number of healds.

Wool and Union Shirtings.—All-wool and union shirting and pyjama cloths, which are milled and raised in the finishing process, are not suitable for the combination of fancy weaves in the ordinary manner, but very elaborate colouring may be employed in the warp, as the formation of the nap on the surface greatly subdues the strength of the colours in the cloth. All wool shirtings (taffetas) may be composed in the warp of from 2/60's to 2/80's botany, and in the weft of from 40's to 70's botany with from 60 to 80 ends, and from 50 to 70 picks per inch. In a union cloth one series of threads may be composed of cotton, or wool, while the other series is a " union," " llama," or " angola " yarn, which consists of a mixture of cotton and

wool fibres (sometimes a mixture of wool and silk, or cotton and silk is employed), or both series of yarns may be union. A llama shirting is composed of union warp and weft—as for instance, 18's warp and 16's weft (worsted count) which contain 70 per cent. wool, and 30 per cent. cotton (stated as 70/30) with 38 ends and 44 picks per inch. A Ceylon shirting is made with cotton warp, and the cloths may be woven with from 64 to 68 ends per inch of from 36's to 40's cotton warp, and 56 picks per inch of 22's (worsted count) weft which contains from 70 to 85 per cent. of wool. The colours require to be specially fast dyed on the cotton warp in order that they

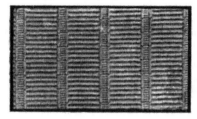

Fig. 135.

will stand the milling process, and as the dyeing is liable to somewhat weaken the yarn, it is necessary for a good quality of warp to be used. As regards the weave ornamentation of these cloths, the raised surface does not prevent the development of fancy weaves in lustrous threads which are crammed in the reed, in the manner illustrated by the example given in Fig. 122.

Combination of Bedford Cord and Pique Weaves.—Bedford cords, piques, honey-combs, and other special weaves are combined in very diverse ways in blouse fabrics, skirtings, vestings and shirtings, with and without coloured threads. If coloured threads are introduced they should be dyed fast to bleaching, as the ground yarns are generally woven grey and bleached in the piece. Fig. 135 represents a cloth in which a Bedford cord weave is combined in stripe form with two sizes of pique cords. The corresponding design is given in Fig. 136, in which the diagonal strokes indicate the plain face weave that is formed by two-thirds of the ends. The remaining third serves as wadding ends—as indicated

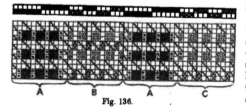

Fig. 136.

by the dots — in the Bedford cord sections, which are lettered A, and as tight stitching ends— as shown by the crosses —in the pique cords, the smaller of which is lettered B, and the larger C. The picks 5, 6, 9 and 10 which float on the back of the Bedford cord stripes, form the wadding picks of the pique stripes, as indicated by the circles.

CONSTRUCTION OF HEALD KNITTING PLANS FOR STRIPE DRAFTS

In weaving stripe drafts in knitted healds it is necessary—particularly if the stripes are broad—for the healds to be knitted to coincide with the pattern in order to ensure smooth working. There should be the required number of mails on each shaft, and each mail should be in the correct place on the shaft in relation to the

position in the reed of the end which passes through it. The order of knitting the healds is decided by three factors: (a) the draft ; (b) the order of denting ; (c) the number of splits of the reed per unit space. A heald-knitting plan can be conveniently indicated upon design paper, after the draft and denting order have been made out, in the manner illustrated in Fig. 137, in which A shows a stripe draft upon twelve healds, and B the order of denting. The stripe is arranged as follows :—

 16 ends on healds 1 and 2 — 2 ends per split = 8 splits.
 24 ends on healds 3 to 8 — 3 ends per split = 8 splits.
 16 ends on healds 1 and 2 — 2 ends per split = 8 splits.
 16 ends on healds 9 to 12 — 4 ends per split = 4 splits.
 ─────────
 28 splits.

 The heald-knitting plan to coincide with the draft A and denting plan B is given at C in Fig. 137, and it will be seen that C contains as many horizontal spaces as there are healds—viz., 12—and as many vertical spaces as there are splits in the repeat—viz., 28. In constructing C the ends are taken in groups according to the

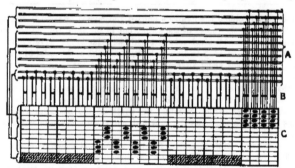

Fig. 137.

order of denting, and marks are indicated on the spaces to correspond with the healds on which the ends are drawn. Thus, commencing with the first split, there are eight splits in each of which two ends are drawn on the healds 1 and 2, and corresponding marks are placed on the first and second horizontal spaces of C. In the ninth split there are three ends which are drawn on the healds 3, 4, and 5, and marks are indicated where the ninth vertical space of C intersects the horizontal spaces 3, 4 and 5, and so on. It will be seen that as many marks are indicated upon each vertical space of C as there are ends passed through the corresponding split, and as many marks upon each horizontal space as there are ends drawn on the corresponding heald.

 A knitting machine can be arranged to knit and miss the leashes in any desired order, and at any required rate per unit space. If, in the example, the rate of knitting is the same as the splits per unit space of the reed, the order of knitting and missing will be found by reading along the spaces of C in Fig. 137 horizontally.

For economical reasons, however, it is advisable to employ as low a rate of knitting as possible, and in the following list a method is shown of adapting the order of knitting to suit a lower sett than the reed sett. In the centre column the order of knitting and missing is given which corresponds exactly with the plan C, the rate of knitting being taken as the sett of the reed; while in the third column the order is given for the healds 3 to 12 taking the rate to be equal to half the reed sett :—

Position of Heald.	Rate of knitting = splits per inch of reed.	Rate of knitting = ½ splits per inch of reed.
Healds 1 and 2	knit 8 8 / miss 8 4	
Healds 3, 4, and 5	knit 1 1 1 1 / miss 8 1 1 1 13	knit 4 / miss 4 6
Healds 6, 7, and 8	knit 1 1 1 1 / miss 9 1 1 1 12	knit 4 / miss 4 6
Healds 9 to 12	knit 4 / miss 24	knit 4 / miss 10

In the second column the numbers knitted and missed total 28 to correspond with the 28 splits in the repeat of the stripe, but in the third column the total is half that number—viz., 14, which coincides with the reduction in the rate of knitting by one half. All the healds 3 to 12 may be knitted alike in the order of 4 knitted, 10 missed; the leashes being afterwards placed on the shafts in correct relative position. It is impossible to reduce the rate of knitting the healds 1 and 2 to one-half the sett of the reed, but it might be reduced to three-fourths the sett, in which case the order would be knit 8, miss 3, knit 8, miss 2—a total of 21. In giving the knitting instructions either the width of the healds or the number of repeats of the pattern may be specified along with the rate and order of knitting.

A more elaborate draft than the preceding example is shown on design paper at A in Fig. 138, whilst B illustrates the corresponding heald knitting plan. The healds are numbered at the side of A, No. 1 representing a doup and front crossing heald. Arrows are indicated below the draft to show where splits of the reed are left empty, while above the order of denting is given. Lines connect each group of ends with the corresponding vertical space in B. The ends in the first split are drawn on the healds numbered 2 and 3, therefore, marks are indicated on the second and third squares of the first vertical space of B. In the second split three ends are drawn on the healds 2, 3, and 4, and in the third split, four ends on the healds 2, 3, 5, and 6, and marks are indicated on the corresponding squares of the second and third vertical spaces of B.

As before, the plan B shows the exact relative positions that the heald leashes should occupy, and gives the order of knitting and missing if the rate is the same as the splits per unit space of the reed. The number of splits in the repeat is 40, and assuming that the rate is taken as one-half the reed sett, the healds numbered 1, 13, and 14 might be knitted in the order of 8 missed and 12 knitted—giving a total of 20. The rate of the healds 4 to 12 might be taken as one-fourth the reed sett, in which case the order would be : knit 2, miss 8—giving a total of 10.

COMPARISONS OF STRUCTURES

The designs and cloths which have been described and illustrated clearly show that different settings are required, not only for distinct classes of fabrics, but also for different weaves in similar structures, and for the same weave in different structures. The setting of cloths has in the past been almost entirely based upon experience and experiment, and, therefore, has offered considerable difficulties to those

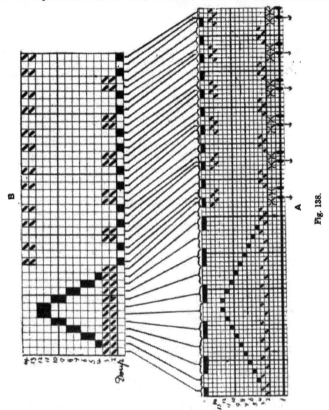

Fig. 138.

with limited experience, or with limited facilities for carrying out experiments. In the following a basis is given that will enable the counts of the yarns and the threads per unit space, which are suitable for a given structure of cloth in a certain weave, to be reasoned out. Also the method may enable useless experiments in building cloths to be avoided, while by it weaves and structures can be readily compared and the effects produced in the woven fabric be more clearly realised.

A complete treatise on the setting of cloths would be out of place here, and the calculations and allowances to be made are therefore given in a simple form (the angle of curvature of the threads is not taken into account). The results will be found none the less valuable, however, for practical purposes. The diameters of the yarns, the number of threads per unit space, the relative number of intersections in the weave, and the type of structure to be made (which includes the class of raw material of which the warp and weft are composed, and the kind of finish that is applied), are the leading factors in the calculations; but in building a cloth, the price at which it can be sold has, of course, to be taken largely into account.

Diameters of Yarns.—The approximate diameter of a given count of yarn may be ascertained by finding the square root of the yards per lb. and deducting 8 per cent. for silk, cotton, and linen yarns, 10 per cent. for worsted yarns, and 15 per cent. for woollen yarns.

(1) The diameter of a 1/40's cotton yarn $= \sqrt{40 \times 840} - 8$ per cent. $= \frac{1}{168}''$.

(2) The diameter of a 2/60's worsted yarn $= \sqrt{30 \times 560} - 10$ per cent. $= \frac{1}{116}''$.

It is obvious that if a 1/40's cotton yarn is $\frac{1}{168}$ of an inch diameter, 168 of such threads can be placed side by side just touching each other in one inch; and, in the same manner, 116 threads of 2/60's worsted. It is convenient to express the diameter of a yarn, not as a fraction of an inch, but as so many diameters per inch (the reciprocal of the diameter). Thus, the diameter of a 1/40's cotton yarn may be expressed as 168 diameters per inch, and of a 2/60's worsted yarn as 116 diameters per inch.

Setting of Simple Structures.—Simple fabrics may be divided broadly into three distinct classes, as follows:—

(1) Ordinary structures, in which the warp and weft threads bend about equally.

(2) Warp rib structures, in which the weft threads lie straight and only the warp threads bend.

(3) Weft rib structures, in which the warp threads lie straight and only the weft threads bend.

In the ordinary structures the warp threads are separated from each other by the intersections of the weft threads, and the weft threads by the intersections of the warp threads. In the warp and weft rib structures the threads of the straight series are separated by the intersections of the threads which bend, but the latter are not separated by the intersections of the straight threads.

The approximate maximum setting in the loom of " square " ordinary cloths is found by the formula:—

$$\frac{\text{Diameters per inch of the yarn} \times \text{number of threads in one repeat of the weave}}{\text{Number of threads} + \text{number of intersections in one repeat of the weave}}$$

(3) The number of ends and picks per inch in a square plain cloth woven in 40's cotton yarn (see the first calculation) =

$$\frac{168 \text{ diameters} \times 2 \text{ threads}}{2 \text{ threads} + 2 \text{ intersections}} = 84.$$

(4) In a square 2-and-2 twill cloth in 2/60's worsted yarn (see the second calculation) the number of ends and picks per inch =

$$\frac{116 \text{ diameters} \times 4 \text{ threads}}{4 \text{ threads} + 2 \text{ intersections}} = 77.$$

In a rib structure the maximum number of threads per inch of the series which bend may be taken as equal to the number of diameters per inch, while the number per inch of the straight series will be found by the preceding formula. Thus, for a warp rib cloth woven in 40's cotton warp and weft in plain weave, as in the third calculation, the number of ends = 168, and the number of picks = 84. For a weft rib cloth woven in 2/60's worsted warp and weft in 2-and-2 twill, as in the fourth calculation, the number of ends = 77, and the number of picks = 116.

The particulars ascertained in the foregoing methods will produce very firm and sound cloths, which, however, may be too hard for certain purposes, and also too costly. Fewer threads per inch than the calculated number may be employed within limits (usually from 10 to 15 per cent. less) and a good saleable structure will yet result. Thus the ends and picks per inch given in the third calculation may be reduced, for price reasons, from 84 to 76, or the cloth might be modified to 80 ends and 72 picks per inch, and still yield a reasonably good structure. Similarly the 2-and-2 twill cloth in the fourth calculation might be reduced to 70 ends and picks, or 72 ends and 68 picks per inch.

Cloths that are shrunk by milling and felting in the process of finishing should be set lower than an unfelted cloth, at least in the proportion of the greater degree of shrinkage. Further, the operation of felting imparts additional firmness to a cloth so that if it is desired an even greater reduction in the sett can be allowed.

(5) Assuming that a 2-and-2 twill ordinary cloth is woven in 20 skeins woollen yarn—

The diameter of the yarn $= \sqrt{20 \times 256} - 15$ per cent. $= \frac{1}{64}."$

$$\frac{64 \text{ diameters} \times 4 \text{ threads}}{4 \text{ threads} + 2 \text{ intersections}} - 10 \text{ per cent. for extra shrinkage} = 38 \text{ threads per inch.}$$

Cloths in which the Warp and Weft Threads are different in Thickness.—If the counts of the warp and weft are different, but not very much different, the ends and picks per inch for an ordinary cloth may be judged from the average of the diameters.

(6) In an ordinary plain cotton cloth woven in 40's warp (168 diameters) and 50's weft (188 diameters) : the intersection theory gives respectively 84 and 94 ends and picks, which may be used as a basis of the setting. 88 ends and 88 picks per inch may be taken as about the maximum, but according to whether the ends or picks are required to predominate the cloth may be reduced to the neighbourhood of, say, 88 ends and 80 picks per inch, or 80 ends and 88 picks per inch.

Warp face cloths are usually woven with more ends than picks per inch and finer warp than weft, while in weft face cloths the conditions are the reverse. A 3-warp and 1-weft twill is just as firm as a 2-and-2 twill, and the particulars given in the fourth calculation will produce a similarly sound cloth in either weave. For the warp face twill, however, it is much more appropriate to increase the calculation number of ends from 77 to 84 per inch or more, and to reduce the number of picks to about 68 per inch ; while if thicker weft than warp—say 20's worsted (95 diameters)

is used, the picks may be reduced to 56 or 60 per inch (63 is the calculation number for 95 diameters in 3-and-1 twill). The increase in the number of ends per inch and in the thickness of the weft changes the structure of the cloth towards that of a warp rib. The particulars of a 3-and-1 weft face twill will be the same as the preceding if weft be substituted for warp.

In warp and weft rib structures the straight threads are mostly thicker than the threads which bend, and only a comparatively few straight threads per inch are employed.

(7) In a warp rib cloth woven in plain weave with 2/80's cotton warp (168 diameters) and 3/30's cotton weft (84 diameters); the maximum number of ends per inch = 168.

A suitable number of picks per inch =

$$\frac{84 \text{ weft diameters} \times 2 \text{ picks in weave}}{2 \text{ picks} + 2 \text{ intersections in weave}} = 42.$$

A reasonably good cloth, and one with a softer feel, will result by changing the particulars to 144 ends and 36 picks per inch.

(8) Assuming that the yarns given in the seventh calculation are required in a 2-and-2 warp rib weave, the ends per inch will be as before—viz., 168.

A suitable number of picks per inch will be found on the intersection theory as follows :—

$$\frac{84 \text{ weft diameters} \times 4 \text{ picks in weave}}{4 \text{ picks} + 2 \text{ intersections in weave.}} = 56.$$

The bending series of threads in loosely woven rib weaves, such as the 3-and-3 and 4-and-4 effects, may be set from 5 to 10 per cent. finer than the number of diameters per inch, although this is not necessary in order to produce a good cloth. The setting of corkscrew weaves is similar to that of the looser woven rib weaves.

In sateen weaves the intersections do not support each other, and the cloths may be set up to the diameters per inch of the threads which form the face and nearly up to the diameters per inch of the threads on the back.

(9) In an 8-thread warp sateen cloth woven in 30's worsted warp (116 diameters) and 20's worsted weft (95 diameters), the number of ends per inch will be 116.

A suitable number of picks per inch will be :—

$$\frac{95 \text{ weft diameters} \times 8 \text{ picks in weave}}{8 \text{ picks} + 2 \text{ intersections in weave}} = 76.$$

More picks than 76 could be inserted while retaining the maximum number of ends, but in a warp sateen the face of the cloth is of chief importance so that it is advisable to cheapen the cloth in the weft. A reasonably good cloth will result, with from 104 to 108 ends per inch instead of 116. In an 8-thread weft sateen the setting will be opposite to that of the warp sateen.

While an 8-thread sateen weave may very well be set up to the diameters per inch of the face yarns, a 5-sateen weave, on account of its greater firmness, will handle rather hard if set so fine.

(10) In a 5-thread weft sateen cloth woven in 30's cotton weft (143 diameters), and 20's cotton warp (118 diameters), the picks per inch may range from 140 to about 120.

A suitable number of ends per inch =

$$\frac{118 \text{ warp diameters} \times 5 \text{ threads in weave}}{5 \text{ threads} + 2 \text{ intersections in weave}} = 84.$$

Comparative Setting of Weaves.—It is a very good method in reasoning out the setting of weaves to which the intersection theory cannot be applied to find the diameters of the yarns that are considered suitable, and also the threads per inch based on the intersection theory. A comparison of the figures will then usually enable the setting to be decided upon which is suitable for the method of interlacing, and the effect that is desired in the cloth. A twill weave that is re-arranged in sateen order usually requires to be set firmer than the original twill, but how much firmer varies according to the degree in which the intersections in the re-arranged weave support each other. A comparison of the designs K, L, M, N, and O in Fig. 28 (p. 31) will make this clear.

(11) Assuming that the designs K, L, M, N, and O are required to be woven in 20's cotton yarns (116 diameters)—

For the design K the number of ends per inch by the intersection theory =

$$\frac{118 \text{ diameters} \times 11 \text{ threads}}{11 \text{ threads} + 6 \text{ intersections}} = 77.$$

The number of ends and picks per inch may, if desired, be reduced from 77 to the neighbourhood of 70.

The designs L, M, N, and O are looser in structure than the design K; O being firmer than the others, while L is firmer than M and N. It is necessary, however, to consider the effects that the weaves will produce in the cloths. The design L produces a flat twill and the weft should therefore predominate over the warp. The warp may be set with 77 ends per inch, as found in the eleventh calculation, while the picks may be increased to about half-way between 77 and the 118 diameters per inch, viz., about 98 picks.

The designs M and N are very loose and may be set almost up to the diameters per inch, but half-way between 77 and the 118 diameters—viz., 98 ends and 98 picks—may be taken as reasonable setting.

The design O produces a steep twill, and it is therefore advisable to allow the warp to predominate over the weft. The weave is nearly as firm as the design K, and taking 77 ends and picks as the maximum setting of the latter design, an increase in the number of ends to about 88, and a decrease in the number of picks to about 68 may be taken as suitable for the design O. A looser woven steep twill would require to be set finer, and very loose weaves, such as those shown at H and L in Fig. 33 (p. 35) might be set in the warp about up to the diameters per inch. Thicker weft than warp also should be employed.

A consideration of honeycomb weaves will show that the warp and weft should be similar, and in reasoning out the setting of the cloths a comparison may be made between the threads per inch of a plain ordinary cloth, and the diameters per inch of the yarns.

(12) Assuming that 20's cotton yarns (118 diameters) is employed for a honeycomb weave : The intersection theory gives 59 ends and picks per inch as maximum setting for plain cloth. About half-way between 59 and 118 (diameters)—viz., 88 ends and picks per inch will be suitable for an ordinary honeycomb. A large loosely woven honeycomb weave may be set finer.

A Bedford cord weave has a warp surface and the warp should therefore be finely set. The surface is really plain weave, but only half the picks are on the face in the cord stripes. The setting therefore requires to be finer than plain weave in both warp and weft. In 30's cotton warp and weft (146 diameters) a number half-way between the threads per inch for plain cloth (73) and 146 diameters—viz., 110—will give a reasonable basis of the setting. The warp may be set rather finer or rather coarser, according to price, while the picks may be reduced, if desired, to about 84.

The face of a pique structure is an ordinary plain fabric, and plain weave may therefore form the basis of the setting. If 40's cotton (168 diameters) is used for the face warp and weft, 84 face ends and picks is the maximum setting for plain weave. In the pique cloth, however, stitching ends are woven into the face fabric and impart firmness to it, and it is therefore quite appropriate to reduce the setting from 84 to an average of about 72 face threads per inch. The stitching ends require to be thicker than the face ends, while thick weft is generally used for the wadding picks.

An open imitation gauze weave is quite different from an ordinary cloth, but the warp and weft should be similar. By basing the setting upon plain weave, and placing each group of ends in one split with a split missed between the groups, a reasonably good result will be obtained. Thus if the 4 × 4 imitation gauze weave is required in 30's cotton yarns (146 diameters) a reed with 37 splits per inch may be employed dented 4 ends per split, 1 split missed.

The foregoing methods of arriving at the weaving particulars of cloths can be compared with the particulars of structures that have been previously given. No hard and fast rules are laid down, as the correct setting of cloths is very largely a matter of good judgment, but theory can be made a very useful adjunct to practice. It will be found serviceable to compare the known particulars of good cloths with the results ascertained by the diameter and intersection theory.

CHAPTER X

COLOUR THEORIES AND PHENOMENA

Purpose of Colour. *Light Theory of Colour*—Wave Theory of Light—Cause of Colour—How Colours are affected—Mixtures of Coloured Lights. Complementary Colours—Effect of Fatigue on Colour Nerves—The Chromatic Circle. *Pigment Theory of Colour*—Comparison with Light Theory—Mixtures of Coloured Pigments—Colour Constants—Qualities or Attributes of the Primary and Secondary Colours—Modification of Colours—Coloured Greys—Contrast and Analogy. *Colours in Combination*—Kinds of Contrast—Effect of Contrast—Simultaneous Contrast—Contrast of Hue—Contrast of Tone. *Harmony in Colour Combinations*—Harmony of Analogy—Harmony of Contrast—Basis of Colour Harmony—Relative Spaces occupied by Colours—Divisional Colours. How Colours are modified in Textile Fabrics.

Purpose of Colour.—In certain classes of textiles, which range from simple structures to elaborately figured damasks and gauzes, and compound fabrics such as fancy toilets and quilts, colour is not employed; the ornamentation being due to the method in which the threads are interwoven, and to the variation in the reflec-

tion of the light from the different parts of the cloth. On the other hand, there are fabrics in which colour forms the predominant decorative feature—the weave simply serving as the structural element of the texture. For instance, cloths which are finished with a raised surface may have the weave pattern completely concealed, the ornamentation then being entirely due to the introduction of colour ; while in many kinds of rugs, tapestries, and carpets, the form produced by the weave is solely for the purpose of displaying colour. In other classes of cloths, as for example, ordinary figured textures and extra warp and extra weft figured styles, colour is used as a supplementary agent to the effect produced by the system of interlacing, its purpose then being to improve the design by giving greater precision to the form. There are also styles in which the design is due to the combination of a particular scheme of interlacing with a certain order of arranging coloured threads. When colours are employed it is with the definite object of brightening and beautifying the fabric, and it is therefore very important that harmonious colour combinations be obtained. Frequently colour is of more consequence than form, since it is possible for a good scheme of colouring to redeem an otherwise uninteresting design, whereas a displeasing colour combination will render worthless a good form.

There are two theories of colour, viz., the " Light " theory and the " Pigment " theory. These are based upon entirely different principles, and unless this is remembered, confusion is liable to arise between them. In mixing differently coloured lights the colours are added, whereas mixing coloured pigments, as in dyeing, is a process of subtraction, since one colour absorbs or counteracts the other.

Fig. 139.

Light Theory of Colour.—The simple experiment of Sir Isaac Newton's, illustrated in Fig. 139, enables the composition of white light to be determined, and demonstrates that light is the source of colour. A beam of sunlight, A, entering a small hole and passing across a dark room, is intercepted by a glass prism, C. In its passage through the prism the beam is refracted, and is split up into its constituent elements, with the result that it forms a band, not of white light, but of different colours which may be displayed upon a screen as represented at D. The band of coloured light thus obtained is called the solar or prismatic spectrum, and the colours—which are arranged in the same order as the colours in a rainbow, are known as spectral or spectrum colours. For convenience, the colours are classified in six divisions—viz., Red, Orange, Yellow, Green, Blue, and Violet ; but every gradation of colour is shown in the spectrum, the change from one to another being imperceptible. Thus, red changes through different degrees of reddish-orange to orange ; orange through orange-yellows to yellow ; yellow through yellowish-greens to green ; green through greenish-blues to blue ; and blue through bluish-reds to violet. The preponderating colours in the spectrum are blue and colours containing blue, and it is customary to describe these as the cold sombre colours, and red, orange,

and yellow as the warm luminous colours. The refraction of the light rays increases
from the red to the violet, and in addition to the visible rays ultra-red or dark heat
rays and ultra-violet or chemical rays are found which lie outside the red and violet
rays respectively. These are only known by their chemical action.

Wave Theory of Light.—Bodies such as the sun, a gas flame, etc., are self-
luminous and are rendered visible by the light that they emit. The majority of
bodies are non-luminous and become visible only by reflecting the light that reaches
them from luminous bodies. Non-luminous bodies owe their *colour* to the reflection
of the light that falls upon them, no colour being visible when there is no light ;
and colours are simply sensations due to the action of decomposed light upon the
retina of the eye. It is a generally accepted theory that the transmission of light
is due to wave motion of the ether (with which it is presumed space is filled and
all bodies are permeated), the undulations in which are set up by the rapid vibrations
of the molecules of which the source of the light is composed. The waves of light
from a self-luminous body, on striking an object, are in part re-transmitted, and
ultimately, if the object is within view, they fall upon the retina of the eye, and by
means of the optic nerve communicate the sensation of vision, or light and colour,
to the brain. White light is composed of innumerable rays which vary as to their
undulatory speed—that is, their wave length (distance from crest to crest), and to
this variation the difference of colour is due. Thus, the waves of red light are the
longest or least rapid, and of violet the shortest or most rapid, the intermediate
colours becoming shorter as to their wave length, or more rapid, in order from red
to violet.

Cause of Colour.—The colour of an object is not inherent in the matter itself,
but all bodies have the property of selective absorption, *i.e.*, the power to break up
the light that falls upon them, and to absorb or reflect the different waves or colour
rays of which the light is composed. *The colour of a body is determined by the character
and intensity of the light rays that it reflects.* For instance, assuming that a cloth is
composed of black, white, and red stripes, it may be stated— in a general way—that
the black portion absorbs all the waves of light that touch it and reflects none ;
the white portion reflects all the waves of light and absorbs none ; while the red
portion reflects most of the red waves of light, and absorbs all, or nearly all, the
others. In the same manner a blue object reflects nearly all the blue waves, and
a green object nearly all the green waves, the other waves in each case being mostly
absorbed and the colours extinguished. The "Absorption Spectra " of objects show
what colours are reflected, and it is found that a black object reflects some light,
and a coloured object a greater or less proportion of the rays other than those which
determine its colour.

How Colours are Affected.—Since it is by the modification of light that colour
is produced the colour of a body is affected, first, by the nature of the light—a change
of light frequently causing a change of colour, this being especially the case with
dyed fabrics ; and, second, by the properties of the material upon which the light
falls, the brightness and precision of the same colour varying, for instance, according
to whether it is applied to silk, wool, or cotton. Also, the perceptive powers of the
eye in different individuals is an influencing factor, as some people are " colour-
blind," or insensitive to a particular colour, and cannot distinguish, for example,
red from green.

Mixtures of Coloured Lights.—Although, in the light theory, the colours are

classed in six divisions, there are really only three pure or " primary " colours—viz., red, green, and blue (ultramarine), since by combining the lights of these colours in pairs in different proportions (Rood's experiments) all the other colours of the spectrum can be produced. The following results are obtained from the combination of coloured lights :—Yellow from red and green ; bluish green from blue and green ; purple from blue and red ; orange from red and yellow ; yellowish green from green and yellow, etc., the resultant colour being intermediate in the spectrum between the colours that are mixed. By mixing the three primary light colours white is produced, while white (or a very light grey) also results from mixing a primary light colour with the colour that results from mixing the other two primary colours. Thus, a mixture of blue and yellow, green and purple, and red and bluish-green lights produces white light.

Complementary Colours.—The light colours, which, by admixture in pairs, produce white light, are considered to be complementary to each other. Thus, blue and yellow, green and purple, and red and bluish green are complementary. There are many other complementary pairs, every colour of the spectrum having its complement in another part, as, for instance, orange and blue-green, violet and yellow-green, etc. *Complementary colours are in the greatest possible contrast to one another.*

Effect of Fatigue of Colour Nerves.—The complement of a colour may be determined by placing a disc of the colour upon a sheet of white paper, looking at it intently for a time, and then transferring the gaze to another white surface. The complementary colour will appear in the form of the disc of the original colour, the image being termed the negative or after-image, while the first impression is called the positive image. In explanation of this it is supposed (the Young-Helmoltz theory) that in the retina there are three groups of nerve fibres, one group of which is sensitive to the red waves of light, the second to the green waves, and the third to the blue waves. When a colour is looked at the corresponding nerves are excited, and if the gaze be continued for a considerable time, become fatigued, while the other nerves are resting. When the eye is transferred to another surface the rested nerves produce sympathetically an after-image which is complementary in colour to the first colour. Thus, by looking at red the nerves that are sensitive to red become fatigued while the green and blue groups of nerves are resting. If a white surface (which excites the red, green, and blue groups equally) be then looked upon, the red nerves are too exhausted to respond, whereas the green and blue groups act together, so that a bluish-green after-image appears. By looking at yellow both the red and the green nerves are fatigued, and a blue after-image results, and so on.

The exhaustion of the colour nerves causes a colour, when looked at for some time, to appear duller, and in examining dyed cloths, in order to avoid this defect, it is necessary to pass from one colour to another, as for instance from red to green or olive, or to transfer the gaze at intervals to a colour which is complementary to the colour of the cloths. Further, the fatigue of the nerves has an effect upon the appearance of a colour which is viewed immediately after another colour has been looked at, and in the following list examples are given of the changes that take place :—

If red has previously been looked at—blue appears greener ; yellow appears greener ; orange appears yellower, and green appears bluer. If blue has previously been looked at red appears more orangy ; yellow appears more intense ; orange

appears yellower ; and green appears yellower. If green has previously been looked at red appears more violet ; yellow appears more orange ; blue appears more violet ; and orange appears redder. The term " successive contrast of colour " is applied to the effect produced by viewing colours one after the other.

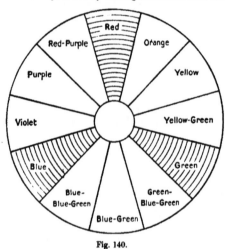

Fig. 140.

The Chromatic Circle. —Any two complementary colours are in the greatest possible contrast to one another, and Fig. 140 illustrates how a chromatic circle may be made which enables the colours that are complementary to be readily seen. The circle is divided into a convenient number of equal parts, in this case twelve, and at equal distances from each other the primary light colours — red, green, and blue (ultramarine)—are painted in. From the red to the green the colours are then changed through orange, yellow, and yellow - green; from the green to the blue through greenish - blue to bluish - green; and from the blue to the red through violet, purple, and reddish purple. Opposite colours in the circle are complementary and in extreme contrast to one another.

PIGMENT THEORY OF COLOUR

Comparison with Light Theory.—The effects obtained by mixing dyes or coloured pigments together are different from those resulting from the mixing of coloured lights. Thus, the combination of red and green lights produces yellow, and of yellow and blue lights white ; whereas red and green pigments yield a dull brown, and yellow and blue pigments green. It has been previously stated that in mixing differently coloured pigments one colour tends to absorb or counteract the other. A third colour is produced because colouring matters reflect colour rays other than those of the predominating colour. The *absorption spectra* of coloured bodies give the colours that are reflected by them, and it is found that both yellow and blue pigments reflect green light, so that when they are mixed the combined action of the two causes practically all the light to be absorbed except the green rays. That is, the blue absorbs the red, orange, and yellow rays of light, and the yellow the violet and blue rays, so that the reflected rays of the mixture are green. It is the reflected light rays, which are common to the pigments, that govern the colour that is produced by their mixture, and the more the reflected rays of the pigments overlap the brighter is the resulting colour, while the fewer reflected rays there are in common the duller is

the colour. Both red and yellow pigments reflect orange light, red also reflects a little yellow, and yellow a little red, and the luminous orange results from their mixture. The reflected rays of red and green overlap in yellow, orange, and red light, but the quantity of each is only small, hence in this case a dull brown hue results from the mixture.

Mixtures of Coloured Pigments.—The effects produced by mixing coloured pigments is very well explained by the Brewster theory, which is adopted in the practical application of colours in dyeing. In this theory red, yellow, and blue are taken as *simple*, or *primary* colours, because they cannot be obtained by mixing other pigment colours, whereas by their admixture in different proportions, and with the addition of black and white pigments, practically all other colours can be produced. When two of the simple colours, or the three, are mixed the resultant colour is termed a *compound* colour. By mixing the primary colours in pairs *secondary* colours are formed, while the mixing of the secondary colours in pairs produces *tertiary* colours, as indicated in the following list :—

CLASSIFICATION OF COLOURS.

Primary.	Secondary.	Tertiary.
Red	Green (Yellow and Blue)	Russet (Purple and Orange)
Yellow	Purple (Red and Blue)	Citron (Green and Orange)
Blue	Orange (Red and Yellow)	Olive (Green and Purple)

In forming the secondary colours yellow and blue produce green, red and blue produce purple, and red and yellow produce orange ; while the tertiary colours—

russet, citron, and olive—respectively result from the mixing of purple and orange, green and orange, and green and purple. The tertiary colours thus result from the mixture of the three primary colours, but in each case one of the three is in excess of the other colours. Compared with the primary and secondary colours the tertiary colours are grey and dull, the colour being due to the predominating colour. Thus, red is the predominating element in russet, yellow in citron, and blue in olive. The relation of the primary, secondary, and tertiary colours to each other is shown diagramatically in Fig. 141, and it will be found useful to the beginner to paint out such a

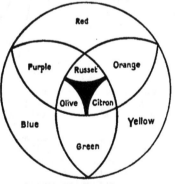

Fig. 141.

diagram with the colours indicated, using—say—carmine or crimson lake, Indian yellow, and Prussian blue, as the three primaries.

A useful diagram is also given in Fig. 142, which shows the arrangement of the primary, secondary, and intermediate colours in the Brewster theory. The circle is divided into eighteen parts, and the primary colours, red, yellow, and blue, are

placed equidistant from each other, with the secondary colours between them. Between each primary and secondary colour two intermediate colours are indicated in which the primary is in excess of the secondary in different proportions.

The term " complementary " is used in a different sense in the light and pigment theories of colouring, as in the latter theory each primary colour and the secondary colour that results from the mixing of the *other two* primaries are considered to be complementary to each other. Thus, red and green, yellow and purple, and blue and orange form complementary pairs. In the same manner each secondary colour, and the tertiary colour which results from the mixing of the other two secondaries, are taken to be complementary; green and russet, purple and citron, and orange and olive, forming complementary pairs. In Figs. 141 and 142 complementary pairs are shown opposite to each other, and it will be found useful to compare these diagrams with Fig. 140, which illustrates the *true* complementary pairs.

Fig. 142.

Colour Constants. — Colours differ from each other in " hue," in " luminosity or brightness," and in " purity," which are termed the three constants of colour. The colours of the spectrum, which are pure colours, are accepted as the normal colours, and they are generally taken as the standard for comparisons.

The constant *hue* varies according to the wave length of the light rays. A difference in hue means a difference in colour, the terms blue, red, yellow, violet, etc., being employed to distinguish different colour sensations or hues from each other. A blue and a green may be exactly alike as regards luminosity and purity, but they are different in hue because the wave lengths of the blue and green light rays are different. The hue of a colour is always the predominating colour in it; thus, if an orange colour contains more red than yellow it is an orange with a red hue, whereas if yellow predominates over the red it is an orange with a yellow hue.

The constant *luminosity* varies according to the degree of light that a colour reflects, no colour being as luminous—that is, as bright or intense—as white. Yellow is the most luminous colour, then orange, and then red, while violet is the least luminous. Two reds, or two greens might be alike as to hue and yet appear different on account of one being more luminous than the other.

The constant *purity* signifies the degree in which a colour is free from white light. All pigment colours are mixed more or less with white light, and when

compared with the corresponding spectral colours appear paler. When a colour fades it loses in purity, but at the same time it may also change in hue, and in such a case there is a change in both hue and purity. A colour that is very pure is said to be saturated.

Qualities or "Attributes" of the Primary and Secondary Colours.—Different effects are produced on the mind by different colours, the impression of brightness, warmth, and nearness being conveyed by some, and of coldness and distance by others. Red is a brilliant and cheerful colour, and gives the impression of warmth. It is a very powerful colour and appears to advance slightly towards the observer. Yellow is a very luminous and vivid colour and conveys the idea of purity. It is not so warm looking as red, but appears more distinctly to advance to the eye. Blue is a cold colour and appears to recede from the eye. The qualities of the secondary colours are somewhat intermediate between the primary colours of which they are composed. Thus orange is a very strong colour and possesses warmth and brightness, but it is not so intense as yellow. Green is a retiring and rather cold colour, but appears cheerful and fresh. Purple is a beautiful rich and deep colour, and for bloom and softness is unsurpassed. The primary and secondary colours are too strong and assertive to be used in large quantities in their pure form except for very special purposes. They are chiefly employed in comparatively small spaces for the purpose of imparting brightness and freshness to fabrics ; their strength being usually much reduced by mixing with black or white when they are used in large quantities as ground shades.

Modification of Colours.—Pigment colours may be modified in the following three ways :—(1) By mixing with another colour. (2) By mixing with black. (3) By mixing with white. A scale or range of colours may be obtained by each method, or by the methods in combination. Mixing a colour with another colour produces a change in hue ; thus, crimson results from adding to red a small quantity of blue, and scarlet from adding to red a small quantity of yellow. The degree of the change of hue is determined by the proportionate quantities of the colours mixed. For instance, if the yellow predominates in a mixture of yellow and blue the hue is a yellowish green, but if the blue predominates a bluish green is produced. A scale of seven hues of green, running from a very yellow green at A to a very blue green at G, results from mixing yellow and blue in the proportions indicated in the following list :—

	A	B	C	D	E	F	G
Yellow	4	3	2	1	1	1	1
Blue	1	1	1	1	2	3	4

In the same manner, but with a change in the relative proportions of the colours mixed, a scale of seven hues of orange can be obtained by mixing red and yellow, as shown in the following :—

Red	1	2	3	4	5	6	7
Yellow	7	6	5	4	3	2	1

When a colour is mixed with white or black a change of *tone* results. By mixing a colour with white in different proportions *tints* of the colour are produced ;

while by mixing with varying proportions of black, *shades* of the colour result.
A tint is therefore a tone which is lighter, and a shade a tone which is darker, than
the normal colour ; and a scale of tones of a colour may be obtained running from
the lightest tint to the darkest shade. The relative proportions of the colour and
the white or the black may be arranged on the principles illustrated in the foregoing
examples, or as shown in the following :—

White or Black	7	6	5	4	3	2	1
Colour	1	1	1	1	1	1	1

Another method of arrangement is as follows :—

White or Black	7	5	3	1	1	1	1
Colour	1	1	1	1	3	5	7

The following list gives some of the tones of the primary and secondary
colours :—

The shades of red	form browns,	and the tints	rose colours and pinks.
,, ,, yellow	,, olive and drab,	,, ,,	straw, lemon, and primrose colours.
,, ,, blue	,, slates and indigos,	,, ,,	lavenders and pale blues.
,, ,, green	,, greenish olives,	,, ,,	pea-green, and light greens.
,, ,, orange	,, olive browns,	,, ,,	salmons and creams.
,, ,, purple	,, maroons and puces,	,, ,,	lilacs and heliotropes.

Coloured Greys.—Certain neutral or broken colours—termed coloured greys—
result from mixing a normal colour with both black and white in varying proportions.
Thus, a scale of red greys, running from dark to light results from mixing white,
black, and red in the proportions given in the following list :—

White	1	2	3	4	5	6	7
Black	7	6	5	4	3	2	1
Red	1	1	1	1	1	1	1

The white and black alone would produce a scale of seven pure greys running
from dark to light, but to each of these is added the same proportion of red—viz.,
one part of red to eight parts of grey. The scale thus varies as to light and shade,
but is equal as to colour. In the next list a different arrangement of the proportions
is given, an increasing quantity of colour being added to an equal amount of pure
grey ; the seven blue greys which result thus varying as to colour, but being equal
as to light and shade except for the influence of the colour.

White	4	4	4	4	4	4	4
Black	4	4	4	4	4	4	4
Blue	1	$1\frac{1}{2}$	2	$2\frac{1}{2}$	3	$3\frac{1}{2}$	4

A " mode " shade is a broken colour in which a certain hue predominates over
a pure grey.

Contrast and Analogy.—These terms are used in reference to the hue and tone
of colours. Colours which are very dissimilar, such as green and red, blue and
yellow, blue and red, etc., are said to be in colour contrast ; while colours which are
alike, or contain a common element, such as red and reddish-orange, green and

bluish-green, etc., are said to be analogous in colour. In the same manner there is contrast of tone, as in dark blue and light blue, or light green and dark red ; and analogy of tone as in light blue and light yellow, and mid blue and mid green, etc. Two colours may be in contrast in both colour and tone, or in analogy in both, or in contrast in one and in analogy in the other.

COLOURS IN COMBINATION

Kinds of Contrast.—There are two heads under which colour combinations are classed—viz., mono-chromatic contrasts, and poly-chromatic contrasts. Mono-chromatic contrasts are those in which different tones of the same colour are combined ; as, for instance, two shades of red, or three tints of blue, etc. Softly graded contrasts result which are specially suitable for such fabrics as overcoatings, suitings, and costumes. Poly-chromatic contrasts include all combinations of two or more different colours which may be alike or different in tone—e.g., light green and light blue, and light green and dark red. A style partakes of both classes of contrast when a ground pattern, consisting of different tones of the same colour, has bright threads of another colour introduced upon it at intervals for the purpose of improving the effect.

Effect of Contrast.—Two kinds of contrast may be formed by colours that are in combination—viz., " successive contrast " and " simultaneous contrast." In successive contrast (which is referred to on page 134) the colours are such a distance apart that one is perceived after the other. In simultaneous contrast the colours are placed in juxtaposition, or side by side, so that both are seen at the same time. The same law governs both classes of contrast, and in each case the colours have the property of changing each other's qualities ; but the change is greater when the colours are in actual contact than when they are seen separately.

Simultaneous Contrast.—Colours that are in juxtaposition are subject to two kinds of contrast—viz., " contrast of hue " and " contrast of tone."

Contrast of Hue.—In contrast of hue each colour influences its neighbour, *since each appears to be tinged with the complementary hue of its neighbour.* Thus, in a cloth consisting of red and blue stripes the red appears tinged with yellow—the complementary of the blue, and the blue with bluish-green the complementary of the red. As a further illustration, it may be assumed that in a stripe fabric, the colours are arranged in the order of red, blue, red, green, blue, and green, a blue stripe being formed between two red stripes and then between two green stripes. The blue stripes, although dyed exactly the same, would appear different, because in one case the blue is tinged with bluish-green—the complement of red, and in the other case with purple—the complement of green. One stripe of blue would thus appear greener, and the other more violet than is actually the case.

The change in colours due to simultaneous contrast can be readily judged by an examination of the chromatic diagram given in Fig. 140. The effect is to make the colours that are in contact appear further apart in the circle ; thus in a combination of blue and red the blue inclines towards blue-green, and the red towards orange ; while in a combination of purple and yellow the purple becomes more violet and the yellow rather greener. It will be seen that simultaneous contrast makes the colours more unlike, and when colours that are opposite in the circle are combined

the contrast between them is intensified, and if suitably proportioned both colours are enriched.

Contrast of Tone.—This comes into play when two tones of the same colour are in juxtaposition—*e.g.*, dark blue, and light blue—and when dark and light colours are placed together—*e.g.*, dark blue and light green. The dark colour, by contrast, makes the light colour appear lighter than it actually is, while similarly, the light colour makes the dark colour appear darker than it is. On a white ground colours appear deeper and darker ; on a grey ground they appear about normal ; whereas on a black ground they look brighter and lighter.

HARMONY IN COLOUR COMBINATIONS

Harmony of colour is not governed by fixed principles, and any combination of hues that is pleasing and gives full satisfaction to the observer may be said to constitute harmony. The colour sense in different persons, however, varies—being more highly developed in some than in others—and what may appear harmonious to one may be more or less inharmonious to others. In combining colours the influence that one colour has upon another should be carefully thought out, so that they may be arranged in such a manner that they will enhance and enrich, rather than impoverish each other. Harmony is obtained when the proper hues are so associated that every particle of colour is helpful to the complete colour scheme. It is usual to distinguish between two kinds of harmony—viz., harmony of analogy and harmony of contrast.

Harmony of Analogy.—There are two ways of producing a harmony of analogy—(1) By the combination of tones of the same colour that do not differ widely from each other. (2) By the combination of hues which are closely related and are equal or nearly equal in depth of tone. Different tints of blue, or shades of green when combined, yield a " harmony of analogy of tone " if the difference between them is not too marked. Tone-shaded effects are produced by combining a series or scale of tones of a colour which are so graded and arranged as to run insensibly one into another. In a combination of yellowish-green and bluish-green, yellow and blue are differentiating colours ; but there is a common element in green, and if the two hues are nearly equal in depth of tone, and are harmonious when united, they form a " harmony of analogy of hue." Harmonies of analogy are of chief value in producing quiet effects.

Harmony of Contrast.—There are two ways of producing a harmony of contrast—(1) By the combination of widely different tones of the same colour. (2) By the combination of unlike colours. Thus, a pleasing combination of two tones of blue, the interval between which is marked, forms a " harmony of contrast of tone," while the union of red and green, red and blue, or blue and yellow, if harmonious, forms in each case a " harmony of contrast of hue." Harmonies of contrast are useful when clear smart effects are required. As previously stated (p. 139) there may be analogy in tone and contrast in hue, or contrast in tone and analogy in hue in a combination.

There is also " harmony of succession—or gradation—of hue " (which partakes somewhat of both kinds of harmony) in which there is a succession of hues that pass insensibly one into the other—the spectrum being a typical example. Red and yellow, when combined, are in colour contrast ; but by introducing between them

a series or scale of hues of orange—running from reddish-orange to yellowish-orange—the two colours may be so blended one into the other that there is no sharp contrast, and an effect closely related to harmony of analogy is produced. Similarly, yellow may be passed imperceptibly into blue through a series of hues of green, and blue into red through hues of violet and purple.

Basis of Colour Harmony.—Complementary hues are harmonious, but in their pure state they yield contrasts that are too strong. The colours still form similar complementary pairs when reduced by means of black, or white, or both black and white, and in this condition they form most harmonious combinations. A study of the complementary hues, and their shades, tints, and broken colours, is therefore of great value as an introduction to the combining of colours, and as a basis of colour harmony. The painting out of colour circles, such as those shown in Figs. 140, 141, and 142, is a useful means of acquiring a knowledge of hues that harmonise, as colours that are opposite in the circles go well together except when they are too strong.

It is not necessary, however, to only select colours that are complementary in order to produce harmony, and it is generally considered that it is better to combine hues which are from 20 to 30 degrees on one side or the other of their complements, as these are not so strongly in contrast. It will be noted that in Fig. 142 (Brewster's theory of arrangement) opposite colours are not so strongly in contrast as in Fig. 140, in which the colours are arranged according to the Young-Helmholz theory. The effect of contrast, when complementary or near complementary colours are in contrast, is to enrich the colours.

In producing a harmony of contrast it is a good rule to select colours that are separated by at least 90 degrees on the chromatic circle, shown in Fig. 140. Related colours, which are from about 30 to 90 degrees apart on the circle, such as blue and purple, yellow and green, etc., are in most cases inharmonious. Colours that are very near together in the chromatic circle can be combined in producing a harmony of analogy of hue. When a large number of hues are employed in a design colours that are similar usually preponderate. For example, in a green scheme of colouring—greenish-blues, bluish-greens, and blue can be employed on the one side, and greenish-yellow, yellowish-greens, and yellow on the other side; and in this way all the colours can be run through—in this case, of course, with greens predominating. In any combination of colours, one hue should predominate somewhat over any other hue, either in area or intensity, in order that the design will possess character. If the colours are united so as to be about equally prominent, the design will appear monotonous, however well the hues harmonise; this being especially the case if the colours are bright.

Dark grounds are more suitable for the application of bright colours, such as red, orange, and yellow, than light grounds, as their qualities of brightness and intensity are improved on the former, and diminished on the latter. On the other hand sombre colours, such as violet and purple, are deepened and enriched on light grounds and suffer on dark grounds.

Relative Spaces occupied by Colours.—While allowing for a predominating hue it is usual to arrange the spaces occupied by the several colours in a design in accordance with the relative intensity of the hues. Too great an excess of a colour is injurious to an effect, and it is necessary to employ a strong colour more sparingly than a less intense colour. Thus, a combination of a shade of blue with intense

yellow might be harmonious if the space occupied by the blue largely predominated ; whereas with the yellow predominating, the effect would be displeasing on account of the blue being overpowered by the greater luminosity of the yellow. In the same manner. a few threads of bright red on a toned green foundation might prove pleasing where a large number of threads of red would appear crude.

In combining threads which are in strong contrast, the space occupied by each hue or tone should be small, but if the contrast is subdued, the space alloted to each may be large. · This is illustrated in a general way by the following lists in which the contrast is represented relatively by the terms black, grey, and white ; the black and white producing a strong contrast, and the black, or white with grey more subdued effects, as the grey more nearly approaches the black or the white.

(a)	2 threads black and			2 threads	white.		
(b)	4	,,	,,	,,	4	,,	light grey.
(c)	8	,,	,,	,,	8	,,	mid grey.
(d)	16	,,	,,	,,	16	,,	dark grey.

or

(e)	2 threads white and			2 threads	black.		
(f)	4	,,	,,	,,	4	,,	dark grey.
(g)	8	,,	,,	,,	8	,,	mid grey.
(h)	16	,,	,,	,,	16	,,	light grey.

Divisional Colours.—In many combinations the contrast has the effect of making the colours appear blurred and confused at their joining. In such a case, and when the colours are too strong in contrast, hues of a neutral character, or black, grey, or white may be employed to separate the colours. The strength of the contrast is thereby reduced, and the colours are made to appear clear and precise. When a colour is used to form the divisional line its qualities should be about inter-mediate between those of the two colours, or a paler tone of either colour may be suitable. Black can always be successfully used to separate two bright colours, while white and grey are useful in separating a bright and a sombre colour, or two sombre colours, grey being used instead of white when the latter forms too strong a contrast.

Although black is not so useful in separating a bright and a sombre colour as two bright colours, it can be successfully employed in combination with the sombre colours, such as blue and violet, and the darker shades of the luminous colours, in forming a harmony of analogy.

HOW COLOURS ARE MODIFIED IN TEXTILE FABRICS

The following factors tend to modify colours in their application to textile fabrics :—(a) The physical structure of the raw material ; (b) The mechanical construction of the yarn. (c) The structure of the cloth. (d) The finish applied to the cloth after weaving. The presence or absence of lustre in a fabric to which colour is applied has a great influence upon the appearance of the colour, and in very many cases lustre is imparted to cloths in the process of finishing for the purpose of enhancing the brightness of the colour. On the other hand, cloths are finished with a rough fibrous surface in order that the colours will appear deep and full.

(a) The different raw materials vary extremely as to lustre. The silk fibre is perfectly smooth, is somewhat transparent, and has the greatest lustre ; hence

colours upon silk are most brilliant and rich. The fibre has such a high-reflecting power that low-toned colours appear well upon it which may readily show dull and poor when applied to other materials. In wool the lustre varies according to the class of the material. The fibres of long wool (and mohair and alpaca) have comparitively large and flat outer scales, and being smoother this class of wool takes a brighter colour than short wools, the outer scales of which are small and have free protruding edges which disperse the light. The special quality of the colour upon long wools is its brightness, and upon short wools fulness and softness. The cotton fibre has a downy surface, and in its natural condition possesses very little lustre, hence in dyed cotton the colour is lacking in brightness as well as softness. In mercerised cotton the colour has a much brighter appearance owing to the material being made smoother and more transparent. Flax, hemp, and jute also take a dull tone of colour; but China grass, which is more lustrous, ranks next to long wool and mercerised cotton in giving brightness of hue when dyed.

(b) The tone of a colour is influenced to a considerable extent by the way the fibres are arranged in the thread, as the straighter and more parallel the fibres are laid the more lustrous is the thread. Thus worsted yarns, in which the fibres are arranged as straight as possible, take a bright tone of colour, while in woollen yarns, in which the fibres are intermingled and crossed with each other, the tone of the colour is soft and mellow. In the same manner a combed and gassed cotton thread takes a brighter tone of colour than the rougher carded cotton thread.

(c) The manner in which the warp and weft threads intersect each other, and the frequency of the intersections influence the brightness of the colour, as they affect the smoothness of the surface of the cloth. Other things being equal, the more frequent the intersections are the more subdued is the tone of the colour; but the way in which the intersections are arranged has a considerable effect upon the brightness. Thus a warp twill weave produces a rougher surface and appears duller than a warp sateen weave on the same number of threads; the latter type of weave yielding the smoothest surface it is possible to construct, and therefore giving the brightest tone to the colour.

(d) Two distinct types of finish are applied to cloths—a clear finish and a raised finish. In the clear finish all the loose fibre is removed from the face of the cloth, and the operations tend to promote smoothness and lustre of surface and to increase its reflecting power, hence the brightness and precision of the colour are enhanced. In the raised finish the fibres are drawn on to the surface of the cloth, which is covered with a soft even nap into which the light penetrates and becomes saturated with the colour before being reflected. The colour appears soft and subdued; but it is brighter in tone when the surface fibres are laid smoothly in one direction than when they are made to stand vertically from the foundation. In the latter case the light is dispersed and the colours acquire greater fulness and depth of tone.

CHAPTER XI

APPLICATION OF COLOUR—COLOUR AND WEAVE EFFECTS

Mixed Colour Effects—Methods of Production—Fibre Mixture Yarns—Twist Yarn Mixtures. *Combinations of Differently Coloured Threads* — Colour Stripes and Checks—Simple Regular Patterns—Simple Irregular Patterns—Compound Orders of Colouring—Counter-Change Patterns—Graduated Patterns—Modification of Stripe and Check Patterns—Balance of Contrast in Pattern Range Designing—Colour Combinations in Relation to Weave. *Colour and Weave Effects*—Representation of Colour and Weave Effects upon Design Paper—Methods of producing Variety of Effect in the same Weave and Colouring—Classification of Colour and Weave Effects—Simple Colour and Weave Effects—Continuous Line Effects — Shepherds' Check Patterns — Bird's Eye and Spot Effects—Hairlines—Step Patterns—All-Over Effects.

COLOURS may be dyed upon textile materials at various stages of manufacture—*e.g.*, in the loose fibre state, in the sliver or top condition, and in the form of the spun thread or the woven cloth. The object in each case may be to produce a solid colour effect in the woven cloth by employing only one colour. On the other hand, different colours may be combined at one or other process of manufacture with the object of producing either a mixed or intermingled colour effect, or an effect in which each hue appears distinctly as a solid colour.

MIXED COLOUR EFFECTS

Methods of Production.—The following methods of producing mixed colour effects are employed :—

(1) By blending differently coloured fibres which have been dyed in the raw or the sliver condition, producing " mixture yarns." A somewhat similar mixed colour effect is obtained in " melange " yarns, which are produced by printing the slivers in bands of different colours that the subsequent drawing operations cause to be more or less thoroughly intermingled in the spun thread.

(2) By introducing small patches of dyed fibres into the slivers at the later stages of the processes preceding spinning ; a thread spotted with the colour being produced.

(3) By spinning from differently coloured rovings, producing " marl " yarns, in which the colours are blended only to a limited extent ; the resultant thread, in some cases, having almost the appearance of being composed of two differently coloured threads twisted together.

(4) By printing the spun thread in bands of different colours.

(5) By twisting together differently coloured threads producing various kinds of fancy twist yarns.

(6) By combining (either as a fibre mixture or a twist) two materials in the undyed state which have different affinities for colouring matters—*e.g.*, wool and cotton, and submitting the woven cloth to two dyeing operations (cross-dyeing).

(7) By employing differently dyed threads, arranged one, or at most two, threads at a place, and using weaves of a crêpe or broken character.

Fibre Mixture Yarns.—In mixtures of differently dyed fibres the degree in which the colours are intermingled varies according to the number and character of the processes which follow the blending. The mixing may be done in the later stages prior to spinning with the object of producing a colour mixture in which each colour retains its purity. On the other hand, by blending in the early stages, colour effects are produced which are quite unlike those obtained by mixing colours in any other way. The differently dyed fibres are so thoroughly intermingled that a new colour results, in which, however, the separate colours can be distinguished by close examination. For instance, an intimate mixture of yellow and blue fibres produces a hue of green which is quite different from any green that can be obtained by mixing yellow and blue pigments, because in the fibre mixture each colour retains, in some degree, its individuality, whereas in the pigment mixture the original colours are effaced.

Various classes of fibre mixtures are included in the following list :—

(1) Mixtures of white and black producing greys.

(2) Mixtures of one colour with white or black producing tones of the colour.

(3) Mixtures of different tones of the same colour.

(4) Mixtures of two or more colours.

(5) Mixtures of two or more colours with white or black.

(6) Mixtures of black and white (grey) with one or more colours producing coloured greys.

In producing a scale of hues, tones, or greys, the quantities of the different constituents may be arranged on the principle illustrated in the examples of mixing pigments (pp. 137 and 138). The best arrangements, as a rule, are those in which the sum of the proportions is the same in each hue or tone, as in the following example :—

Colours	A	B	C	D	E
Dark Olive	5	5	5	5	5
Black	1	2	3	4	5
White	2½	2	1½	1	½
Lavender	2½	2	1½	1	½
Orange	1	1	1	1	1

The most suitable materials for fibre mixtures are the fairly strong and lustrous medium wools, such as are used in the manufacture of mixture serges and tweeds.

In selecting the colours to be mixed the following rules are of general application :—(a) In a mixture of two tones of the same colour there should be a distinct difference between the two. (b) The colours should harmonise when laid side by side before mixing. (c) The proportionate quantities should be in accordance with the relative intensities of the hues, subdued colours, and black and white being chiefly employed, while bright colours are introduced in small quantities for the purpose of imparting brightness.

Twist Yarn Mixtures.—In yarns composed of differently coloured threads twisted together there is no intimate intermingling of the fibres, so that each colour is seen separately, the twisting of the threads simply breaking the continuity of the colours.

10

The prominence of an intense colour can be reduced without its purity being affected, and the yarns are, therefore, specially useful in cases in which the introduction of a self-coloured thread would cause the hue to show too strong.

The various classes of fancy twist threads include the following :—

Grandrelle yarns are composed of two or more differently coloured threads twisted together. These yarns sometimes predominate in a cloth. as for instance in covert-coatings, and analogous colours are then used, such as two tones of olive or brown, etc. When, however, the threads are only used in small quantities in a cloth one of the colours should be strong ; thus scarlet, orange, bright blue, or light green may be twisted with black. A class of grandrelle shirting is woven in which cotton twist threads predominate, and in these yarns white and a rather strong colour, such as blue or red, are largely used in combination.

Spiral yarns are composed of two threads twisted tightly together (which may be alike or in different colours) round which a soft spun thread is twisted spirally.

Gimp yarns, which mostly handle somewhat harsh, consist of a central hard twisted thread, and a soft spun thread, which is given in more rapidly than the centre thread.

Diamond yarns consist of a thick centre thread, round which two fine threads are twisted in opposite directions, thus producing a diamond effect.

Curl or *Loop* yarns consist of a fine foundation thread, a soft-spun thick thread, which is given in rapidly so that it forms loops at intervals, and a fine binder thread.

Knop yarns are composed of one or two foundation threads which are twisted with a third thread, but the latter, at intervals, is wrapped round and round the former so as to produce lumps or knops.

Cloud, Slub, or *Flake* yarns are composed of two foundation threads, with which pieces of short-fibred twistless slivers are twisted at intervals.

Different hues, and also different materials, can be combined in various ways in the yarns. In the grandrelle, spiral, gimp, and diamond yarns the colours appear regularly, whereas in the curl, knop, and cloud threads a special colour can be shown prominently at intervals. In the same thread combinations of two or more of the effects can be produced in diverse ways.

COMBINATIONS OF DIFFERENTLY COLOURED · THREADS

Effects are produced by combining differently coloured threads as follows :— (*a*) With the warp in one colour and the weft in another colour, forming a " shot " effect. (*b*) With the warp in different colours and the weft in one colour, producing a stripe. (*c*) With the warp in one colour and the weft in different colours, producing a cross-over effect. (*d*) With both the warp and the weft in different colours, producing a check style. In addition, in the production of special stripe, spotted, and figured designs, different colours may be introduced by employing one or more series of extra weft, extra warp, or both extra weft and extra warp threads.

Colour Stripes and Checks.—An arrangement of weft threads in a cloth can also be employed for the warp threads, and *vice versa* ; therefore. stripe and check colour combinations are considered together in the following. The patterns result from the combination, in equal or unequal spaces, of two, three, or more colours, and in their construction it is necessary to have the following in mind :—

(a) Colours which harmonise, and tones that will assist harmony should be selected.

.(b) Each colour or tone should be allotted a suitable extent of surface.

(c) The appearance of a colour is influenced by the weave, as different weaves break up the colours on the surface of a fabric in a varying degree ; the effect, for instance, of a 2-and-2 twill being quite different from that of a 1-and-3 warp twill or sateen. A continuous warp face weave, although suitable for a stripe, is quite inapplicable to a check. To produce a *perfect* check, weaves with equal warp and weft float should be employed and the weft threads should be similar to the warp threads as regards number, thickness, material, and colour arrangement.

Stripe and check effects may be conveniently classified into : patterns in two colours, and patterns in three or more colours ; both of which may be subdivided broadly into regular and irregular orders of colouring. Arrangements of coloured threads are also classified into—simple orders, and compound orders.

Simple Regular Patterns.—Examples of regular patterns in two colours are— 4 threads dark and 4 threads light, or 16 threads dark and 16 threads light ; and a three-colour style—8 threads dark, 8 threads medium, and 8 threads light. A four-colour regular pattern may be arranged—6 threads first colour, 6 threads second colour, 6 threads first colour, 6 threads third colour, 6 threads first colour and 6 threads fourth colour ; in which the second. third and fourth colours are separated from each other by the first colour. The regular arrangements do not, as a rule, yield interesting styles, but small patterns are more effective than large patterns. In some cases, however, the combination of the weave with the colour scheme modifies the stiffness of the form and makes it more pleasing. A regular order is very often employed as a ground effect in a special stripe or check design ; while sometimes a slight change in a pattern is made at intervals in order to render it more interesting. For instance, a 6 × 6 order of colouring might be arranged— 6 threads first colour, and 6 threads second colour for five times ; then 6 threads first colour, 2 threads second colour, 2 threads third colour, and 2 threads second colour. In check patterns a two-colour scheme gives three ; the third hue being produced where the two colours cross each other. In the same manner six colour effects are produced in a three-colour scheme—viz., colours 1, 2, and 3 separately, 1 and 2 together, 1 and 3 together, and 2 and 3 together.

Simple Irregular Patterns.—The irregular colour arrangements permit much more detail and diversity to be introduced than the regular styles. Examples in two colours are 6 threads dark and 2 threads light, or 16 threads dark and 8 threads light ; while a three-colour irregular pattern is—12 threads dark, 8 threads medium, and 4 threads light. The last example, if produced in check form, gives a variety of shapes—viz., 12 × 12, 8 × 8, 4 × 4, 12 × 8, 12 × 4, and 8 × 4.

Compound Orders of Colouring.—A compound order of colouring is a combination of two or more simple orders, each of which is repeated a number of times. A variety of arrangements is given in the following list (p. 148).

Example 1 is a combination of three regular simple orders in two colours ; example 2, of two regular orders in three colours ; example 3, of two irregular orders in two colours ; example 4, of three irregular orders in three colours ; while example 5 illustrates the arrangement of regular and irregular orders in two colours, and example 6, in three colours.

EXAMPLES OF COMPOUND ORDERS OF COLOURING.

1

1 dark ⎫
1 light ⎬ 8 times
2 dark ⎫
2 light ⎬ 4 times
1 dark ⎫
1 light ⎬ 8 times
4 dark ⎫
4 light ⎬ 4 times

2

2 dark ⎫
2 medium ⎬ 6 times
2 light ⎭
4 dark ⎫
4 medium ⎬ 3 times
4 light ⎭

3

2 dark ⎫
1 light ⎬ 8 times
4 dark ⎫
2 light ⎬ 6 times

4

3 dark ⎫
2 medium ⎬ 6 times
1 light ⎭
1 dark ⎫
2 medium ⎬ 6 times
3 light ⎭
1 dark ⎫
4 medium ⎬ 3 times
1 light ⎭

5

2 dark ⎫
2 light ⎬ 8 times
3 dark ⎫
1 light ⎬ 4 times
2 dark ⎫
2 light ⎬ 2 times
1 dark ⎫
3 light ⎬ 4 times

6

3 dark ⎫
3 medium ⎬ 4 times
3 light ⎭
4 dark ⎫
3 medium ⎬ 4 times
2 light ⎭

Counter-change Patterns.—The term counter-change is applied to styles in which the colours change positions; one colour being allowed to predominate in one section of the pattern, and another colour in the next section in exactly the same proportion. An illustration in two colours is—8 threads dark, 2 threads light, 8 threads dark, then 8 threads light, 2 threads dark, and 8 threads light. Three colours may be introduced on this principle, as for example—12 threads dark, 4 threads medium, 12 threads dark; then 12 threads medium, 4 threads light, and 12 threads medium.

Graduated Patterns.—In these styles the spaces occupied by the colours are gradually increased or decreased in size, as shown in the following examples :—

EXAMPLES OF GRADUATED PATTERNS.

1.	First Colour	1	3	5	7	9	11	
	Second Colour	2	4	6	8	10	12	
2.	First Colour	2	6	10	14	10	6	
	Second Colour	4	8	12	12	8	4	
3.	First Colour	2	4	8	16	8	4	
	Second Colour	4	8	16	8	4	2	
4.	First Colour	2	4	6	8	10	12	
	Second Colour	12	10	8	6	4	2	
5.	First Colour	2	4	6	8	6	4	
	Second Colour	3	3	3	3	3	3	
6.	First Colour	1	3	5	7	7	5	3
	Second Colour	2		6		6		2
	Third Colour		4		8		4	

Example 1 illustrates " single-shading," in which the threads are graduated in one direction only, whereas examples 2 and 3 show "double-shading" the number

of threads of each colour being gradually increased and then decreased. Example 4 illustrates inverse shading; the number of threads of one colour increasing, while those of the other are decreasing. In example 5 the first colour is double-shaded, whereas the second colour is stationary; and example 6 is illustrative of shading in three colours.

Modification of Stripe and Check Patterns.—One of the principal features in the designing of colour stripes and checks is the production of a great variety of effects by repeatedly introducing slight changes in the arrangement of the threads. The modifications may be made in the warp at intervals, either while the threads are being run on the weaver's beam, or in the loom; the changes in the weft pattern to correspond offering no difficulty. The examples given in Fig. 143 illustrate, in a general way, the system of working as applied to the modification of a stripe. Two colours only are mostly represented, but the method holds good when more colours are used. Commencing with the regular stripe, indicated at A, the first modification consists of bisecting each stripe, as shown at B, and the second by introducing two stripes in the centre, as represented at C. The stiffness of a symmetrical pattern may be reduced by introducing a line in a different colour, in the manner indicated by the differently shaded line in C. This line, in a check style, will produce an over check. Example D in Fig. 143 shows a modification which is symmetrical in form; while in each example E and F one half of the pattern is symmetrical and the other half non-symmetrical. A compound arrangement of the threads is illustrated at G and a graduated pattern at H.

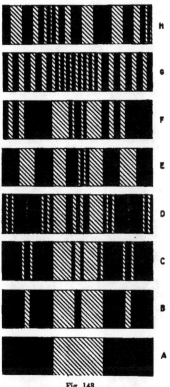

Fig. 143.

In painting out coloured stripe patterns the form of the design may be first lightly indicated in pencil; then in order that the stripes will be clearly defined lines of colour should be ruled at the edges by means of a ruling pen. The liquid colour can be readily inserted in the pen with the brush that has been employed in mixing the pigment, and the brush can be used in washing in the colour between the ruled lines. In some cases it is convenient to paint the ground shade entirely over the surface of the design before the specially coloured stripes are painted in;

or, in place of this method, suitably coloured paper may be used for the ground shade upon which the special stripes are painted.

Balance of Contrast in Pattern Range Designing.—The examples given in Fig. 143 are all different in form, and each therefore constitutes a distinct style. In pattern designing, however, it is frequently necessary to produce a range of effects which will form only one style. In the latter case the arrangement of the threads requires to be exactly the same in each pattern in the range. The difference between the patterns is due to different colours being used; and it is necessary to obtain the same degree of contrast in colour and tone in each pattern. After the form of the style has been decided upon, the number of colours to be used, and their relative intensity in the different sections may be determined; the most intense colour, of course, being allotted to the smallest section. The colours of the first pattern may then be selected, and when found satisfactory, these are employed as the toning of every other pattern in the range. The system of working is illustrated by the following example of a range of stripes :—

Form of Stripe	A	B	C	X	Y
16 threads	Black	Black	Black	Black	Brown
4 threads	Dark Green	Dark Blue	Brown	Orange	Black
16 threads	Black	Black	Black	Black	Brown
2 threads	Red	Orange	Light Green	Dark Blue	Light Green

In each pattern A, B, and C the least intense colour or black is allotted to the largest section (16 threads), the medium colour to the next largest section (4 threads), and the brightest colour to the smallest section (2 threads). The dark green, dark blue, and brown, in the medium-size section, should be equal in depth of tone, and there should be the same degree of contrast between the dark blue and the orange in pattern B, and between the brown and the light green in pattern C, as there is between the dark green and the red in the first pattern A.

Patterns X and Y in the list illustrate a wrong principle of arrangement. The same colours are employed as in the patterns B and C respectively, and the threads are arranged in the same order, but the position of the colours is changed, therefore the effects produced by X and Y would be out of balance with each other

Fig. 144.

and with the first pattern. This is illustrated in Fig. 144, in which the relative intensities of the colours are represented diagrammatically. In each pattern A, B, and C, in the above list, the colours would appear relatively as shown at A in Fig. 144, only one style being formed; but in patterns X and Y the colours would be relatively as shown at X and Y in Fig. 144, each forming a distinct style on account of the difference in the contrast between the sections.

Colour Combinations in Relation to Weave.—The weaves that are employed in conjunction with combinations of coloured threads may be broadly divided into the following three classes :—(1) Weaves which bring the warp and weft threads equally, or nearly equally, to the surface of the cloth, and enable the colours to be applied in both warp and weft. This type gives the greatest scope for colour effects. (2) Warp face weaves, in which the weft is almost entirely concealed, so that it is necessary to apply the colours chiefly in the warp. (3) Weft face weaves, in which the warp is nearly concealed, and in which it is seldom possible to apply the colour except in the weft. In some styles, however, notably hair-line effects, it is necessary to introduce the colours in both warp and weft, although one of the yarns is chiefly on the underside.

COLOUR AND WEAVE EFFECTS

A colour and weave effect is the form or pattern in two or more colours produced by colour and weave in combination. It is frequently quite different in appearance from either the order of colouring or the weave, because (a) the weave tends to break the continuity of the colours of warp and weft ; and (b) a colour shows on the face of the fabric, whether it is brought up in warp float, or in weft float. This is illustrated in Fig. 145, where, in the 2-and-2 twill weave, A shows the effect produced by colouring 3 black, 3 white in the warp, with white weft ; B, 3 black, 3 white in the weft, with white warp ; and C, 3 black, 3 white in both warp and weft. Each effect consists of a small black form on a white ground ; but while in A the floating of the black warp on the face produces the form, in B it is produced by the floating of the black weft, and in C by the combination of black warp float and black weft float on the surface.

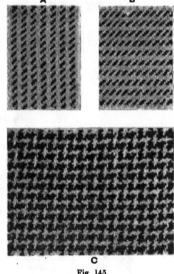

Fig. 145.

Representation of Colour and Weave Effects upon Design Paper. — Colour and weave effects may be readily indicated upon point - paper, and for experimental purposes the method is useful, since it enables the designer to see the effect any colour plan will produce with a given weave. Also, by viewing the point-paper sketch through a cloth-counting glass held at a suitable distance, the appearance of the pattern, when reduced approximately to the size it will be in the cloth, can be observed. Three things require to be known—viz., the order of warping, the order of wefting, and the weave. The examples D to I in Fig. 146 illustrate in stages the working out of an effect in which the threads are arranged 3 dark, 3 light in warp and weft, while the weave is

2-and-2 twill. The example corresponds and may therefore be compared with that shown in Fig. 145. The size of the repeat is obtained by finding the

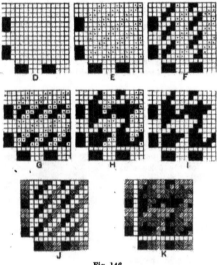

Fig. 146.

L.C.M. of the number of threads in one repeat of the colour plan, and in one repeat of the weave—in this case 12 ends by 12 picks. At D the arrangement

Fig. 147.

of the ends as to colour is indicated along the bottom, and of the picks up the side of the reserved space. At E, the weave is inserted lightly in pencil; the

weave marks indicating warp float. At F the dark ends are followed vertically

in successive order, and where there are weave marks—that is, where the warp is floated on the surface — the squares are filled in solid. At G the dark picks are followed horizontally in successive order, and where there are blanks in the weave—that is, where the weft is floated on the surface—the squares are filled in solid. H shows the appearance of the sketch at this stage, while I represents

Fig. 148.

the complete effect with the weave marks on light threads rubbed out,

If the weave marks indicate weft, the blank spaces are filled in solid in following the dark ends, and the marked spaces in following the dark picks.

In the plan I in Fig. 146 the marks represent one colour and the paper the other colour. In working out an effect in colours, the ground may be indicated in the second colour after the first colour has been painted

Fig. 149.

in in the manner described; or the lighter colour may be first painted

entirely over the space, and the pattern in the darker colour be afterwards indicated over it.

The method of working is similar when more than two colours are employed, as shown at J and K in Fig. 146. The weave is 2-and-2 twill, and the warp and weft threads are arranged 2 dark, 2 medium, 2 light—the different colours being represented by different marks. The ends are followed first, each colour being dealt with in

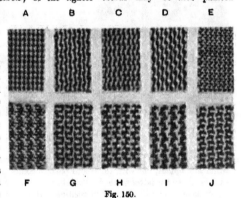

Fig. 150.

turn, and where there are weave marks the squares are filled in with the required colour, as shown at J. Afterwards the effect is completed by following the picks, and filling in the squares which are blank with the required colour, as shown at K. In small patterns it is usually better for the sketch to be extended over two or more repeats in each direction.

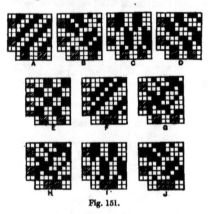

Fig. 151.

Methods of Producing Variety of Effect in the same Weave and Colouring.—An important factor to note in designing colour and weave effects is that different patterns can usually be obtained in one order of colouring and one weave by changing their relative positions. This is illustrated by the patterns represented in Fig. 147, and the corresponding plans, similarly lettered, given in Figs. 148 and 149. Each pattern, L to 8 in Fig. 147, is produced by the combination of a 4-and-4 order of warping and wefting, with a 2-and-2 hopsack weave. There are two ways in which the change of effect may be brought about: (1) As shown at L to 8 in Fig. 148, the warp and weft threads may be arranged as to colour in the same manner throughout (viz., 4 dark, 4 light), but with the weave placed in a different position in each

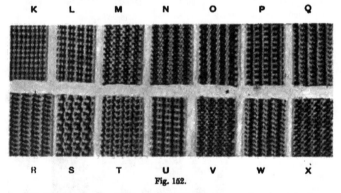

Fig. 152.

case. (2) As shown at L to 8 in Fig. 149, the weave may be placed in the same position throughout, but with the colour pattern commencing in a different manner in each case. In the latter method either the warp, or the weft, or both the warp and the weft colours may be changed in position. It will be noted in Fig. 147 that the

difference of effect in some cases is very slight, one-half of the patterns when turned over being simply duplicates of the other half. The example, however, is illustrative of the necessity in weaving of always retaining the same relation betwen the colouring and the weave throughout the length of the cloth. In subsequent examples it is shown that the change of effect thus produced can be made use of, not only in designing small patterns, but also in the economical production of stripe and check designs in very great variety.

Classification of Colour and Weave Effects.—A convenient classification of the orders of colouring the threads is as follows : (a) Simple warping and simple wefting; (b) compound warping and simple wefting; (c) simple warping and compound wefting; (d) compound warping and compound wefting. In (a) and (d) the order of warping may be the same, or different from the order of wefting. To each order of colouring, simple, stripe, and check weaves may be applied.

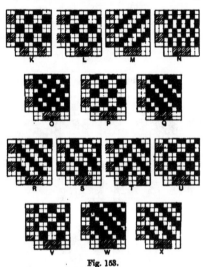

Fig. 153.

The style of pattern which is produced by the

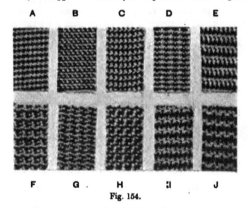

Fig. 154.

combination of each order of colouring with each type of weave, is given in the accompanying list.

Order of Colouring	Simple Weave	Stripe Weave	Check Weave
Simple Warping and Simple Wefting	Simple Pattern	Stripe Pattern	Check Pattern
Compound Warping and Simple Wefting	Stripe Pattern	Stripe Pattern	Check Pattern
Simple Warping and Compound Wefting	Cross-over Pattern	Check Pattern	Check Pattern
Compound Warping and Compound Wefting	Check Pattern	Check Pattern	Check Pattern

In addition to the foregoing styles, special orders of colouring and weaves are arranged to coincide with each other in such a manner as to produce special effects.

Simple Colour and Weave Effects. — In these styles the arrangement of the threads as to colour may be regular (as for example, 4 dark, 4 light, or 3 dark, 3 medium, 3 light), or irregular (as, for example, 2 dark, 1 light, or 3 dark, 2 medium, 1 light). Many good effects are also obtained by arranging the weft in a different order from the warp (as, for example, 2-and-2 warping crossed with 1-and-1 wefting, or 4-and-4 warping crossed with 2-and-2 wefting).

Fig. 155.

The effects produced by applying simple weaves to simple orders of colourings comprise continuous line effects, shepherd's-check patterns, bird's-eye and spot effects, step patterns, hairlines, and all-over patterns.

Continuous Line Effects.—Examples of continuous effects, in which the lines run lengthwise of the cloth, are given at A to X in Figs. 150 and 152. The corresponding weaves, lettered the same, are shown in Figs. 151 and 153, the weave marks indicating warp float. The exact position of the dark threads in relation to the weave is indicated by the shaded marks along the bottom and at the side of the plans. All the particulars are thus given for reproducing the effects, and for the beginner it will be found good practice to sketch the patterns on point-paper in the manner previously described, and compare the sketches with the woven effects.

Fig. 156.

A in Fig. 150 shows the typical line effect produced by colouring the 2-and-2 twill in the order of 2 dark, 2 light; while in the effects shown at B to J the lines are more or less of a symmetrical zig-zag character. In K to O in Fig. 152 the lines are symmetrical and straight; in P to S they are serrated on one side, and in T to X small spots occur between the lines.

A to J in Fig. 154 show effects in which the lines run continuously across the piece, the corresponding weaves similarly lettered, being given in Fig. 155. As a general rule, patterns in which the horizontal lines show prominently are satisfactory only when used in combination with other effects.

Shepherd's-check Patterns.—Typical examples of shepherd's-check effects are shown at K and L in Fig. 156. In each the order of colouring is 4 dark, 4 light in warp and weft, and

Fig. 157.

the weave 2-and-2 twill, the slight difference between the effects being due to the weave having been placed in different positions in relation to the colouring. M to R in Fig. 156 show useful variations of the shepherd's-check style. The weaves K to R in Fig. 157 correspond with, and are lettered the same as, the examples given in Fig. 156.

Bird's-eye and Spot Effects.—The term bird's-eye is applied to patterns in

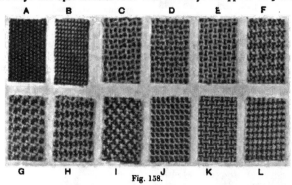

Fig. 158.

which the surface of the cloth is covered with small, distinct, detached spots of colour. Examples are given at A to L in Fig. 158, while the corresponding plans, lettered the same, are shown in Fig. 159. The weave marks in the plans indicate warp float, while the positions of the dark threads are shown by the shaded squares. The simplest style of bird's-eye pattern is obtained by introducing the spotting yarn in the warp, and using the same shade for the weft as the ground shade of warp, as shown at A and B.

Good spot patterns may be obtained in practically all the simple orders of warping and wefting, because where a warp colour is intersected by the same colour of weft, a spot formed of that colour appears on the surface of the cloth, whether the warp, or weft, or both are floated. Therefore, by suitably arranging the floats where different colours intersect, a required form of pattern may be produced. Thus, the effect shown at L in Fig. 158 results from each of the arrangements given at L, M, N, and O in Fig. 159, a comparison of which will show that the weaves vary only where dark crosses dark, and light crosses light, the interlacing of the threads being exactly the same in all the plans where one colour crosses the other.

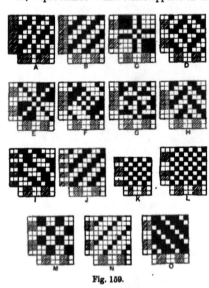

Larger spot effects are shown at P to Y in Fig. 160, for which the corresponding weaves are given in Fig. 161. With the exception of example T, it will be noted that the patterns are symmetrical, which is due in each case to the centre of the weave having been arranged to coincide with the centre either of the solid dark or the solid light space.

Fig. 159.

In the spotted effects represented in Fig. 162, the weft is arranged in a different

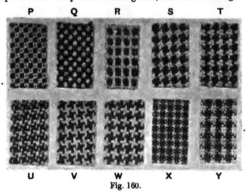

Fig. 160.

order from the warp, as indicated by the orders of colouring given along with the

corresponding plans in Fig. 163. A further series of patterns is illustrated in Fig. 164, and the corresponding plans in Fig. 165, in which the dark threads are grouped together in such a manner as to form enclosed spaces of the light colour. It will frequently be found that the grouping of the threads causes the woven effect to appear different from the point-paper sketch, the small details in some cases being entirely concealed in the cloth, and in others brought out prominently.

Hairlines. — These patterns consist of solid vertical or horizontal lines in 2, 3, 4, or more colours ; the term hairline being specially used to distinguish effects in which each line of colour is equal to the width of one thread. By suitably arranging the weave and colouring, however, solid lines of colour may be produced which are equal in width to two or more threads. Examples of vertical hairlines

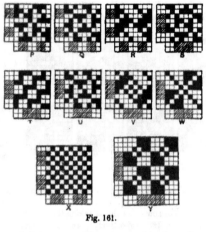

Fig. 161.

are given at C to H in Fig. 166, and the corresponding plans (with the orders of colouring indicated by different marks alongside and at the bottom) in Fig. 167, the weave marks representing warp float. C and D in Fig. 166 respectively

show the single and double thread vertical hairline in two colours ; the former being produced by colouring the plain weave 1 dark, 1 light in warp and weft, and the latter by colouring the 2-and-2 hopsack weave 2 dark, 2 light, as shown at A and B respectively in Fig. 167. The patterns C and D in Fig. 166 can also be produced in the 4-thread warp sateen weave, as shown at C and D in Fig. 167. This weave is preferred to the plain weave for the single - thread effect in some classes of fabrics, because the

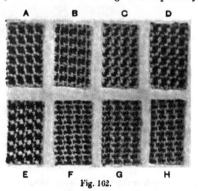

Fig. 162.

cloth is fuller and softer to handle, and can be made heavier, at the same time that it can be woven in looms with changing-boxes at one end only. Also when used for the double-thread effect, the 4-thread sateen D yields a smoother and softer texture than the 2-and-2 hopsack weave B, and in the latter weave

there is, in addition, a tendency for the threads which work alike to twist round each other.

Patterns E to H in Fig. 166, and the corresponding plans E to H in Fig. 167, show further examples produced in the 4-thread warp sateen weave, the effect at E being 3 dark, 1 light; at F, 2 dark, 1 medium, 1 light; at G, 1 dark, 1 medium, 1 dark, 1 light; and at H the single-thread hairline in 4 shades.

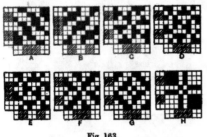

Fig. 163.

The hairline effects obtainable in the 4-thread sateen weave can also be produced in the 4-thread twill. Thus the patterns C to H in Fig. 166 respectively result from the arrangements given at I to N in Fig. 167, in which the 1-and-3 warp twill weave is employed. The 4-thread sateen, however, is usually better than the 4-thread twill, because a straight twill always tends to yield a harsher texture than a weave of the sateen type.

The plans in Fig. 168 are lettered the same as the plans in Fig. 167, and correspond to them, except that in this case the weaves and colourings are arranged to produce horizontal hairlines, taking the weave marks to indicate warp. Thus, A and B in Fig. 168 respectively produce the single and double thread horizontal hairlines in two colours, which are shown at O and P in Fig. 166. Plans C to H in Fig. 168 show the 4-thread weft sateen, and plans I to N the 4-thread weft twill

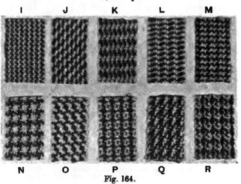

Fig. 164.

arranged to produce horizontal effects, which will correspond to the vertical hairlines given at C to H in Fig. 166. If the weave marks in Fig. 168 are taken to indicate weft, the plans will produce vertical hairlines. On account of their barry appearance the horizontal hairlines are not much used, except in combination with the vertical hairlines and other effects in the construction of stripe, check, diagonal, and spotted patterns.

The construction of hairlines in the 3-thread twill weaves is illustrated at Q to T in Fig. 169, Q producing a vertical effect in two colours, and R in three colours while S and T produce corresponding horizontal patterns. U in Fig. 169, which will produce exactly the same style of stripe as R—viz., 1 dark, 1 medium, 1 light, shows the 1-and-2 twill modified to fit a loom with changing-boxes at one end only. The plans given at V and W, which are also modifications of the 1-and-2 twill, will each produce a pattern in 2 dark, 2 medium, 2 light ; and as the weaves U, V, and W are looser in structure than the 3-thread twill, they permit a larger number of ends and picks per inch to be inserted, and can therefore be used for heavier makes of cloth. The weave X shows the 1-and-2 twill specially modified to produce the vertical hairline represented at X in Fig. 166, in which the colours are arranged 2 dark, 2 medium, 2 dark, 2 light. This pattern also results from the arrangements given

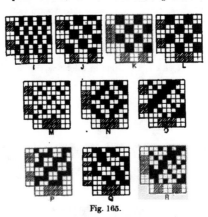

Fig. 165.

at Y and Z in Fig. 169, which are modifications of the 4-thread warp sateen. The plans U to Z thus show how an ordinary weave may be modified to fit a required order of colouring when a special cloth structure or special effect is desired.

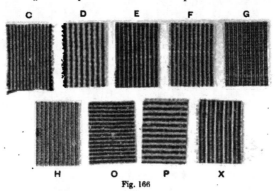

Fig. 166

A comparison of the weaves with the orders of colouring in Figs. 167, 168, and 169 will show that in constructing solid coloured hairline patterns the following rules are applicable :—The same shades should be used for the weft as for the warp. For vertical hairlines each warp thread should pass under the corresponding colour

11

of weft, and be raised over the other colours. For horizontal hairlines, each weft
pick should pass under the corresponding colour of warp, and over the other colours.
For example, assuming that a single thread vertical hairline in five colours is required,
the weave must, necessarily be so arranged that each end is down for one pick and
up for four picks; hence the 5-thread warp twill, or, as shown at A in Fig. 170,
the 5-thread warp sateen may be employed. B shows the colour plan for the warp
indicated along the bottom, the five shades being represented by different marks.
The order of wefting, in the same five shades as the warp is obtained by noting,
pick by pick, the colour of the warp thread which is depressed. Thus, as shown at C,
the first pick is the same in colour as the first end, which is depressed on the

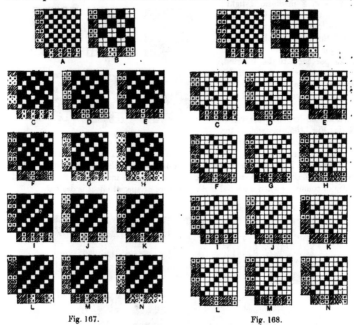

Fig. 167. Fig. 168.

first pick, The second pick is in the same colour as the fourth end; the third
pick, as the second end; the fourth pick, as the fifth end; and the fifth pick, as
the third end.

For the single-thread horizontal hairline in five colours, each pick must pass
under one end and over four; the colour of each being determined by the colour
of the end which it passes under, as shown at D in Fig. 170. If the 1-and-4 twill
weave is employed, the order of wefting is the same as the order of warping, as shown
at E and F, which correspond with C and D.

Other examples of 5-thread vertical hairlines, producible in the 5-thread warp
sateen weave, are given at G to K in Fig. 170, the effect at G being 1 dark, 4 light;

at H, 2 dark, 3 light ; at I, 2 dark, 1 light, 1 dark; 1 light ; at J, 2 dark, 2 medium, 1 light ; and at K, 3 dark, 1 medium, 1 light.

Step Patterns.—In these, vertical and horizontal lines unite and form zig-zag lines of colour which run in a diagonal direction. Examples are given at L to P in Fig. 171, and the corresponding plans similarly lettered in Fig. 172. They can be constructed with any ordinary twill weave in which there are two inter-sections, and the floats of warp and weft are equal, by arranging the colour plan on a number of threads, which is equal to half the number of threads in the repeat of the weave. Thus, at L the 2-and-2 twill is coloured 1 dark, 1 light ; at M, the 3-and-3 twill is coloured 2 dark, 1 light ; and at N, the 4-and-4 twill is coloured 2 dark, 2 light. A 3-shade step pattern can be produced in the 3-and-3 twill by colouring 1-and-1 in three shades, and in the 4-and-4 twill by colouring 1-and-1 in four shades. O shows a form of step pattern which

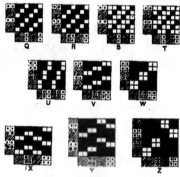

Fig. 169.

is produced by colouring the mayo weave 2 dark, 2 light, while P is an irregular effect produced by colouring an 8-thread twill 2-and-2 in the warp and 1-and-1 in the weft. The weave Q in Fig. 172 produces exactly the same style of pattern in the 2-and-2 order of colouring as the 4-and-4 twill, and can be used in place of the latter when greater firmness of cloth is required. The 3-thread twill,

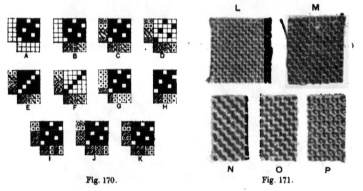

Fig. 170. Fig. 171.

when coloured 1-and-1, as shown at R in Fig. 172, produces an interesting step pattern, while a great variety of effects can be obtained in the 1-and-1 order of colouring by using twill weaves in which the floats are combined with plain weave, as shown at S.

All-over Effects.—In all-over patterns the colour effect runs more or less connectedly over the surface of the cloth. They are best constructed by arranging the repeat of the colour plan and the repeat of the weave on such numbers that two or more repeats of each are required to produce one complete repeat of the pattern. For example: Assuming that the 2-and-2 twill is coloured 4 dark, 4 light, 4 dark, 3 light, fifteen repeats of the weave and four repeats of the colour plan are necessary, the complete effect being on

Fig. 172.

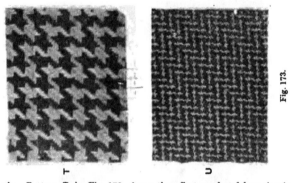

Fig. 173.

60 threads. Pattern T in Fig. 173 shows the effect produced by colouring the

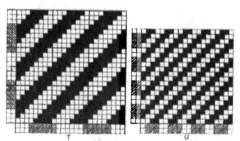

Fig. 174

4-and-4 twill 6 dark, 6 light; while pattern U shows the 2-and-2 twill coloured 3 dark, 2 light, as indicated at T and U respectively in Fig. 174.

<div align="center">CHAPTER XII</div>

COLOUR AND WEAVE STRIPES AND CHECKS

Stripe Colour and Weave Effects—Changing the relative Position of the Weave and Colouring—Simple Weave and Simple Wefting with Compound Warping—Stripe Weave and Simple Wefting with Simple and Compound Warpings. *Check Colour and Weave Effects*—Changing the relative Position of the Weave and Colouring—Simple Weave, Compound Warping, and Compound Wefting—Stripe Weave and Compound Wefting with Simple and Compound Warpings—Cross-over Weave and Compound Warping with Simple and Compound Weftings—Check Weave and Simple Wefting with Simple and Compound Warpings.

STRIPE COLOUR AND WEAVE EFFECTS

Changing the Relative Position of the Weave and Colouring.—It has previously been shown that variety of pattern can be produced in the same weave and the same

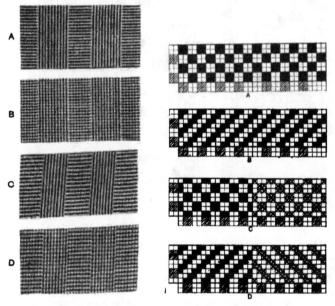

Fig. 175. Fig. 176.

order of colouring by changing the position of one in relation to the other. The change of effect thus obtained may be made use of in the production of colour-and-weave stripe patterns, by modifying the warp colour, or the weave, in such a

manner that their relative positions are different in succeeding sections of the design.

Examples illustrating the method of modifying the warp colour order are given at A and B in Fig. 175, and of modifying the weave at C and D. The corresponding plans, with the positions of the dark threads indicated by the shaded marks, are shown at A to D in Fig. 176, the weave marks representing warp float. In order to obtain the same width of stripe as is shown in the patterns, each section on the point-paper will require to be repeated. Sufficient is indicated of each section, however, as will enable the patterns to be reproduced, and it will be understood that

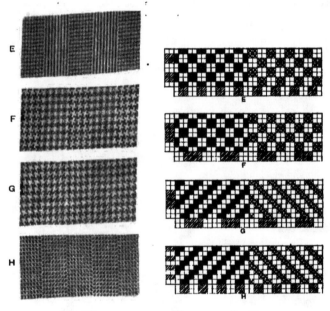

Fig. 177. Fig. 178.

diversity of form can be obtained by varying the widths of the sections. The object in preparing these and subsequent examples has been, by working on broad lines, to enable the different effects to be readily seen. It will be observed in A, Fig. 176, that the 2-and-2 hopsack weave is employed throughout, and in B the 2-and-2 twill. But in the warp, instead of the 2 dark, 2 light order of colouring being continuous a 4 of light occurs at each change of the pattern, the colouring being arranged in the first section in the order of 2 dark, 2 light, and in the second section 2 light, 2 dark, finishing with 4 light. The introduction of the 4 light throws the colouring on to a different footing in relation to the weave. In C and D, on the other hand, the order of colouring is 2-and-2 throughout, but while the weaves are the 2-and-2 hopsack

and the 2-and-2 twill respectively, a change of footing is made in them where the pattern changes. A comparison of A and B with C and D in Fig. 175 will show that the two methods produce similar styles. The first method is usually the more convenient, since with a straight draft it is necessary only to modify the warp order of colouring according to the form of pattern required, whereas in the second method a special order of drafting is necessary.

Further examples illustrating the effect of changing the position of the weave are given in Fig. 177, and the corresponding plans, similarly lettered, in Fig. 178. In E and F the modified 2-and-2 hopsack weave is respectively coloured 2 dark, 2

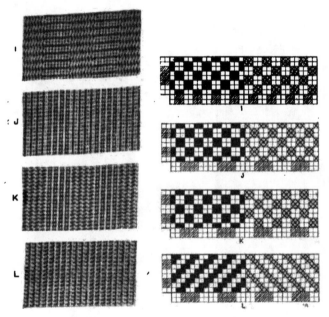

Fig. 179.　　　　　　　　　Fig. 180.

light, and 4 dark, 4 light in warp and weft ; in G the 2-and-2 twill reversed in sections, is coloured 4 dark, 4 light, while H shows the same weave coloured 2-and-2 in the warp, and 1-and-1 in the weft. The patterns I to L in Fig. 179 and the corresponding plans in Fig. 180 are similar styles in which a 2-and-2 order of colouring in one direction is combined with a 4-and-4 order in the other direction.

Usually colour and weave stripe patterns are produced in simple orders of wefting by employing :—(1) simple weaves and compound orders of warping ; (2) stripe weaves and simple orders of warping ; (3) stripe weaves and compound orders of warping.

Simple Weave and Simple Wefting with Compound Warping.—Examples of this class are represented at M to P in Fig. 181, and the corresponding plans similarly lettered, are given in Fig. 182. In each example the weave is 2-and-2 hopsack, while the arrangement in the warp is a compound of 2 dark, 2 light, and 4 dark, 4 light orders of colouring. A 2-and-2 order of wefting is employed for both M and N, the difference of effect in which is due entirely to the positions of the weft colours having been changed by turning the pattern chain forward two picks. This system of varying the relative positions of the weaves and colouring in some cases does not enable all the possible effects to be obtained, but it is usually the simplest and

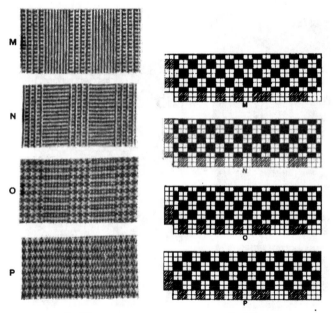

Fig. 181. Fig. 182.

most expeditious method of effecting a distinct change in any form of colour and weave pattern.

The difference of effect between the patterns O and P in Figs. 181 and 182, which are coloured 4-and-4 in the weft, is due to varying the position of the weave, the change in this case not being possible by simply altering the position of the weft colours.

The patterns represented at Q to T in Fig. 183, and the corresponding plans given in Fig. 184 show the application of the 2-and-2 twill weave to a compound of 2 dark, 2 light, and 4 dark, 4 light orders of warping. The wefting plan at Q is 1-and-1; at R and S, 2-and-2; and at T, 4-and-4. It will be noted that the difference between R and S is entirely due to the weft colours having been reversed in position.

The illustrations given in Figs. 181 to 184 only illustrate the application of one compound order of warping to two weaves, and only a few orders of wefting are shown. Very many different compound orders of warping can be readily arranged, to which different weaves and orders of wefting can be applied; and it will be evident that even within the limits of tappet shedding there is very great scope for the production of stripe colour-and-weave effects.

Stripe Weave and Simple Wefting with Simple and Compound Warpings.— Examples of both of these classes of stripe colour-and-weave patterns are for convenience illustrated together in the following figures. The fabrics represented in

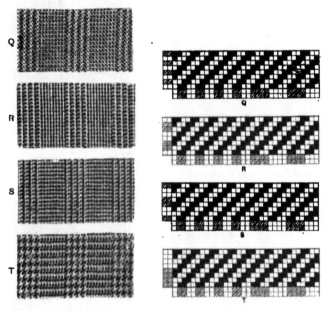

Fig. 183. Fig. 184.

Figs. 185, 186, 187, and 188 result from the designs and orders of colouring given in Fig. 189. Three orders of warping are employed for each design, while the wefting plan in all cases is 2-and-2, as shown along the bottom and at the side of Fig. 189, by the shaded squares, which indicate the positions of the dark threads. In Fig. 189 a letter is indicated in each case alongside the order of warping, which, in conjunction with the design above and the 2-and-2 order of wefting, will produce the pattern which is lettered to correspond in Figs. 185 to 188. The three patterns in each figure are produced by the same design and the same order of wefting, the difference between them being due to the order of warping being varied. Thus, the design for A, B, and C in Fig. 185 consists of a modified 2-and-2 twill and ordinary twill; for

D, E, and F in Fig. 186 of an 8-thread cut weave and 2-and-2 twill ; for G, H, and I
in Fig. 187 of the 8-thread twilled mat and 2-and-2 twill ; and for J, K, and L in Fig.

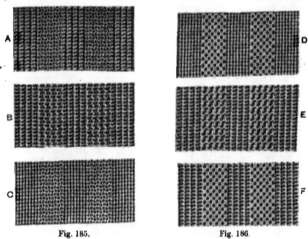

Fig. 185. Fig. 186.

188 of the Mayo weave and 2-and-2 hopsack. The first pattern in each figure is
warped 2-and-2, and the second 4-and-4, while in the third pattern the warping
plan is a compound of a 2-and-2 and a 4-and-4 order.

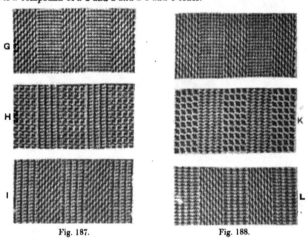

Fig. 187. Fig. 188.

The examples in Figs. 190, 191, 192, and 193 show further diversity of effect

produced in the same warping and wefting as the previous patterns. The designs, with the orders of colouring indicated, are given in Fig. 194, the weave marks, as before indicating warp float. The letters alongside the orders of warping will enable each arrangement to be compared with the corresponding pattern. The design for M, N, and O in Fig. 190 is a combination of the Mayo weave and 2-and-2 twill, and by comparison with the examples shown in Fig. 188, in which the Mayo weave is also used, the patterns are a good illustration of the

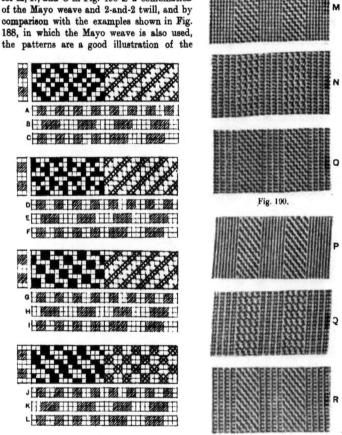

Fig. 189. Fig. 190.

 Fig. 191.

complete change of effect which frequently results when the relative positions of the weave and colouring are changed. The design which produces P, Q, and R in Fig. 191 is a combination of a fancy 8-shaft twill and 2-and-2 hopsack,

the former weave being used in preference to the 4-and-4 twill (which produces a smilar effect) because it is firmer in structure, and about equal in wefting capacity to the hopsack weave with which it is combined. In S, T, and U in Fig. 192 a fancy 8-shaft weave is combined with a 4-thread weave which is based on the 4-and-4 twill, while for V, W, and X in Fig. 193, the same 8-shaft weave—turned over and commenced in a different position in relation to the colouring—is combined with a weave based on the 2-and-2 twill.

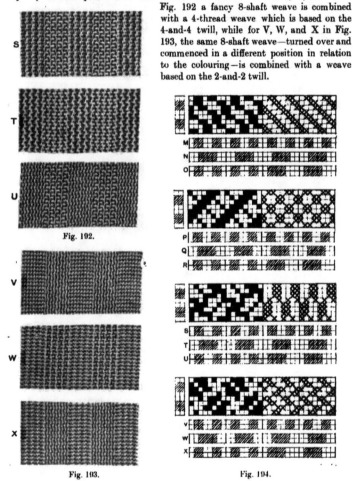

Fig. 192.

Fig. 193.

Fig. 194.

The examples illustrated in Figs. 195, 196, 197, and 198 correspond with the plans given in Fig. 199. The warp and weft orders are lettered and connected by curved lines in Fig. 199, in order that each combination may be compared with the

corresponding fabric that is lettered the same in Figs. 195 to 198. In Figs. 195,196, and 197 the first pattern is warped and wefted 2-and-2 ; and the second, 4-and-4 ;

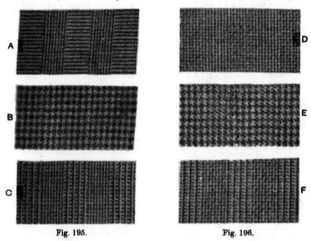

Fig. 195. Fig. 196.

while in the third, a compound of a 2-and-2 and a 4-and-4 order of warping is crossed with 2-and-2 wefting. In Fig. 198 the first pattern is warped and wefted 4-and-4 ;

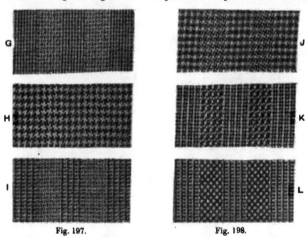

Fig. 197. Fig. 198.

the second pattern is warped 4-and-4, and wefted 2-and-2 ; and in the third pattern the compound warping order is crossed with 2-and-2 wefting. The design for A, B,

and C in Fig. 195 is a combination of 2-and-2 twill and 2-and-2 hopsack, which may be produced by 4-shaft tappets ; for D, E, and F in Fig. 196, of a fancy 8-shaft weave and 2-and-2 twill; for G, H, and I in Fig. 197 of an 8-shaft weave, and 2-and-2 twill ; and for J, K, and L in Fig. 198 of an 8-shaft cut weave and 2-and-2 hopsack.

In the fabrics represented in Figs. 200 and 201 a 4-and-4 order of wefting is crossed with three orders of warping as shown in the corresponding arrangements given in Fig. 202. The

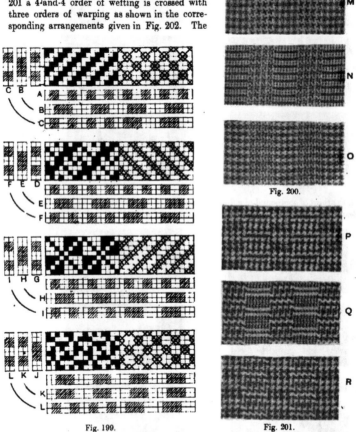

Fig. 199.

Fig. 200.

Fig. 201.

design for M, N, and O in Fig. 200 is a combination of a fancy 8-shaft weave and 2-and-2 hopsack, while P, Q, and R in Fig. 201 can be woven by means of 3-and-3 twill tappets.

The examples S to X in Fig. 203 are illustrative of the diversity of pattern

which may be obtained in colour and weave effects by varying the form of the stripe. The corresponding arrangements, similarly lettered, are given in Fig. 204, different weave marks being used to represent the different sections. Pattern S

shows the simplest form of stripe, and consists of two sections which are equal in size. The colouring is 2-and-2 in warp and weft, and the weaves given in S, Fig. 204,

Fig. 203.

are arranged 32 threads of each alternately. Pattern T, which is coloured 4-and-4 in the warp and 2-and-2 in the weft, shows a simple modification, in which one section is bisected by a narrow stripe of the same pattern as the other section. The 8-shaft

and 4-shaft weaves, given in T, Fig. 204, alternate with each other, as regards the number of ends, in the order of 32, 16, 8, 16. Pattern U is coloured 2-and-2 in warp

Fig. 204.

and weft, and shows a further modification which repeats on the same number of ends as pattern T, the first weave in U, Fig. 204, alternating with the second in the

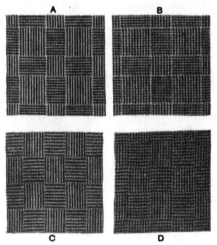

Fig. 205.

order of 16, 16, 16, 8, 8, 8, ends. Pattern V shows a stripe consisting of two sections which are unequal in size. The weave is 3-and-3 twill throughout, and the wefting

plan 1 dark, 2 light; while the warp is arranged 6 dark, 3 light for 36 ends, and 4 dark, 2 light for 18 ends. Pattern W is 2-and-2 hopsack weave throughout, wefted in 2-and-2 order, and warped in four sections as follows :—2 dark, 2 light for 16 ends ; 2 dark, 4 light for 24 ends ; 2 dark, 6 light for 16 ends ; and 2 dark, 4 light for 24 ends. In pattern X the wefting plan is 2-and-2, and a compound warping order is combined with the stripe weave given at X in Fig. 204, as follows :—

1st weave in	4	dark,	4	light colouring,	for	16	ends.
2nd ,,	2 ,,	2	,,	,,	8	,,	
1st ,,	4 ,,	4	,,	,,	16	,,	
2nd ,,	2 ,,	2	,,	,,	24	,,	

Fig. 206.

CHECK COLOUR AND WEAVE EFFECTS

Changing the Relative Position of the Weave and Colouring.—The fabrics represented at A, B, C, and D in Fig. 205 illustrate the method of producing check effects in one weave and one order of colouring, by varying the position of one in relation

12

to the other. In A and C, each section consists of 2-and-2 hopsack weave, and 2-and-2 warping and wefting : and in B and D of 2-and-2 twill weave, and the same order

Fig. 207.

of warping and wefting. The corresponding plans, similarly lettered, are given in Fig. 206 : and it will be noted in A and B that while the weaves are continuous the

Fig. 208.

2-and-2 order of colouring is broken, a 4 of light occurring at each change of the effect. Thus, although the weave and colouring in every section are the same, the change

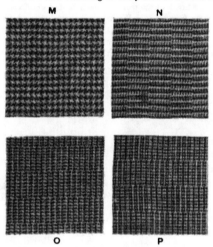

M N

O P

Fig. 209.

of footing in the colouring causes the relative positions to be changed, and alternate

Q R

S T

Fig. 210.

sections of vertical and horizontal lines result. Plans C and D produce similar styles, but in this case the order of colouring is continuous, the change of footing being obtained by making a break in the weave at each change of effect.

An analysis of the four plans in Fig. 206 will show that each requires 4 healds ; but the first method, illustrated by A and B, is more convenient and more economical than the second. Thus, while A and B can be produced in a regular draft by means of tappets, C and D require a special draft and (on account of the large number of

Fig. 211.

picks in the repeat) a dobby shedding motion. The boxing plan in the first method is more complex, but this does not materially affect the question, since a check motion is required in either case.

Additional examples of check patterns, in each of which the change of effect is due to changing the footing of the weave in relation to a continuous order of colouring are given at E to P in Figs. 207, 208, and 209. Also, examples are given at Q to T in Fig. 210, which show the appearance of these weaves when the warping is a compound of two different orders, and the wefting is simple. The corresponding plans

for producing all the examples are given in Fig. 211, each order of warping being lettered and linked with a similarly lettered order of wefting which, in conjunction with the accompanying design, will produce the pattern that is lettered to coincide. Thus patterns E, F, G, and H in Fig. 207 ; I, J, K, and L in Fig. 208 ; and P in Fig. 209, result from different modifications of the 2-and-2 hopsack weave, in the various combinations of 2-and-2 and 4-and-4 warping and wefting ; while M, N, and O in Fig. 209 result in the same manner, from the 2-and-2 twill weave reversed in sections. The order of warping for the examples in Fig. 210 is a compound of 2-and-2 and 4-and-4 colouring ; Q and T resulting from the modified 2-and-2

Fig. 212.

hopsack weave in 2-and-2 wefting, and R in 4-and-4 wefting ; while in F the reversed 2-and-2 twill weave is wefted 2-and-2.

In addition to the foregoing styles check designs are produced in each of the following combinations :—

1.	Simple	weave,	compound warping,	compound wefting.		
2.	Stripe	,,	simple	,,	,,	,,
3.	,,	,,	compound	,,	,,	,,
4.	Cross-over	,,	,,	,,	simple	,,
5.	,,	,,	,,	,,	compound	,,
6.	Check	,,	simple	,,	simple	,,
7.	,,	,,	compound	,,	,,	,,
8.	,,	,,	simple	,,	compound	,,
9.	,,	,,	compound	,,	,,	,,

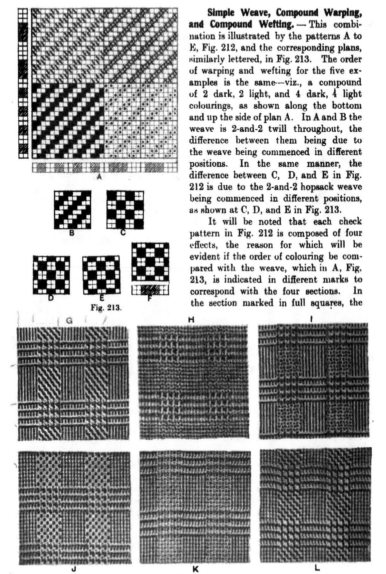

Fig. 213.

Fig. 214.

Simple Weave, Compound Warping, and Compound Wefting. — This combination is illustrated by the patterns A to E, Fig. 212, and the corresponding plans, similarly lettered, in Fig. 213. The order of warping and wefting for the five examples is the same—viz., a compound of 2 dark, 2 light, and 4 dark, 4 light colourings, as shown along the bottom and up the side of plan A. In A and B the weave is 2-and-2 twill throughout, the difference between them being due to the weave being commenced in different positions. In the same manner, the difference between C, D, and E in Fig. 212 is due to the 2-and-2 hopsack weave being commenced in different positions, as shown at C, D, and E in Fig. 213.

It will be noted that each check pattern in Fig. 212 is composed of four effects, the reason for which will be evident if the order of colouring be compared with the weave, which in A, Fig. 213, is indicated in different marks to correspond with the four sections. In the section marked in full squares, the

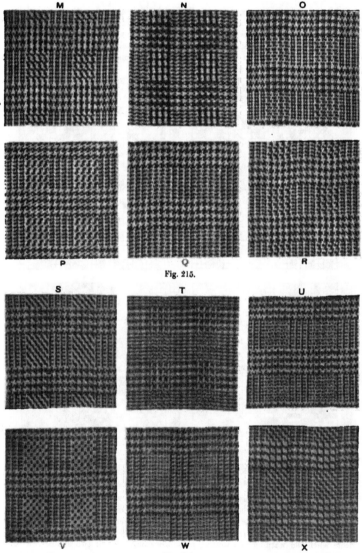

Fig. 215.

Fig. 216.

2-and-2 order of warping is crossed with 2-and-2 wefting, and in that marked in crosses, the 4-and-4 warping order with 4-and-4 wefting. Where the weave is indicated by diagonal marks, the 2-and-2 warping is crossed with 4-and-4 wefting, and where the dots are inserted, the 4-and-4 warping with 2-and-2 wefting. The best effects usually result in the sections where the warping and wefting orders are

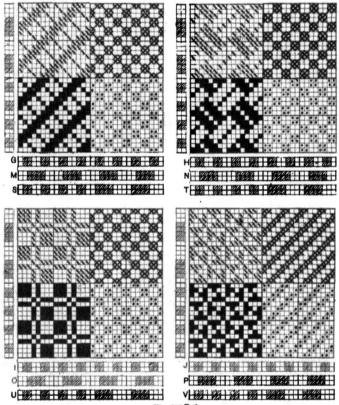

Fig. 217.

the same—viz., in the examples where the warping and wefting are both 2-and-2, or both 4-and-4. The cross effects produced where one order of colouring is crossed with another, while not so good, usually give sufficient variety to make the patterns interesting. In the same manner that the pattern consists of four effects when the warping and wefting plans are compounds of two simple orders, nine effects result from compounds of three-colour schemes and sixteen effects

when the arrangement is a compound of four-colour schemes, because each warping order is crossed with all the wefting orders.

Pattern F in Fig. 212 is introduced to show the style of crossover effect which

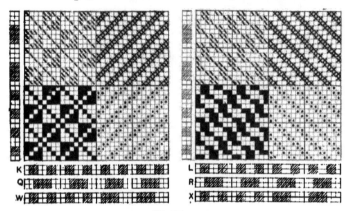

Fig. 217A.

results when a simple weave and a compound order of wefting are employed in conjunction with a simple order of warping. The corresponding weave is given at F in Fig. 213, the order of warping being 4 dark, 4 light, as shown along the bottom, while the order of wefting is the same as that indicated at the side of plan A.

Stripe Weave and Compound Wefting with Simple and Compound Warpings. — The patterns lettered from G to L in Fig. 214 and from M to R in Fig. 215, illustrate a combination in which a stripe weave is employed in conjunction with a simple order of warping, and a compound order of wefting; while those lettered from S to X in Fig. 216 show a combination, in which the weave is in stripe form, and both the orders of warping and wefting are compound. The arrangements for producing all the examples are

Fig. 218.

grouped in Figs. 217 and 217A, and a letter is placed alongside each order of warping which, in conjunction with the design above and the compound

order of wefting, will produce the pattern that is lettered to coincide. The six patterns in each of Figs. 214, 215, and 216 are thus respectively produced by the six designs given in Figs. 217 and 217A, the difference between the figures

Fig. 219.

being due to three different warping orders being employed. The order of wefting in every case is a compound of a 2 dark, 2 light, and a 4 dark, 4

Fig. 220.

light order. In Fig. 214 the order of warping is 2-and-2; in Fig. 215 4-and-4; and in Fig. 216 is in the same compound order as the weft. Each design in Figs. 217 and 217A is a stripe composed of two weaves, but in order that

it may be readily noted how the four effects of which each pattern consists are formed, a different kind of mark is used for each section. In G to L the 2-and-2 order of warping, and in M to R the 4-and-4 order of warping,

Fig. 221.

are crossed with 2-and-2 wefting—in the first weave—where the full squares are inserted, and—in the second weave—where dots are used ; and with 4-and-4 wefting

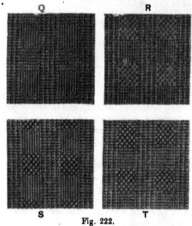

Fig. 222.

—in the first weave—where diagonal marks are used, and —in the second weave—where indicated by crosses. In S to X the 2-and-2 warping order—in the first weave—is crossed with 2-and-2 wefting where indicated by full squares, and with

4-and-4 wefting where indicated by diagonal marks; while the 4-and-4 warping order—in the second weave—is crossed with 2-and-2 wefting where the dots are inserted, and with 4-and-4 wefting where the crosses are employed.

Cross-over Weave and Compound Warping with Simple, and Compound Weftings.—These combinations respectively produce similar effects to those which result from the preceding combinations, but no illustrations are given, since their appearance can be noted by turning the patterns in Figs. 214, 215. and 216 round 90°; while, in the same way, the method of construction can be observed by turning the plans in Figs. 217 and 217A round to the same angle. In examining the patterns, however, it is necessary to take into consideration that the effects have been made rather longer than wide, as is usually the case with check styles, and therefore when turned round appear flat. The chief point of difference is that in the previous method the weaves are arranged to form stripes lengthwise of the

Fig. 223.

cloth, and in this method to form stripes across the cloth. The former type of design necessitates the use of a special method of drafting, and of two or more sets of healds; but the pegging plan repeats on a small number of picks. In the latter, on the other hand, the draft is straight over, and one set of healds only is necessary for the two or more weaves; but the pegging-plan is on a large number of picks.

Check Weave and Simple Wefting with Simple, and Compound Warpings.—The construction of check colour-and-weave effects, by combining a check weave with a simple order of warping and a simple order of wefting, is illustrated by the patterns A to P in Figs. 218, 219, 220, and 221; and with a compound order of warping and a simple order wefting, by Q to X in Figs. 222, and 223. The four designs given in Fig. 224 correspond with the four patterns in each figure; while for each design there are six different colour combinations, as indicated along the bottom and up the side. Each order of warping is lettered and linked with a similarly lettered order of wefting, which, in conjunction with the accompanying design, will produce the

pattern which is lettered to coincide. Thus, in A to D, Fig. 218, the four designs are warped and wefted 2-and-2, and in E to H, Fig. 219, 4-and-4. In I to L, Fig. 220, the warping is 4-and-4, and the wefting 2-and-2; while in M to P, Fig. 221, the warping is 2-and-2, and the wefting 4-and-4. In Q to T, Fig. 222, the warping is compound of a 2-and-2 and a 4-and-4 order, crossed with 2-and-2 wefting; and in U to X, Fig. 223, the same order of warping is crossed with 4-and-4 wefting.

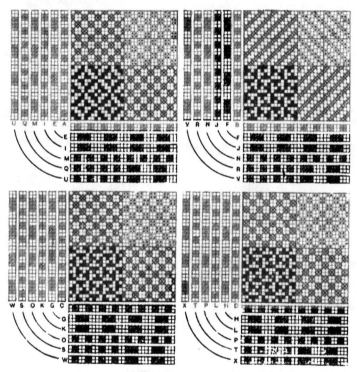

Fig. 224.

As previously stated, in arranging weaves in check form, the most important factor to note is that on the surface no long warp floats occur at the horizontal junctions, and no long weft floats at the vertical junctions. Considerable care is frequently necessary in getting the weaves in satisfactory relation to each other, at the same time that the desired colour-and-weave pattern is secured.

The patterns represented at M, N, O, and P in Fig. 225 result from the check combination of two weaves, one of which completely surrounds the other, as shown in the corresponding plans given in Fig. 226. In each example the order of wefting

is 4-and-4, while in M and O the order of warping is 4-and-4, and in N and P a compound of a 2-and-2 and a 4-and-4 order. The effects produced by the form of check design, indicated in Fig. 226, are usually stiffer and less interesting than those which result from check designs composed of three or four weaves. A considerable improvement may, however, be effected in them by introducing a bright coloured overcheck on the weave which occupies the bulk of the space ; and in the pattern O in Fig. 225, such an overcheck is represented.

The foregoing colour - and - weave patterns illustrate standard styles, and the numerous examples that are given will, by examination and comparison, make clear how a very large variety of

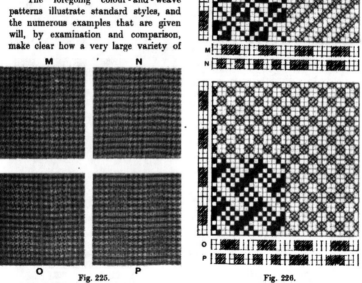

Fig. 225.

Fig. 226.

effects can be produced by the combination in different ways of a comparatively few units.

CHAPTER XIII

SPECIAL COLOUR AND WEAVE EFFECTS

Colouring of Rib and Corkscrew Weaves—Application of Special Weaves to Simple Orders of
Colouring—Construction and Analysis of Special Effects—Combinations of Special Weaves
and Special Yarns.

Colouring of Rib and Corkscrew Weaves.—Ordinary warp rib weaves, such as
are illustrated at A to F in Fig. 3 (p. 5), and such special rib weaves as those shown
at A, B, and C in Fig. 99 (p. 92), naturally lend themselves to a 1-and-1 order of
colouring in the warp. Straight and waved horizontal lines in alternate colours
are respectively produced by the two classes of weaves. In the same manner, a
1-and-1 order of colouring in the weft is suitable for similar weft rib weaves, by which
vertical lines in alternate colours are formed. A regular rib weave may also be
coloured in sections in the manner illustrated by the design S in Fig. 75 (p. 74), in
which the order in the warp is 1 dark, 1 light for 16 threads, and 1 light, 1 dark for
16 threads ; the arrangement producing a small check effect in different colours,
as previously described.

The warp cord designs, shown at F and G in Fig. 99 (p. 92), will produce solid
vertical lines in alternate colours by arranging the ends—6 dark, 6 light, and the
picks 1 dark, 1 light ; while the Bedford cord designs, given in Fig. 101 (p. 95) will
yield similar effects if the ends are arranged in sections in different colours, and a
2-and-2 order of wefting is employed. A special arrangement of coloured threads
may be applied to such designs as that shown at H in Fig. 99, which, for instance,
may be coloured in the warp in the order of 6 dark ; 3 light ; 1 dark, 1 light for
6 threads ; 3 dark ; 6 light ; and in the weft in the order of 1 dark, 1 light. The
effect will be a stripe of 6 ends warp cord—solid dark ; 3 ends weft rib—solid light ;
6 ends warp rib—dark and light lines alternately ; 3 ends weft rib—solid dark ;
and 6 ends warp cord—solid light. Check combinations of warp and weft rib weaves,
an example of which is given at K in Fig 117 (p. 109), may be coloured 1-and-1 in
both warp and weft, and an effect in four colours is produced by employing colours
in the weft that are different from the warp colours.

Ordinary warp and weft corkscrews, which are illustrated in Fig. 98 (p. 91), are
appropriately coloured in 1-and-1 order in warp and weft respectively : twill
lines being produced alternately in two colours in this case. Further, such designs
as L and P in Fig. 99 (p. 92) are particularly suitable for 1-and-1 warp colouring,
in the same manner that the design N in Fig. 99 may be very aptly coloured
1-and-1 in the weft. In most cases, particularly in warp effects—a special
order of colouring can be used in conjunction with solid colouring. Thus, a
warp corkscrew weave may be coloured 1-and-1 and solid alternately, so as to
produce a stripe design.

Fig. 227 represents a corkscrew fabric, in which twill lines are produced alter-
nately in two colours, and the example also illustrates the combination of an ordinary
with a special corkscrew effect. In the cloth the ordinary corkscrew weave appears
like an ordinary twill, and the special effect like a broken twill.

A broken twill appearance can be produced in the corkscrew structure in two
ways : (1) By modifying the corkscrew weave and using a 1-and-1 order of colouring

throughout. (2) By modifying the 1-and-1 order of colouring and using an ordinary corkscrew weave throughout. For example, at A in Fig. 228 a 9-thread broken twill

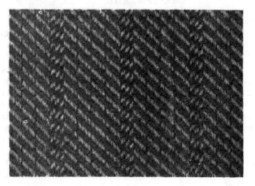

Fig. 227.

weave is indicated, while B shows the weave modified on the warp corkscrew principle to fit a 1-and-1 order of colouring, the different marks representing different colours, C in Fig. 228, on the other hand, shows a continuous 9-thread corkscrew weave in

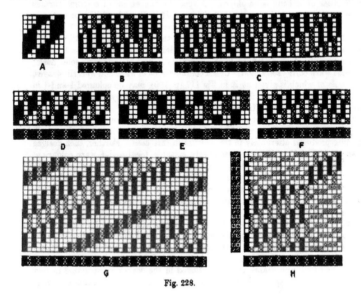

Fig. 228.

which a similar broken effect is produced by colouring the warp in the order of 1 dark, 1 light for six threads, and 1 light, 1 dark for six threads, as indicated along the bottom of the design. The usual close setting of the ends in the corkscrew weave will cause both B and C to appear similai to the motive weave A—assuming that the latter is woven in—say, dark warp and light weft.

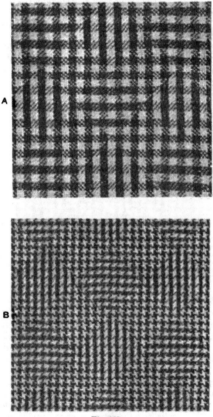

Fig. 229.

Three modifications of a warp corkscrew, which may be specially coloured and used in combination with an ordinary weave of the same class, are given at D, E, and F in Fig. 228. At D the weave is arranged to coincide with a 2-and-1 order of colouring, and at E with a 2-and-2 order, while F produces a waved effect in 1-and-1 colouring.

G in Fig. 228 shows a form of corkscrew weave which, in 1-and-1 colouring in the warp and solid colouring in the weft, produces differently coloured twill lines of warp, brings up the weft as a third effect, and also produces a twill line in which the warp colours are intermingled.

The design H in Fig. 228 is a check combination of warp and weft corkscrew weaves, which if woven in two colours of warp and two different colours of weft, as indicated along the bottom and at the side respectively, will produce an effect in four colours. The example repeats upon an odd number of threads, therefore, if the order of colouring is arranged 1-and-1 throughout, the colours in certain sections will change positions in succeeding repeats. As a rule, in a combination of warp and weft corkscrew weaves, the warp-face weave forms the bulk of the design. The sections of the design H may be repeated any required number of times.

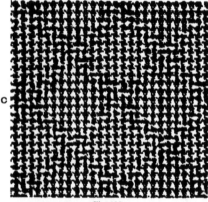

Fig. 229ᴀ.

Application of Special Weaves to Simple Orders of Colouring.—Special effects are most readily produced by using special weaves in combination with simple orders of warping and wefting. The fabrics represented in Figs. 229 and 229ᴀ illustrate a variation from the usual form of check colour-and-weave effect, which is particularly suitable for costume fabrics, cloakings, etc. The corresponding designs, which are shown in Figs. 230 and 231, are constructed on diamond bases, the spaces in the former consisting of 2-and-2 hopsack, 3-and-1 warp twill, and 3-and-1 weft twill weaves, and in the latter of 2-and-2 hopsack in two positions, and 3-and-3 twill. Both A and B in Fig. 229 result from the design shown in Fig. 230, the former being coloured 8-and-8, and the latter 4-and-4, as indicated at the side and along the bottom. C in Fig. 229ᴀ results from the design given in Fig. 231, which is coloured 4-and-4. Thus, by comparison A and B show how difference of effect is produced in the same design by changing the colouring, and B and C in the same colouring by changing the design. The given plans, however, are only about half the size necessary for producing the effects, but they illustrate how the weaves should be arranged in relation to each other, and to the colouring, so as to obtain a uniform pattern. Thus, it will be noted that (1) the centre of each diamond space coincides

with a central position of the colouring; (2) no long floats occur at the junctions of the weaves; (3) each weave is so combined with the colouring as to produce the required effect. The designs also illustrate two methods of arranging weaves in diamond form; Fig. 230 being composed solely of equal diamond spaces, while in Fig. 231 one weave (3-and-3 twill) forms interlacing lines, which enclose the diamond spaces.

The patterns D and E in Fig. 232, and the corresponding designs given in Fig. 233 show how special effects may be obtained in 1-and-1 warping and wefting. It has

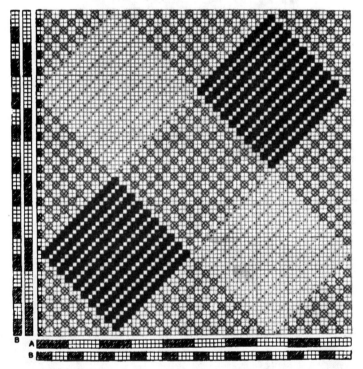

Fig. 230.

previously been noted that in this order of colouring both the 2-and-2 and the 2-and-1 twill will produce step patterns. The floats in the design D, Fig. 233, partake of both these weaves, and the result, shown at D in Fig. 232, is an irregular combination of step patterns, which gives the cloth a crêpy appearance. Additional variety is obtained in the example by the introduction of an overcheck.

The effect shown at E in Fig. 232 chiefly consists of the single-thread vertical hairline produced in the plain weave, which, however, is broken irregularly by the

introduction of weft floats, as shown at E in Fig. 233. Where the weft floats occur the lines of colour follow the direction of the weft with the result that the vertical

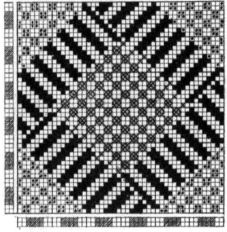

Fig. 231.

lines are broken in irregular order, and an intermingled effect is obtained. In this pattern, also, an overcheck is introduced.

The fabric represented in the lower portion of Fig. 234 illustrates a method of

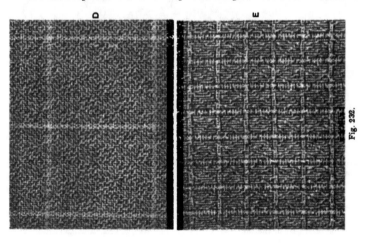

producing figured styles in one weave, and one order of colouring, by varying the position of the former in relation to the latter. Plain weave is used for both figure

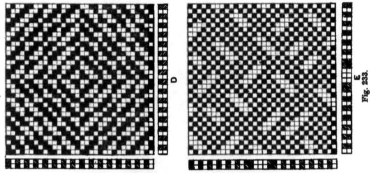

and ground, while the 1-and-1 order of colouring is continuous, but the weave is arranged to produce a horizontal hairline effect where the figure occurs, and a vertical

Fig. 234.

hairline effect in the ground. The underside of the cloth is exactly the opposite, as shown in the upper portion of Fig. 234, the figure being formed in vertical and the

ground in horizontal hairline. A portion of the corresponding design is given in Fig. 235, the different positions of the weave being represented by different marks, which, as in former examples, indicate warp float. Where the figure and ground join there is necessarily a float of two, either of weft or warp; and it is upon the proper arrange-

Fig. 235.

ment of these floats that the clearness of the outline of the figure depends. One of the colours—and usually, the lighter of the two is the more suitable—should form a fine line separating the figure from the ground. otherwise the form will be indefinite.

Fig. 236.

Assuming that the figure is required to be outlined in the lighter shade, as in the example, the following should be observed in marking the edge of the figure :—Where the floats of two are alongside each other they should be in weft float on the light picks, and in warp float on the dark picks; while. where the floats of two

are one above the other, they should be in warp float on the light ends, and in weft float on the dark ends. In the case of outlining the figure in the darker shade, the conditions will be exactly the opposite.

Construction and Analysis of Special Effects.—The fabrics represented at A and B in Fig. 236 illustrate a special class of small figured effects produced in simple orders of colouring. A shows a diamond form (the corresponding point-paper sketch of which is given at A in Fig. 237), which results from applying the reversed 3-and-3 twill weave to a 6-and-6 order of colouring, as shown at C in Fig. 237. It is only to a limited extent, however, that modified simple weaves can be used in producing a special style of pattern, whereas by constructing special weaves there is almost

Fig. 237.

unlimited scope for the production of small figure effects. Example B in Fig. 236, and the corresponding sketch B and plan D in Fig. 237, illustrate the principle. In this system advantage is taken of the fact that where a colour of warp is intersected by the same colour of weft, that colour will appear on the surface whatever the weave is, which enables plain or other firm weave to be employed at these places in order to give the cloth the necessary strength. Where a colour intersects another colour, either may be made to appear on the surface, in forming the required pattern, by arranging the warp and weft floats to correspond. Thus in pattern B, which is arranged 12 black, 12 white, where black ends interweave with black picks, and white ends with white picks, plain weave is employed, as shown by the dots in D.

Fig. 237. Where the design is required to show black on white picks the black ends are raised, and where white on black picks the white ends are raised, as shown by the solid marks in D. Where the design is required to show black on white ends the black weft is floated, and where white on black ends the white weft is floated, as indicated by the blank squares.

E in Fig. 237 shows the application of the principle illustrated in D to the plan C—*i.e.*, the 3-and-3 twill is replaced by plain weave where black crosses black, and white crosses white. E thus contains more intersections than C, and may be used to produce the pattern A, Fig. 236, in a cloth in which greater firmness is required.

A convenient method of procedure in sketching an effect, and in indicating the weave on design paper, is illustrated in Fig. 238. The arrangement of the threads

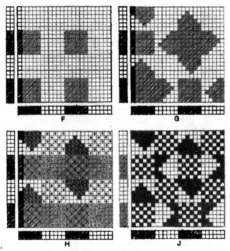

Fig. 238.

is 6 dark, 6 light, and the repeat of the pattern extends over two repeats of the colour plan. Assuming that a dark figure on a light ground is required, the first stage, as shown at F, consists of marking the squares faintly where dark ends and dark picks intersect, as at these places the pattern must be dark. Second, as shown at G, marks are added, in accordance with the desired effect, above and below, and at both sides of one or more of the shaded sections in F. In the third stage, shown at H, the required weave is obtained as follows—the weave marks indicating warp float: (a) Plain (or other simple weave) is inserted where each colour intersects its own colour, as shown by the dots ; (b) the light picks are followed horizontally, and where there are figuring marks on dark ends weave marks are inserted, as shown by the crosses ; (c) the light ends are followed vertically, and where there are blanks on dark picks weave marks are inserted, as indicated by the circles. At J the weave is represented in one kind of mark, and the chief point to note is that marks, where

dark ends and light picks intersect, produce a similar effect to blanks where light ends and dark picks intersect, and *vice versa*.

The system is not limited to the production of detached figures, as by suitably

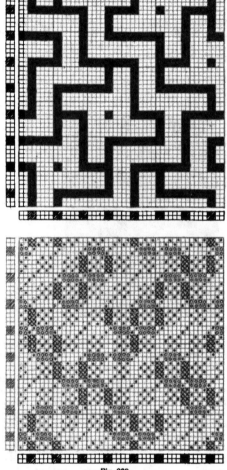

Fig. 239.

floating the threads of one colour entirely over those of another colour, many interesting effects, consisting of interlacing lines, can be obtained. The point-paper sketch in the upper portion of Fig. 239 is an example arranged on a 2 dark, 4 light

order of colouring. The corresponding design is given in the lower portion of the figure, the plain weave, where each colour intersects its own colour, being indicated by the dots, the lifts of the dark ends on the light picks by the crosses, and of the light ends on the dark picks by the circles. Large effects of this character may be readily produced in healds by special drafting ; thus, 20 shafts are required for the effect given in Fig. 239. Also different materials, one of which is more costly than the other, may be economically combined—as, for example, in Fig. 239 the dark shade may be in silk or wool, and the light shade in cotton.

Combinations of Special Weaves and Special Yarns.— A special colour and weave style is represented in Fig. 240, in which yarns of different materials and different thicknesses are combined, a pattern in white silk and thick dark worsted being formed on a ground composed of fine light cotton threads. The arrangement in warp and weft is indicated along the bottom and at the side of the corresponding

Fig. 240.

plans in Fig. 241 ; the solid marks representing the white silk, the shaded squares the dark worsted, and the blanks the light cotton threads. The point-paper sketch in the upper portion of Fig. 241 represents the appearance of the effect, but it does not give a correct idea of how it will be necessary for the threads to interweave, because the structure causes considerable distortion of the thick dark threads to take place. An examination of the actual weave given in the lower portion of Fig. 241 will show that where the worsted ends intersect with the worsted picks, in alternate sections the weave is 2-and-2 twill surrounded by a 4-and-4 order of interweaving with the silk threads, while in the other sections the weave is plain with the silk threads floating on the back. The 2-and-2 twill weave is sufficiently loose to enable the thick threads to approach each other readily, and they therefore group together at these places, and are retained firmly in position by the 4-and-4 stitching of the silk threads. Where the weave is plain, however, the intersections are too frequent for the thick threads, which therefore spread out, there being no obstacle to their distortion, since on every side of the plain interweaving the float is absolutely

loose. The fine cotton ends and picks interweave with each other, and with the silk threads in plain order, but the spreading out of the thick threads partly conceals them, and gives an oval shape to the rectangular space occupied by the fine threads.

Fig. 241.

The pattern shown in Fig. 242 illustrates another method of giving interest to a special style, as in this case not only are yarns of different materials and different counts combined, but alternate sections of the fabric are crammed. This is repre-

sented by the different sizes of squares in the corresponding plan given in Fig. 243.
The arrangement in warp and weft is 8 threads pink silk, 4 threads thick hard-
twisted worsted, 8 threads white silk, and 4 threads thick hard-twisted worsted ;
8 threads of silk occupying the same space as 4 worsted threads. It will be seen in
Fig. 243 that the weave is plain where
the silk ends and the silk picks intersect,
and also where the worsted ends and
worsted picks intersect. The silk ends

Fig. 242.

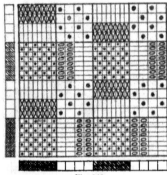

Fig. 243.

are raised over the two worsted picks that precede and follow alternate intersecting
places of the silk threads, while the silk picks float at each side over two worsted
ends. Alternate pink and white silk spots are thus formed which the distortion
of the worsted threads causes to appear round in the cloth.

CHAPTER XIV

JACQUARD MACHINES AND HARNESSES

Ordinary Jacquard Machines—The Single-Lift Jacquard—The Centre-Shed Jacquard—The
Double-Lift, Single-Cylinder Jacquard—The Double-Lift, Double-Cylinder Jacquard—
The Open-Shed Jacquard—Sizes of Jacquards and Cards—Ordinary Harness Ties—
Harness Drawing-in, Card-Cutting, and Card-Lacing. *Jacquard, Harness, and Design
Calculations*—Sett of the Harness—Number of Harness Cords to Each Hook—Casting-out
in Jacquards—Size of Repeat—Methods of Modifying the Repeat in a Lay-over Tie—
Counts of Design Paper—Summary of Calculations—Irregularly Dented Jacquard Designs.
Special Harness Ties—Centre or Point-Ties—Mixed Ties—Ties for Bordered Fabrics—
Cross-Border Jacquard Arrangements.

A JACQUARD shedding motion is necessary in weaving designs that are beyond
the scope of dobby shedding. It is also frequently found convenient and economical
to use a jacquard for dobby designs in pattern range weaving, and when rather short
lengths of cloth are required in complicated drafts. A great advantage of the
Jacquard system of shedding is that the draft of the warp threads is very simple and

does not (as a general rule) require altering when the design is changed; but the principal features are the facility with which large and intricate designs can be woven and the comparatively small space that is occupied by the machine and harness.

The machines may be classified as : (a) *Ordinary jacquards*, of which there are five principal types—viz., single-lift; centre-shed ; double-lift, single-cylinder ; double-lift, double-cylinder ; and open-shed. (b) *Special jacquards*, which include cross-border machines, gauze and leno jacquards, split-harnesses and jacquards, pressure harnesses, twilling, twin, double-cloth, and quilt jacquards. The special machines are described and illustrated along with the particular classes of cloths for which they are used in the accompanying book entitled "Advanced Textile Design." Of the ordinary machines the difference in type makes practically no difference to the textile designer ; but the principle of action of one or more types should be thoroughly understood in order that the meaning of the terms " ties," " setts," " repeats," etc., may be properly comprehended.

ORDINARY JACQUARD MACHINES

The Single-Lift Jacquard.—A jacquard machine may be conveniently divided into three sections—viz. (a) the engine ; (b) the harness ; and (c) the mechanisms which connect the engine with the loom. The engine contains the parts by which the warp threads are selected in forming the design as the cloth is woven. In the single-lift jacquard the horizontal needles A (see Fig. 244) are each connected to a vertical hook B by forming a loop or a half bend round the latter, and are supported towards one end by a needle-board C, through which they project about half an inch. The rear end of each needle, which is formed into a narrow loop through which a vertical pin is passed, receives support from a horizontal wire D, and is pressed against by a spiral spring E contained in a spring-box F. In order to prevent a hook B from turning sideways the lower end is made double, and is passed through a narrow slit in a grate G with the bent end resting on a spindle H when the hook is out of action. The arrangement of eight needles in each short row, as shown in Fig. 244, is very common, but in some machines there are four, and in others ten, twelve, or sixteen needles in each short row according to the size of the jacquard. As many short rows of needles and hooks are placed side by side in long rows as will give the required size of machine. It is a general rule to connect the needles and hooks in the order shown in Fig. 244, the top needle being connected to the hook nearest to, and the bottom needle to the hook farthest from the cylinder K. The same number of inclined lifting knives I are carried in an iron frame or griffe J as there are hooks B in a short row. A 4-sided card-cylinder K, over which the pattern cards L pass, contains on each surface a hole opposite the end of each needle. Each face of the cylinder is provided with two adjustible pegs which fit into holes cut in the cards.

The cards L are composed of stiff paper, and are perforated according to the design ; in an ordinary machine a separate card is required for each pick of weft, and the cards which form the complete repeat of a design are laced together with twine at the sides and in the middle ; then the last card is joined to the first so that an endless chain is formed. The pitch of the needles, the springs in the spring-box, and the holes in the needle-board, card-cylinder, and cards is exactly the same.

In one method of suspending a "set" of cards in proper position in relation to the cylinder, a wire, which is about 1½ inches longer than a card, is tied at intervals of twelve or more cards to the twine with which the cards are laced together. By means of the wires the cards hang from a frame or "cradle" which consists of two parallel iron bars that are rather further apart than the width of the cards, and the latter pass over supporting rollers. When long sets of cards are not used — say below 200 in a set — the cradle may consist of a curved tin channel in which the cards rest, the wires then being dispensed with.

The harness consists of neck or tail cords M that are suspended from the hooks B; harness cords N, which are connected to the tail cords and passed separately through holes in a comber-board O; mails P; and lingoes or weights Q. The number of harness cords, mails, and lingoes, connected to each neck-cord M, varies according to the "tie" and "sett" of the harness. The cord that connects a mail with a lingoe is double, and is termed the "lower coupling," while that which is connected to the top of a mail is also double to where a knot is indicated, and is termed the "upper coupling," the part above the knot being termed the "mounting thread." By means of the lingoes Q, the warp threads, cords, and hooks are returned to their original position after they have been raised.

The purpose of the comber-board O (sometimes termed hole-board) is to keep the harness

Fig. 244.

cords in position and to determine the number of cords per unit space. There are three forms of comber-boards in use—viz. (1) A " harness reed," which is similar to a coarse weaving reed except that the end pieces are broad and flat. This reed is supported horizontally in the loom, and stout cords, which are secured in holes bored in the end pieces, are laid on its upper surface at right angles to the reed wires, so that small holes are formed for the reception of the harness cords. (2) A solid wood comber-board in which the holes are pierced in rows. (3) A wood comber-board which is built up in sections, each section consisting of strips of wood from 1 to 3 or more inches broad which are held together in a grooved frame. The sections are pierced with holes in rows as in a solid board, and an advantage of the arrangement is that the outer strips, which wear out more rapidly than those in the centre, can be economically renewed. It is also possible to increase the width of the harness somewhat by inserting thin strips of wood between the sections, but this cannot be carried very far without disturbing the level of the mail eyes. The comber-board is adjustably supported at each end by means of a slotted bracket fixed to the loom frame, and it is placed from nine to twelve inches above the mails.

To a crank or eccentric, fixed to the end of the driving shaft of the loom, a long vertical rod is connected, and the upper end of the rod is attached to the end of a lever R, Fig. 244, which is fulcrumed at S. Each revolution of the crank shaft, by means of the eccentric, connecting rod, and lever R, imparts a rising and falling motion to the griffe J and the lifting knives I. By means of another eccentric on the crank shaft, and connecting rods and levers, the card cylinder is caused, at each pick, to move against and away from the ends of the needles A. (In hand-loom weaving the parts which operate the card cylinder are contained within the engine). On its outward movement the cylinder, at one corner, engages with a catch or " sneck " by which it is turned one-fourth of a revolution, so that a fresh card is presented at each pick to the needles.

Circular holes are punched in each card to correspond with the warp threads that are required up, and the method of action is as follows :—At each pick a card is pressed against the needles A at the time that the lifting knives I are in the lowest position. Where the card is not perforated (as represented opposite the four bottom needles in Fig. 244) the holes in the cylinder are covered and the needles and the corresponding hooks are pressed back, so that the bent upper ends of the latter are moved away from the path of the lifting knives I. Where there are holes in the card (as represented opposite the four top needles in Fig. 244), the needles enter the cylinder and the hooks remain vertical so that they are caught by the ascending knives I and are raised. In Fig. 244 the griffe J is shown partly raised in order that it will be readily seen which hooks are engaged by the lifting knives and which are left down. The card cylinder K continues to press against the needles until the hooks are securely held by the knives ; it then moves outward, when the hooks that have been pressed back are returned to their normal position by the action of the springs E. The knives are inclined in order that in descending they will not damage the heads of the hooks, and they fall a sufficient distance to place them with the upper edges quite clear of the bent portion of the hooks. Each lifted hook raises as many warp threads as there are harness cords connected to the corresponding neck-cord. Warp threads are moved from the bottom of the shed to the top and back again, or twice the depth of the shed at every pick ; and on account of the great distance traversed by the threads and the consequent strain put upon them, and the

absence of counterpoise in the machine, the single-lift jacquard is not suitable for high speeds. It is, however, particularly serviceable in weaving certain classes of gauze fabrics, and is also employed to some extent in the manufacture of complex cloths in which for other reasons quick running cannot be attained.

The Centre-Shed Jacquard.—In the centre-shed jacquard the arrangement of the hooks, needles, neck-cords, harness-cords, and card cylinder is the same as in

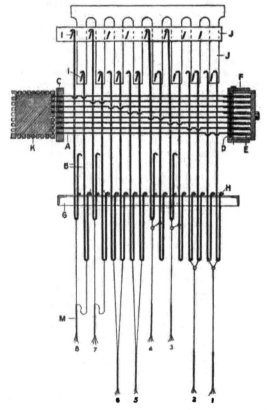

Fig. 245.

the single-lift machine, but there are both a rising and a falling griffe. The warp threads, when at rest, are in the centre of the shed; where there are holes in the cards the corresponding hooks are raised to the top through the action of the rising griffe, while the remaining hooks are lowered to the bottom by means of the descending griffe. The threads move only half the distance that they move in single-lift

jacquard shedding, and the rising shed is balanced by the falling shed, but as every thread is in motion a detrimental swinging movement is set up in the harness if a speed much greater than that of the single-lift is attempted. The centre-shed principle is found useful, however, in weaving certain classes of heavy cloths, for which a slow-running loom is required.

The Double-Lift, Single-Cylinder Jacquard.—The principle of arrangement of a double-lift, single-cylinder jacquard is illustrated in Fig. 245, in which corresponding parts are lettered the same as in Fig. 244. Each needle A is connected to two consecutive hooks B, and from each pair of hooks one neck-cord M is suspended. There are two griffes J, and two sets of lifting knives I which are operated in alternate order, one griffe and its knives rising while the others are descending. One set of lifting knives acts upon the odd hooks, and the other set upon the even hooks ; therefore, to correspond with a hole in a card, a neck-cord may be raised by either hook of a pair according to which set of knives is raised after the press of the card. The griffes J are operated by a double-throw crank fixed to the end of the low shaft of the loom, a separate connecting rod and top lever being employed for each griffe. The card cylinder K, which is operated from the driving shaft as in the single-lift machine, is pressed against the needles when one griffe is at the top and the other at the bottom—that is, at the time that hooks which have been raised on the preceding pick are held by the knives I at the top. What takes place will be understood from an examination of Fig. 245, in which it is assumed that the needles 1, 2, 5, and 6, (counting from the bottom) have been pressed back by the previous card, the corresponding neck-cords thus being left down, while the needles 1, 2, 3, and 4 are shown pressed back by the card that is in action ; or, what is the same thing, a lift of the neck-cords 3, 4, 7, and 8 has to be followed by a lift of the neck cords 5, 6, 7, and 8. As the top set of knives descends, and lowers the hooks that have been raised, the bottom set rises and lifts the hooks required up on the next pick, so that the neck-cords (or warp threads) which are required up on two consecutive picks— e.g., the neck-cords 7 and 8—are lowered half way by the descending knives, and are then carried back to the top by the ascending knives. Thus, the threads that have to be raised on several picks in succession, after being raised to the top of the shed for the first pick, simply move from the top to the centre, and back again to the top, as many times as desired, a semi-open shed being formed.

In Fig. 245 the hooks which govern the neck-cords 5 and 6 have been left down on the preceding pick, and are shown in position for being raised by the knives at the bottom. The neck-cords 3 and 4, which are shown raised, have to be down on the next pick, therefore the corresponding needles are pressed back in order that the hooks at the bottom will be away from the path of the lower set of knives. In pressing back the bottom hooks, however, it is necessary for the corresponding hooks 3 and 4, which are held by the knives at the top, to be bent back, which puts extra strain on the needles. The strain is reduced by making the hooks long and flexible, and in some cases the double lower portion of the hooks is made gradually narrower towards the bottom end so as to allow of a slight backward movement in the slits of the grid G. It will be found useful to reason out how the hooks are raised in forming different weaves ; thus, in plain weave half the hooks are never raised, whereas in 2-and-2 warp rib they are lifted equally.

Two methods of connecting the hooks in pairs to the neck-cords are illustrated in Fig. 245. Each neck-cord numbered 5, 6, 7, and 8 is shown connected by a

14

separate cord from each hook of a pair. The disadvantages of this arrangement are that as the connecting cords are alternately slack and tight, they are subjected to a certain amount of strain when the load is transferred from one to the other, while the breaking of one cord does not prevent the other from continuing in action, so that a defect may be formed in the cloth which may escape observation for some time Each neckcord numbered 1, 2, 3, and 4 in Fig. 245 is connected to a pair of hooks by means of a single cord and a wire link If the single cord breaks the threads are immediately put out of action and the consequent defect in the cloth is readily seen.

The chief advantages of the double-lift motion, as compared with the single-lift, are :—(a) Less power is required, because descending threads balance those that are being raised ; (b) greater speed can be obtained, because the shed is formed in less time since rising and falling threads move simultaneously ; (c) heavier lifts can be woven, and there is less strain on the warp so that weaker yarns can be used, as a portion of the warp only moves one-half the depth of the shed ; (d) a better " covered " cloth can be produced on account of the shed being partly open at the time of beating up.

In obtaining a high speed the chief disadvantages are that a great amount of work is put on the cylinder, which has to act at every pick, and there is more wear and tear of cards, needles, hooks, and cords, while the initial cost is greater than that of a single-lift machine

The Double-Lift, Double-Cylinder Jacquard.—This machine is similar in most respects to the double-lift single-cylinder machine, but the use of two cylinders enables each to be run at the same speed as each griffe, i.e., at one-half the speed of the loom. The principal defect of the single-cylinder machine is thus got over, and if other conditions are suitable for quick running a higher speed can be obtained. The card cylinders are operated alternately, and the cards are laced in two sets— the odd cards forming one set, and the even cards the other. In one type of machine each cylinder acts upon a separate set of needles, and there are two needles and two hooks to each neck-cord, the machine really consisting of the principal parts of two single-lift engines which are combined in one frame. In this arrangement one set of cards must be laced forwards, and the other set backwards (see Fig. 250), because they are required to turn towards the machine from opposite sides. In another type of machine the two cylinders operate against the opposite ends of one set of needles, the springs and spring box being dispensed with. In this case both sets of cards are laced in the same direction, but one set is turned inside out.

The necessity of having the cards in two sets is the chief disadvantage of the double-cylinder machines because the storing of the cards is not so convenient, greater care is required in placing the cards on the cylinder, and the cards are liable to get out of proper rotation. A " stop " motion may be applied by means of which the cards (acting through two special needles and hooks and suitable connections to the starting lever of the loom) automatically cause the loom to stop if they do not follow each other in proper order.

The Open-Shed Jacquard.—Many different types of open-shed jacquards have been brought out, of which only one or two have successfully stood the test of experience, and these, on account of the greater complexity of the parts, have been adopted only to a limited extent. One of the best arrangements is constructed on the double-lift, single-cylinder principle, illustrated in Fig. 245, the only change from which is in the form of the link that connects two hooks of a pair together, and in the provision

of a series of fixed dwelling knives. Each link is extended upward at one side through the grate G, forms a loop round a hook, and is bent at the top so as to form a hook. The lift of either hook of a pair raises the link so that its bent upper end is over a dwelling knife, which retains it at the top so long as the corresponding neck-cord is required to be raised on successive picks. Less power is required, the wear of harness is reduced, and there is less strain on the warp, hence the arrangement is most applicable in weaving cloths right side up in which the warp largely predominates on the surface.

Sizes of Jacquards and Cards.—British made machines range in size from 100 to 600, and occasionally 900 hooks (in double-lift machines two hooks are counted as one) which are arranged as shown in the following list :—

100	size,	with	26	rows of	4	hooks per row	= 104	hooks.
200	,,	,,	26	,, ,,	8	,, ,, ,,	= 208	,,
300	,,	,,	38	,, ,,	8	,, ,, ,,	= 304	,,
400	,,	,,	51	,, ,,	8	,, ,, ,,	= 408	,,
500	,,	,,	51	,, ,,	10	,, ,, ,,	= 510	,,
600	,,	,,	51	,, ,,	12	,, ,, ,,	= 612	,,
900	,,	,,	77	,, ,,	12	,, ,, ,,	= 924	,,

The 300, 400, and 600 sizes are in most general use, and very frequently a large machine is obtained by placing two or more smaller machines side by side over the loom—e.g., a 600-size by combining two 304-hook machines ; a 1,200-size by combining two 608-hook machines ; and an 1,800-size from three 608-hook machines. The number of hooks given in the last column of the foregoing list indicates the figuring capacity of the respective machines—that is, the number of warp threads that can be operated independently of each other if all the hooks are tied up. In the sizes ranging from 408 to 924 hooks, however, one row of hooks is intended to be employed in operating the selvage threads of the cloth, but at each side there is a part row of hooks—in line with the positions occupied by the pegs in the card cylinder —which, if necessary, can be used for the purpose. In the 304-hook machine these extra hooks (six at each side) are mostly employed as selvage hooks. Either all or a portion of the total hooks in a machine may be tied up, but generally, the number that is employed should be a multiple of several smaller numbers, as this gives facilities in producing designs which repeat upon one-half, one-third, etc., the number of hooks, and ground weaves which repeat upon different numbers of threads.

Continental machines are chiefly of two types—the Vincenzi and the Verdol— both of which are finer in pitch than British made jacquards. The Vincenzi type is arranged with 16 needles and hooks in each short row, and is generally made in sizes of 440, 880, 1,320, and 1,760 hooks. The Verdol machine is made with 16 hooks in each short row and 8 needles, but the needles are arranged alternately—two rows corresponding to one row of hooks. The machines are made in multiples of 112 hooks, common sizes being 448, 896, 1,344, and 1,792 hooks. In the Vincenzi machine the cards act upon the needles in the same manner as in British machines, and a separate card is used for each pick. The Verdol type, however, is different, as the cards, which are in the form of an endless sheet of paper, act upon the needles indirectly.

The cards (fully perforated) for different sizes of machines are illustrated in

Figs. 246 and 247. A, B, and C in Fig. 246 represent 304, 408, and 612—British

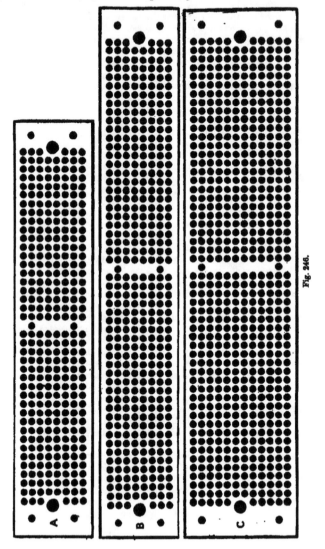

Fig. 246.

sizes, which are respectively 12¾ ins. × 2⅜ins., 16¼ ins. × 2⅝ ins., and 16¼ ins. × 3½ ins. in length and breadth. D in Fig. 247 shows the 1,320—Vincenzi size, which is

Fig. 247.

14⅞ ins. long × 2¾ ins. broad. E in Fig. 247 represents the equivalent of three Verdol cards of 896 size, each of which occupies the space of 12⅝ ins. × 1¹⁄₁₆ ins

F and G both show the comparative size of one Verdol 896-card, and these examples demonstrate two methods that are adopted of reducing the capacity of a Verdol machine. F shows the capacity of 896 hooks reduced to $672\frac{1}{4}$ by reducing each row of 8 to 6 ; and G to 448 hooks by employing only the alternate rows of 8.

In further comparision of the difference in pitch of British and Continental machines—in an ordinary British machine there are approximately 14 needles per square inch, whereas there are 40 needles per square inch in the Vincenzi, and 80 in the Verdol. In weaving large designs in very fine silk fabrics a fine pitch is a necessity in order that the machine will be contained in reasonable compass. Several British jacquard makers manufacture a machine which is nearly as fine in pitch as the Vincenzi, and these have been adopted to a limited extent. In fine pitch machines it is particularly necessary for card paper to be used which will be affected as little as possible by changes in atmospheric conditions. An advantage of the Verdol machine—in addition to its comparatively small size—is in the light weight of the paper, and its corresponding cheapness.

Fig. 248.

With the exception of the Verdol type shown at E, F, and G the cards illustrated in Figs. 246 and 247 show how the hooks and needles are arranged in the machines, and will make clear the meaning of the terms " short row," and " long row," as applied to the needles, hooks and harness cords. In looking at a fully-punched card the holes (with the exception of the peg and lace holes) represent the tops of the hooks, and the ends of the needles ; or, in other words, each hole represents the connection of a needle to a hook (or a pair of hooks in a double-lift single-cylinder jacquard). Further, a card represents one pick, or one horizontal space of the design paper, and each hole (or position where a hole may be punched) a small square of a horizontal space ; and each small square also indicates where an end and a pick intersect. A card is perforated and left blank in the order indicated by the painting of the design ; if certain marks, or the blanks, represent warp up, a hole is cut to correspond with each small square thus indicated (as shown in Fig. 250).

Ordinary Harness Ties.—A jacquard may be placed in relation to the loom with the card cylinder at the right or left side, or at the back or front. If the cylinder is

at one side the long rows of hooks are at right angles to the length of the comber-board, therefore the harness cords are crossed with each other in passing from the neck-cords to the holes in the comber-board. This arrangement, which is illustrated in Fig. 248, is termed a London, crossed, or quarter-twist tie. If, however, the card cylinder is at the back or front of the loom, the long rows of hooks are parallel with the length of the comber-board, so that the harness cords are not crossed. This tie is illustrated in Fig. 249, and the term Norwich or straight tie is applied to the arrangement.

In tying up a harness the first hook in the row nearest the head of the cylinder (the "sneck" or "catch" side, which is invariably on the right when facing the cylinder) is taken as the first hook in the machine. The other hooks in the same row follow in consecutive order from 2 to 8, as indicated by the numbers in Figs. 248 and 249; then the hooks 9 and 16 are the first and last in the second row; the hooks 17 and 24, the first and last in the third row, and so on. If the jacquard contains as many hooks as there are figuring threads in the full width of the cloth, as, for instance, in certain classes of carpet jacquards, only one harness cord is connected to each hook, and the tie is termed a "*single*" tie. The most commonly used arrangement, however, is the "*lay-over*" or "*repeating*" tie, which is illustrated in Figs. 248 and 249, and is also represented in the lower portion of Fig. 244. In this tie, commencing with the first hook (or neck-cord) of the machine, the first harness cord is connected to it, the second harness cord to the second hook, the third to the

Fig. 249.

third, and so on in succession until each hook has one harness cord connected to it. This gives one "division" or "repeat" of the harness, which occupies a certain width of the comber-board and contains as many harness cords as there are hooks tied up. The process is then repeated—commencing with the first hook, and a second harness cord is successively connected to each, a second division of the harness being thus formed in the comber-board. Again the process is repeated (and again and again if necessary) until the required width of the harness in the comber-board is obtained.

In Figs. 244, 248, and 249 the divisions of the comber-board are clearly indicated, and it will be readily understood, that as in each division the harness cords are

attached in exactly the same order to the hooks (or neck-cords), the figure formed by the first division will be formed just the same by the second division, and then again by the third division. That is, the design will be "repeated" across the width of the cloth by the repetition of the tie, in the manner illustrated by the sectional designs below the comber-boards in Figs. 248 and 249. In the lay-over tie the number of hooks tied up gives the maximum number of threads in the repeat in width of a design; by casting out (see page 219) designs may be woven which repeat upon a less number, while any division of the number of threads may be employed.

Fig. 250.

Harness Drawing in, Card Cutting, and Card Lacing.—The warp threads may be drawn through the harness mails in the order shown at A in Fig. 250, or as indicated at B. In the former method the first thread in a design (at the left as viewed from the front of the loom) is drawn upon a harness cord at the front of the comber-board, and if the card cylinder is at the back of the loom (which is most common) the

needle that controls the first thread is at the bottom of the first short row. In the latter method, under similar conditions, the first thread is drawn upon a harness cord at the back of the comber-board, and the needle which controls it is at the top of the first short row.

The construction of a design is not affected by the way in which the threads are drawn in, but a difference is made in the card-cutting. This is illustrated in Fig. 250 in which C shows a small design, and D sections of two cards which are cut to correspond with the first and second horizontal spaces, or picks of C—assuming that the harness draft A is employed and that the marks of the design indicate warp up. The design is placed in front of the card-cutter in the position that it has been constructed and as it is required to appear in the cloth. The bottom horizontal space corresponds with the first card, and the card-cutter follows it from left to right, each series of spaces between the thick lines of the paper coinciding with a short row of the card. If the draft indicated at B in Fig. 250 be employed, the design is turned one-half round, as shown at E. The first horizontal space is then at the top, and the first card is cut from it by reading from right to left. Thus, F shows sections of cards cut from the two top horizontal spaces of E. One method of drawing in and card-cutting is employed in certain districts, and the other method in other districts—e.g., in Yorkshire the first method is common, and in Lancashire the second method. As to which is the better method is a matter of opinion, but the first method has an advantage in the respect that it corresponds with ordinary heald drafting.

Confusion sometimes arises when cards are transferred from one district to another, but cards cut for one draft can be used for the other simply by turning the set inside out. It will be seen that the cards shown at D in Fig. 250, when turned over, are exactly like those given at F. If, in the same factory, some of the jacquards have the cylinder at the back of the loom and others at the front, draft A should be used for one arrangement and draft B for the other, otherwise the cards will require to be laced "forwards" in one case, and "backwards" in the other case. A uniform system of card-lacing can be employed by using the two systems of drafting to correspond with the two positions of the cylinders, the cards being turned inside out in changing from one to the other.

The cards are numbered at the end where the cutting is commenced to correspond with the numbers of the horizontal spaces of the design, and they are laced together with the numbers arranged in consecutive order. Generally the numbers follow each other from one upward in the direction shown at D in Fig. 250, which is termed "lacing forwards." Sometimes, however, as for instance in order to reverse the direction of a twill-ground weave, they follow each other in the opposite direction as shown at F, which is termed "lacing backwards." As a rule the numbered ends of the cards are placed at the right (when facing the cylinder) or "sneck" side of the cylinder, and if the cards are laced forwards they rotate in order from the first to the last, whereas if they are laced backwards they rotate from the last to the first. An exception to this occurs when two cylinders are employed at opposite sides of the jacquard.

JACQUARD, HARNESS, AND DESIGN CALCULATIONS

Sett of the Harness.—The number of harness mails per unit space is decided by the rate at which the rows of holes are formed in the comber-board, and the number of holes in each row. Usually there are as many holes in each row of the comber-

board as there are hooks in each short row of the jacquard. Thus, in an 8-row machine there are 8 holes in each row, and in wooden comber-boards in coarse setts, the holes may be pierced as indicated at G in Fig. 251, whereas in medium setts, in order to give as much space as possible between the holes, they are arranged alternately, as shown at H. In a 12-row machine the rows are 12 holes deep arranged alternately. In very fine sett harnesses, however, in order that there will be sufficient space between the rows, each row in the comber-board mostly contains twice as many holes as there are hooks in a short row of the jacquard. The arrangement for an 8-row machine is then as shown at K in Fig. 251, and in tying up the harness the cords from the first row of hooks are passed through the odd holes, and

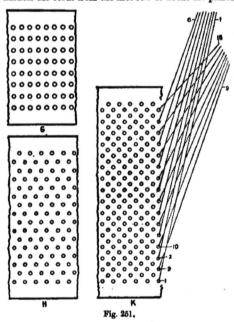

Fig. 251.

from the second row through the even holes, as represented on the right of K. The warp threads are drawn through the harness mails in corresponding order—threads 1 to 8 on the odd mails in succession, and threads 9 to 16 on the even mails, and so on.

Sometimes, for special purposes, as for instance in weaving broad crammed stripes, the comber-board is pierced at different rates to conform with the sett and width of the respective sections of the warp threads. Such an arrangement, however, is seldom necessary. For instance, a warp might be dented in the reed in the order of 200 threads, 4 per split, and 200 threads, 2 per split, but a uniform distribution of the harness cords in the comber-board would cause no difficulty in weaving, because the cords yield (much more readily than in heals) to the draw of the reed.

The number of harness cords per inch is equal to the number of rows per inch multiplied by the number of holes per row. For example, if 72 harness cords per inch are required—in an 8-row machine there will be $72 \div 8 = 9$ rows of holes per inch, and in a 12-row machine—$72 \div 12 = 6$ rows per inch.

Number of Harness Cords to each Hook.—In a lay-over or repeating tie the number of hooks tied up, and the width and sett of the harness, determine the number of harness cords to each hook. For instance, assuming that 400 hooks are tied up, 50 inches wide in the harness, with 96 harness cords per inch—the total number of

harness cords in the full width = 50 × 96 = 4,800; and 4,800 cords + 400 hooks = 12 harness cords to each hook. That is, the harness will be in 12 divisions, and will produce 12 repeats of a design that is constructed upon 400 threads. As a further illustration, let it be assumed that 804 hooks are tied up, 40 inches wide, with 72 harness cords per inch. In this case there will be 40 × 72 = 2,880 cords, and 2,880 + 304 = .9 divisions + 144 cords. It is customary to tie one-half of the cords that are in addition to the full divisions at one side of the jacquard, and the other half at the other side, and the following arrangement will therefore be suitable :

Hooks 233 to 304	=	72 harness cords.	
„ 1 to 304 × 9 repeats	= 2,736	„	„
„ 1 to 72	= 72	„	„
	2,880	„	„

Thus, 144 hooks will be tied up with 10 cords per hook and 160 hooks (304-144) with 9 cords per hook. In the foregoing, no provision is made for the selvages, but assuming that 4 hooks are employed for the purpose, and that 24 cords are tied up at each side, each selvage hook will have (24 + 24) + 4 hooks = 12 cords attached to it.

Casting-out in Jacquards.—Casting-out consists of leaving empty a portion of the mails in each repeat of the harness, and of allowing the corresponding needles, hooks, and harness cords in the machine to remain idle. The warp threads should occupy the same width in the harness as in the reed : the sett of a harness, however, is fixed when it is tied up, whereas the sett of the warp in the reed is changed according to requirements (except that it should not be finer than the sett of the harness). Casting-out may therefore be defined as a process by which a jacquard is adapted, without retying, to suit conditions that are different from those for which the harness was constructed. For instance, if a harness is tied up to 400 hooks, with 96 harness cords per inch, the conditions are perfectly suited to weaving designs repeating upon 400 threads with 96 threads per inch. It may, however, be found necessary to use the machine—(a) in weaving designs that repeat upon a less number of threads than 400 ; and (b) in weaving cloths with less than 96 threads per inch. These are the two chief purposes of casting-out ; but, in addition, the process is employed to some extent in producing special effects in a straight repeating tie.

It is possible to weave designs that repeat upon any number of threads less than the number of hooks tied up, but it is obviously impracticable to employ a higher number. Very small designs can be repeated across the cards a number of times— e.g., in a 400-tie, a design repeating upon 64 threads can be carried across the cards five times, with a remainder of 80 hooks cast out, or six times with 16 hooks cast out. The examples C and D, or E and F, in Fig. 250 illustrate the method in which a small design is repeated across the cards. Casting out 80 hooks, in a jacquard in which 400 hooks are tied up, leaves only 320 hooks in use, and under these conditions the machine is limited to designs which repeat upon 320 threads, or a number which is a measure of 320.

It is important to note that the sett of the harness is reduced in ratio to the proportionate number of hooks that are cast out ; and the sett of the warp in the reed should be the same (or very nearly the same) as the reduced sett of the harness. By means of the following formula, which is of general application, an unknown factor can be readily found :—The sett of the harness : the sett of the warp in the reed : :

the number of hooks tied up : the number of hooks employed, or the number of threads in the design.

Two problems arise in weaving designs that repeat upon a less number of threads than the number of hooks tied up : (1) To find the sett of warp to suit a given sett of harness. (2) To find the sett of harness to suit a given sett of warp. In illustration of both problems let it be assumed that it is desired to weave a design repeating upon 320 threads in a 400-tie. (1) Taking the sett of the harness as 90 cords per inch, the sett of the warp should be :—

$$400 : 320 :: 90 : 72 \text{ threads per inch.}$$

(2) Taking the sett of the warp as 80 per inch, the sett of the harness should be :—

$$320 : 400 :: 80 : 100 \text{ cords per inch.}$$

That is, in each case the sett of the harness should be finer than that of the warp in the proportion of the number of hooks tied up to the number of threads in the design.

When it is desired to weave a cloth with fewer threads per inch in the reed than there are harness cords per inch, it is necessary to find the number of threads in the repeat of the design relative to the number of hooks tied up. For example, assuming that a warp with 64 threads per inch in the reed, has to be woven in a 304-tie, with 80 harness cords per inch, the number of threads in the repeat of the design will be :—

$$80 : 64 :: 304 : 243 \text{ threads.}$$

In this case however, a more convenient number is 240 threads, then the number of hooks cast out $= 304 - 240 = 64$.

In some special cases the hooks are cast out in long rows, which, as regards the card cutting, reduces the number of hooks in each short row—e.g., if two long rows are cast out, a 12-rowed machine is reduced to 10 rows, and an 8-rowed machine to 6 rows. Most frequently, however, the casting out is done in short rows, and if a considerable number of rows are cast out, they should be distributed as regularly as possible across the card. Also, a definite system should be employed in selecting the rows, otherwise when a cast out is changed, it may be necessary to fill up mails at one place at the same time that threads are broken out at another place. Fig. 252 illustrates a principle upon which the cast out rows may be selected. A represents one long row of a 304-card, which is in two halves, each consisting of 19 rows, and it will be understood that each black circle corresponds to a short row of eight. For a cast out of 32 hooks the 1st and 19th rows in each half are cast out, as shown at B. To increase the cast out to one of 48 hooks, the 10th row in each half is added, as indicated at C. For a cast out of 80 hooks the 7th and 13th rows in each half are also added, as shown at D ; to which the 4th and 16th rows in each half are added for a cast out of 112 hooks, as shown at E. This is further increased to a cast out of 144 hooks by adding the 6th and 14th rows in each half, as represented at F.

It will be seen that when the cast out is increased it is only necessary to break out the additional number of ends in each division of the harness ; and in the same way, when the cast out is reduced, it is only necessary to fill in the required number of mails. Also as both halves of the card are exactly alike, the cutting of small designs is simplified, as they can be readily carried across the card without being extended to more than one repeat.

Another important point to note in selecting the rows to be cast out is to arrange them, if possible, in such a manner that they are in the same order when counted from

either end of the card. This has been kept in view in selecting the rows for the cast outs shown at B to F in Fig. 252. For example, from whichever side of cast out E the rows are counted, the numbers are 1, 4, 7, 10, 13, 16, 19, in each half. The advantage of this arrangement is that the cards will fit on the cast out when turned round, which, in certain of the most common arrangements of figures, enables the cards for the second half of the design to be repeated from the cards which are cut from the first half, thus saving time both in the designing and card cutting. Such an arrangement cannot be made in the 408 and 612-hook machines, because one side of the cards contains 26 rows and the other side 25 rows, but the machines can now be obtained in a modified form in which there are 25 rows in each half.

When only a given size and sett of jacquard is available for producing a design, it sometimes occurs that the proper number of ends for the repeat, obtained by calculation, is different from the number of ends in one or more repeats of the design. For example, assuming that a 66 sett warp is required to be woven in a 76 sett 304 jacquard, the correct number of ends for the repeat =

$$76 : 66 :: 304 : 264 \text{ ends}$$

and the correct cast out =

$$304 - 264 = 40 \text{ hooks.}$$

In practice, the number of ends (264) for the repeat can be varied from about 256 to 272, but a large design, repeating on, say, 288 ends, or one repeating on, say, 240 ends, will require to be modified in size to suit the size of repeat which can be obtained in the given jacquard. Small designs may also require to be modified in size, as, for example, a design repeating on 48 ends may be altered to repeat on (264 + 6 repeats) = 44 ends, or (260 + 5 repeats) = 52 ends. When, however, it is impossible for the repeat of a small design to be altered in size, the warp may be kept straight between the harness and the reed by casting out in the following manner :—

Fig. 252.

A B C D E F G

Assuming that the calculation number of ends for the repeat is 264, and that the design repeats on 48 ends, the design is carried out on a larger number of ends than the calculation number. Thus, in this case, by repeating the design six times, the size of the repeat = 288 ends, which in the 304 jacquard gives a cast out of 16 hooks, or two rows for the card cutting. The number of harness mails (16) which are cast

out in every division of the harness is then too little by (288 — 264) = 24 mails ; but as the design repeats on 48 ends only, it is possible, without injury to the weaving, and without causing a break in the pattern, to cast out a block of 48 harness mails in addition to the 16 mails in any division of the harness. The number of times it will be necessary to cast out in blocks of 48 may be found as follows—

Assuming that the warp contains 3,200 ends, the number of divisions which the warp requires to occupy in the harness =

$$3,200 \div 264 = 12 \text{ divisions and 32 ends.}$$

$$\frac{12 \text{ divisions} \times 24 \text{ mails cast out too little}}{48 \text{ mails in each block.}} = 6 \text{ times.}$$

It is necessary to assort the 6 places regularly across the 12 divisions which the warp occupies ; therefore, in this case, the odd divisions may be cast out 16, and the even divisions $16 + 48 = 64$ mails. The plan of the cast-out card is shown at G, Fig. 252, the shaded circles indicating a convenient position for the 48 mails or 6 rows which are cast out or filled in according to requirements. It will be understood that the cards for weaving the design must be cut as though the harness was cast out only on the first and last rows.

Size of Repeat.—Cloths contract in weaving and also in most cases in finishing, hence in the finished state a fabric contains more threads per unit space than are inserted in the loom. A jacquard design requires to be constructed in accordance with the finished conditions of the cloth for which it is intended, and if a cloth, when finished, contains 60 picks and 80 ends per inch, a design 8 ins. long by 5 ins. wide will repeat upon $60 \times 8 = 480$ picks or cards, and $80 \times 5 = 400$ ends.

The length of repeat that can be obtained in a jacquard is generally considered to be unrestricted, but in practice there is a limit to the number of pattern cards that can be conveniently suspended and made to work satisfactorily in a machine. Very long sets of pattern cards can by special arrangements be employed but in practically all cases if a certain limit is exceeded the productiveness of the loom is liable to be affected. Also it should be taken into account that the cost of a design is about in proportion to the number of cards that are required, and for this reason many special jacquard arrangements have been devised chiefly with the idea of saving cards. In ordinary jacquards, however, a separate card is required for each pick, and if it be assumed that the maximum number that can be conveniently used in a given machine is—say 2,000, the designer should endeavour to restrict his designs accordingly. Thus, in this case, in designing for a cloth with 100 picks per inch, the length of the repeat should not exceed 20 inches, and for a cloth containing 160 picks per inch, $12\frac{1}{2}$ inches ; any less length of repeat, of course, being readily obtained.

The width of repeat that can be woven in an ordinary jacquard and tie is much more restricted than the length, as in the loom it cannot (in ordinary circumstances) exceed the space occupied by one division of the harness in the comber-board. The number of hooks tied up, the sett of the harness, and the contraction of the cloth, are the governing factors. For example, assuming that a cloth contracts 10 per cent. from the reed width to the finished width—a 400 tie with 80 harness cords per inch will give : $(400 \div 80) - 10$ per cent.$= 4\frac{1}{2}$ ins. width of repeat in the finished cloth. The result is not affected if a cloth is woven with fewer threads per inch in the reed than the number of harness cords per inch, because the hooks require to be cast out

to correspond with the difference in the setts. Thus, if a cloth is woven in the fore
going tie with 60 ends per inch in the reed, there will be

$$80 : 60 : : 400 : 300 \text{ hooks employed,}$$

and $(300 + 60) - 10$ per cent.$= 4\frac{1}{4}$ ins. width of repeat as before.

Methods of Modifying the Repeat in a Lay-over Tie.—Although, in a general way

Fig. 253.

it is true that the figure produced
in one division of a lay-over tie
will be produced exactly the
same in each succeeding division,
and that the width of the repeat
is correspondingly limited, yet
it is possible by means of special
methods of drawing in and casting
out to modify the size of the
repeat and to obtain special
effects. For instance, when the
sett of the warp is not more than
half the sett of the harness, the
following method of casting out
may be employed in order to
double the size of the repeat of
the jacquard. Assuming that it
is required to weave a warp with
54 ends per inch in a 304-tie with
114 mails per inch, the number
of mails in each division which
require to be filled in =

114 mails : 54 ends : : 304 : 144 ;

and the number of mails cast out
in each division of the harness =

$$304 - 144 = 160.$$

Instead, however, of throwing
160 hooks entirely out of action,
288 hooks may be employed for
figuring by making the design on
$144 \times 2 = 288$ ends (which for
the card cutting gives a cast out
of $304 - 288 = 16$ ends), and
by arranging the rows in the
harness as follows : The first and
last rows of hooks are cast out
in every division of the harness ; in alternate divisions of the harness half of the
remaining rows, say the even rows, are cast out, and the odd rows are filled in ;
then in the other divisions the odd rows are cast out, and the even rows are
filled in. One repeat of the figure will thus extend across two divisions of the
harness. In order to cut the cards conveniently from the design, it is necessary

to cut the sheet of point-paper into longitudinal strips, and to arrange a strip from the second half of the design alternately with a strip from the first half.

This method may be employed in various ways in the production of special effects in an ordinary machine. For example, the figured skirting fabric, represented in Fig. 253, was produced in an ordinary 304-jacquard by using the odd rows of hooks for the figure and the even rows for the ground. Where the border figure appears the even rows were cast out, while in the ground of the fabric the odd rows were cast out. The sett of the warp was half of that of the harness. In designing such a style the chief points to note are that the position of each part of the ornament on the point paper corresponds with the hooks which are available for its production, and that the warping plan coincides with the width and form of the border which can be obtained.

Fig. 254.

Fig. 255.

Another method of producing a novel effect by casting out in a special order is illustrated by the pattern represented in Fig. 254. In this case an ordinary ground figure, running transversely from selvage to selvage, is broken at intervals of two or more repeats by a separate and distinct longitudinal stripe in which the figure is produced by means of extra warp. The fabric was woven with 70 ends per inch, in an ordinary 384-tie with 84 harness mails per inch. The calculation number of ends in the repeat of the design therefore = 84 mails : 70 ends :: 384 hooks : 320

ends; and the cast out = 384 − 320 = 64 ends. The horizontal ground figure was designed upon 320 ends, and the extra warp stripe upon 64 ends, the complete design thus occupying 384 ends for the card cutting. The point-paper plan of the extra warp stripe is shown in Fig. 255. Where the ground figure was required to run continuously for two or more repeats, the hooks, which were employed for the

Fig. 256.

extra warp effect, were cast out; but where the extra warp figure was introduced the mails for it were filled in, and a corresponding number of ground mails cast out.

Further, in figuring with two colours of warp arranged 1-and-1 in the harness it is possible by casting out an odd number of mails to obtain a repeat of figure which is apparently double the width of the repeat of the jacquard. For example, if one harness mail of a 304-tie be cast out, the number of ends in the repeat of the point-

15

paper plan = 303, and, as the 1-and-1 warping plan repeats on two ends, the design in the cloth will repeat on a number of ends which is common to 303 and 2—viz., 606. The ends of the first colour will be on the odd mails in one division, and on the even mails in the next division of the harness, and correspondingly the ends of the second colour will be on the even mails and then on the odd mails. The result of such an arrangement will be understood from an examination of the design shown in Fig. 256, only half the repeat of which needs to be painted out on the design paper. The two colours of warp, in which the figure is intended to be developed, will replace each other in succeeding divisions of the harness, hence the repeat of the design in the cloth will be on twice as many ends as the point-paper plan. A

Fig. 257.

point-paper section of the design is shown at Fig. 257, which illustrates the end-and-end arrangement of the figure. The following are suitable weaving particulars :—

Warp.

1 thread 2/40's mercerised cotton, maroon.
1 ,, 2/40's ,, ,, gold.
84 threads per inch.

Weft.

All 16's black cotton.
76 picks per inch.

Counts of Design Paper.—Design paper is divided by thick lines usually into square blocks, each of which is subdivided into horizontal and vertical spaces. Each horizontal space corresponds to a pick of weft, and each vertical space to a warp thread and a hook of the jacquard. For convenience in the point-paper designing and card cutting the vertical ruling of the paper is arranged to coincide with the arrangement of the jacquard hooks—that is, each large square is divided vertically into as many spaces as there are hooks in a short row of the jacquard. Thus, in the

design paper used for an 8-row machine there are 8 vertical spaces between each pair of thick lines, and for a 12-row jacquard, 12 spaces, so that in each case the number of vertical spaces between the vertical thick lines corresponds to one row of the card. In order to facilitate the drafting (or draughting) of figure designs the number of horizontal spaces in each large square requires to be in the same proportion to the number of vertical spaces as the picks are to the ends per unit space in the finished cloth. Since, however, the number of vertical spaces is fixed by the

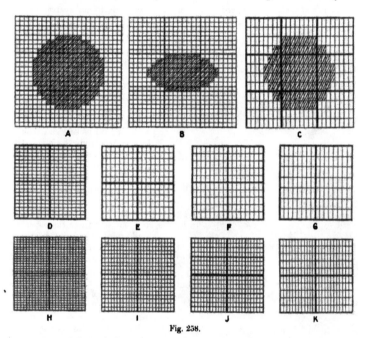

Fig. 258.

arrangement of the hooks in the jacquard, it is necessary for the number of horizontal spaces in each square to be varied according to the ratio of picks to ends in the cloth. Design paper can be purchased to suit practically any conditions, and in Fig. 258 a number of different rulings are illustrated. A and B represent 8 × 8 design paper which is used in designing for cloths in which the ends and picks per unit space are equal, while C shows 8 × 4 paper which is suitable for a cloth which contains twice as many ends as picks per unit space. The first number of the count of the paper indicates the vertical ruling.

In order to illustrate the necessity of using properly ruled paper a small spot is indicated at A, B, and C in Fig. 258 ; and, assuming that the spot is required to be one-quarter inch in diameter in a cloth containing 64 ends and 64 picks per inch, it will extend over 16 ends and 16 picks, as shown at A. If, however, the same size

of spot is required in a cloth containing 64 ends and 32 picks per inch, it will extend over 16 ends and 8 picks, as indicated at B, in which, however, the 8 × 8 paper shows the spot entirely out of proportion. On the other hand, by using paper that is ruled 8 × 4 to suit the ratio of 64 ends to 32 picks per inch in the cloth the spot is in proper proportion, as shown at C.

The proper counts of design paper to suit any given particulars of cloth (finished) may be found from the formula :

Ends per inch : Picks per inch : : Vertical spaces : Horizontal spaces.

The examples D to G in Fig. 258 are suitable for 8-row jacquards, and respectively show 8 × 10, 8 × 6, 8 × 5, and 8 × 3½ papers ; while H to K are suitable for

Fig. 259.

12-row machines and are ruled respectively—12 × 15, 12 × 9, 12 × 8, and 12 × 5. D and H are in proper ratio, for instance, for a cloth with 80 ends and 100 picks per inch ; E and I for a cloth with 96 ends and 72 picks ; F and J for 88 ends and 56 picks : and C and K for 144 ends and 62 picks. In some cases 12-row paper is ruled with a line in the centre which is intermediate in thickness, as shown at J. It is generally near enough for practical purposes to take the nearest number for the horizontal spaces, but sometimes the paper is specially ruled to include a fraction. Thus at G the horizontal thick lines are twice as far apart as the vertical thick lines, and the paper is equivalent to 16 × 7, or 8 × 3½.

Summary of Calculations.—In the following, which is chiefly a summary of the foregoing in a practical form, the calculations that are involved in designing, and the conditions to be observed are illustrated. Assuming that the design represented in Fig. 259 (in which the lines indicate exactly one repeat) is required to be woven in a cloth that counts, when finished, 126 ends and 96 picks per inch, and has shrunk 8 per cent. from the reed width to the finished width, while the ground weave repeats upon 20 ends and 12 picks—the particulars may be ascertained as follows :—

(a) Number of ends and picks (or cards) in one repeat of the design.

(b) Number of ends per inch in the reed.

(c) Suitable capacity of jacquard and sett of harness to produce the design exact in size.

(d) Counts of design paper.

(a) The repeat is $1\frac{7}{8}$ ins. in width and $3\frac{3}{8}$ ins. in length. The number of ends in the repeat—$126 \times 1\frac{7}{8} = 236$, which, in order to fit with the ground weave, must be modified to 240 ends.

The number of picks in the repeat—$96 \times 3\frac{3}{8} = 324$.

(b) The number of ends per inch in the reed—$126 - 8$ per cent. $= 116$.

(c) A suitable standard capacity of jacquard is an 8-row 304-tie which will require to be cast out : $304 - 240 = 64$ hooks.

The sett of the harness requires to be finer than the sett of the warp, because 304 harness cords have to occupy the same width in the comber-board as 240 ends in the reed, and the proportion is therefore—

240 ends : 304 hooks : : 116 ends per inch : 146 harness cords per inch.

(d) The count of the design paper—

126 ends : 96 picks $= 8 \times 6$.

The example may be used in further illustration of practical conditions, by assuming that the design shown in Fig. 259 is required to be woven in the same cloth as before, but in a 304-jacquard, which is tied up with 128 harness cords per inch. In this case the number of ends in the repeat of the design will be less than 304 in the proportion of 128 (the harness sett) to 116 (the reed sett). The number of ends is therefore—

$$128 \; : \; 116 \; :: \; 304 \; : \; 276,$$

which it is necessary to modify to 280 to coincide with the repeat of the ground weave. This causes the repeat in width of the design to be increased from the preceding by 40 ends, and a corresponding increase in length should be made in order that the design will be in the same proportion as the original. The number of picks will therefore be—

$$240 \; : \; 280 \; :: \; 324 \; : \; 378,$$

which, to fit with the 12 picks in the repeat of the ground weave, should be modified to 372 or 384 picks.

Irregularly Dented Jacquard Designs.—In designing figured crammed stripes, extra warp figures, etc., a suitable capacity of jacquard may be decided upon from the number of threads in the repeat of a pattern, but such calculations as the following are involved in maintaining an even balance between the harness and the reed. The calculations vary in different circumstances, but usually the factors to consider are the number of ends and splits in the repeat, and the setts of the reed and the harness.

1. With a given order of denting and a given sett of reed, to find the sett of the harness.

2. With a given order of denting and a given sett of harness to find the sett of the reed.

3. With a given sett of reed and a given sett of harness, to find the amount of cram or number of extra threads which may be introduced.

By dividing one side into the other an unknown factor can be obtained from the formulae :—

$$\frac{\text{Hooks tied up in jacquard} \times \text{splits per inch in reed}}{\text{Mails per inch in harness} \times \text{splits in repeat of design}}$$

In illustration, a stripe fabric is represented in Fig. 260, which is dented as follows :—

36 ends—		narrow figure stripe—	4	ends per split			=	9 splits.
12	,,	warp twill	6	,,	,,	,,	= 2	,,
208	,,	broad figure stripe	4	,,	,,	,,	= 52	,,
12	,,	warp twill	6	,,	,,	,,	= 2	,,
36	,,	narrow figure stripe	4	,,	,,	,,	= 9	,,
96	,,	ground	2	,,	,,	,,	= 48	,,

400 ends. 122 splits.

The design repeats upon 400 ends, so that a 400-hook jacquard is suitable.

1. Assuming that the reed contains 30 splits per inch, and the sett of the harness is required—

$$\frac{\text{Hooks tied up} \times \text{splits per inch in reed}}{\text{Splits in repeat of design}} = \frac{400 \times 30}{122} = 98 \text{ mails per inch.}$$

Fig. 260.

2. Assuming that the sett of the harness is 98 mails per inch and the sett of the reed is required—

$$\frac{\text{Mails per inch in harness} \times \text{splits in repeat of stripe}}{\text{Hooks tied up}} = \frac{98 \times 122}{400} = 30 \text{ splits per inch.}$$

3. Assuming that the sett of the harness is 98 mails per inch, and the reed has

30 splits per inch, the amount of cram, or number of extra ends, may be obtained by first finding the number of splits in the width of one repeat of the harness—

$$\frac{\text{Hooks tied up} \times \text{splits per inch in reed}}{\text{Mails per inch in harness}} = \frac{400 \times 30}{98} = 122 \text{ splits in repeat.}$$

Taking the ground to be 2 ends per split, the number of ends that may be added to form the cram = 400 hooks — (122 splits × 2) = 156, which may be distributed as required. Thus the number of splits which may be arranged 4 per split = (156 + 2 ends added per split) = 78 ; 5 per split = (156 + 3 ends added per split) = 52 ; 6 per split = (156 + 4 ends added per split) = 39 ; while a combination of 4's and 5's, or 4's and 6's, etc., may be employed, so long as not more than 156 ends are added, and the total number of splits does not exceed 122.

A smaller amount of cram than 156 ends may be introduced by casting out a number of hooks to correspond, as is shown in the following example, which is a modification of that given in Fig. 260 :—

12 ends,	6 per split	=	2 splits	—	8 ends added.		
88 ,,	4 ,,	=	22 ,,	---44 ,,		:.	
24 ,,	4 ,,	=	6 ,,	— 12 ,,		.,	
88 ,,	4 ,,	=	22 ,,	---44 ,,		.,	
12 ,,	6 ,,	=	2 ,,	— 8 ,,		,,	
136 ,,	2 ,,	=	68 ,,				
360 ,,			122 ,,	116 ,,		,,	

The number of ends is reduced to 360, and in a 400-tie 40 hooks will therefore require to be cast out. The foregoing formulæ, however, apply exactly the same, the total splits in the repeat of the design, and not the total ends, being taken into account in relation to the number of hooks tied up. Thus, with 30 splits per inch in the reed, the sett of the harness will be --

$$\frac{400 \text{ hooks} \times 30 \text{ splits per inch}}{122 \text{ splits in repeat}} = 98 \text{ mails per inch as before.}$$

It may be assumed for the purpose of illustration, that the latter stripe has to be woven in a 384-tie with 40 splits per inch in the reed, in which case the sett of the harness will require to be—

$$\frac{384 \text{ hooks} \times 40 \text{ splits per inch}}{122 \text{ splits in repeat}} = 126 \text{ mails per inch.}$$

SPECIAL HARNESS TIES

From an examination of Figs. 248 and 249 (pp. 214 and 215) it will be readily understood that the harness cords do not necessarily require to be passed through the holes in the comber-board in the same order that they are connected to the hooks (or neckcords), but that they may be passed from one to the other in different orders according to requirements. That is, in tying up a harness various orders of " drafting " the cords may be employed (in the same manner that in dobby weaving the warp threads may be drawn in different orders through the healds) for the purpose

of enabling special forms of designs to be woven economically. The principal
variations from the ordinary lay-over tie are :—(1) centre or point ties ; (2) mixed
ties ; (3) ties for bordered fabrics ; (4) sectional ties (see "Advanced Textile
Design"). Two or more of the systems may be used in combination.

Centre or Point Ties.—This class of tie is the simplest modification of the ordinary
straight tie, and is the same in principle as point-drafting in healds (p. 52). The
object of the arrangement is to enable bi-symmetrical designs to be woven which
repeat upon twice as many ends as there are hooks in the jacquard. The cost of
painting out and card cutting is comparatively small, as the full design is obtained
from one-half of the width of the repeat. Fig. 261 illustrates the principle in reference

Fig. 261.

to a 400-hook jacquard ; the har-
ness cords are tied up consecutively
from the first to the last hook, and
then in reverse order from the last
to the first hook. The cords which
are tied in reverse order are indi-
cated by dotted lines. The figure
formed in the first half of the tie is
reproduced in the second half but
turned the opposite way in the
manner illustrated by the sketch
B below the comber-board A in
Fig. 261. The fabric represented
in Fig. 260 and the sketch given
in Fig. 329 also illustrate the form
of centre tie designs. Although a
400-centre tie will produce a design
repeating upon 800 ends, it is
customary to leave out one end
where the tie reverses, in order to
avoid having two consecutive
ends working alike. The actual
full repeat is therefore 798 ends
produced from a plan painted out
upon 400 ends. The reversing of
the tie also reverses the direction
of twill and other ground weaves,
and in some cases more than one
thread is left out in order to pre-
vent the formation of long floats
where the ground weave is turned.

One repeat of a centre tie may extend the full width of the harness and cloth
(in which case only two cords are connected to each hook) or the tie may be repeated
two or more times across the width, as shown in Fig. 261. The arrangement of the
cords, illustrated in Fig. 261, is suitable when the short rows of hooks are parallel
with the short rows of holes in the comber-board (the Norwich system), but it is
necessary in drawing in the warp to draw from front to back in one half of the tie,
and from back to front in the other half. When, however, the short rows of

hooks are at right angles to the short rows in the comber-board (the London tie—see Fig. 248, p. 214) it is quite convenient to connect the first hook to the front hole and the last hook to the back hole of the comber-board in both halves of the tie, which enables the ends to be drawn in in the same order throughout the full width of the harness.

In the case of designs which turn over vertically as well as horizontally (illustrations of the type are given in Figs. 264, 308, and 315), it is only necessary to paint out and cut the cards from one-fourth of the complete repeat. The figure is turned over horizontally by means of the harness tie (as previously explained), and vertically by causing the cards to turn first towards the machine and then in reverse order away from the machine. In one method of accomplishing this, the last but one of the cards that form the half repeat in length, is perforated so that a special hook is raised. This, by releasing a weighted cord, causes the upper catch of the card cylinder to be made inoperative and the lower catch to be put into action, and *vice versa*.

Mixed Ties.—This class of tie is used in various ways ; one useful arrangement consisting of a modification of a point tie that is employed for designs which, although

Fig. 262.

partly pointed, are required to be less stiff and formal than the pure bi-symmetrical patterns. Thus, a modification of the tie shown at A in Fig. 261 might be arranged with—say, 40 cords on each side of the middle positions tied to separate hooks, which would enable one side of each centre to be designed differently from the other side. The arrangement of the tie would then be 1 to 400, 320—81, as indicated at C in Fig. 261, a design repeating upon 640 ends being obtained from a plan painted out upon 400 ends.

A mixed system of tie-up is employed for the purpose of enabling a certain portion of figure to be introduced more or less frequently than another portion, and the stripe design represented in Fig. 254 might be thus woven. The principle is illustrated by the sketch shown in the lower portion of Fig. 262, and the tie (for a 400-hook jacquard) in the upper portion. The complete design repeats upon 719

ends (allowing for casting-out one end in the centre of the bi-symmetrical stripe), and results from a plan painted out upon 400 ends.

Ties for Bordered Fabrics.—In a bordered fabric the figure at one or both sides of the cloth is different from that formed in the centre. If the ornament in neither border nor centre is repeated, which is generally the case in the better qualities of table cloths, quilts, etc., an ordinary single, a pointed, or a mixed-pointed tie may be employed. Many cloths are made, however, in which the central figure is repeated a number of times, but, as a rule, only one repeat of the border figure is made at each side. The following list comprises the principal ties for cloths, with or without repeating centres, and with a similar border at each side ; the order of tying is given, assuming that a 400-hook jacquard is employed, and that one half of the hooks are employed for the borders and the other half for the centre.

Left Border Tie	Centre Tie	Right Border Tie
Straight Hooks 1-200	Straight Hooks 201-400	Straight Hooks 1-200
Straight Hooks 1-200	Straight Hooks 201-400	Turned-over Hooks 200-1
Straight Hooks 1-200	Pointed Hooks 201-400 and 400-201	Straight Hooks 1-200
Straight Hooks 1-200	Pointed Hooks 201-400 and 400-201	Turned-over Hooks 200-1
Pointed Hooks 1-200 and 200-1	Straight Hooks 201-400	Pointed Hooks 1-200 and 200-1
Pointed Hooks 1-200 and 200-1	Pointed Hooks 201-400 and 400-201	Pointed Hooks 1-200 and 200-1

Any proportionate number of the available hooks may be employed for the border and centre—*e.g.*, one-third for the border and two-thirds for the centre— while a mixed order of tying may be introduced. Very frequently considerable ingenuity is necessary in adapting a design and the tie to suit the size of jacquard that is available.

The form of design and the tie illustrated in Fig. 263 corresponds with the second example in the foregoing list. The border figure is turned over, and the centre is repeated four times, and in order that the different sections may be more readily distinguished the lines which represent the centre harness cards are shown dotted. The complete design will be formed by painting out one border and one repeat of the centre each upon 200 ends.

Fig. 264 corresponds with the last example in the foregoing list in which both the border and the centre are pointed. In this case a square is represented in which a central repeating figure is surrounded by a border figure, and the latter by a narrow unfigured portion. Usually the unfigured portion is woven in a twill or sateen weave, and in the tie indicated in the upper portion of Fig. 264 the hooks 1-8 (of the 26·row

side) are set aside for the purpose. 200 hooks are used for the borders, and the same number for the centre, and if a plain or other selvage is also required the hooks that are in line with the peg-holes may be utilised.

Cross Border Jacquard Arrangements.—Different methods are employed in weaving cross-border fabrics in which the figure is repeated several times, with the idea of using as few cards as possible. The complete square, shown in Fig. 264, contains, both vertically and horizontally, two repeats of the border and four repeats of the central figure. The repetition and arrangement of the different sections of the design, horizontally, is due to the special harness tie that is employed. A

Fig. 263.

similar repetition and arrangement can be obtained vertically by employing two sets of cards, which are brought into action in turn. One set forms the corner and the cross-border figures, and the other set the side-border and central figures. All the cards require to be cut to operate the selvages and the unfigured portion at the sides.

The complete square shown in Fig. 264 might be woven by cutting as many cross-border cards as will weave the portion indicated by the arrow A, and as many centre cards as will produce the portion represented by the arrow C. The two sets of cards are then brought into operation in turn as follows :—First—the border cards turning towards the machine, as indicated by the arrow A, and then away from

the machine until the border figure is completed, as indicated by the arrow **B.**
Second—the centre cards turning alternately towards and away from the machine,
as indicated by the arrows **C** and **D** respectively, for four repeats. Third—the
border cards turning towards the machine to weave the figure portion, as indicated by
the arrow **E,** and then away from the machine, as represented by the arrow **F.** The

Fig. 264.

border cards are then retained in operation, while the first border of the next
square is woven.

In some cases an ordinary form of jacquard is employed and the cards are
changed by hand, but this method is convenient only when the changes have to be
made at long intervals. An ordinary double-lift, double-cylinder jacquard may be

modified in such a manner that it can be used as two separate single-lift machines, provision thus being made for each set of cards to be placed on a separate cylinder. A short vertical rod, which is permanently connected to the crank on the driving shaft of the loom, is attached first to the rod from one griffe and then to the rod from the other griffe, according to which cylinder is required to be operated. The two cylinders are linked together in a special way so that one is made inoperative at the time that the other is put into action. The change from one set of cards to the other is made more quickly than by the hand method ; but as the machine is single-lift the speed of the loom is limited.

Special forms of cross-border jacquards are made on the double-lift, single-cylinder principle, but an extra cylinder is provided upon which the border cards are placed. The centre cards act on the needles and hooks in the ordinary manner, while the border cards, either by means of a series of supplementary needles which are connected to the ordinary needles, or through the medium of specially shaped hooks, produce the same result as if they had been placed upon the other cylinder. The border cards are laced together in the same way as the centre cards, but they require to be turned inside out.

<div style="text-align:center">

CHAPTER XV

JACQUARD FIGURED FABRICS—POINT-PAPER DESIGNING

</div>

Construction of Point-paper Designs—Process of Drafting a Sketch Design—Drafting Designs from Woven Fabrics. *Development of Figures*—Prevention of Long Floats—Bold and Flat Development—Development of Large Figures—Warp and Weft Figuring—Figure Shading—Shaded Weave Bases—Double Shading—Shaded Development of Figures. *Insertion of Ground Weaves*—Printed Ground Weaves—Joining of Figure and Ground—Crêpe Ground Weaves—Stencilling Ground Weaves. Correct and Incorrect Design Drafting.

CONSTRUCTION OF POINT-PAPER DESIGNS

THE construction of jacquard designs includes the preparation of a draft or card-cutting plan upon squared paper, which, if an ordinary jacquard machine is used, shows the complete working of every thread in the repeat. The point-paper design may be constructed from an original sketch, or from a woven sample of which the design is required to be reproduced. In either case the process generally involves an enlargement of the motive design, the degree of increase in size varying, in the same pitch of design paper, according to the fineness in sett of the cloth.

It is first necessary to ascertain the proper counts of the design paper and the most convenient number of ends and picks, or vertical and horizontal spaces of the design paper, upon which to draft the design, as previously described (pp. 217 to 231). It is shown in the calculations that the number of ends and picks, found by multiplying the ends and picks per inch respectively in the finished cloth by the width and length in inches of the repeat, may require to be modified to suit the sett and capacity of the jacquard and the repeat of the ground weave. That is, it is necessary to either select a jacquard which will give the width of repeat of the design, or to construct the

design upon a number of ends that is suitable for a given jacquard. The formula :—

$$\frac{\text{hooks in jacquard} \times \text{sett of warp in reed}}{\text{sett of harness}} =$$

the number of ends upon which the design should be made in order that the warp will be perfectly straight between the harness and the reed. In practice, however, the calculated number is not rigidly adhered to, as it is found that it can be varied, within limits, to suit the conditions of manufacture with practically no deteriorating

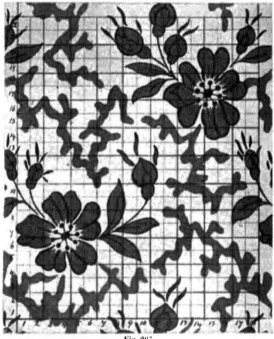

Fig. 265.

effect upon the weaving of the warp. It is a good method to decide upon a number of ends for a repeat which is a multiple of several smaller numbers, and to use this number for cloths which vary slightly in fineness. For example, a 72 sett warp is perfectly straight between the harness and the reed when woven in a 76 sett 304-tie jacquard with the design repeating on 288 ends ; and designs repeating upon 288 ends, or a measure of 288, can be woven in the machine in cloths which vary in sett from 70 to 74. Again, with the same sett of harness, 240 is the calculation number for a 60-sett warp, which may be employed for cloths varying in sett from 58 to 62, The limits given are frequently exceeded in practice. This principle of working.

in addition to avoiding the necessity of filling up mails or breaking out ends when slight changes in the sett of the warp in the reed are made, which would be required if the cast out were also changed, enables the same design to be applied to the different setts without re-making.

After the number of ends and picks required for one repeat of the design have been decided upon, the point-paper work may be divided into the following processes : (1) An enlarged outline of the figure is drawn in pencil or chalk on the point-paper ; (2) the figure is painted in with colour which is strong yet transparent ; (3) the necessary weaves for the suitable development or binding of the figure are inserted in a second colour ; (4) the ground weave is painted in. The work is frequently very tedious and occupies a large amount of time, and considerable skill and experi- ence are required in reproducing a motive design to the best advantage. Much of

Fig. 265.

the work, however, is almost mechanical, and ingenious methods have been adopted to reduce the amount of time and labour involved.

Process of Drafting a Sketch Design.—Previous to drawing the outline of the figure it is necessary to prepare one repeat of the motive design so that it can be enlarged exactly to the required scale. Fig. 265 illustrates the method of procedure in drafting a sketch design. It is assumed that the repeat is upon 288 ends and 352 picks, and the design paper is 8×8. One exact repeat is indicated by ruling vertical and horizontal lines which respectively pass through similar parts of the figure. If the sketch has been correctly constructed, these lines are at right angles to each other. The repeat is then divided into small spaces, each of which represents a certain number of ends and picks in the cloth and of small squares on the point-paper. Any number of threads may be represented by each small space, but usually a sketch is ruled so that each space corresponds to one, two, or more of the large squares of the design paper. In designing for medium and low-sett cloths, it is very convenient

to so rule the sketch that the lines correspond with the thick lines of the design paper. With the same rate of ruling for fine-sett cloths, however, the spaces in the sketch are so small that they are difficult to follow and for cloths which count over 80 threads per inch the method illustrated in Fig. 265 will be found useful. The repeat of the sketch is so divided that each space represents 2 × 2 large squares, or 16 ends and 16 picks in this case. The repeat in width is thus divided into 18 spaces of 16 ends each to correspond with the repeat of 288 ends, and in length into 22 spaces of 16 picks each to correspond with the repeat of 352 picks.

Very frequently a scale is employed in dividing a repeat into the required number of parts, but as shown in Fig. 266 design paper can be readily used for the purpose. The width of the repeat is indicated on a narrow strip of paper; this is placed on

Fig. 267.

point-paper and moved to such an angle that it covers a number of small squares which is a multiple of the number of divisions required. The strip of paper is then marked at the proper intervals where its edge intersects the vertical lines on the point-paper. Fig. 266 shows the width of the repeat of Fig. 265 divided into 18 parts; the strip of paper is shown angled, so that the repeat covers 36 vertical spaces of the design paper, and the paper is marked where its edge intersects the alternate vertical lines of the design paper. Afterwards the strip is placed along the bottom and top of the sketch to which the marks are transferred to indicate the positions for drawing the vertical lines. The same method of procedure is employed in dividing the repeat horizontally.

The different stages of drafting a figure are illustrated in Fig. 267, which corres-

ponds with the bottom left-hand corner of Fig. 265. The portion A in Fig. 267 shows how the outline is copied from the sketch to the scale of 16 ends and 16 picks to each space in Fig. 265. The process of drawing the outline is very much facilitated by indicating distinctive lines at regular intervals in ruling the sketch, and by ruling lines at corresponding distances apart on the design paper. Thus, in Fig. 265 alternate lines are thicker than the others, while in Fig. 267 lines are lightly indicated, to correspond with the thicker lines, upon the last space of every fourth square. The distinctive lines enable corresponding portions of the figure in the sketch and point-paper to be readily found and retained.

The second stage of working, which is illustrated at B in Fig. 267, consists of painting in the small squares along the outline, and then filling in the figure solid

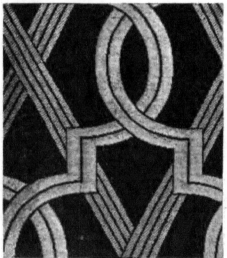

Fig 268.

with a wash of transparent colour. The parts lettered C illustrate the third stage in which the long floats are stopped and the figure developed by inserting marks in various orders in a colour that is in contrast with the first colour. Vermilion is chiefly used in painting in the figure, and blue for the binding weaves.

Drafting Designs from Woven Fabrics.—Woven patterns are employed in two ways by the designer. In some instances the design is required to be reproduced exact in every respect to the original and in a similar cloth ; in other cases the patterns are only intended to serve as indications, the designs being modified and adapted to suit cloths which, perhaps, have very little resemblance to the original textures. In the former case it is essential that—(1) A suitable jacquard be employed to get the same size of repeat ; (2) an exact copy of the form be obtained on the point paper ; (3) the weaves in the figure and ground respectively of the pattern are correctly analysed and reproduced in the new design.

16

The second method of using woven patterns is much more common than the first, and it is probably due to such a large variety of effects being now required for a comparatively short length of cloth that the system has recently attained such prominence. The patterns are purchased by manufacturers and merchants from firms who make a speciality of collecting the latest productions, and when a range of designs is required in a given cloth a number of suitable samples are selected to be reproduced. Only a portion of the ornament in a cloth may be used, and sometimes a portion from one sample is combined with a portion from another. From the manufacturer's point of view the question as to whether such a system should or should not be employed simply resolves itself into one of economy and expediency. The time which would otherwise be occupied in sketching new figures is saved, while

Fig. 269. Fig. 270.

a larger variety of effects can usually be obtained in any given range than when the designer's creative skill solely is relied upon. Further, the advantage to the designer of seeing and studying the various combinations of forms, colours, and materials observable in these patterns, cannot be over-estimated.

The character of the cloth in which a design is reproduced is an important factor in deciding how much resemblance there is between the new design and the original. The new cloth may be composed of different materials ; it may be necessary to increase or decrease the amount of detail in drawing the outline of the figure on the point-paper ; also various weave changes may be required in the figure and ground in order to adapt the design to the new texture. The result is that frequently an effect is produced in which the original design cannot be recognised.

In a range of motive designs the repeats may vary extremely in size, but they require to be modified to the size which can be obtained in the machine in which they have to be woven. It should be kept in mind that the number of ends and picks per inch to the scale of which the figure is drawn upon the point paper is not necessarily the same as that of the cloth for which the effect is intended, but that it varies according to the difference in size between the repeat of the indication and that which the jacquard will give. As an illustration, let it be assumed that designs repeating on 5 in., 3 in., and 2 in. respectively are required to be reproduced in a cloth with 96 ends and 64 picks per inch, and that 360 ends have been decided upon for the repeat. The design on 5 in. will require to be worked out at the rate of $360 \div 5 = 72$ ends per inch and $(64 \times \frac{72}{96}) = 48$ picks per inch ; that on 3 in. at the rate of $360 \div 3 = 120$ ends and $(64 \times \frac{120}{96}) = 80$ picks per inch ; that on 2 in. should be arranged on half the repeat and be worked out at the rate of $180 \div 2 = 90$ ends and $(64 \times \frac{90}{96})$ $= 60$ picks per inch.

Designs which are entirely geometrical in form, such as that shown in Fig. 268, can be reproduced from woven patterns directly on to the point-paper with the aid of compasses and ruler. The positions of the base lines and centres can be obtained by calculation after the number of threads in the repeat have been determined ; also the number of squares to allot on the point paper for any portion of the figure can be found by measuring and calculating from the number of ends and picks per inch to which the design is

Fig. 271.

being worked out. Fig. 269 illustrates, in a very reduced form, the method of drawing the base lines directly upon design paper from the pattern represented in Fig. 268. After these have been indicated it is only necessary to clothe the lines with the calculated size of float.

In drafting woven designs that are not geometrical in form it is necessary to divide one repeat into small spaces in the same manner as in drafting a sketch design. Different methods of accomplishing this are employed, one of which consists of first making a sketch of the figure. A copy is readily made upon transparent tracing paper if the figure can be seen through it. If tracing paper is impracticable the method illustrated in Fig. 270 may be employed. The sample of cloth is pinned or

pasted, at two opposite edges, on to a sheet of plain paper, and the outline of the figure is pricked round with a fine needle. By placing a piece of carbon paper between the cloth and the sheet of paper, with the carbon side downwards (it is better to use paper

Fig. 272.

which is carbonised on one side only) the outline of the figure is shown in small black dots. A pen or pencil is then drawn through the dots to complete the sketch, as shown in the bottom left-hand corner of Fig. 270. Rather more than one repeat should be made, in order that two lines parallel with the weft and two parallel with the warp may be drawn which pass through similar parts of the figure and enclose one complete repeat. This is then divided up by drawing other lines, at regular distances apart, in the manner previously described in reference to a sketch design. It is frequently found that the warp and weft threads are not exactly at right angles to each other, as the finishing processes have a tendency to distort the cloth, and for this reason care should be taken in dividing up the repeat to have the two series of lines parallel

Fig. 273.

with the warp and weft threads respectively, or the figure will not join up correctly at the sides and at the top and bottom of the sheet of point - paper. In drawing the outline on the point-paper the shape of the figure should be observed in the cloth as well as in the sketch.

The construction of a sketch from a woven pattern is chiefly useful when changes in the design have to be made, and when the sketch has to be submitted for approval. If the method is used solely for the purpose of enabling a repeat to be squared out, it is really a waste of time, as other methods may be employed in which the design is made directly from the cloth. In

one method, which, however, is not a very good one, a repeat of the design is squared out by drawing lines on the face of the cloth with coloured chalks. In

another method the pattern is placed on a sheet of cardboard round which threads are wound, vertically and horizontally, at intervals of about a quarter of an inch. By notching the edges of the cardboard, or inserting pins at regular distances

Fig. 274.

Fig. 275.

along the edges, the threads are evenly distributed over the surface of the cloth, so that the design is divided into spaces that are equal in size.

A very quick method of squaring out woven designs by means of threads is illustrated in Fig. 271. An apparatus is used that consists of a wood frame A, which is nicked at regular intervals along the outer edges with a fine saw. Threads are passed vertically and horizontally along the under side of the frame, in such a manner that its interior is divided into small squares. The frame A rests on a flat board B, and is hinged to the latter at C, so that the opposite end of A can be raised while the pattern is placed on the board. The frame is then dropped so that the

Fig. 276.

threads rest lightly on the cloth until the latter has been drawn with a needle into such a position that the picks are parallel with the horizontal threads of the frame, and the ends parallel with the vertical threads, after which the frame is pressed down and secured with a small catch. No difficulty is found in squaring out patterns which are distorted, as the pressure of the threads retains the cloth in any position into which it has been pulled before the frame is pressed down.

The threads are wound at fixed, equal distances apart, so that the surface of the cloth is divided into equal spaces. Taking the spaces to be ¼ in. square, which is a convenient distance apart of the threads, the number of squares of the point paper,

which each division of the pattern represents, may be found as follows:—Assuming that a design has to be worked out at the rate of 64 ends and picks per inch, each division represents 16 squares on the point-paper; if at the rate of 78 per inch, each division represents 19½, or 19 and 20 squares alternately on the point paper. Again, assuming that the pattern shown in Fig. 271 has to be made upon 288 ends and 384 picks—the repeat occupies 16 divisions in width, and rather over 18 divisions in length, therefore each division will represent $288 \div 16 = 18$ ends, and $384 \div 18 = 21$ picks, with six over, which may be allotted to the portion of figure which exceeds

Fig. 277.

the 18 divisions. A figure is drawn on the design paper much more readily if the threads are passed across the frame in alternate colours, the design paper being then ruled, at the required intervals, with alternate colours of pencil to correspond.

DEVELOPMENT OF FIGURES

After a figure has been correctly painted in with transparent colour the next process is, usually, to insert suitable weaves upon it. The weaves should be selected with the following objects in view:—(1) To produce a good texture—that is, a texture in which the threads are interwoven to such a degree that they are not liable to slip or fray when the fabric is subjected to strain and friction during wear. (2) To develop the figure in such a manner that the form is shown to the best advantage in the finished cloth.

Prevention of Long Floats.—In some designs, of which an example is given in Fig. 272, the form breaks up the mass of the figure to such a degree that no weave is

required to be inserted either for stopping the floats of yarn or for developing the effect. This condition occurs particularly when lustrous yarns are employed in forming small figures, which, if broken up too much, appear less bold and effective. Fig. 273 shows the point-paper design of a portion of Fig. 272. The example illustrates the necessity of painting in the squares in odd numbers on the edge of a figure when plain ground, or a ground based upon plain weave, is employed, in order to ensure perfect joining of the ground weave with the figure.

When boldness of effect is required in large figures very frequently binding marks are inserted only where the floats on the face or back of the fabric will other-

Fig. 278.

wise be too long. Such a method of development is illustrated by the sectional plan given in Fig. 274, which represents a weft figure surrounded by warp sateen ground. The example also illustrates how an open figure may be made to appear massive by inserting in the interior a weave—in this case a crêpe—which contrasts well with the ground weave.

Bold and Flat Development.—In some massive styles the form can be effectively developed by inserting a large twill or sateen weave regularly over the surface of the figure, the former being employed when a lustrous and bold appearance is required, and the latter in producing a flat and less prominent effect. Fig. 275 shows how both

twill and sateen weaves may be employed in developing the same figure, the effect in this case being to bring out the twilled portion of each leaf more prominently and with a brighter appearance than the other portion.

Another method of developing leaves, which is similar in principle to the fore-

Fig. 279.

going, is shown in Fig. 276. In this example one of each pair of leaves is brought up massive and bold, while the other appears much less prominent at the same time that its massive appearance is retained. As shown in the corresponding sectional plan, given in Fig. 277, the form of the bold leaf is developed by simply bringing up the

veins in warp flush with a few additional binding places inserted to stop the floats which are too long. The other leaf is developed in fairly bold weft flush along the outer edges, and the interior is filled in with a four-thread weft sateen, except where the veins are shown in warp flush. This plan also shows the correct method of developing the fine lines which form the veins and stems. It is important that these show up distinctly at the same time that they do not detract from the prominence of the main feature of the design, which in this case, is formed by the leaves.

Development of Large Figures.—The pattern shown in Fig. 278 illustrates how a large number of weaves may be employed in developing a massive figure. The contrast in the appearance and the variation in the light and shade of the different weaves give interest to the effect, and assist in showing up the parts of the form clearly. A point-paper section of the main feature of the design is given in Fig 279.

Fig. 280.

Such a combination of weaves in one figure is specially suitable for fabrics composed of cotton warp and silk or mohair weft, which, if woven with plain ground, should be set with from 60 to 80 ends and picks per inch.

The design shown in Fig. 280 is in decided contrast to the preceding example as here only one weave is employed in developing the figure. Such a weave can only be suitably applied to a massive style, in which considerable latitude may be taken in following the outline. A point-paper section of the design is given in Fig. 281, and it will be observed that, in order to prevent long floats and to show up the figure more distinctly, a few threads of plain separate the figure

weave from the ground weave. The example also illustrates a method of employing an expensive material in an economical manner. The following are suitable weaving particulars :—

Warp.

All 2/40's ordinary cotton, shade 1.
72 threads per inch.

Weft.

1 pick 30's ordinary cotton, shade 1.
2 picks 2/40's mercerised cotton or silk, shade 2.
1 pick 30's ordinary cotton, shade 1.
72 picks per inch.

Shade two is brought up prominently in the figure, and, in the 4-thread imitation gauze weave ground, it is arranged to fall on the picks where there is a 4-float of

Fig. 281.

weft on the face. The ground of the fabric is therefore covered with minute spots of mercerised cotton or silk weft, and is in contrast with the figured portion, which is composed of larger spots of the same material.

Warp and Weft Figuring.—The development of a figure in both warp and weft float is illustrated in Fig. 282. This method is chiefly applicable to cloths in which there is a contrast between the colours of warp and weft, and when the two series of threads are brought about equally to the surface in the ground of the fabric. A point-paper draft of a portion of Fig. 282 is given in Fig. 283. In drafting a figure formed in warp and weft float, the outline may be drawn in the ordinary way, then the weft figure is indicated in one colour, say red, and the warp figure in a second colour, say blue. The long flushes in the weft figure are then stopped by inserting blue marks, and in the warp figure by inserting red marks. The colour which is used for the ground weave will usually be the same as that used for the weft figure, and in that case the warp figure should be marked round with red to separate it from

the warp floats in the ground. The card cutting particulars will then be cut blanks and blue. In Fig. 283 both the warp and weft figure is surrounded by plain

Fig. 282.

Fig. 283.

weave, which joins with the 3-and-3 twill ground and assists in showing the figure distinctly.

Figure Shading.—The shaded development of figures enables different degrees of light and shade to be obtained in a graduated form, so that a flower or leaf can be represented in a somewhat natural manner. In Fig. 299 the petals of a rose are shown shaded, while in Fig. 284 portions of a leaf are shaded so as to form a subdued but pleasing contrast with the parts that are developed in bold floats. The principle is applied most successfully to fine silk, cotton, linen, and worsted textures in which the yarns are smooth and even.

Shaded Weave Bases.—The most common forms of shading are produced by using a twill or sateen weave as the base and varying the floats of weft and warp, as shown in Figs. 285 and 286. For instance, a 6-thread twill basis enables five

Fig. 284.

changes to be made—viz., 1-and-5, 2-and-4, 3-and-3, 4-and-2, and 5-and-1, as shown at A in Fig. 285. The space to be shaded, in this case 36 ends, is divided into five sections, and the 1-and-5 twill is marked in, as shown by the crosses. The first section is left as it is, one mark is added in the 2nd section, two marks in the 3rd, three marks in the 4th, and four marks in the 5th, with the result that the warp float is gradually reduced, and the weft float correspondingly increased, and 5 degrees of light and shade are produced.

In the method shown at A in Fig. 285, the warp and weft are brought about equally to the surface of the cloth, hence both series of threads should be of good quality. B illustrates a shaded weave, based upon six threads, which is suitable

for shading a cloth in which, taking the marks to indicate weft, the weft is better material than the warp. There is less variation in light and shade, however, than in the former method. The 1-and-5 twill, indicated by the crosses, is changed to the 1-and-2, 2-and-1, 5-and-1, and 11-and-1 twills in succeeding sections. The last weave is suitable to use in forming the edge of a figure when a prominent outline is required, as represented in Fig. 284.

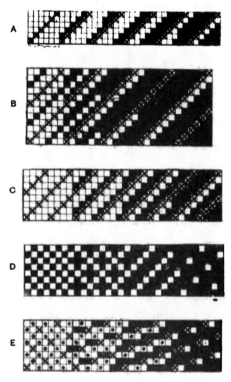

Fig. 285.

C in Fig. 285 shows, in the first three sections, how a 4-thread twill may be changed from warp to weft surface, and, in the 4th section, to 7-and-1 twill.

In the form of shading shown at D in Fig. 285, the floats on the face are arranged to fit with plain ground. This method is suitable for fabrics in which only one yarn is required on the face, as, for example, when silk or lustre worsted weft is employed in forming the figure, and a fine cotton warp is used. The end section shows how the 4-thread twill may be changed to the 8-thread sateen.

E in Fig. 285 illustrates the principle of shading the 8-thread sateen to fit with plain ground. The figure may be either weft or warp surface, according to whether the marks are missed or cut. The 10-thread sateen may be shaded in a similar manner.

F and G in Fig. 286 show two methods of shading the 8-thread sateen weave, each of which gives seven degrees of light and shade. The sateen base weave is indicated by the crosses; in F the marks are added at the top, and in G at the side

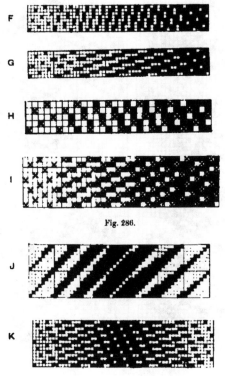

Fig. 286.

Fig. 287.

of the base marks. A comparison of the warp and weft floats in the centre five sections of F and G will show that the method of adding the marks influences the appearance of the weave. F gives more of a warp than a weft surface, as the horizontal weft floats are broken up; hence this method is suitable for fabrics in which the warp is better material than the weft, or when a preponderance of warp float is required on the surface in the figure. G is directly opposite to this, as the

addition of the marks at the side yields a gradually increasing weft surface and breaks up the warp floats ; and this method should therefore be employed when the weft is the better material. As a general rule, a richer effect is obtained by adding the marks at the side because the weft is usually more lustrous than the warp.

H and I in Fig. 286 illustrates two methods of shading applied to the 5-sateen weave. In H the marks are added to the top of the base marks, and four degrees of

Fig. 288.

light and shade are formed. I is similar to H except that the marks are added at the side, while the 5-sateen is changed to the 10-sateen in the end section in order to give further variety.

Double Shading.—The examples given in Figs. 285 and 286 illustrate the principles upon which weaves are shaded, but in the form shown, the designs may be used in the production of shaded weave stripes. Only single-shading, however, is represented—that is, the weaves are shaded only in one direction, so that a com-

plete change from weft to warp surface is made where the first and last ends join. In double-shading, which is illustrated at J and K in Fig. 287, the severe contrast in light and shade, produced in single-shading, is avoided, as the weaves gradually merge into each other in both directions. J in Fig. 287 shows the combination of 8-thread twills, running from 1-and-7 to 7-and-1 by adding one mark more in each section, and then back again to 1-and-7 by adding one mark less in each section. K in Fig. 287 is based upon a 7-thread sateen weave, and is constructed in a similar manner to J, the additional marks being placed at the side of the base marks.

Fig. 289.

Shaded Development of Figures.—Fig. 288 illustrates, step by step, the method of developing a figure in 5-sateen weaves as a shaded effect after the outline of the figure has been indicated on the point-paper. (1) As shown at A, the space to be shaded is divided into as many sections as there are changes in the base weave, and the latter is inserted entirely over the space. The sections need not be equal in size as the given space may be divided up unequally so as to allow either warp or weft to preponderate on the surface. (2) As shown at B, the weave in the first section is left as it is, and a mark is added to each sateen mark in the 2nd, 3rd, and 4th sections. (3) As indicated at C, a second mark is added in the 3rd and 4th

17

sections ; and (4) as shown at D, a third mark is added in the 4th section. It is better to add the marks always at the same side of the base marks, and it is usually more convenient to add them singly, as shown, than to paint over the whole of the figure in one colour, and put in the shaded weave in a second colour.

For the purpose of illustration, several different methods of shading a figure

A B C

Fig. 290.

are shown in Fig. 289. At A the 8-sateen weave is employed for the base, and the weft is brought mostly to the surface, the method therefore being suitable for a fabric in which the warp is inferior to, or possesses less lustre than the weft. The twill method of shading, indicated at B, is suitable for a somewhat coarse texture in which a plain ground, or a ground weave based upon plain, is employed. The binding of

Fig. 291.

the figure in twill order brings out the effect more boldly and with greater lustre than when a sateen weave is employed. The shading shown at C is based upon the 5-thread sateen, and as this weave is firmer in structure than the 8-thread sateen, it may be used in a lower texture than the latter. Boldness of outline and variety

of effect are obtained in C by changing the 5-sateen to the 10-sateen along the outer edge of the figure. At D the 6-thread twill is employed as the base; this weave being changed to the 11-and-1 twill along the outer edge of the figure. A, B, C, and D correspond with the methods illustrated in Figs. 285 and 286; but E shows another system of development, which is sometimes employed when boldness and variety of effect are required. The 8-sateen weave about the centre of E produces a somewhat flat effect compared with the outer edge and the shaded portion of the figure.

INSERTION OF GROUND WEAVES

The difference in appearance between the figure and ground of a design may be due to a difference in material, colour, or weave, or a combination of these; the distinction should always be sufficiently pronounced for the figure to show clearly. When the ground pattern is due to the method in which the threads are

Fig. 292.

interlaced, it is usually necessary to avoid weaves that will produce a bold effect, in order that the prominence of the figure will not be reduced.

Printed Ground Weaves.—Design paper can be purchased upon which the most commonly used ground weaves are printed in small dots, as shown at A, B, and C in Fig. 290. The 1-and-3 twill dot shown at A is chiefly employed for plain and 1-and-3 twill grounds. In addition to enabling the cards to be cut without the ground weave being filled in, the dots enable the outline of the figure to be easily painted in so as to fit with the ground weave.

Joining of Figure and Ground.—In using design paper upon which the 5-sateen weave is printed, as shown at B in Fig. 290, certain of the ground dots that are in contact with the edge of the figure require to be taken out, in order that a proper junction will be made between the figure and the ground. Also, when this causes a float of more than five to be formed it is necessary for the float to be broken by the insertion of an additional mark. This is illustrated by the design shown in Fig. 291, which is arranged with the lines of the figure running at different angles on the point-paper. The crosses show the dots which require to be taken out, and the full squares the marks which are then inserted to stop the long warp floats which

would otherwise appear as stitching marks on the face of the cloth. In inserting any ground weave which does not fit with the moves at the edge of the figure, modifications require to be made at the junction of the figure and ground, as shown in Fig. 291, in order to stop floats that are too long, and to ensure that a clear edge to the figure is formed.

The style of printed design paper, shown at C in Fig. 290, is chiefly used for ordinary fabrics woven with plain ground, in place of the 1-and-3 twill dotted paper. It is, however, specially useful in designing for plain ground cloths in which alternate warp threads are composed of a special yarn which is employed in forming the figure. The dots serve as a guide in painting in the warp figure to fit with the plain ground, and also enable the figuring threads to be readily distinguished from the others. The design shown in Fig. 292 illustrates these points, and shows how the dots on the alternate even threads should be modified under the figure to prevent the formation of long floats of weft on the back of the cloth.

Crêpe Ground Weaves.—The insertion of ground weaves of a crêpe character, such as those shown at D and E in Fig. 293, is usually a tedious process unless a special method of working is employed. A careful examination will usually show that

D Fig. 293. E

the weave marks have not been put together in a haphazard fashion in a crêpe, but that a definite system of construction has been employed which can be made use of in filling in the weave as a ground effect. In the examples different marks are used for the different parts of the weaves, in order that in each the basis of construction may be more readily seen. Thus both D and E in Fig. 293 are arranged on the turnover or reversed principle, and by inserting the weaves, step by step, in the order in which the different marks are indicated a complex effect may be made to appear simple, as the different parts can be put together from memory. For example, the weave shown at E in Fig. 293 may be inserted at four stages. First, that portion of the weave which is shown by the full squares is filled in over the required surface. This is followed by the portion indicated by the crosses, and the ground at this stage has a diagonal appearance, which is afterwards converted into a diamond shape by inserting the portion shown by the circles. The space which remains is then readily filled in by inserting the weave represented by the dots.

When the different parts of a figure are somewhat detached from each other, so that a fair amount of ground space is left between them, the method shown in Fig. 294 may be adopted with advantage in inserting a difficult weave. The

ground weave is first indicated upon a separate piece of point-paper cut the full width of the design, and upon a convenient number of picks. A line is then drawn as close to the figure as is convenient for the correct joining of the figure with the ground, and the ground is inserted around the figure within the lines. Commencing with the first portion of the design the ground sheet of point paper is doubled to fit the space in which there is no ground inserted, and it is pinned to the design until the cards have been cut from this section. It is then moved to the next position, re-

Fig. 294.

doubled (if necessary) to fit the space between the parts of the figure, and another section of the design is cut, the process being repeated until the cutting is completed.

Stencilling Ground Weaves.—In another method of inserting difficult ground weaves, the weave is indicated upon a separate piece of design paper, and small holes are punched in the squares where marks are shown. The separate piece is then placed on the design sheet and brushed over with a wash of colour, and the process is repeated until the whole of the ground has been stencilled in except at the edges of the figure. The joining of the ground and the figure is afterwards readily effected.

CORRECT AND INCORRECT DESIGN DRAFTING

The chief points to note in painting in a figure on the point-paper are (1) to

Fig. 295.

Fig. 296.

form a good outline, and (2) to have the figure sufficiently massive and without weak places caused by fine lines. To obtain these results it is not always advisable to strictly follow the outline drawing, but to modify the form of the figure in painting it in. Typical illustrations of defective and good point-paper work are given for comparison at A and B in Fig. 295. In A the outline is defective because, in following the curves,—say, in moving from the horizontal or the perpendicular to the angle of 45°, as shown at 1—the moves are not properly graduated. For example, commencing with the bottom pick of the figure shown at A, a float of 8 is followed by moves of 3, 4, 2, 3, 1, 2, on succeeding picks. The proper outline, as shown at B, is obtained by moves of 4, 3, 3, 2, 2, 1;

that is, the distance moved at each succeeding pick is gradually reduced as the curve approaches the angle of 45°, after which the distance moved is gradually increased on succeeding ends until the perpendicular is reached.

In binding the long floats of the figure in twill order, a good outline and mass may be made weak if the binding weave is inserted too near the edge of the figure. This defect is shown at the places marked 2 in A, Fig. 295, whereas B shows the binding weave inserted in such positions on the figure that the outline and mass are preserved. Further, a comparison of the lower portion of A and B will show how weakness of outline and of mass, due to fine lines, may be avoided.

An unsuitable method of designing a figure on the point-paper is sometimes the cause of an otherwise well-balanced design showing a line or bar in the woven effect. This may occur under the following conditions:—(1) When both the warp

Fig. 297.

and weft yarns are floated in turn on the face of the fabric, or when two colours of warp or weft are used in producing the figure, without sufficient care being

Fig. 298.

taken to ensure that each kind of float is regularly distributed. The defect is made more pronounced when there is a strong contrast between the figuring

colours. (2) When a horizontal section of the design is given a longer float, and consequently made to show more prominently than the succeeding section, although there may be an equal amount of ornament in each section. (3) When the ground of the fabric is very firmly woven, the ground picks which precede and follow a portion of figure, tend to crowd the loosely bound picks of the latter together, and barriness is thus promoted, because the space occupied by the figure is reduced. In the texture shown in Fig. 296, which has been produced from the sketch given in Fig. 297, a bar appears, which may be said to be due to the combined influences of the preceding. As shown in the corresponding sectional plan given in Fig. 298, the leaves are developed in weft and the flowers in warp float, which instead of being regularly distributed, occur at intervals in large masses. Also, the contrast between the colours of warp and weft is strong, while in addition, the firmly-woven ground of the fabric, by crowding the lightly-bound figure to some degree, has increased, in some parts, the relative amount of the space occupied by the ground. A suitable method of developing the design would be to form all the figure in weft float, not too loosely bound, with the veins in the leaves and the flowers in warp float.

The construction of a design upon point-paper can, in most cases, be greatly simplified by employing a method of working that is appropriate to the basis upon which the design is constructed. For this reason, in the following chapters, the designing of figures upon the recognised bases is considered along with convenient methods of point-paper construction.

CHAPTER XVI

COMPOSITION OF DESIGNS AND ARRANGEMENT OF FIGURES

Methods of Composing Jacquard Designs—Conditions to Observe in Designing Figured Fabrics—Factors which Influence Woven Design—Construction of Sketch Designs—Bases of Textile Design—Geometric Ornamentation—Unit and Repeat Compared. *Construction of Symmetrical Figures. Reversing Inclined Figures. Unit Repeating Designs.*

Methods of Composing Jacquard Designs.—There are three chief ways in which figure designs for textile fabrics are composed, viz. :—

(1) By geometric arrangement.

(2) By the conventional treatment of natural or artificial forms.

(3) By the adaptation or reproduction of earlier designs.

(1) Designs which are purely geometric in form result from the embellishment of intersecting vertical, horizontal, diagonal, circular, and radiating lines ; and from the creation of spaces by the lines. Such designs may include conventionalised forms, or they may be adaptations of earlier styles.

(2) In " conventionalising " a natural or artificial object the form is treated in a manner that renders it a suitable ornamental feature of the texture upon the surface of which it is displayed. It is generally necessary to simplify the form of an object, only the essential and characteristic features being abstracted ; and, as a rule, the most important and beautiful parts are emphasised at the same time that they

are made subservient to the general arrangement of the design. Realistic treatment in the cloth, except in such textures as " woven pictures," should not be practised beyond what will assist in showing the form to advantage. As an example, the conventional treatment of a rose is illustrated in Fig. 299 (which represents a silk trimming fabric), in which the " weave development " imparts a certain degree of realism to the form. The different weaves in the figure, however, have the effect of showing the ornament more clearly by causing the light to be reflected in a varying manner from the different parts. If all the figure had been treated in the same way it would have appeared flat and uninteresting, and would have been less suitable for the purpose of the cloth, while the expensive material, of which the figuring yarn is composed, would not have been made the best use of. In contrast with Fig. 299, the flat treatment of a leaf is illustrated in Fig. 368, which suits the structure and purpose of the cloth, and the means by which it has been woven.

In some cases woven forms are used to convey a meaning, as in representations of the thistle, the shamrock, a lover's knot, etc., the term " symbolic " being then applied to the treatment. Most frequently, however, the sole object of employing conventional forms is to beautify the material, in which case, the treatment is termed " aesthetic." Sometimes, conventionalised natural forms are combined with forms that are " invented," as shown in Fig. 325, while again designs are sometimes composed entirely of invented forms.

Fig. 299.

(3) The adaptation of earlier designs has been practised from the earliest periods, and it may be said that almost all modern styles have resulted from previous ones by the process of evolution. " To adapt " is a more rational method of procedure than to endeavour to work entirely originally by putting aside all that has been previously accomplished. There are innumerable ways in which former designs may be modified and applied ; by small variations new styles may be gradually evolved which finally possess few of the original features.

The term " traditional " is applied to ornament which has been handed down from age to age without losing its original characteristics, although it may have been modified from time to time to suit the requirements of different periods. More or less exact reproductions of historic designs are yet made from famous rugs, tapestries, altar cloths, etc., while copies of recent designs are made by competitors in the same market, and when similar effects are required in cloths that are cheaper than the originals. At the present time, however, designs are most frequently adapted from cloths with the idea of reproducing the ornament in a new form (see p. 242).

Conditions to Observe in Designing Figured Fabrics.—The following is a summary of the principal conditions that have to be observed in designing figured fabrics :—

(1) The ornament should be applicable to the build of the cloth, the nature of the materials employed, and the mechanical means of production, and be suitable for the purpose of the fabric. A style of ornament, that is appropriate to one class of cloth, may be quite unsuited to another class ; the same form may, however, be suitable for different classes of cloths, but it may require to be treated in a different manner in each case.

(2) With some few exceptions, the ornament should be chiefly in solid form or mass, and not in outline. The structure of a woven texture makes it necessary for even the finest lines of a design to be massive (to a greater or less degree according to the cloth) in order that they will show in proper contrast with the ground.

(3) One complete repeat of a design (as in all mechanically repeated designs) must be capable of being enclosed within a rectangular space, the boundary lines of which correspond vertically and horizontally with the direction of the warp and

Fig. 300.

weft threads. The rectangular shape makes it necessary for all textile designs to conform, to some extent, to a geometric basis of construction, but the ornament itself need not be geometrical.

(4) The ornament must join perfectly at the top and bottom, and at the sides of the repeat, in order that when the design is repeated longitudinally and transversely, the pattern will be continuous and unbroken. "Woven squares," in which the ends and sides are not required to join, as in carpets and tablecloths, are an exception to this rule, but usually in these cloths a central figure is required to join to a border. In stripe designs it is only necessary to ensure that the figure joins correctly at the top and bottom of the repeat. This is illustrated in Fig. 313, the dotted horizontal line in which indicates the position where repetition occurs. The width of a stripe must, however, be suitable for the repeat in width of the complete design, while the figures in each stripe must be in proper relation to those in the neighbouring stripes.

(5) The ornament should be properly balanced. A design is defective if the repetition of the figure causes vertical, horizontal, or diagonal lines to be formed in the cloth when such are not desired. Uniform distribution of the primary masses is first necessary, then any details that are added should be arranged to give even balance of the ground spaces. The analysis of good textile designs will show that the orderly arrangement of the parts is almost invariably due to certain bases or principles having been employed in their construction. Previous to sketching a design, base lines may be drawn within the rectangular repeat area in order to

divide the latter into spaces in systematic order. The lines of the figure can be arranged to distinctly follow the base lines, or the latter may be partly or entirely eliminated. In the last case the use of the base lines is simply to ensure that proper balance and accurate repetition are secured.

Factors which influence Woven Design.—In textile fabrics the style of the ornament and the way in which it should be developed are largely influenced by the following :—

(1) The comparative smoothness, lustre, fineness, and sett (or number per unit space) of the threads.

(2) The kind of finish that is applied to the cloth.

(3) The purpose of the cloth.

(4) The mechanical means of production.

(1) Silk fabrics, owing to the lustrous nature of the material, the smoothness and fineness of the threads, and the large number of threads per unit space that are generally employed, lend themselves in the highest degree to elaborate figure ornamentation. It is possible in these fabrics, to obtain extreme fineness of detail, but, as a general rule, the rich, lustrous quality of the material is displayed to the greatest advantage by treating the ornament boldly, and varying the weave development of the figure in the manner illustrated by the example given in Fig. 299.

Elaborate ornamentation and minute weave detail can be introduced in cotton and

Fig. 301.

Fig. 302.

linen fabrics that are fine in structure and finished with a clear surface, as shown in the texture represented in Fig. 300. On the other hand, in coarse fabrics composed

either of cotton or other material, fine weave variations cannot be introduced. In order to illustrate how the relative number of threads per unit space in a cloth

Fig. 303.

influences the weave development and the amount of detail that can be used in a design, a portion of the figure, represented in Fig. 300, is shown worked out on design paper in Figs. 301 and 302. Fig. 301 shows the figure drafted at the rate of 96 ends and 120 picks per inch (this corresponds with the sett of the cloth), whereas in Fig. 302 the sett is taken as 64 ends and 64 picks per inch. The plans will produce exactly the same size of figure in the respective setts; but while in the finer structure it is possible to get a figure intricately developed and graceful in outline, in the coarser fabric the curves of the figure turn more rapidly, and there are fewer spaces to work upon, so that it is necessary for simpler treatment to be employed. The example, further, is illustrative of the adaptation of a design from a fine to a coarser fabric.

Fig. 304.

In figuring with mohair or lustre-worsted yarn it is desirable that the brightness of the material be developed as much as possible. These yarns are frequently employed in conjunction with cotton or woollen yarns, and the cloths are not usually fine in structure. The ornament, as a rule, should be somewhat massive in order that it may be developed boldly in fairly long floats of the lustrous threads. A lustrous cloth is represented in Fig. 303, which has been woven with 2/120's cotton warp, and 24's mohair weft, 66 ends and 60 picks per inch. A portion of the design to correspond is given in Fig. 304. The ground weave is plain, and a crêpe weave, that fits with the plain, is introduced, the example illustrating how a design may be effectively varied without the prominence of the main lines of

the figure being detracted from.
which is illustrative of the
variety of weave effect that
may be introduced in massive
figures which are woven in
lustre-worsted weft.

Botany - worsted fabrics
(which are composed of yarns
made from short fine wool) are
duller in appearance, and have
a less smooth surface than
lustre - worsted fabrics, hence
the designs for them should
be more massive in character
and less elaborately developed
than for the latter. An example
of a botany texture is repre-
sented in Fig. 305, the weaving
particulars of which are 2/60's

Also, in Fig. 278 (p. 248) a fabric is represented

Fig. 305.

warp, and 30's weft, 72 ends and 68 picks per inch. A portion of the design is given
in Fig. 306, in which it will be seen that the figure is woven in a 4-thread weft
sateen weave, and the ground in a similar warp-face weave, but variety of effect is
obtained by the insertion of 1-and-3 twill weave inside the large objects in place of
the 4-sateen ground weave.

(2) The influence of the finish that is applied to a cloth, in deciding the style of

Fig. 306.

ornament and weave development that are suitable, will be understood by comparing
a figured woollen or cotton rug which has a raised surface (see Fig. 141, " Advanced
Textile Design ") with a clear finished cloth. The pile or nap, formed on the surface

by raising, completely conceals the thread structure, so that the introduction of fancy weaves or fine detail in the figure is useless, and only flat massive ornament is suitable.

(3) The effect that the purpose of a cloth has upon the style of ornamentation will be readily evident from a comparison of figured textures that are in regular use such as, carpets, hangings, table-cloths, bed-covers, dress fabrics, mantles, etc. A fabric that is used to cover a flat surface, and is observed from many different points of view, requires different decorative treatment from a texture that has to hang in folds ; while the necessity to cut up cloths for certain uses will render a particular style of ornament totally unfit, whereas another style is quite appropriate.

The use to which a cloth is to be applied, in many cases, largely influences its structure, and the ornament requires to be adapted to the structure as well as the use. Further, cloths that are used for similar purposes may vary extremely in structure, and different treatment of the ornament be necessary in each case.

(4) The mechanical means employed in producing cloths impose very varying limitations, and an intimate knowledge of the type of loom and loom mounting that will be employed is essential to successful designing for most classes of fabrics. Brief consideration will, in most cases, enable the limitations to be realised. For instance, in a plain box loom only one kind or colour of weft can be employed, and in a loom with changing boxes at only one end, the picks of each kind of weft require to be inserted in even numbers ; while the number of boxes limits the number of different kinds of weft that can be used unless changing the shuttles by hand is resorted to.

Different types of shedding mechanism have different limitations : A dobby will operate only a certain number of healds ; the size of repeat of a jacquard is limited ; only a certain maximum number of ends per unit space can be woven in a given harness ; a certain harness tie compels a definite form of ornamentation ; a combination of healds with a harness limits the order in which certain ends can be operated ; in jacquards and harnesses that are specially constructed to produce certain weave structures—e.g. quilts and carpets (see " Advanced Textile Design ")—prescribed orders of interlacing are necessary, etc.

Construction of Sketch Designs.—In sketching a jacquard design the width of repeat that is employed should preferably be equal to, or a measure of that of the machine in which the design will be woven, otherwise the figure will require to be altered in size. The size of a design can be readily increased or decreased in the process of drafting the figure from the sketch, but obviously the nearer the repeat of the design is to the proper size, the truer is the resemblance of the woven effect to the original sketch. It is frequently very difficult to guard against the formation of im-proper stripes or bars in the cloth if only one repeat of a sketch design is made, a defect sometimes not becoming visible until the figure is repeated in width and length in the loom. As a general rule, therefore, it is advisable to roughly sketch several repeats of a design in each direction in order that the relation of the different parts of the ornament to each other in succeeding repeats may be conveniently seen. A simple illustration is given in Fig. 307 which will serve as a general indication of the method of preparing a sketch of a repeating figure. A number of rectangular spaces (in this case two in each direction) are first marked out by drawing lines at the proper distances apart to give the required size of repeat. A vertical waved line is used as the basis of construction in the example, and as this naturally divides the design into two similar parts, each repeat is bisected by drawing vertical and horizon-

tal lines through the centre. The waved line is then drawn in, as shown at A, and repeated in every repeat of the sketch. The chief feature of the ornament, or the "mass," is next introduced, as shown at B, and here great care is necessary. The lines that bisect the repeats enable the position of each mass to be correctly judged, so that approximately equal spaces, in every direction, between the masses, are obtained. When the masses have been traced into each repeat their relative

Fig. 307.

positions can be still more accurately observed, and any imperfection of balance remedied. The next process is the introduction of the detail, as shown as C, and this should be less pronounced in character than the main object, in order that the prominence of the latter will not be detracted from. The detail should be added and copied into each repeat by degrees until the design is complete, care being taken that the different parts balance each other and produce a regular distribution of figure in any given straight line of the sketch.

After a rough drawing of the complete effect has been made over the given number of repeats, it is only necessary for the outline in one repeat to be filled in, as shown at D, for the purpose of indicating how the design should be developed on the point-paper. The last process is necessary only when the sketch is required to be exhibited for approval, as the necessary development can be indicated upon the figure in painting out the design on the point-paper. In the portion D of Fig. 307 the places where the figure may be developed in bold float have been accentuated.

Fig. 308.

Bases of Textile Design.—The bases upon which designs for figured fabrics are chiefly constructed may be conveniently classified as follows :—(1) Geometric bases, which include the square and oblong, the diamond, triangle, hexagon, circle, etc. ; (2) the drop and drop-reverse arrangements ; (3) the ogee and waved line, which may be respectively employed in producing effects similar to those resulting from the second class ; (4) various sateen arrangements.

Geometric Ornamentation.—All repeating textile designs require to be so far constructed on geometrical lines as to enable one exact repeat to be enclosed within a rectangular space, at one edge of which the ornament joins correctly with that at the opposite edge. A distinction may, however, be made between the construction of designs, such as are shown in Fig. 308, which are purely geometric ; and those in which the parts of the ornament consist of shapes in which no geometric form is visible, though the basis of arrangement may be of a geometric character.

At A in Fig. 308, the square is used as the base of construction, as shown by the dotted lines. The design is constructed simply by thickening certain portions of the base lines and leaving other parts blank. This style of ornamentation is chiefly suitable for cloths in which special threads, arranged at regular intervals, are employed in forming the figure.

A similar design to A is given in Fig. 239 (p. 201), while such designs as those shown in Figs. 236, 238, and 242 are readily constructed on the square basis to fit a given order of warping and wefting.

B in Fig. 308 shows a simple geometrical design constructed upon a diamond basis, the lines of which are thickened and left blank in the same manner as in A. The design given in Fig. 309 shows sketch B drafted to a small scale, the solid black figure corresponding with the lines of the sketch, while the grey marks illustrate a method of filling in the ground spaces to give variety to the effect at the same time that firmness of interlacing is produced. By

turning A and B in Fig. 308 round 45° the former shows a design constructed on the diamond base, and the latter on the square base.

C in Fig. 308 shows in the bottom left - hand corner, a repeat divided into rectangles, diamonds, and triangles, which, in most cases, is sufficient to enable very elaborate geometric designs to be made. The design C is constructed by describing circles and arcs of circles, with the intersecting points of the lines taken as centres.

The base lines of the design given in Fig. 310 correspond with the vertical, horizontal, and diagonal lines shown in the bottom left-hand corner of C in Fig. 308. This example illustrates the "counter - change" principle of construction—the

Fig. 309.

weft float in one diamond space corresponding with the warp float in the other.

Fig. 311 shows a suitable method of drafting the design given at C in Fig. 308 to a small scale. The design of a bordered fabric, shown in Fig. 264 (p. 236), and also the design given in Fig. 268 (p. 241), are constructed upon vertical, horizontal, diagonal, and circular base lines, similar to those shown at C in Fig. 308.

The use of any form of squared paper, and, particularly, point paper, is very convenient in designing purely geometric forms, as the small spaces provide a ready means of dividing up a given size of repeat with any number of vertical, horizontal, diagonal, and circular lines, which may then be employed as the framework upon which the pattern is constructed. When design paper is used, in order to avoid having two consecutive threads working alike, the centre of a

Fig. 310.

small space should be taken as the turning point where the figure reverses, as shown in Figs. 309, 310, and 311.

Unit and Repeat Compared.—The difference between the unit and the repeat

18

of a design should be clearly understood. In some designs, in which the form is different in every part, the repeat is formed of one unit. This class of design is illustrated by the example given at A in Fig. 308, in which the unit, forming one complete repeat, is shown shaded. In the same manner, in the design given in Fig. 265 (p. 238), the unit and the repeat are the same.

When a portion of figure is used two or more times in producing a complete design, the unit forms only part of the repeat. Thus, in B, Fig. 308, the portion shown shaded may be taken as the unit, which is used twice in the repeat. Also the unit forms half of the repeat of the design shown in Fig. 294 (p. 261). In C, Fig. 308, the unit, which is again shown shaded, is used eight times in the repeat of the design, and in Fig. 331 a design is shown on point paper which contains the unit

Fig. 311.

eight times in the repeat. A unit figure may thus be used practically any number of times in forming a design, and it may be of any shape, but if it is not rectangular in shape it must be so arranged that the complete repeat of the design is rectangular.

CONSTRUCTION OF SYMMETRICAL FIGURES

Symmetrical ornament may be arranged to form independent figures, or stripe patterns, or, as shown by the geometrical designs given at B and C in Fig. 308, as continuous all-over effects. A given unit, which is used two or more times in forming a complete figure, is either reversed on opposite sides of a centre line, or is turned upon a central point. The most common arrangement is the "bi-symmetrical" or ordinary "turn-over" figure, the construction of which is illustrated in Fig. 312. Two lines are drawn at right angles to each other, and the unit of the figure is built up on one side of the vertical line, as shown by the portion hatched in. As the second half of the figure requires to be exactly like the first half turned over, it can be obtained by copying the unit and the vertical and horizontal lines in pencil upon transparent tracing paper, which is then turned over and placed with the lines upon it coinciding with those of the sketch. By " rubbing " the tracing paper (with a

finger-nail or the back of a knife blade) the outline of the figure is transferred to the sketch. In another method the sketch is doubled inwards along the vertical line

Fig. 312. Fig. 313.

and rubbed. The appearance of the figure can be judged, before the second half is copied, by placing a piece of mirror glass vertically with its lower edge along the vertical line. The arrangement of an independent bi-symmetrical figure, as a complete design, is illustrated in Fig. 335.

Fig. 314. Fig. 315.

The basis of construction of Fig. 313 is the same as that of Fig. 312, but in the former the leaves overlap and interlace with each other in such a manner that the figure forms a continuous stripe. The repeat of the figure from the bottom is indicated by the dotted horizontal line.

A multi-symmetrical figure is shown in Fig. 314, which results from reversing a unit figure, vertically, obliquely, and horizontally. In constructing the style two base lines are drawn crossing each other at right angles, and a second pair crossing the first pair at 45° angle. The unit, shown by the portion hatched in, is sketched in the space of 45°, and thus forms one-eight of the complete figure. The point where the construction lines cross one another is used as the axis upon which the unit is turned in transferring it to the various sections.

Fig. 315 shows a multi-symmetrical figure arranged in stripe form, the unit of which is used four times in the repeat. The all-over design, given in the centre of Fig. 264, is formed by "quadruple reversing" in the same manner as Fig. 315.

Fig. 316. Fig. 317.

Fig. 316 shows the application of the symmetrical principle of construction to a bordered fabric. The narrow border is produced by quadruple reversing in the manner illustrated in Fig. 315, while the broad border is constructed bi-symmetrically, as shown in Figs. 312 and 313.

In Fig. 317 the unit is not turned over, but is simply turned round. Three base lines are drawn which cross each other at 60° angle, as shown by the dotted lines. The point where the lines intersect is used as the axis upon which the unit is turned, and forms the centre of the figure. The central figure and the curved lines are the

same in each space of 60°, but between the curved lines the design is varied by the introduction of a leaf and a flower alternately. The complete unit of the figure thus occupies the angle of 120°, and is turned in three positions.

In the design shown in Fig. 318, which is suitable for the corner of a fabric with a border all round, the unit of the figure is drawn from the corner of the square towards the centre, and is then turned round 90°, and copied in the same relative position from the remaining three corners.

Fig. 318.

In Fig. 319 a simple illustration is given which shows how the unit of a figure may be repeated on point-paper. In this case the unit comprises one half of the complete figure, the second half being obtained by turning the unit round 180°. The centre of the figure is indicated by the crosses, and from this point the second half is copied square by square from the first half.

In constructing such styles as the foregoing, in order that the parts will fit

Fig. 319.

correctly in the complete figure, it is generally necessary for the unit to be built up and copied in stages. Bi-symmetrical figures are specially suitable for hanging

fabrics, while multi-symmetrical designs are useful for textures which are viewed from every direction, as in the case of table-cloths and carpets.

REVERSING INCLINED FIGURES

When an inclined figure is used two or more times in a repeat it is customary to turn it in different ways in order to prevent it from forming twill lines, and to impart a more varied appearance to the design. Fig. 320 illustrates a method of placing a figure in different positions simply by turning it round, its centre being used as the axis ; or, what is the same thing, by placing it each time as centrally as possible within a rectangular space. At A, B, C, and D the figure is inclined at 45° angle; at E, F, G, and H at 22½°; at I, J, K, and L at 67½°; and at M, N, O, and P at 90°.

Fig. 320.

Fig. 321.

In single-make fabrics, in which the figure is formed by interweaving the threads more loosely than in the ground of the texture, the angle of inclination has an effect upon the firmness of the cloth. The nearer the lines of figure approach the vertical or horizontal, the greater is the liability of the threads slipping or fraying when subjected to friction, while the nearer they approach the angle of 45° the firmer is the cloth structure. Of the examples given in Fig. 320, A, B, C, and D, therefore, show the best positions, and M, N, O, and P the most defective, From an examination of A, B, C, and D, however, it will be seen that although the inclination of the figure as a whole is kept the same by turning the tracing round in each case a distance equal to 90°, the inclination of the parts of the figure is not the same in A and C as in B and D. Thus, in A and C the line formed by the small spots approaches the horizontal, and in B and D the vertical. The difference is due to the figure having been simply turned round on its centre, the line a b being placed in a horizontal and in a vertical direction alternately. This does not give a proper reversal of the figure.

A method of reversing is illustrated at R, S, T, and U in Fig. 321, by which the same angle of inclination is obtained not only for the whole, but also for the

parts of the figure. It will be seen that R and T are similar to A and C respectively in Fig. 320, in which, however, no figure is placed the same as S and U. In this method S is obtained from R by turning the tracing of the figure over horizontally. T is obtained from S by turning the tracing over vertically, or from R by turning the tracing round 180°. U is obtained from T by turning the tracing over horizontally, or from S by turning it round 180°, or from R by turning it over vertically. In each position the line a b is in a horizontal direction and parallel with the weft threads, therefore the parts of the figure are always in exactly the same relation to the ends and picks in the cloth. When the same figure is used a number of times in the repeat of a design, this method has the advantage that if the first figure is inclined at the most suitable angle, the remaining figures are equally correct. Also in most arrangements, the figures can be distributed over the given surface with less liability of producing lines or bars in the cloth. However, in some cases, a design appears less stiff and formal if the figure is placed in a multiplicity of different positions. For example, if there are six figures in the repeat four may be placed in different positions at 45° angle, and two at 60°; while with eight figures if four at an angle of 45° alternate with four at 30°, no two figures are placed the same.

R, S, T, and U in Fig. 322, which correspond as to the angle of inclination of the figure with R, S, T, and U in Fig. 321, show how a figure may be reversed on point-paper by copying square by square from the first figure. For small effects this is probably the readiest method. In each case the approximate centre of the figure is indicated by the cross on the twentieth end and sixteenth pick, and a few dots are inserted diagonally from the cross to indicate the direction in which the figure is required to be inclined. The figure is reversed from the cross, the diagonal row of dots enabling the required direction to be readily obtained.

Fig. 322.

B and D in Fig. 322 are obtained by copying square by square from R, but in this case the figure is turned, as shown respectively at B and D in Fig. 320. On

square design paper the only disadvantage of thus turning the figure is that a horizontal line is changed to a vertical line, and *vice versa*. If, however, the cloth is not

built on the square (8-by-6 paper is used in the example), this method of copying throws the figure out of its original shape, as will be seen by comparing the illustrations in Fig. 322. Therefore, in changing the direction of a figure upon paper that is not square, it is necessary for the outline to be drawn or traced each time.

Unit - Repeating Designs

The term unit-repeating is applied to designs in which the unit figure and the repeat are the same. They may be constructed upon definite bases, as shown in certain of the preceding and following examples, but frequently the designs consist of combinations of different forms that are grouped together upon no particular principle, except that they fit

Fig. 323.

satisfactorily together within the repeat area, and join correctly when repeated. With care, variety of effect can be produced which is free from the stiffness

that sometimes characterises designs constructed upon defined bases. Fig. 282 (p. 252) is illustrative of a well - balanced, all - over, unit - repeating design, in which it will be noted that the largest form is comparatively small in relation to the size of the repeat, while the various parts of the ornament are about equally conspicuous.

If one feature of a unit-repeating design shows more prominently than the rest, the repetition of the pattern, from side to side and from end to end of the cloth, is liable to cause the leading feature to form lines in one or both directions. As a rule, when a design contains a distinct object, one or more similar objects

Fig. 324.

should be used in addition, arranged according to a definite base. Such an arrangement may still be unit-repeating, as in the examples given in Figs. 368, 376, and 387.

The unit-repeating principle of arrangement is very suitable for a formal type

of ornament, such as is shown in Fig. 323 and Fig. 407 (p. 345) as the indefinite system, upon which a variety of equally-prominent shapes is introduced, tends to reduce the stiffness of the design. In sketching this type of design a portion of the figure should be drawn in and traced into corresponding positions in the repeat alongside and above the first repeat. Then, by repeating the process carefully and building up the design in stages the various parts can be made to fit correctly together at the edges of the repeat, at the same time that the formation of bars or stripes is avoided.

In the construction of designs for cloths in which a special order of introducing the warp and weft threads is employed, the unit-repeating principle is particularly applicable, as shown in Fig. 324, as it enables the figure to be placed in conformity with the arrangement of the threads.

CHAPTER XVII

HALF-DROP DESIGNS

Half-Drop Bases—The Diamond Base—The Ogee Base—The Diagonal Waved Line Base—The Rectangular Base—Drafting Half-Drop Designs—Half-Drop Stripe Designs—One-third and One-quarter Drop Designs—Defective Half-Drop Designs.

In true half-drop designs the figure in one-half of the complete repeat is exactly the same as that in the other half, and if the repeat is divided into four equal parts by bi-secting it in both directions the ornament in alternate sections is exactly the same. This is illustrated in Fig. 325, in which a half-drop design is shown with the four equal-sized sections detached from each other. It will be seen that the unit-figure comprises one half of the complete design, taken either vertically or horizontally, and that one half of the repeat can be produced from the other half by " half-dropping " the unit longitudinally, or, what is the same thing, by moving the unit one half the width of the repeat.

The half-drop principle of construction is specially useful in designs for carpet fabrics, two or more lengths of which are sewn together at the sides to form a given size of carpet, as the width of the fabric during weaving may be arranged to contain only half the full width of the design. In sewing the lengths together they are adjusted so that each part of the ornament in one length is half the repeat distant from its position in adjacent lengths. The design extends over two widths of the carpet, and is equal in size of repeat to twice the capacity of the jacquard used. The arrangement also has the advantage that in cutting the carpet the amount of waste is sometimes reduced when the length of the repeat of a design is not a measure of the required length of each strip.

Half-Drop Bases.—The chief bases upon which the half-drop principle is applied are the diamond, the ogee, the diagonal waved line, and the rectangle, which are respectively indicated at A, B, C, and D in Fig. 326. The diamond shape is obtained by bisecting the boundary lines of the repeat and drawing lines to connect the points, in the manner shown at A.

The ogee base, represented at B, may be obtained as follows :—The repeat is bisected in both directions, as shown by the dotted lines, and a line E F, which is drawn diagonally from corner to corner of one of the rectangles, is bisected

at G. Lines are then drawn at right-angles to E F, passing through the centres of the lines E G and F G respectively, and cutting the horizontal lines at points H and K. These points form the centres from which the curves are drawn. As a rule, by using tracing paper, the ogee base lines can be drawn with sufficient accuracy freehand.

The waved line, shown at C in Fig. 326, is constructed in a similar manner to

the ogee. In this case, however, instead of the line being turned back in order that it will join with itself in a vertical direction, it is continued in the opposite corner of the repeat, and is joined with itself diagonally.

The square or rectangular plan given at D, is obtained by drawing vertical and horizontal lines through the centre of the repeat. One half of the design is contained within a shaded and a blank section.

The Diamond Base.—The diamond base may be employed in the construction of any form of half-drop design, but it is chiefly serviceable in the arrangement of figures that are more or less diamond-shaped. As shown in the example given in Fig. 327, the leading feature, or the mass of the design is drawn within the diamond space, which is indicated by dotted lines. The four triangular spaces at the corners of the repeat, when united form a second diamond-shaped space equal in size to the first, and the figure is traced into this space in exactly the same relative position as in the first diamond. The correct position of the second figure is obtained

Fig. 325.

by marking the corners of the first diamond on the tracing paper, and then placing the paper so that the marks coincide with the corresponding corners of the second diamond. This ensures that if a line in the first diamond is crossed by a portion of the first figure the corresponding line in the second diamond will be crossed by a similar portion of the second figure in exactly the same relative position. **Two**

or more repeats should be traced in each direction in order that it may be conveniently seen where bare places require to be filled in, or parts curtailed where the figures encroach on each other.

The Ogee Base.—In addition to the form of ogee, illustrated at B in Fig. 326, in which the base lines touch, the lines may be open, as shown at E in Fig. 328; or

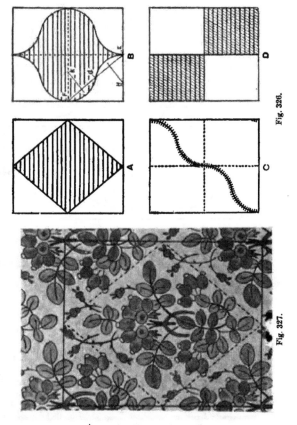

Fig. 326.

Fig. 327.

interlacing, as indicated at F; while closed and open lines may be used in combination, as represented at G; or interlacing and open lines in combination, as shown at H.

Fig. 329 shows the application of a design to the base given at B in Fig. 326. This form of ogee is merely a variation of the diamond base, the ogee lines similarly dividing the repeat into two sections, which are of the same shape and size. A similar method of constructing the sketch may therefore be employed, the figure

which is placed in one space being traced into the other space in exactly the same relative position. The curved lines of the ogee are, however, better adapted than the straight lines of the diamond base for the construction of designs of a graceful flowing character. Designs based on the ogee are specially suitable for hanging fabrics on account of the effective manner in which the lines of the figure play in and

Fig. 328.

Fig. 329.

out of the folds of the textures. In Fig. 329 the large leaves distinctly follow the base lines, and as the latter are in contact the design has a pronounced ogee appearance with the central figures closed in.

A design is given in Fig. 330, which has been constructed upon an open ogee base, similar to that shown at E in Fig. 328. The ogee character is not so pronounced

in this design as in Fig. 329, as the base lines have been used chiefly as a foundation upon which to arrange and connect the parts of the figure.

A design which corresponds with the basis given at G in Fig. 328, is illustrated upon point-paper in Fig. 331, in which a double pair of open lines are shown inter-

Fig. 330.

lacing with a closed pair. The ogee base is naturally adapted to the construction of drop designs of a symmetrical character, and this example illustrates a convenient method of working out such a design directly upon point-paper. The centres from which the lines are turned or reversed are found by dividing the repeat into four equal parts, as indicated by the crosses on the 1st, 17th, 33rd, and 49th squares. The unit

of the figure, indicated by the diagonal marks, is drawn in and painted, and from it the complete figure is obtained by copying square by square.

Fig. 332 illustrates a method of varying the form of ogee lines. There are three pairs of lines in the repeat, and a pair of open lines intersects a pair of lines

Fig. 331.

Fig. 332.

that interlace with each other. The " drop " character of the design is readily seen in the example.

The Diagonal Waved Line Base.—This base is particularly applicable to the arrangement of figures which are required to run in a diagonal direction, as shown in the design given in Fig. 333. In constructing the style, the length of diagonal repeat

is indicated, and the waved line drawn in. The ornament may then be built upon the waved line before the boundary lines are indicated, because the angle of inclination of the line may be varied, within limits, to suit the form of the figure, and to fit the width of repeat that a given jacquard will give. Thus, assuming that the figure shown in Fig. 333 had to be inclined at a steeper angle, the repeat would be increased

Fig. 333.

Fig. 334.

in length, and reduced in width, while by making the figure run at a flatter angle the length of the repeat would be reduced, and the width increased. After the boundary lines have been inserted on the sketch the parts of the figure require to be joined at the edges, and details may be added to the design, if necessary. In Fig. 333 one complete repeat, and its division into four equal parts, are indicated

by the dotted lines, which enable the half-drop principle of arrangement to be observed.

The diagonal basis, although chiefly suitable for the diagonal arrangement of figures, can be employed in the construction of drop designs of an all-over character. An example is given in Fig. 334, in which the waved foundation line is indicated in

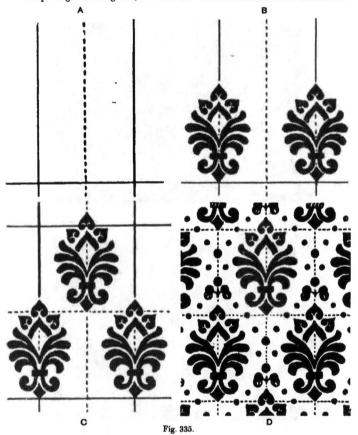

Fig. 335.

the upper right-hand section. It will be noted that a portion of the ornament is inclined in the opposite direction to the base line, and thus counteracts the influence of the latter. There is always a tendency, however, for the diagonal line to assert itself, which prevents its use as a base, except for special styles.

The Rectangular Base.—In the arrangement of given masses or detached

figures upon the half-drop principle, the rectangular base, illustrated at D in Fig. 326, frequently posseses distinct advantages, and except in special cases (as for example,

Fig. 336.

when the ornament is required to definitely follow certain base lines) may be used with greater facility than the other bases. The chief reason for this is that in using a base such as the diamond or ogee it is necessary to indicate both the width and the

Fig. 337.

length of the repeat when the sketch is commenced. With the rectangular basis, however, the length of the repeat can be varied, during the construction of the sketch,

to suit the required size of mass and amount of ground space, at the same time that the width of the repeat is made to coincide with that of a given jacquard. Fig. 325 shows a typical example of a design which can be arranged most satisfactorily on the rectangular plan. The mass is large in proportion to the width of the repeat, therefore, in order to secure proper balance of figure and ground the length of the repeat has had to be made much greater than the width.

Fig. 338.

The method of constructing a drop design on the rectangular basis to fit a given width of repeat is shown in stages at A, B, C, and D in Fig. 335. First, as shown at A, a horizontal line is drawn on the sheet of paper, and three vertical lines, the two outer lines having a space between them equal to the width of the repeat, while

the third, which is shown dotted, divides the repeat into two equal parts. The lines should be drawn in lightly and of unlimited length.

Second, as shown at B, a tracing of the figure is made in a suitable position relative to the base line and the first vertical line. In this case, as the figure is bi-symmetrical, it is conveniently placed with the vertical line passing through its centre. The positions of this line and the horizontal line should be indicated on the tracing paper before the latter is removed, to enable the figure to be again traced in the same relative position to the other lines. A second tracing of the figure is made with the lines on the tracing paper coinciding with the horizontal line and the vertical line on the right. This ensures that the distance from one figure to the other is equal to the width of the repeat, and that the parts of the figure join correctly at the sides.

In the third stage, shown at C in Fig. 335, the position of the intermediate figure is found, and the length of the repeat determined. The tracing paper, placed with

Fig. 339.

the vertical line coinciding with the dotted vertical line of the sketch, is moved in a vertical direction until it is judged that the figure occupies a suitable position in relation to the figures which have already been traced. If placed correctly the horizontal line on the tracing paper will be parallel with the base line of the sketch, and the distance between the two lines will be equal to half the repeat in length. A third tracing of the figure is made and the second horizontal line is drawn in, as shown by the dotted line; then by doubling the distance between the two horizontal lines, the position of the third horizontal line is found. When this is drawn in, the space occupied by one repeat is obtained divided into four equal rectangles.

D in Fig. 335 shows the completion of the sketch. Portions of the figure are traced at the top and bottom, and at the sides, and details of the design are added and traced in stages. By placing the vertical and horizontal lines on the tracing paper to coincide with the corresponding lines of the sketch the additional figure in alternate

sections is readily made the same, and a correct junction formed of the parts of
the figure at the edges of the repeat.

Drafting Half-Drop Designs.—In drafting a true half-drop design upon point-
paper considerable time and labour can be saved by adopting a system which corres-

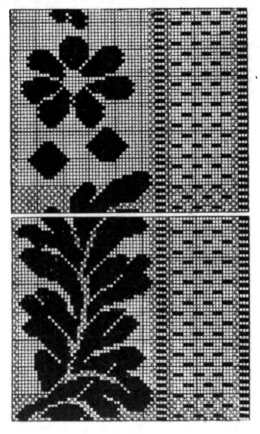

Fig. 340.

ponds with the principle of construction of the design. The method is illustrated
in Fig. 336, which shows the lower half, or the unit, of the design given in Fig. 335
worked out in two sections lettered A and B. Each section is equal to one-fourth of
the complete repeat, and they are placed alongside each other, as shown in Fig. 336,

while the first half of the cards is cut. Then, to enable the cards for the second half of the design to be cut, the two sections are reversed in position, A being placed on the right and B on the left. Only one half of the complete design thus needs to be painted out on the point-paper, but care has necessarily to be taken that the ground weave and the figure at the top of A and B, join correctly with the bottom of B and A respectively.

Fig. 341.

In the construction of all-over designs, in which the figure is rather indefinite in character, the half-drop system is very useful, and an illustration of a design thus arranged is given in Fig. 337. The designer can readily judge the balance of the figure, and the parts can be made to fit correctly together with little difficulty; while in most cases the point-paper work is reduced by about one-half, as compared with a unit-repeating design.

Designs of a formal character, such as the example given in Fig. 338, are frequently drafted directly on the point-paper without the aid of a sketch, and for this class the half-drop system of construction is very convenient, because of the saving in time and labour that can be effected. In drawing and painting in the figure and ground, two sections of point-paper are used, which together comprise one half of the complete repeat, and these are moved about, being placed alongside, and then one above the other, while the parts of the design are made to join up correctly.

Half-Drop Stripe Designs.—In stripe designs the figure is mostly placed at a different level in adjacent stripes, as shown in Fig. 339, in order to prevent the masses from falling into line with each other horizontally. Therefore, although the same ornament is used in each figured stripe, a complete design extends over the width of two or more stripes. In Fig. 339 the different positions of the figure in succeeding stripes is due to dropping it one-half the length of the repeat. In sketching a stripe design, after the figure in the first stripe has been drawn in, its correct position in the second stripe is readily found on the rectangular principle by dividing the repeat horizontally into two equal parts.

In drafting a half-drop stripe design, it is generally only necessary to fully paint out one stripe, as shown in Fig. 340, which corresponds with the example given in Fig. 339. The cards for the first half of the design may be cut with the upper section of Fig. 340 on the right, and for the second half, on the left of the lower section.

One-third and One quarter-Drop Designs.—A unit figure may be dropped each

time a distance equal to one-third or one-fourth of the length of a repeat, and be used
three or four times respectively in the complete design. The method, however,
throws the masses into twill lines, and is therefore only applicable to styles in which
a diagonal effect is not objectionable. A simple illustration is given in Fig. 341,
which shows how a diagonal figure may be readily designed upon point-paper. The
figure is intended to be dropped one-fourth, that is, to repeat diagonally four times,
upon 96 ends and 96 picks. One-fourth of the design is painted out and divided into
four sections, as shown by the portions lettered A, B, C, and D in Fig. 341. Then in

Fig. 342.

cutting the cards the sections are arranged as follows : —First, A, B, C, D ; second,
D, A, B, C ; third, C, D, A, B ; fourth, B, C, D, A.

Defective Half-Drop Designs.—Fig. 342 illustrates the defective appearance of a
design in which an inclined figure is arranged on the half-drop principle. The design
not only has a monotonous appearance, but the arrangement causes twill lines of
figure to show in the cloth. Unless a diagonal effect is desired, only symmetrical,
or well balanced figures are suitable for the half-drop system of construction. An
inclined figure requires to be turned or reversed in the intermediate position.

The half-drop principle may be employed in the arrangement of two figures
which are not alike, and an illustration of the style is given in Fig. 265 (p. 238).
Such a design does not possess the distinctive features of a true half-drop
arrangement, and it is necessary to draft it in the same manner as a unit-repeating
figure.

CHAPTER XVIII

DROP-REVERSE DESIGNS

Half-Drop and Drop-Reverse Designs Compared—Drop-Reverse Bases—Diamond and Ogee
Bases—The Vertical Waved Line Base—The Rectangular Base—Systems of Drafting
Drop-Reverse Designs—Drop-Reverse Stripe Designs—Vertical Reversing of Figures—
Combination of Half-Drop and Drop-Reverse Systems.

Half-Drop and Drop-Reverse Designs Compared.—The pure drop-reverse arrange-
ment is similar to the pure half-drop in the respect that the unit of the design is
contained twice in the repeat, the ornament in one half, in each case, being the
same as that in the other half. The essential difference between the two systems

Fig. 343

is that in the half-drop the figure in both halves is turned the same way, whereas in
the drop-reverse the figure in one half is reversed or turned in the opposite direction
to that in the other half. The latter feature is illustrated in Fig. 343, which shows the
repeat of a drop-reverse design bisected in both directions. In marking the boundary
lines of the repeat in Fig. 343 the vertical lines have purposely been drawn in such
positions that they pass through corresponding parts of the figure in the upper and
lower halves. Each vertical line thus indicates a position where the figure reverses,
and an examination will show that the ornament in alternate sections of the design
is the same, but turned the opposite way. It will also be seen that if the lower half

of Fig. 343 be turned over from side to side and placed above the upper half with the vertical and horizontal lines coinciding, the ornament in the two halves will also coincide.

Drop-Reverse Bases.—The chief bases upon which drop-reverse designs are constructed are the diamond, ogee, vertical waved line, and rectangle, which

Fig. 344.

Fig. 345.

are indicated, in conjunction with a design, at A, B, C, and D, respectively in Fig. 344.

Diamond and Ogee Bases.—In using the diamond or ogee base the figure which is drawn in the one section is placed in the other section in exactly the same relative position to the base lines, but with the tracing turned over. Thus, in Fig. 344, it will

be seen that the unit figure occupies corresponding positions in the diamond spaces of A, and in the ogee spaces of B, a portion of figure that overlaps one space similarly overlapping the other space, but turned over from side to side.

The diamond and ogee shapes are naturally best adapted to the construction of designs in which the lines of the figure follow the base lines. An illustration is given in Fig. 345, in which the large and small central masses are reversed, but the other parts of the figure are bi-symmetrical, and the example shows—in comparison with a style which is entirely bi-symmetrical—how the reversing method tends to reduce the stiffness of a design. Fig. 268 (p. 241) is illustrative of a drop-reverse design which is constructed upon a diamond base.

The Vertical Waved Line Base.—This is a particularly suitable basis to use in the construction of designs of a graceful flowing character. From an examination of C in Fig. 344 it will be seen that the figure is the same on opposite sides of the line, but reversed. The principle of the arrangement is also illustrated by the example given in Fig. 307 (p. 271).

Fig. 346.

The base can also be used with advantage in the construction of designs in which the figure runs continuously in stripe form, as shown in the example given in Fig. 346. The base lines not only afford a suitable foundation upon which to arrange the parts of the ornament, but the addition of the figure, in the same relationship to each half of the line, enables a well-balanced design to be readily produced.

The Rectangular Base.—The relation of the rectangular basis to the diamond, ogee, and vertical waved line will be understood by comparing A, B, C, and D in Fig. 344, in each of which the base lines pass through corresponding parts of the figure. By examination it will be seen that the bases A, B, and C could be similarly indicated upon the design given in Fig. 343 in addition to the rectangular base which is shown. Further, it will be observed that Fig. 343 is arranged similar to D in Fig. 344, except that in the former the sections which contain corresponding parts of the figure are placed alternately, while in the latter they are situated one above another. In both cases, however, the figure in the upper half exactly corresponds with that in the lower half. No matter where the boundary lines of the repeat are

drawn this is a distinct feature of all true drop-reverse designs in which the unit is turned over from side to side. Because of this, and for the reason stated in reference to half-drop designs (p. 289), the rectangular system of arranging a unit figure in the drop-reverse order is frequently preferable to the other bases. Particularly is this the case when the principal figure is not well balanced, or when it is very large in comparison with the width of the repeat. In illustration of the latter point, a design is represented in Fig. 412, in which the figure extends nearly the width of the

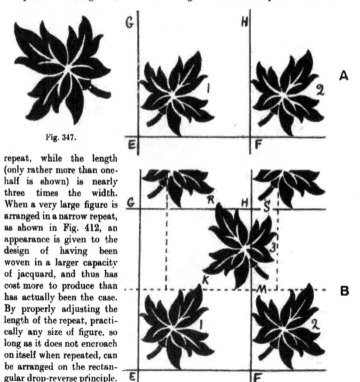

Fig. 347.

repeat, while the length (only rather more than one-half is shown) is nearly three times the width. When a very large figure is arranged in a narrow repeat, as shown in Fig. 412, an appearance is given to the design of having been woven in a larger capacity of jacquard, and thus has cost more to produce than has actually been the case. By properly adjusting the length of the repeat, practically any size of figure, so long as it does not encroach on itself when repeated, can be arranged on the rectangular drop-reverse principle.

The method of arranging a figure (the figure given in Fig. 347 is used) to fit a given width of repeat, is illustrated at A and B in Fig. 348. As shown at A, a horizontal base line E F, and two vertical lines E G and F H, are drawn of unlimited length ; the distance between the latter being equal to the width of the repeat. The figure is inclined at a suitable angle, and a tracing is made, as shown at 1, and the relative positions of the base lines to the figure are indicated on the tracing paper. The figure is then copied.

Fig. 348.

as shown at 2, one repeat distant from the first tracing, in a similar position relative to the vertical and horizontal lines.

B in Fig. 348 shows how the position of the intermediate figure is found. The tracing of the figure is turned over from side to side, and is moved about (the base lines of the sketch and tracing being kept parallel) until it is judged that the reversed figure is in the most suitable position in relation to the figures 1 and 2. Then a third tracing is made, as shown at 3, and the positions of the base lines are transferred lightly to the sketch, as indicated by the dotted lines in C. The reversed figure is usually in the best position when there is an approximately equal space between the figures at K and M ; a smaller overlap, if necessary, being allowed on one side than on the other in order to counteract one side of the figure being heavier than the other side. The position of the third horizontal line G H is found by doubling

Fig. 349.

the distance between E F and the dotted horizontal line, and when this is drawn in one complete repeat is enclosed within the rectangle E G H F. The main feature is again copied above the repeat, as shown, then, if correctly placed, the figures are in exactly the same relation to each other at R as at K, and at S as at M.

As shown in Fig. 349, the sketch is completed by adding the details of the design in one half, and reversing them in the same relative position in the other half. A distinct advantage of this method of arrangement is that, if a proper balance of the ornament is obtained in one half of the design, a similar balance is ensured in the other half.

Systems of Drafting Drop-Reverse Designs.—Different methods of constructing the point-paper design of a true drop-reverse figure may be employed either in working from a sketch or a woven pattern. One method consists of drawing the

complete outline of the figure on the design paper in the same manner as in drafting

Fig. 350.

a unit-repeating design. In another method one half of the design (the unit) is drawn and painted on the design paper ; then a starting point of the second half is found, and the figure is copied in the reverse direction, square by square, from the first half. Thus, in Fig. 350, which shows the design given in Fig. 349 worked out

Fig. 351.

upon 96 ends and 118 picks, the position lettered A corresponds with that lettered B. The latter, therefore, shows a suitable place to commence the copy of the figure in the reversed position and it will be seen that the number of picks from A to B is half of the total number of picks in the repeat. In a third method the first half of the design is drawn on the point-paper, and a copy is made upon tracing paper.

Fig. 352.

Then the tracing is turned over from side to side, placed in the proper position on the design paper, and a reversed copy of the figure made by following the outline with a pencil, or by rubbing. In each of the foregoing methods the boundary lines of the repeat may be drawn in any position in relation to the figure.

A fourth method is illustrated by Figs. 349 and 350, in which the special features of the drop-reverse arrangement—described in reference to Fig. 343 (p. 295)—are

Fig. 353.

taken advantage of to reduce the amount of work in drafting a design. The first vertical boundary line of the repeat is drawn in such a position that the figure is cut in the same relative position in each half, as shown by the line T W in Fig. 349.

(The position of the line T W is exactly between the line E G and the first dotted line in B, Fig. 348.) The lower half of the repeat, taken from left to right, is thus made to exactly coincide with the upper half, taken from right to left. In Fig. 350 the two halves of the design, which are shown detached from each other, correspond with the arrangement of the repeat shown in Fig. 349, and it will be seen, by comparing the picks in succession, that the marks and blanks in the lower half, read from left to right, are the same as in the upper half, read from right to left. It will therefore be clear that it is quite possible to cut all the cards from one half of a plan such as that given in Fig. 350. Sometimes the half-repeat is worked out on transparent design paper, which enables the cards for the second half of the design to be cut by turning the paper over, but ordinary design paper can be used quite conveniently. Further, if the figuring rows of the jacquard are arranged the same from each side

Fig. 354.

(see Fig. 252, p. 221, and the accompanying description) a saving of time can be effected in the card-cutting, as after the first half of the cards have been cut from the design, the second half can be cut from them in a repeating machine. The repeated cards are then turned round (not over) separately, and all the cards are laced together in proper rotation to form the complete set.

The foregoing system is only applicable to designs in which the ground weave can be arranged to read the same from each side, and it is necessary to make the design upon a number of picks which is suitable for the reversing of the ground weave. Thus, in Fig. 350 each half of the repeat is made with an odd number of picks in

order to fit with plain ground. A number of examples are given in Fig. 351, which will reverse properly at the half-repeat if the design contains an odd number of repeats of the ground weave in each case.

The preceding method is quite as applicable in constructing the design from a

Fig. 355.

woven sample as from a sketch. If a thread arrangement is used in dividing up the design (see Fig. 271, p. 243), the sample is adjusted, as shown in Fig. 352, so that a vertical thread cuts the figure in the same relative position in both halves of the repeat, this thread being taken as the commencement of the point-paper plan.

When the ground weave does not reverse it is necessary for the complete design to be made, and a method is illustrated in Figs. 352 and 353, which enables the outline of the figure to be drawn in very readily. The example is a pure drop-reverse, and in Fig. 352 the figure reverses from the vertical line A B ; that is, the figure in the lower half of the repeat is in the same relative position to the line as the figure in the upper half, but on opposite sides. The line AB corresponds with the first end of Fig. 353, and the line C D with the first pick, the position of the latter line,

Fig. 356.

however, being immaterial. The design is divided into spaces (as previously explained in reference to Figs. 265 and 271) commencing with the lines A B and C D. Two sheets of design paper are used, each containing one-half, or rather more than one-half, of the number of picks in the full repeat, and one sheet is turned over horizontally and placed below the other sheet so that the ruled surfaces are on the outside. (By pricking two holes in corresponding positions in each sheet, which are made to coincide when the sheets are put together the

20

squares of the lower sheet can be placed directly below the squares of the upper sheet.) The sheets are secured by pins, and black carbon paper is placed below them

Fig. 357.

with the carbon side upward. As the outline of the figure in the first half of the design is drawn on the upper sheet of point-paper, an exact copy is produced at the same time on the under side of the lower sheet by the pressure on the carbon paper.

Then, as shown at Fig. 353, when the lower sheet is turned over, the figure upon it is reversed, as in the second half of the design, and is approximately in the correct position in relation to the figure in the first half when the sheets are placed together. Some little adjustment of the outline may be necessary where the sheets join.

Drop-Reverse Stripe Designs.—In each stripe of the design given in Fig. 354 the figure is dropped one-half of the repeat, and turned over from side to side. Also, the ornament in the second stripe is dropped one-fourth of the repeat from its position in the first stripe, the complete repeat in width thus extending over two stripes. The mass in one stripe is brought opposite the space between the masses in the other stripe, and the barriness, which would have resulted if the figure in both

Fig. 358.

stripes had been placed on the same level, is avoided. The dotted horizontal lines, which divide the repeat of Fig. 354 into four equal parts, show how correct distribution of the figure is secured.

. A ready method of drafting the style of design illustrated in Fig. 354 is indicated in Fig. 355, which shows the design worked out as a weft figure upon 2-and-1 twill ground, with the narrow stripe developed as an extra warp effect. The complete design of one stripe only is made, but the sheet of point-paper is divided into four equal parts, as shown at A, B, C, and D in Fig. 355. The full design is produced by cutting the cards with the parts placed alongside each other as follows :—First, A and B ; second, B and C ; third, C and D ; and fourth, D and A.

The figure in each stripe of the fabric represented in Fig. 356 is also dropped one-half of the repeat in length and reversed, but in this case the repeat in width

extends over three stripes. In order, therefore, to get a proper balance of the orna-ment, the figure in the second stripe is dropped one-third from its position in the first, and in the third stripe, one-third from its position in the second.

The point-paper design of one stripe of Fig. 356 is given in Fig. 357, which, in order to enable the full design to be cut from it, is divided into three equal parts, A, B, and C. In cutting the cards the parts are arranged alongside each other : First, A, B, C ; second, B, C, A ; and third, C, A, B. The fabric represented in Fig. 356 is composed of silk warp and cotton weft, and the figure is formed in warp float. The figure is surrounded by plain weave, and, as shown in Fig. 357,

Fig. 359.

a 5 × 5 imitation gauze weave is introduced in the ground of the figured stripe, while between the stripes a proper gauze structure is formed.

Vertical Reversing of Figures.—The style of figure illustrated in Fig. 358, which is much heavier on one side than the other, is frequently very difficult to arrange on the drop-reverse principle by turning it over from side to side. It is impossible to get a proper balance of the ornament, on account of the heavy sides coming together in one line, and the light sides in another line. In Fig. 358 the figure has been thus arranged in order to make it fit in the space between the vertical waved lines, which are developed in a simple weave. The presence of the waved lines makes the uneven balance of the design less noticeable than it otherwise would be.

The difficulty of arranging such a style can frequently be got over by turning the figure over from top to bottom in the second position, as shown in Fig. 359. The correct position of the second figure, and the length of repeat which is suitable, may be obtained as follows :—A horizontal base line A B, two vertical lines A C and B D (the distance between the latter being equal to the width of the repeat), and a third vertical line E F, equidistant between A C and B D, are drawn of unlimited length. The figure is traced in a suitable position in relation to the lines A C and A B, and copied, as shown at 2, in the manner described in reference to Fig. 348, care being taken that the positions of the lines A B and A C are correctly indicated on the tracing paper. The tracing is then turned over from top to bottom, and placed with the vertical line upon it coinciding with the line E F. It is moved in a vertical

Fig. 360.

direction until it is judged that the reversed figure is in the best position in relation to the first two figures; and a third tracing is made, as shown at 3. The size of the repeat in length is found by turning the tracing back again, and placing it with the vertical line coinciding with the line A C extended, in such a position that there is approximately the same space between the figures at H as at G. Portions of the figure are then traced at the top, bottom, and sides, in order to show the repeat, and additional detail is added, if necessary. If the sketch is correctly constructed there will be exactly the same space between the figures at K as at G, and at M as at H.

The foregoing system is useful in cases where the figure is required to appear the same way up, when viewed from either end of the cloth. It may also be advantageously used when some distinct shape of flowers or leaves occurs at one side of the figure, as will be seen from a comparison of the sketches given in Figs. 360 and 361. In Fig. 360 the figure is alternately turned over from side to side in the ordinary manner, with the result that the flowers form a pronounced line length-

wise of the design, and the leaves another line. By turning the intermediate figure over from top to bottom, as shown in Fig. 361, the second figure is moved one-half the width of the repeat from the first figure, and the striped appearance is avoided. It will be noted, however, that the stems of the figure come together and form a line across the sketch, while a similar effect is produced by the tops of the leaves falling into a line. The defect, however, is less noticeable than the distinct stripe produced by the arrangement shown at Fig. 360.

From this and the foregoing examples it will be understood that in using a given figure it is necessary to select a system of arrangement which is most suitable for it ; while, with a given system of arrangement, the parts of the figure require to be so distributed that an evenly balanced design will result. Thus, Fig. 362 shows how the flowers and leaves might be re-distributed in order to render the figure suitable for arranging on the principle illustrated in Fig. 360.

In order to show the distinctive features of the design given in Fig. 361, and to illustrate a convenient method of drafting the effect on point-paper, one

Fig. 361.

Fig. 362.

complete repeat of the design is enclosed within the rectangle A B D C, which is bisected by the vertical line E F. The horizontal boundary lines A B and C D cut the figure in the same relative position in each vertical half ; therefore, the figure in one half of the design is exactly like that in the other half, except that it is turned over vertically. Hence, if the line A B be used as the commencement of the design, the complete outline of the figure may be obtained on the point-paper in a similar manner to that illustrated in Fig. 353 (p. 302). In this case the sheet of point-paper is cut vertically into two equal portions, which are placed one above the other, the lower portion being turned over from top to bottom. Thus, in Fig. 363, which shows the complete plan of the design, given in Fig. 361, the two portions are shown detached from each other, and it will be seen that the figure in one half, followed from the bottom, exactly corresponds with that in the other half taken from the top.

Combination of Half-Drop and Drop-Reverse Systems.—Fig. 364 illustrates

a system of arrangement which is particularly useful in securing even distribution of the ornament when the figure is badly balanced. In the example the figure is not only heavier on one side than the other but a distinct floral shape occurs on one

Fig. 363

side at the top. The figure is used eight times in the repeat, and is turned in four directions, and the complete design is a combination of the half-drop and the drop-reverse arrangements. The multiple reversing of the figure prevents the flowers from falling into lines, either horizontally or vertically, while the inclusion of eight

figures in the repeat makes the design less stiff and formal than is the case when only two figures are used. Compared with a two-figure arrangement the chief dis-advantages are that twice as many cards are required, and such large figures cannot be woven because the figuring capacity of the jacquard is practically reduced by one half. It will frequently be found, however, that the system can be employed for

Fig. 364.

figures which are too large to arrange in sateen order, while it possesses many of the advantages of the sateen distribution.

The repeat of Fig. 364 is shown bisected by dotted lines, and it will be seen that the ornament in alternate sections is the same. In drafting the design upon point-paper, it may therefore be treated as a half-drop arrangement, so that only one-half of the effect needs to be worked out, the complete set of cards being cut from the half-repeat in the manner described in reference to Fig. 336 (p. 289).

CHAPTER XIX

SATEEN SYSTEMS OF ARRANGEMENT

Regular and Irregular Sateen Arrangements Compared—Advantages of Sateen Bases. *Regular Sateen Arrangements*—Methods of Distributing the Figures—Methods of Reversing the Figures—Size of Repeat—Methods of Drafting Sateen Arrangements. *Irregular Sateen Bases*—Four-Sateen Arrangements—Six-Sateen Arrangements—Irregular Eight-Sateen Arrangements.

Regular and Irregular Sateen Arrangements Compared.—One of the most important functions of sateen weaves (the construction of which is described and illustrated in pp. 16 to 20) is their use as bases in the distribution of figures. The most commonly used sateens are illustrated in Fig. 365, in which the examples A to G are regular, and H to M, irregular sateens.

In Fig. 366 examples of designs are given which illustrate the comparative effects produced by using the two kinds of sateens as the bases of distribution. In the upper design the spots are arranged in the order of the 8-thread regular sateen, shown at B in Fig. 365, and it will be noted that continuous diagonal lines of figure are formed. This tendency of the primary masses to fall into twill lines is frequently an objectionable feature of the regular sateen orders of distribution. In the lower design the figures are arranged in the order of the 6-thread irregular sateen given at I in Fig. 365. In this case the spots tend to run in threes, the direction of one line opposing that of another, so that there is no possibility of the figures

Fig. 365.

falling into twill lines. A feature of the broken arrangements is the tendency of the figures to group in twos, threes, or fours.

Advantages of Sateen Bases.—Compared with the ordinary half-drop and drop-reverse systems, the best sateen arrangements possess the following advantages :—
(1) There is less liability of stripes or bars occurring in the cloth, as uniform distribution of the primary masses is more readily secured ; (2) a design is more effective because the main feature can be turned and reversed in diverse ways, which enables stiffness and sameness of appearance to be more readily avoided ; (3) the repetition of the pattern is better concealed. The chief disadvantages are that with the same

size of repeat smaller masses are necessary, or, on the other hand, with the same size of mass the capacity of the jacquard must be larger, while there is usually greater expense in cards.

REGULAR SATEEN ARRANGEMENTS

In using the regular sateens as bases it is important that the figures or masses are placed at approximately uniform distances apart. Under ordinary circumstances this condition is secured by selecting a base weave in which there is a similar distance between the marks when viewed from different directions, as in the plans A, B, C, and D, in Fig. 365. These are four of the best regular sateen bases, the suitability of each being due to the feature that a twill line of dots in one direction is crossed by another line about equally prominent in the other direction. Such bases as E, F, and G in Fig. 365, in which the marks form a more prominent diagonal line in one direction than the other, are usually unsuitable. The applicableness of the different sateens will be seen by comparing the examples given in Fig. 367. In each design A, B, C, and D in Fig. 367, the bases of which respec-

Fig. 366.

tively correspond with the plans similarly lettered in Fig. 365, there is an approximately equal space between the figures, while the twill lines, into which the figures fall, are about as prominent in one direction as another. On the other hand, designs E and F in Fig. 367, the bases of which respectively correspond with E

and F in Fig. 365, are defective, because the spaces between the figures are unequal, and the figures form a more pronounced line in one direction than in the other. Circumstances sometimes arise, however, which render such a base as E or F necessary in order to obtain uniform distribution ; as for instance, when the figure is longer in one direction than another, or when there is a considerable difference between the width and length of the repeat.

Methods of Distributing the Figures.—In sketching designs in which the figures are arranged in sateen order, either of the two methods of dividing up the repeat illustrated in Fig. 367, may be employed. In the first method the repeat is divided each way into as many parts as there are figures, as shown by the dotted lines. The number of rectangular spaces in the repeat area is equal to the square of the number of figures, and corresponds with the number of small spaces in the repeat of the sateen base weave. The correct positions of the figure are found by marking the spaces in the order of the sateen base, or by similarly marking the places where the lines intersect. B in Fig. 367 shows the figure placed each time as centrally as possible upon the allotted space; whereas in C the figure is placed each time with its centre as near as possible to the selected place where a vertical and a horizontal line intersect.

In the second method, as shown by the solid lines in Fig. 367, the repeat area is divided into the same number of spaces of uniform size and shape as there are figures. The spaces, in this case, indicate the relative positions of the figure which is traced as centrally as possible within each space.

Fig. 367.

The method in which the positions of the intersecting diagonal lines are obtained will be readily understood by comparing the sketches with the corresponding sateen bases given in Fig. 365. In each base the sateen marks form lines with each other in opposite directions, flat lines being crossed by steeper lines. By drawing lines to connect the weave marks each boundary line of the repeat is divided into a number of equal parts. Thus, to correspond with the sateen bases, in the design A in Fig. 367, the points of connection are found by dividing

the boundary lines of the repeat into two equal parts; in B by dividing the horizontal lines into three parts, and the vertical lines into two parts; while in D the boundary lines are divided into two and also three equal parts. On account of the designs in Fig. 367 having been arranged to fit the two methods of dividing up the repeat, the figures do not coincide in position with the marks in the corresponding weave bases given in Fig. 365. Thus, the first horizontal series of spaces in the design A corresponds with the fifth pick of weave A, and in the design B, with the fourth pick of weave B.

Methods of Reversing the Figures.—The manner in which a figure is turned over or reversed in a sateen distribution has a considerable influence upon the

Fig. 368.

appearance of the design. A in Fig. 367 shows the figure inclined at a different angle in each position—a system which is chiefly suitable for such textures as carpets and table-cloths, in which the design is required to appear similar from any point of view. B in Fig. 367 illustrates a good system of reversing a figure in the 8-sateen order of arrangement, four positions being shown, each of which is repeated. The object is always inclined at the same angle, and is therefore retained in the same relation to the threads in the cloth. Two consecutive figures are inclined to the left and two to the right, in either the steep or the flat twill line; and the same feature will be observed in the corresponding arrangement represented in Fig. 366, in which, however the figure is only turned in two directions. If the figure is inclined alternately to right and left in the 8-sateen regular distribution, cross twill lines of figure are formed, in each of which all the figures are inclined in the same direction, and the design is defective. In the 10-sateen arrangement, shown at C in Fig. 367, the figure is turned in two ways, and in both the steep and the flat twill line the angle of inclination is to the left and right alternately. In the 13-sateen arrangement, given at D in Fig. 367, no two figures are turned the same, which is a particularly suitable method for such a stiff figure in preventing sameness of appearance. In the design E, the figure is turned in four positions, but in F all the figures are placed the same, which not only causes the design to appear uninteresting, but the twill-line effect, due to the unsuitable base, is accentuated.

In addition to turning the same figure in different directions in order to make a design more effective, every figure in the repeat may be different in form, as shown in the example given in Fig. 368. In this design, massive figures turned in diverse ways, are arranged in 5-sateen order. All the figures possess the same characteristics but the difference in shape makes the design appear freer and more attractive.

Size of Repeat.—A convenient method of finding the size of repeat which is suitable for a given figure in a proposed system of arrangement is illustrated in Fig. 369. The size occupied by two figures (roughly sketched in alternate order), with the necessary amount of ground space, is first found, as shown

Fig. 369.

at A. Then the corresponding width and length of repeat for the sateen distribution are obtained by multiplying the ascertained dimensions by—

$$\sqrt{\frac{\text{number of figures required.}}{\text{number of figures given.}}}$$

This formula is applicable to all calculations on changing the number of figures while retaining the same proportion of ground space (see also p. 72). For example, taking the repeat of A in Fig. 369 to be 2 in. wide by 3 in. long, the repeat for the 8-sateen distribution shown at B =

$$2 \text{ in.} \times \sqrt{\frac{8 \text{ figures}}{2 \text{ figures}}} = 4 \text{ in. wide.}$$

$$3 \text{ in.} \times \sqrt{\frac{8 \text{ figures}}{2 \text{ figures}}} = 6 \text{ in. long.}$$

It may be necessary for the repeat in width to be changed to fit the capacity of a given jacquard. Thus, assuming that it is necessary for the design B to repeat

Fig. 370.

on $3\frac{1}{4}$ in., the length of repeat, which will give the same proportion of ground space, will be found as follows—

$$\frac{4 \text{ in. wide } \times 6 \text{ in. long}}{3\frac{1}{2} \text{ in. wide.}} = 6\frac{6}{7} \text{ in.}$$

Changing the relative width and length of the repeat in the foregoing manner is not always practicable, however, because the twill line of figures is liable to be accentuated

in one direction, while it is possible that the change will cause the figures to encroach on each other.

Methods of Drafting Sateen Arrangements.—The following methods of drafting a sateen arrangement of figures from a sketch design or a woven sample can be employed : (1) The full repeat is squared out and all the figures are drawn and painted in independently upon the design paper. (2) One figure is drawn and painted on the design paper, and the remainder are copied square by square from it. (3) One figure is drawn on the design paper and the outline copied upon transparent tracing paper by means of which the remaining figures are traced. The second and third methods are illustrated in Fig. 71 (p. 69), which also shows how the figures are placed in correct relative position to each other on the point-paper.

Fig. 371.

Certain of the sateen arrangements enable abbreviated methods of drafting to be employed, as shown in subsequent examples.

The 8-thread regular sateen base is one of the most convenient to use, not only because even distribution of the figures is readily secured, but on account of the expeditious manner in which the arrangement can be drafted. This will be understood by comparing the design shown at B in Fig. 369 with the corresponding point-paper plan given in Fig. 370. By analysis, it will be seen that the design B in Fig. 369 possesses two distinct features : (1) If the repeat be bisected in both directions, the figure in alternate sections is exactly the same ; (2) the boundary lines of the repeat are drawn in such positions that they pass through the figure in the same way at the top and bottom, and at the sides ; hence, the design appears exactly the same, whether viewed from the top or the bottom. Either feature may be taken advantage

of to reduce the point-paper work by one half. For example, although only **half** of the complete repeat is given in Fig. 370, the second half of the cards can be cut **from** it : (*a*) by dividing the plan vertically into two parts, and reversing the **sections** ; or (*b*) by turning the plan round. The former method can be employed for **an** 8-sateen arrangement whether the figure is turned in two or four directions, but **the**

Fig. 372.

latter only when it is in four positions. Another point worthy of notice, in the latter method, is that if the rows are arranged the same from either end of the **cards,** both halves of the set of cards can be obtained at the same time, by cutting two cards alike from each horizontal space of the design. Thus, the half-repeat shown in Fig. 370, contains 96 cards, and numbers 1 to 96, when turned round, are succes- sively the same as numbers 192 to 97 in the full repeat. In further illustration of

this, it will be seen by comparison that the upper half of the repeat of Fig. 369 exactly corresponds with Fig. 370 when the latter is turned round 180°. It is necessary, of course, for the ground weave to be commenced in such a manner that it will be continuous throughout, but as the direction of a twill line is not reversed, by thus

Fig. 373.

turning the cards, it will be found that the majority of twill and sateen weaves offers no obstacle to the method.

IRREGULAR SATEEN BASES

Four-Sateen Arrangements.—Different methods of arranging figures in 4-sateen order are illustrated in Figs. 371, 372, and 373. The figure in the first example is bi-symmetrical, and it is therefore placed the same in each position. In Figs. 372 and

21

373 inclined figures are used which are turned in different directions ; A in Fig. 372
showing the figure turned in two ways, and B in four ways. In both C and D in
Fig. 373 the figure is also turned in four ways, but the system of reversing is different
in each case. The method of reversing which is most suitable is decided by the

Fig. 374.

shape of the figure and its size, as compared with the size of the repeat. A method
which is convenient for one figure might produce a defective design if employed for
another of different shape. It will be noted in each design B, C, and D, that corres-
ponding parts of the figures are in line with each other, and there is thus a liability

of lines showing in the cloth; but frequently this feature can be made use of to give additional interest to the grouping of the masses.

The positions of the figures are obtained by dividing the repeat each way into four equal parts, and marking the spaces in the order of the 4-sateen weave. If each object is placed centrally on its allotted space the grouping of the figures in pairs is very noticeable, as shown in Fig. 371. It is, therefore, usually better for each object

Fig. 375.

to be slightly moved horizontally and vertically away from the centre of its space, in the manner illustrated by the examples given in Figs. 372 and 373. The distance between the figures of each pair is thereby increased, while that between the pairs is reduced, which not only gives the design a better all-over appearance, on account of the masses being more evenly distributed, but figures can be employed which would otherwise encroach on each other.

The working out of the designs on point-paper can frequently be materially simplified if the basis of construction is taken into consideration. For example, if A and B in Fig. 372 are examined it will be seen that in each design the boundary lines are in such positions that the ornament in the lower half, taken from left to right, is exactly like that in the upper half taken from right to left. The designs thus possess the distinctive features of a pure drop-reverse arrangement, and a corresponding method of drafting can be employed (see p. 299).

In the same manner the design C in Fig. 373 coincides in arrangement with the examples given in Figs. 359 and 361, in which the second half is like the first half turned over vertically.

Fig. 376.

From an examination of D in Fig. 373 it will be seen that the method of construction causes the design to appear the same, whether viewed from the top or the bottom. It is therefore possible, with certain ground weaves, for the complete set of cards to be cut by drafting the half repeat of the design, as shown in Fig. 374, which corresponds with the lower half of D in Fig. 373. The picks, from the first to the last in the given half of the design, are respectively like the last to the first in the other half, taken from opposite sides. The plan shows a fancy crêpe, that fits with plain weave, arranged so that the ground weave will be unbroken where the two halves of the repeat join.

The designs given in Figs. 372 and 373 simply illustrate different methods of arranging the primary masses, but in each system further variety of effect can be produced by introducing additional ornament. Thus, in Fig. 375, two floral figures which form one mass, are arranged in the method shown at A in Fig. 372, while leaves

Fig. 377.

Fig. 378.

and stems are introduced on the drop-reverse principle to fill up the spaces between the figures.

Fig. 376 illustrates a 4-sateen arrangement in which diversity is produced by

the use of a different, although similar, figure in each of the four positions, while small buds and leaves are employed to fill up the ground spaces.

Six-Sateen Arrangements.—Different methods of arranging figures in 6-sateen

Fig. 379.

Fig. 380.

order are illustrated in Figs. 377 to 381. In this case the positions of the figures are found by dividing the repeat both ways into six equal parts and marking the spaces

he 6-sateen weave. The masses group in threes both upward and
secure even distribution it is necessary to place each mass as cen-
upon its space.

)f its symmetrical form the figure in Fig. 377 is placed the same in
Inclined figures, however, afford considerable scope for producing
t, as a variation in the method of reversing causes a change in the
iasses to each other. This is illustrated by the designs shown in
/, while many other arrangements can be made.

·iven in Fig. 380 shows how the 6-sateen order naturally permits

Fig. 381.

two different forms to be introduced, one of which occupies the central position
of each group of three figures. It will be noted in the example that the central
figures are distributed in the drop-reverse order, and form the main features of the
design ; while the remaining figures are subsidiary, but in such positions that they
overlap and give perfect distribution.

The design given in Fig. 381 shows how variety of effect may be produced by
combining a 4-sateen order with the 6-sateen. The figure in the latter order is
turned in two directions, and forms the main feature of the design ; while that in the
4-sateen order is made subsidiary and quite distinct in character, in order that the
contrast will be effective. The centres of the secondary figures can be conveniently

found by drawing two lines diagonally from corner to corner through three spaces, as shown, and marking off from the extremities a fourth of the length of each line.

It will be noted in each design given in Figs. 378 to 381 that instead of the first figure being placed on the first space it is placed on the sixth, the order of arrangement thus being changed from 1, 3, 5, 2, 6, 4, to 6, 2, 4, 1, 5, 3. This enables the grouping of the figures to be more readily seen, but the chief advantage is that the figures are

Fig. 382

in such positions in relation to the boundary lines of the repeat that the design can be readily made with the lower half exactly like the upper half turned over. An examination will show that Figs. 379, 380, and 381 are thus arranged, and the feature may be made use of to simply the construction of the point-paper plan, in the same manner as in drafting a drop-reverse arrangement. Thus, Fig. 382 shows the half-repeat of Fig. 379 drafted upon 128 ends and 80 picks, and so far as regards

the figure the marks from left to right in this half correspond with those from right to left in the second half. With ground weaves that will reverse the arrangement

Fig. 383.

Fig. 384.

enables all the cards to be cut from the half-repeat, but the ground weave shown in Fig. 382 requires the full design to be made.

Two methods of giving additional interest to designs in which the 6-sateen is used as the basis of distribution, are illustrated in Figs. 383 and 384. In the former

Fig. 385.

the sateen figure is turned in two directions, while the space between the figures is filled in with a trail effect arranged on the drop-reverse principle. The lower half of the design is exactly like the upper half turned over from side to side. In Fig. 384 the sateen figure is turned in four directions, but in this case the ground space is filled in with four additional masses, arranged in alternate order. The arrangement is such that one-half of the design is exactly like the other half turned over vertically, and the example therefore corresponds, as regards the method of drafting, with that shown in Fig. 361 (p. 310).

Irregular Eight-Sateen Arrangements.—Standard irregular 8-sateen arrangements are shown in Figs. 385 and 386 ; the object in the former being placed on

Fig. 386.

the spaces in the order of 2, 4, 8, 6, 3, 1, 5, 7, and in the latter in the order of 2, 5, 8, 3, 7, 4, 1, 6. The chief difference between the arrangements is in the manner in which the figures group in pairs. Even distribution of a given mass can be secured upon either basis, by suitably proportioning the length and width of the repeat, but the shape of the ornament generally decides which arrangement is the more suitable. Thus, in Fig. 385 the figures group in pairs outwardly, the greatest distance between them being in a vertical direction, so that the arrangement is suitable for figures which are longer than they are broad.

In Fig. 386, on the other hand, the figures group in pairs vertically, and the greatest distance between them is in a horizontal direction, hence this arrangement is more suitable for flat figures.

The designs given in Figs. 385 and 386 are constructed in a manner that enables them to be readily drafted upon point-paper. Thus an examination of Fig. 385 will show that the figure is so reversed, and the boundary lines are in such positions, that the design appears the same whether viewed from the top or the bottom. Therefore if the ground weave is suitable, the design may be drafted, as illustrated by Fig. 374. In Fig. 386 the upper half of the design is exactly like the lower half turned over, and the design can therefore be drafted in one of the methods previously described in reference to a drop-reverse arrangement.

A representation of a fabric in which the figure is arranged upon the same basis as Fig. 386, is given in Fig. 387, but in this case a different shape of figure is used in each position, so that no simplification of the point-paper work is possible.

Fig. 387.

Fig. 299 (p. 265) illustrates a third grouping of the figures in the 8-sateen irregular order, which can be used

Fig. 388.

to yield good results. The flowers which form the masses are placed in the order of 3, 1, 5, 2, 6, 8, 4, 7, and small buds are inserted to fill up the ground spaces.

The design given in Fig. 388 is arranged upon the same basis as Fig. 299, but in this case each unit is formed of two figures, which are reversed in such a manner that they fall into straight lines. The example illustrates that the basis readily lends itself to the production of a design of a geometrical character, which is arranged on the drop-reverse principle. Figs. 299 and 388 show, by comparison, how widely different styles can be constructed in the same basis of arrangement, the ornament in the former being as free as in the latter it is stiff.

CHAPTER XX

CONSTRUCTION OF DESIGNS FROM INCOMPLETE REPEATS

Completion of Repeats by Sketching and by Drafting upon Design Paper

FREQUENTLY designs have to be reproduced from small cuttings of cloth which show only a portion of the complete repeat of the figure. This is due, in many cases, to the original sample having been cut by the merchant into several pieces to enable quotations to be obtained simultaneously from different manufacturers. In some instances, it is only necessary for the ornament which is introduced to complete the design to be in keeping with the given portion of figure. In other cases, however, and particularly in cloths for Eastern markets, it is very necessary that as little deviation as possible be made from

the original design. Good judgment, combined with an intimate knowledge of the various bases upon which designs are constructed, and of what constitutes a well-balanced design, will generally enable an accurate copy of the original figure to be obtained in an expeditious manner.

If the repeat in width is incomplete, an endeavour should be made in filling in the missing portion, to adapt the figure to the size of repeat which can be obtained in the jacquard for which the design is intended. The missing portion of figure may be added, either by making a complete sketch of the design, or by working directly on the point-

Fig. 389.

paper from the sample ; and the method of drafting the figure will vary according to the basis upon which it is judged that the design has been constructed.

Assuming that the figure is required to be reproduced from the small sample of cloth represented in Fig. 389, a sketch of the complete design may be constructed, as shown in Fig. 390. In this method an accurate copy of the outline of the given portion of figure is first made, either by tracing or by pricking round the edges, and a horizontal line is drawn parallel with the weft threads. In Fig. 390 the solid

assumed that the portion of figure, shown at G in Fig. 393, corresponds with that indicated at H when turned over from top to bottom. The distance in a horizontal plane from G to H is then equal to half the width of the repeat, so that the construction of the complete design is similar to the example illustrated in Fig. 359 (p. 308). The two halves of the repeat are indicated, as represented by the vertical

Fig. 392. Fig. 393.

lines in Fig. 393, and by means of tracing paper the given portion of figure is copied the width of the repeat distant, as shown by the lightly-shaded figure on the right.

Taking the two floral shapes to be the main feature of the design, the tracing is turned over from top to bottom, and placed with the vertical lines corresponding,

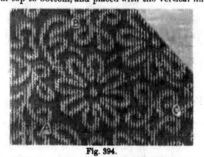

Fig. 394.

one half the repeat to the right from the first figure. It is then moved in a vertical direction until it is judged that there is about the same space between the main figures at I as at J, and a tracing is made as shown by the darker shaded figure. The repeat of the design in length is thus indicated, and portions of the main

figure are traced at the top and sides, and the missing parts are drawn in, as shown by the figure in outline. The ornament which is introduced to fill up the ground space, can either be made to reverse from top to bottom in the same manner as the main feature, or it can be filled in on the all-over principle, as in the example.

In most cases the readiest method of drafting an incomplete design is to draw the outline of the given portion of figure to scale directly from the cloth on to the point-paper, some form of thread arrangement being used for squaring out the pattern. It is also convenient, although not so expeditious, to sketch the given portion of figure, and divide it into spaces by ruling lines. It is not, as a rule, necessary for time to be occupied in making a complete sketch of the design, as the figure can be completed on the point-paper after the given portion has been drawn and painted in. This is illustrated by the example shown in Figs. 394, 395, and 396. An analysis of the pattern given in Fig. 394, and the corresponding sketch shown in the lower portion of Fig. 395, will show that the same shape of figure occurs at the positions

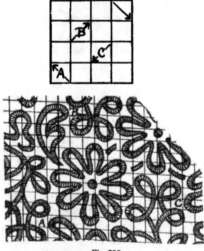

Fig. 395.

lettered A, B, and C. Taking A as the starting-point, at B the figure is turned over from side to side, and at C from top to bottom. The distance between two horizontal lines which pass through corresponding parts of the design at A and B thus gives half the repeat in length, and similarly the distance between two vertical lines which pass through corresponding parts at A and C gives half the repeat in width. The basis on which the design has been constructed is therefore the 4-sateen, the unit being placed and reversed as shown in the upper portion of Fig. 395. The sketch in the lower portion is shown squared out in preparation for drawing the figure to scale on point-paper, the half repeat in width (from A to C) being divided into 11 parts, and in length (from A to B) into 10 parts. The complete point-paper

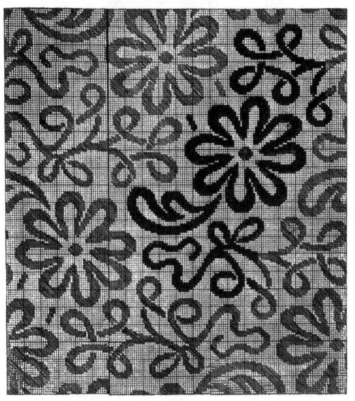

Fig. 396.

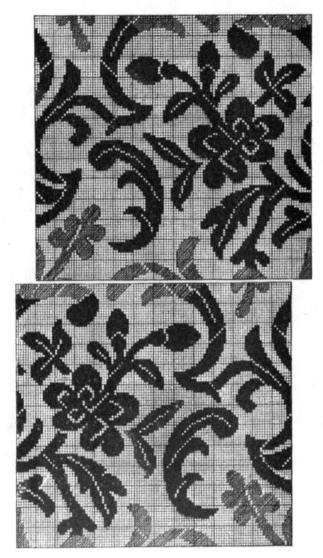

Fig. 397.

plan is shown in Fig. 396, each division of the sketch being taken to represent eight ends and picks, so that the full design repeats upon 176 ends and 160 picks. In drafting the figure on the point-paper it is first necessary to indicate the unit of the design, as shown by the portion filled in solid in Fig. 396. The unit is then repeated three times, as shown by the shaded figure, either by copying square by square, or by the aid of tracing paper, the required positions being readily obtained by comparing with the pattern, and by noting that corresponding parts are half the repeat distance from each other in width or in length. A further point to note is that one vertical line (the fifth), in Fig. 395, cuts similar parts of the figure in the same relative position, and is taken as the centre of the point-paper plan. The second half of Fig. 396, when turned over, is therefore exactly like the first half, as in the case of a drop-reverse design.

When the given figure of an incomplete design is somewhat massive, and there is no indication of the basis of construction, as in the example shown in Fig. 398,

Fig. 398. Fig. 399.

a convenient method of procedure consists of arranging the mass on the drop-reverse principle. The given portion of figure is thus made full use of by being included twice in the repeat, and the style of the design is retained, while the minimum of space has to be filled in with missing figure. The method illustrated by Fig. 398, and the corresponding complete design given in Fig. 397, is based upon the system (described in reference to Fig. 353), in which the two halves of a drop-reverse design are drawn at the same time by using two sheets of point-paper, one of which is turned over and placed directly below the other sheet, with a sheet of carbonised paper underneath. The width of repeat that is most suitable for the design is estimated, and the given figure is drafted to scale accordingly. Before separating the sheets of point-paper an endeavour is made to join up the figure at the sides. Then the two sheets are put together and adjusted so as to get a suitable length of repeat and even balance of the figure ; and, if necessary, a portion of the upper sheet is transferred from one side to the other. Thus, in Fig. 397, the solid marks in both halves

show the portion of figure obtained from the pattern in Fig 398 at the first drawing, and the shaded marks the portion added, while in order to make the design fit correctly eight threads require to be transferred from the right side to the left of the upper half.

Figs. 399 and 400 show another convenient method of constructing the complete point-paper design from a small cutting, which, however, can only be used when

Fig. 400.

the given figure is evenly balanced. The point-paper draft, shown in Fig. 400, is made upon a comparatively small number of threads, and is therefore different in several respects from the figure represented in Fig. 399. Only one half of the complete design is given in Fig. 400, but the main feature is so arranged on the point-paper and the additional details are drawn in in such a manner that the second half

of the design is exactly like the first half turned round 180°. The first to the last pick in the first half taken from left to right, correspond with the last to the first pick in the second half, taken from right to left, the lower portion of the first figure thus forming the upper portion of the second figure, and *vice versa*. The main feature of the design is arranged in alternate order, but as turning the figure round 180° does not alter the angle at which it is inclined, the method is not suitable for inclined figures.

CHAPTER XXI

FIGURING WITH SPECIAL MATERIALS

Imitation Extra Weft Figures—Imitation Extra Warp Figures—Figured Warp-Rib Fabrics—Rib Designs produced in Two Colours of Warp—Methods of Ornamenting Warp-Rib Structures.

BY careful and judicious arrangement special materials can be employed in such a manner in developing a design as to give the impression that extra threads are included in the cloth. The special figuring threads may be introduced, either in the weft or the warp, the latter method being usually the more convenient. In intermittent figured fabrics bright lustrous threads, either warp or weft, may be inserted

Fig. 401.

where the figure is formed, and an ordinary class of yarn in the spaces between, both classes of threads being interwoven in the same manner in the ground portions of the cloth. Under certain conditions the difference between the yarns is scarcely observable in the ground, and a bright lustrous figure is produced with a minimum use of the more expensive yarn.

Imitation Extra Weft Figures. The fabric represented in Fig. 401, and the corresponding sectional plan given in Fig. 402, show how an ordinary fabric may be made to appear as if figured with extra weft. The figure and the order of wefting are arranged to coincide, and in the example the picks are inserted in the order of 16 dark and 16 light, to correspond with the arrangement of the figure, which in Fig. 402 is indicated in the same order by different marks. In order to produce the imitation extra weft effect, it is necessary for the ground of the cloth to be warp surface, in strong colour contrast with both wefts, and very finely set ;

as for example, for the 8-thread sateen ground weave—160 ends per inch of 2/80's cotton. Except for a slight shadiness, the weft intersections in the ground are concealed by the fine setting of the warp, and the figure is developed in two distinct colours on what is practically a solid-coloured ground.

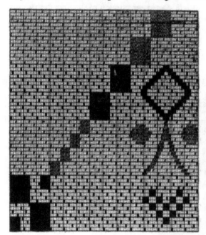

Fig. 402. Fig. 403.

Imitation Extra Warp Figures.—The foregoing principle can be employed in producing an imitation extra warp effect by colouring the ends in sections to correspond with the form of the design. Fig. 402, turned one-quarter round, is illustrative of the method, the marks being taken to indicate warp so that a warp figure in different colours will be formed upon a weft-face ground.

Another method of figuring with special warp threads is illustrated in Fig. 403, and the corresponding design given in Fig. 404, in which the marks indicate warp. The arrangement in the warp is 2 ground threads of 2/60's cotton to 1 figuring thread of 2/10's mercerised cotton, or 2/15's worsted, 48 threads per inch;

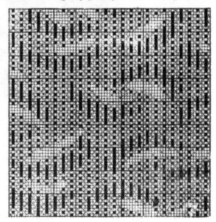

Fig. 404.

while the weft is 20's cotton in the same colour as the ground warp, 56 picks per inch. The cloth is chiefly ornamented by floating the thick warp threads, as

indicated by the solid marks in Fig. 404, but weft figure is also formed, as shown by the blank spaces in the design. Similar styles are woven in which the warp threads are arranged in the proportion of 3 ground to 1 figuring, or 4 ground to 1 figuring, etc., the decrease in the proportion of the figuring threads being usually compensated for by an increase in their thickness.

Figured Warp-Rib Fabrics.—As previously explained in reference to Figs. 94 and 95 (p. 87), a typical warp-rib structure is composed in warp and weft of a fine thread alternating with one thick thread, or two or more threads working together as one, while with the weft all the same thickness a good warp rib results so long as the ends are properly balanced. In figured warp ribs the ends which form the rib are generally composed of a lustrous material, and they are floated on the surface in the manner illustrated by the fabric represented in Fig. 405. The following are suitable weaving particulars :—

Warp, 2 figuring ends (in one mail) of 2/40's mercerised cotton, 1 binding end of 2/60's cotton, 40 double-figuring ends, and 40 binding ends per inch.

Fig. 405.

Weft, 36's worsted or 24's cotton in the same colour as the binding ends, 54 picks per inch.

A in Fig. 406 shows the complete weave of a portion of the design represented in Fig. 405, the solid marks indicating the lifts of the double figuring ends, and the diagonal marks those of the binding ends. The ground of the cloth is plain weave, and the figuring warp floats are arranged to fit with the plain, which, as shown in Fig. 405, causes the figure to appear very prominently, but with a stepped outline. It will be seen in A, Fig. 406, that all the figuring ends are raised on the even picks; the binding ends are raised on the odd picks in the ground, but where the figure is formed they are lifted in alternate order. The odd binding ends, however, work alike in plain order throughout the design, and they, therefore, may be drawn upon a heald placed in front of, or behind the harness, and be operated independently. This arrangement enables the figuring capacity of a jacquard to be increased by one-third, as compared with a full-harness mount—that is, 80 harness cords per inch are required in a full-harness mount to suit the foregoing particulars of the cloth; whereas in a heald-and-harness arrangement only 60 harness cords per inch are

necessary. In the latter method the design is indicated, as shown at B in Fig. 406,
8 × 7 design paper being used to correspond with the 8 × 5 paper given at A.

Fig. 406.

 In another method of producing the figured warp-rib structure, all the binding
ends are drawn through a heald, the capacity of the jacquard thus being doubled.

On the even picks all the harness is raised, and on the odd picks the heald and as many harness cords as are required to be lifted to form the figure. The chief dis-

Fig. 407.

advantage of the method is that on the picks on which the heald lifts long floats of

Fig. 408.

weft are liable to be formed on the under side of the figure; but, on the other hand, small jacquards can be adapted to produce large repeats, while the construction of

the point-paper design is very much simplified. Thus, the design to correspond with A in Fig. 406 will be constructed, as shown at C, in which the lifts of the figuring threads on the odd picks only are indicated, the ground ends being raised by the heald. In cutting the cards the marks of C are cut on the odd cards, while the even cards are fully perforated, if the cloth is woven right side up. The harness lifts are made much easier by weaving the cloth wrong side up.

Fig. 406.

The combination of weft figure with a warp-rib figure is illustrated by the fabric represented in Fig. 407. The inclusion of the weft figure makes it necessary for all the ends to be operated by the harness, and the design is constructed in the method shown at A in Fig. 406, except that the weft effect is indicated in a different colour in order that it may be cut opposite to the warp figure.

Rib Designs produced in two Colours of Warp.—The fabric represented in Fig. 408 illustrates a class of figured warp rib which is different in structure from the

Fig. 410.

foregoing. In this case all the ends are similar except as regards colour, the

Fig. 411.

arrangement being an end of pink and light green alternately. In the ground differently coloured horizontal rib lines are formed, and both colours are employed

in producing the figure. A section of the design on point-paper is given in Fig. 409, the full squares representing the figure produced by the pink warp, and the crosses that formed by the light green warp ; while the shaded squares show how a subsidiary effect is obtained by floating both colours of warp together, the intermingling of the colours giving a grey appearance to this portion of figure. Since both colours of warp are used separately for figuring, the warp threads should be finely set, and equally lustrous. The weft requires to be even and smooth, and of a neutral shade, while fewer picks per inch than ends may be inserted—as, for example, for plain

Fig. 412.

ground weave, 60 picks per inch of 30's ordinary cotton, and 80 ends per inch of 2/40's mercerised cotton.

In the fabric represented in Fig. 410, the warp threads are arranged alternately in two colours, as in the preceding illustration, but in this example a portion of the figure is formed by the weft, the colour of which is in contrast with the warp colours. Thus, as is shown in the corresponding point-paper section given in Fig. 411, the flower is formed by floating the odd ends in one section, as indicated by the full squares, and the even ends in the other section, as represented by the crosses, while the weft forms the leaves and stems, as shown by the blank squares. The example is also illustrative of a very good method of giving interest to a style by the modifi-

cation of the ground weave. It will be noted that the ground weave is 2-and-1 warp rib, the greater portion being formed by the even ends predominating on the surface, but a trail pattern is introduced in which the odd ends predominate;

Methods of Ornamenting Warp-Rib Structures.—In order to further illustrate the diversity of effect that can be produced in the rib structures, a fabric is represented in Fig. 412, which shows a method of figuring by means of bright silk weft. Also a number of rib weaves are shown separately in Fig. 413, two or more of which can be used in combination. It is assumed that in the plans two figuring ends alternate with a fine binding end, and a fine pick with a thick pick, the figuring ends in the ground passing under the former and over the latter, as shown at A. In some cases the rib ground is given a very rich appearance by employing brightly-coloured silk weft for the fine binding picks. Where the silk weft floats over the

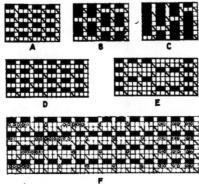

Fig. 413.

double-figuring ends, it shows as a fine line of bright colour between the ribs formed by the warp.

B in Fig. 413 shows the weave that is used in the ground of Fig. 412, and this and other variations of the rib-structure can be employed along with, or instead of, the ordinary plain rib. C illustrates the usual method of figuring with the rib ends; each float should be arranged to commence and terminate with a thick pick.

The plan D shows how brightly-coloured binding picks can be floated on the surface so as to diversify the form of a design; while, as represented at E, the thick picks can be similarly floated. The plan F illustrates the introduction, between the fine binding and the rib picks, of special figuring picks, the floats of which are represented by the circles. These special picks, which are really extra, can be used to spot the rib ground, as shown on the right of F, and to form a weft figure, as indicated on the left, both of which systems of interweaving are represented in Fig. 412. All the ends are lifted on the extra picks, except where the circles are indicated in F, Fig. 413, and the centre portion of the plan shows how the picks are bound in on the underside of the cloth.

INDEX

Printed in the USA
CPSIA information can be obtained
at www.ICGtesting.com
LVHW021742071023
760473LV00010B/1102